Please remember that this is a library book,
and that it belongs only temporarily to each
person who uses it. Be considerate. Do
not write in this, or any, library book.

# Doing ART Together

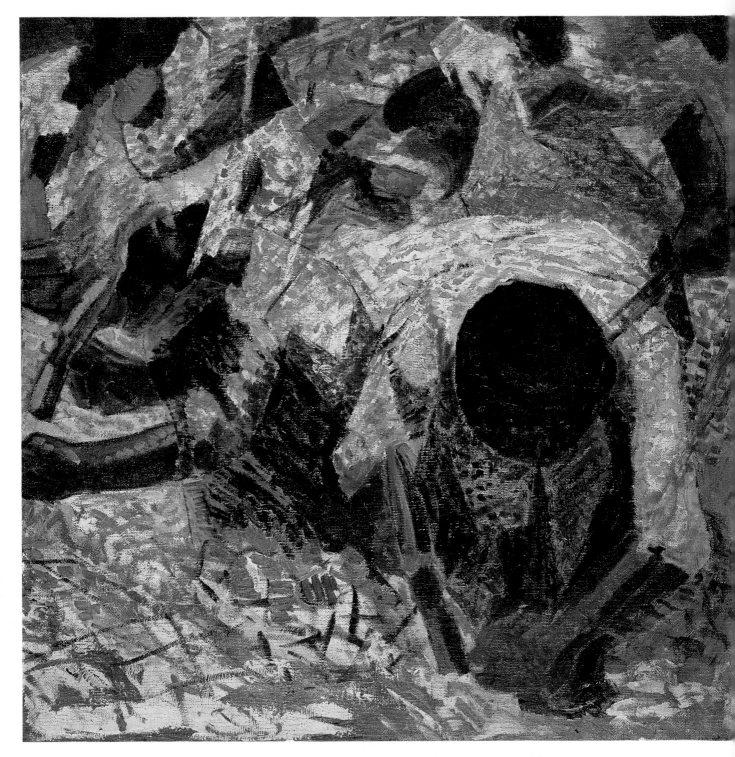

UMBERTO BOCCIONI (Italian, 1882–1916). *The Street Pavers.* 1914. Oil on
canvas, 39⅜ x 39⅜". The Metropolitan Museum of Art, New York, Bequest
of Lydia Winston Malbin, 1989 (1990.38.5)

# Doing ART Together

Discovering the joys of appreciating and creating art as taught at
The Metropolitan Museum of Art's famous parent-child workshop

Muriel Silberstein-Storfer with Mablen Jones

Harry N. Abrams, Inc., Publishers

# Contents

# Acknowledgments

Dedicated to
Herb, with deepest appreciation
for his consistent unconditional
support and advice. My unbounded
love and gratitude always
And to
Lois, who for years has shared her
great wisdom as an art educator
and her beautiful photographs
And to
Electra, who understands and
practices the true meaning of
doing art together

So much in life is a matter of connected circumstances that comprise an interdependent web of people and ideas, which can motivate and spin into creative acts. How fortunate I have been in having the supportive assistance and friendship of many wonderful people, so many in fact that it would be impossible to name them all within the space allowed. Certainly each of those with whom I have had the privilege of doing art together—family, teachers, students, and colleagues—has contributed in some way to the pages that follow.

The idea that art and life are inseparably intertwined like vines growing in and out of the branches of trees became clear to me at Fieldston High School in Riverdale, New York, where the arts were a strong part of the core curriculum. Victor D'Amico's art classes led to the knowledge that disciplined art skills and aesthetic awareness could enhance every area of life. He guided, supported, and respected our efforts as we found excitement in the discovery of art in the world around us. We exchanged ideas, developed a team approach in our relationships, and learned to understand the importance of respecting the differences between our own aesthetic choices and those of other people. We experienced what it meant to work individually, even though we sat side by side at a table, and to share and collaborate as a group.

After studying costume and scene design at the Carnegie Institute of Technology School of Fine Arts, my work in theater and interior display made it feel natural for me to transfer my art skills to hospital and community work. Early on, Dr. Richard Silberstein's strong and brilliant leadership in the fields of child development, community mental-health education, and drug prevention provided me with opportunities for greater understanding of the importance of lifelong education in fulfilling human potential.

When my first child was three, I enrolled in the parent-child workshops at The Museum of Modern Art (MoMA), where Victor D'Amico had become Director of Education. His fundamental belief was that parents are children's first teachers and therefore must learn how to promote sensory awareness and creativity in order to enhance affective and cognitive growth. After sharing Jane Bland's wonderful class with my daughter, Wendy, I returned with my two sons to continue taking parent-child workshops. Simultaneously during those years, I also had the opportunity to observe at the Staten Island Mental Health Society child-development workshops for parents and educators designed for the prevention of mental illness. Both organizations (The Museum of Modern Art and the Staten Island Mental Health Society) understood that interactive shared experience is more effective than lectures. They recognized that active participation in a group stimulated greater awareness in addressing similar problems, whether they dealt with art projects or daily family life.

The realization that my children and others needed a better arts education than their schools were offering catalyzed my decision to return to MoMA and enroll in Jane Bland's highly regarded teacher-training course. Her program offered fundamental information for leading art workshops and motivating students. She taught us how to find alternative materials for those that were unavailable, to improvise facilities, and to create inviting teaching environments, even with limited resources. Hers was a philosophy that could be incorporated into everyday life. Jane believed that children's time was too precious to waste in unproductive "busy work." She encouraged us to test tools and materials before offering them to anyone else in order to be certain that they would work well for the students.

I taught at MoMA until 1970, when the Institute closed down, and continued as art consultant for a variety of Staten Island Mental Health Society day-care and preschool programs for children, teachers, and families. Both experiences reinforced the validity of Jane's and Victor's philosophy that "art is a human necessity." One depressed young mother with five children, who lived below the poverty line with a very troubled husband, joined the Mental Health Head Start School art workshop for parents. She told me that she felt transported while doing art and happy about her workshop accomplishments. Subsequently, she sought a position as a teacher's aid in order to be close to the program. Later on she received scholarships to continue training and eventually became a successful art teacher in the Head Start School. These experiences transformed her life.

Leading workshops for several other organizations further proved to me that the courses would thrive no matter what the environment or background of the students. During those years I taught classes on a college campus, in a low-income housing project, and even in someone's unfurnished living room. With good organization, basic tools and materials, and a positive attitude, these methods seemed to work everywhere.

In 1971, Thomas Hoving, then Director of The Metropolitan Museum of Art, invited me to become involved with its programs and proposed my election as the Staten Island Community Trustee to the Board of Trustees of the museum. Shortly thereafter, in 1972, I was asked by Harry Parker III, then Director of Education at the museum, and Louise Condit, Museum Educator in charge of the Junior Museum, if I would teach parent-child workshops for members and their children. I have had the great pleasure of doing so ever since. I wish to

express particular thanks to those who were most supportive during those early years. Douglas Dillon as Chairman of The Board of Trustees; Roswell L. Gilpatric and J. Richardson Dilworth, Vice-Chairmen; and former President William B. Macomber were always supportive of my active role in the area of educational services. Current Director, Philippe de Montebello; Kent Lydecker, now Associate Director for Education; and Nicholas Ruocco, Museum Educator, have expressed enthusiasm for the workshops. Under their leadership the museum continues to offer an atmosphere of serious purpose and exciting, ever expanding projects for the future. I am deeply grateful for the climate of stimulating ideas and concern for learning in which this book has been nurtured.

The original and revised editions of this book benefited from extraordinary support and guidance from Bradford D. Kelleher, formerly Vice-President and Publisher at The Metropolitan Museum of Art and now Consultant for its Publishing and Merchandising Activities; graciously aided by Faye E. Lee, his executive assistant. Many departments and individual staff and board members at the museum contributed to this current volume, especially Sharon H. Cott, Secretary and General Counsel; Cristina Del Valle, Associate Counsel; Lowery S. Sims, Curator of Twentieth-Century Art; Nan Rosenthal, Consultant for Twentieth-Century Art; Beatrice G. Epstein and Mary F. Doherty, Associate Librarians; Deanna D. Cross, Photographic and Slide Library Coordinator; Eileen Sullivan, Librarian; and Rosa Tejada, Education Assistant. Thank you also to Gladys Riveros, who manages the art room.

While working on the earlier edition of the book, I met with educators in other countries as a member of the education committee of the International Council of Museums, an experience that led me to broaden my vision for the need to reach underserved populations, both abroad and in our own country. In 1982 I founded a nonprofit, self-supporting organization, in cooperation with The Metropolitan Museum of Art, called Doing Art Together, Inc., to work with public schools, social service agencies, and other special education programs. We believe in the widespread need for art education advocacy and visual literacy. As a result, I have been invited to share and promote the DAT methodology in a number of museums and other institutions in major cities in the United States. My longtime colleague Electra Askitopoulos Friedman, who also continues to teach at the museum, became cofounder of Doing Art Together and is now the Program Director. Her wisdom and passionate commitment to art education has convinced many administrators to bring our programs into their institutions. Her design and organizational skills in setting up workshops are unsurpassed. She has my deepest respect and trust. I would also like to express special appreciation to Audrey Irwin, our creative Administrative Director, and the very special staff of artist/educators, and the remarkable volunteers and members of the Board of Directors and Advisory Board, all of whom have worked diligently to make it possible for our outreach programs to expand and flourish.

Thank you to the many artists, collectors, curators, and art galleries who contributed work to this publication. Among these are Joanne Tully, who took the new photographs both of the workshop and students' work; Seth Joel, who generously allowed us to use photographs from the first edition; and to Lois Lord and George Obremski, two superb photographers, who were particularly gracious in allowing me to use their work. Others to whom I am grateful are Paulus Berensohn; Camille

Billops; William Brill; Mary Griggs Burke and Stephanie Wada of the Burke Collection; Thomas J. Burrell and The Kenkeleba Gallery; Leigh Burton; Ivan Chermayeff and Lori Shepard; Chuck Close; Emilio Cruz; Patricia Cruz, Deputy Director for Programs, and Pam Tillis, Curator, at The Studio Museum in Harlem; Earl Davis; The Edward Thorpe Gallery; Amy Ernst; Joan Giordano; Mimi Gross; Renee Gross and April Paul of The Renee and Chaim Gross Foundation; Richard Haas; Grace Hartigan; Valerie Jaudon; Paul Jenkins and Suzanne Donnelly Jenkins; Jacob Lawrence; Hana Machotka; Juan Moreira and Tina Spiro, Chelsea Gallery, Kingston, Jamaica; Petrona Morrison; Elizabeth Murray; Mike Nevelson; Nina Nyhart; Sanda Zan OO; PaceWildenstein; The Paula Cooper Gallery, Inc.; Judy Pfaff; Howardina Pindell; John Rhoden; Lucas Samaras and Pace Editions; Juan Sanchez; Robin Schwab; The Sheldon Ross Gallery; Todd Siler and Ronald Feldman Fine Arts; Doug and Mike Starn and PaceWildensteinMacGill; Betty Blayton Taylor; Ursula von Rydingsvard; The Walter Wickhiser Art Gallery, Inc.; Randolph Williams; and Philemona Williamson, Sherry Bronfman, and The June Kelly Gallery

I am deeply grateful to others involved in the process of bringing this work to publication: especially to Harriet Whelchel, editor of this volume; designer Darilyn Carnes; to Margaret Kaplan, Senior Vice-President and Executive Editor of Harry N. Abrams, Inc., who showed interest in a new edition and presented the idea to Paul Gottlieb, President, Publisher, and Editor-in-Chief; to Berenice Hoffman, Literary Agent, whose negotiation skills facilitated consummation of the project; and to Cynthia Smith, for her many efforts in countless ways. Thanks also to Debra Zichichi for help in assembling the manuscript.

Once again I have had the good fortune to work with Mablen Jones who was tireless in making certain that we found the right reasons for the language we used and the right words to support them. Her wide-ranging knowledge was consistently helpful and our book enriched by her experience as a practicing artist, writer, photographer, and teacher.

M.S.S.

# Preface

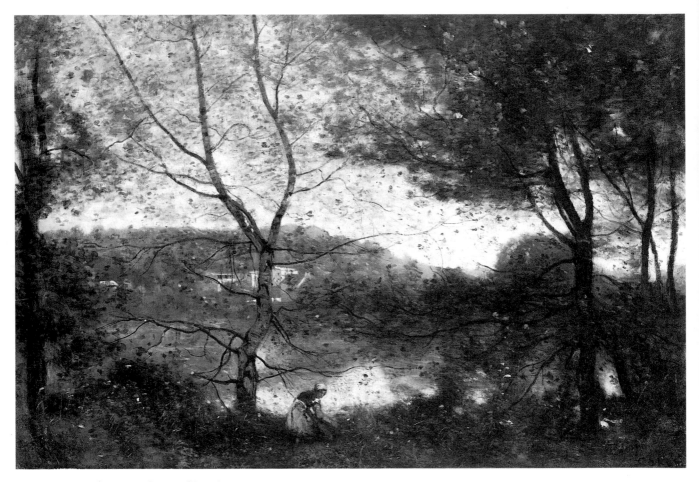

JEAN BAPTISTE CAMILLE COROT (French, 1796–1875). *Ville d'Avray.* Oil on canvas, 21⅝ x 31½". The Metropolitan Museum of Art, New York, Catharine Lorillard Wolfe Collection, Bequest of Catharine Lorillard Wolfe, 1887 (87.15.141)

Many artists, scientists, and philosophers have pondered the power of the mind for both positive and negative output. Sylvia Ashton-Warner, who wrote *Teacher* based on her work with Maori children in New Zealand, saw the mind of a five-year-old "as a volcano with two vents, destructiveness and creativeness." She emphasized that "to the extent that we widen the creative channel, we atrophy the destructive one." My belief that anybody's mind can have the energy of a volcano leads me to see Todd Siler's painting *Mind Icon: Meditating on the Inferno* as a dynamic image for the force of creativity. I have seen studio workshops enhance the potential for personal growth through the joy of working with art materials and discovering diverse images from art and science.

Information gathering cannot replace hands-on experience. Computer-keyboard training offers little observation of the real physical environment, let alone development of hand skills. Indeed, our age of remote control may lead to shortened attention spans with habituation to fast video-editing styles and instant, push-button feedback, causing us to miss out on much wonder and beauty in the real world.

The opportunity for guidance with studio practice is even more important than it was in the past since this kind of education is gradually disappearing as school funding for the arts diminishes. Tactile manipulation is a fundamental necessity for human development, and every few years more published research verifies this fact. Adults forget how they learned and often become impatient with beginners of any age. They may also have been unaware of their own classroom group dynamics.

An initial problem for those who want to guide others in the mastery of any skill is not knowing what successful teaching involves. Preparation for taking

TODD SILER (American). *Mind Icon: Meditating on the Inferno.* 1988–89. Monotype with mixed mediums and collage on paper, 30 x 44". Courtesy of Ronald Feldman Fine Arts, Inc., New York

*The arts share nature's sole gift—the joy of seeing all possible worlds and of conveying what is seen and experienced. Art explores with or without explanation in mind, with or without description in mouth or in gesture. It lives as the universe lives—open ended.*

—Todd Siler, *Breaking the Mind Barrier: The Artscience of Neurocosmology*

responsibility as a leader includes: setting both spoken and unspoken standards, setting limits on behavior, establishing values about doing things well, and inspiring courage to help others to go from the known to the unknown. Leadership skills can be learned and this book teaches the craft with Tips for Teaching. Besides delegating certain responsibilities to the workshop leader, participants learn how to work independently and how to remotivate themselves when facing barriers.

Learning how to share experiences without being overly intrusive is an important skill in the art of doing anything together. These workshops emphasize learning coexistence and respect for differences of both viewpoint and abilities. Ignoring ethnic or other personal differences makes it more difficult for both

individuals and the group to function well. Some people may have cultural preconceptions and additional physical or psychological disabilities that they may attempt to hide or not even realize. Once when my colleague Electra Freidman was leading a torn-paper project, she asked everyone to work with two colors of construction paper. After a newcomer to the class began arranging a few more different colors, she approached him in a lighthearted way, saying, "I see you are working on next week's project as well as this one." Looking puzzled, he asked, "Why?" After she explained that they were using two colors this week and more later, he revealed that he was color blind—able to see only shades of dark and light—and was concentrating on the shape arrangements. Together they picked two contrasting papers that allowed him to successfully complete the work. If she had assumed that he willfully ignored her instructions and made him feel guilty with criticism, the situation could have become uncomfortable and unproductive.

Studio practice offers an opportunity to hundreds of thousands afflicted with various forms of dyslexia, an impairment of language, number, or reading abilities. These people often have developed compensating skills in other visual and tactile areas. Many artists accepted the challenge of their disabilities early in life with the support of adults who recognized and valued their strengths. For example, Chuck Close said that as a child he had difficulty learning certain kinds of things; however, his drawing ability was advanced, and he received much support from his mother, who valued what he could do. Later, after becoming a successful artist, he suffered a debilitating condition that left him paralyzed. He regained some use of his limbs through intensive therapy but had to learn new ways of working, and he changed his style to accommodate his physical

CHUCK CLOSE (American, b. 1940). *Georgia.* 1985. Pulp paper on canvas, 96 x 72". Courtesy of PaceWildenstein

The artist's early style demonstrates technical virtuosity and control of medium. See also how successfully he adjusted his work later in his career (pages 23–24) to accommodate his changes in dexterity.

disability. The point is that no matter what your limitations, there is some studio practice that almost everyone is capable of doing. An art educator/therapist I know who helps people with attention-deficit disorders and a variety of other problems, has reported excellent remedial results with her studio classes.

Perception occurs with more than the eyes alone; all the senses nourish the mind. Art critic Robert Hughes details this fact in his description of a John Constable landscape painting:

*His childhood was substance rather than fantasy: tactile memories of mold, mud,*

*wood grain and brick became some of the most "painterly" painting in the history of art. The foreground of "The Leaping Horse" is all matter, and the things in it—squidgy earth, tangled weeds and wild flowers, prickle of light on the dark skin of water sliding over a hidden edge—are troweled and spattered on with ecstatic gusto. This is the landscape of touch.*

—Robert Hughes, quoted in Yi-Fu Tuan, *Passing Strange and Wonderful: Aesthetics, Nature, and Culture*

Ideas do not magically come from thin air. Some of our deepest memories evolve from combined sensory impressions. When the deceased heroine in Thornton Wilder's play *Our Town* is allowed to relive a day in her former life, she realizes with regret that her life had gone by so quickly that she had never taken the time to cherish the wondrous details of earthly life: "clocks ticking . . . and Mama's sunflowers. And food and coffee. And new-ironed dresses and hot baths." Vague memories do not produce insight, however; actually making something tangible from them does. In shaping a play that allowed us to learn from his insights, Wilder reminded us how ordinary impressions may become extraordinary through the artist's ability to create form, whether in a play or a painting.

These examples by John Constable and Thornton Wilder demonstrate how sensory impressions can be transformed from one medium to another. One of our studio activities involves doing a painting motivated by the interpretation of a word or sense of place. (See page 92.) Just as life experience is transferable into artwork, studio skills can be transferred to the study of diverse subjects.

Practice with art materials sharpens sensory awareness in a manner that simply looking at things cannot. You may have a color in your mind's eye, but it is not until you mix it yourself that you understand its precise properties, and you still may have no vocabulary for those nuances. According to cognitive scientist Douglas Hofstadter, most of our concepts are wordless even though we try to describe them. Sometimes only making an image or physical object can clarify the meaning. That is why many people like artists and scientists make models.

*At such points where deep human emotion, identification with other beings, and perception of reality meet lies the crux of creativity—and also the crux of the most mundane thoughts.*

—Douglas Hofstadter, "Variations on a Theme as the Crux of Creativity," in *Metamagical Themas: Questing for the Essence of Mind and Pattern*

At his teacher workshops, Victor D'Amico used to say that we come together as a group of strangers, and, through working together, we become a family of friends. I have seen how people from very diverse backgrounds come to identify with a common pursuit, no matter what their differences are. In these studio workshops participants not only identify with the common challenges in a noncompetitive atmosphere, they learn to identify with art makers throughout civilization. By doing art together, we can benefit from each other's insights and build from the collective strength of many minds. If through working together we can learn to respect diversity, we can share our differences without confrontation. If we can pass along the tradition of doing art together from generation to generation, we can build communities transcending our individual lives.

# 1. The Art Experience

AUGUSTUS VINCENT TACK (American, 1870–1949). *Night Clouds and Star Dust.* 1943. Oil on canvas mounted on composition panel, 64 x 32$^1$/$_2$". The Metropolitan Museum of Art, New York, Gift of Duncan Phillips, 1964 (64.250)

*After all it is a great adventure—a great exploration with the infinite beckoning on.*

—Letter from the artist, in Kynaston McShine, ed., *The Natural Paradise*

## Belonging to a Tradition

*T*oday most Americans neither have access to learning how to make things with their hands, nor do they understand how to begin the process. Anesthetized by modern conveniences, relatively few learn and practice a craft. In the past, painting, woodworking, cooking, quilting, and writing letters by hand, activities that provided marvelous tactile and emotional encounters, were passed down from parent to child or from master to apprentice. Often these activities were performed in social contexts and made part of daily life.

Now it seems that many adults have had very little tactile experience since leaving grade school, and many children receive little if any exposure there. Consequently, people of any age often enter into a studio workshop with either tremendous enthusiasm or deep concern. Once in a workshop I noticed a young mother, a highly educated and successful scientist, giggling as she worked. I asked her why she was so amused. She replied, "I'm just feeling so happy! I never thought I could do anything like this."

If you cook, not only do you taste unfamiliar dishes with great interest, savoring the individual herbs and spices, but you also can feel an identification with the other cook who made the meal. If you sew, you appraise new clothing designs with a more precise eye. If you do woodworking, you notice the details and quality of finish in furniture. Deep knowledge often comes by learning things through the hands as well as the mind.

Participating in a communal creative activity may bring a sense of belonging as well as teaching many skills. Studio work can also bridge cultural and linguistic barriers. For example, Wing, a fourteen-year-old who was learning English as a second language, was enrolled with much younger children in a summer remedial reading and art program to help with his verbal and reading skills. Working with colors for the first time, he reacted angrily when younger classmates frequently teased him. While painting, a passing child jostled his arm, and when Wing turned and grabbed the boy the teacher had to intervene. As Wing returned to his paper he cried out in bewilderment, "Who did that? How did that color get on my painting?" A green streak sat where his jostled hand had swept his loaded brushful of blue across a

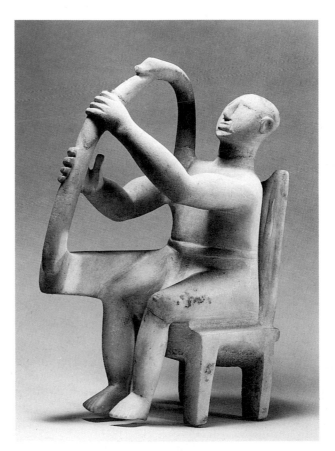

*Seated Man with Harp.* Cycladic, c. 2500 B.C. Marble, height 11½". The Metropolitan Museum of Art, New York, Rogers Fund, 1947 (47.100.1)

Art-history courses provide a certain amount of historical information about art, but the studio process allows one to become part of the universal tradition that has brought forth these works, as well as teaching many skills. This ancient sculpture possesses abstract visual qualities common to some twentieth-century pieces.

still moist yellow area. The teacher recognized her opportunity to make Wing special in the eyes of the other students and exclaimed, "You made green, Wing!" Apparently since the other children had not discovered how to make green, they all gathered around him to see what he had done that was so wonderful. She had him repeat the process of putting blue on yellow to demonstrate for the others how he had done it. Not only had he learned to make green, but his ability to do something special had made him less defensive. Wing's self-confidence grew, along with his interest in studio work, and seemed to carry over to all of his studies.

## Defining Your Expectations of Success

When you teach beginners how to row a boat, you do not necessarily expect them to become ship's captains; when you learn numbers, you do not anticipate becoming a bank president, although both of these things may happen. If you teach people to draw, you cannot expect them to become professional artists. But if you share a body of positive experience with another, you can expect to develop an aesthetic dimension in both your lives, no matter what else you decide to do.

Popular opinion has sometimes held that artistic talent is born, yet not all visual sensitivity is innate. It is created by a mixture of exposure and encouragement. Many kinds of abilities can be developed through the projects described in this book: a talent for making choices, a talent for patience, a talent for sensory awareness and visual discrimination, a talent for finding solutions, and a talent for integrating thoughts into visual forms.

Using your talents or abilities effectively involves an open approach to new ideas and having the self-confidence to execute them. The following projects do not teach facile techniques for pleasing and impressing others with pretty products; rather, they stress learning to trust your own way of seeing the world around you so you can be receptive to all kinds of experiences.

Many people, like Alice in Wonderland, are stimulus bound. They eat the cookie when it says, "Eat me!" Some are defenseless against the sophisticated visual commercials that say, "Want me!" When you notice the visual qualities that make the images so appealing, the changes of scale and proportion, and how images of beauty and energy often have nothing to do with the intrinsic qualities of the products, then you are recognizing the many uses of visual language. These are not merely elements of art but also a means of daily communication. Having a context in which to deal with images makes it possible to evaluate them instead of responding automatically.

It is not productive to judge any beginners, no matter what their age, against those who are experienced with art materials. Beginners may not be able to do something as easily and fluently as those who have already developed fine motor coordination. "Correcting" any beginner's artwork to make it look pleasing deprives them of the confidence to make their own aesthetic choices. Worrying about meeting anyone else's expectations makes novices anxious, and this tension interferes with their visual perception. Students, young and old, must work through every stage of their development because there is no skipping any step along the way.

## Making Connections

Within any group, even within a family group, shared studio activities can provide a lifeline of communication. A young

interesting collage materials such as fossils, seashells, and pieces of rock that we could share together with pleasure.

This is a book for beginners of all ages and for those who would like to pick up where they left off somewhere in the past. You probably enjoyed using paint and clay and cutting up paper sometime in elementary school. Yet if you never were encouraged to create designs of your own,

Sharing aesthetic pleasures with others of any age allows us to discover new experiences and also return to enjoyable ones that we may have left behind.

acquaintance from a small town in middle Florida found that, after living for more than ten years in New York City, he had very few topics of conversation in common with his parents. However, he and his father could go out to the garage and do cabinet work in harmony. Woodworking, the hobby his father taught him, was something they could still enjoy without arguing.

My daughter, Wendy, reintroduced me to painting when we took parent-child classes together. My sons, Jeffrey and Charles, led me to offbeat places to search for unusual materials in the woods and the beaches. Even when we could not agree on some things, my children were always on the alert, wherever they were, for

Adults sometimes have difficulty starting something new because they are reluctant to place themselves in the role of a beginner, particularly with things they think they should know. Yet when you relate studio skills to other things you have learned in your life and put these into a new focus, you may find that you are not as much of a beginner as you thought.

such activities may have never become part of your life. My mother told me in her later years that she would have loved to have known more about art and to have worked with studio materials herself, but she felt self-conscious about trying at her age. Like so many others, she did not know how or where to begin.

You certainly have more basic experiences than children and there is nothing in these workshop projects that does not relate to some skill or sensitivity you have developed in your daily life. For example:

■ If you are interested in music, you may have considered or examined changes of rhythm; color of sound, phrasing, and intervals in melodies; and repetition and contrasts of themes.

■ You may like to photograph nature and enjoy looking at landscapes and natural objects.

■ You have probably learned out of necessity how to organize the spaces in your home and know at least some elementary manual skills of home maintenance, clothing repair, cooking, and setting a table to make a meal more appealing. You may also decorate packages and cakes and make holiday ornaments and color-coordinate your clothing and furnishings.

■ You may seek and evaluate films and theatrical performances that feature dramatic visual effects.

■ If you are a sports fan, you may be sensitive to changes in the visual rhythms and movements that influence the outcome of a game, and you may be a keen observer of the choreography of people's gestures.

■ If you sew and are acutely fashion conscious, you may analyze how the cut of the cloth, patterns, and colors affect a design visually.

■ If you are in the sciences, you may organize visual information and may have developed powers of observation beyond those of the general population.

■ You may make a variety of doodles while at the telephone and write letters in longhand, which would develop fine small-muscle coordination.

Although you may not know how to mix colors or how to start a painting composition, you come to these projects with your own unique package of experiences and skills that you can incorporate into the use of art materials.

Using studio materials develops all our senses. Research has found that touch is intimately connected to visual perception. Those with little tactile experience fail to "see" many things because of diminished kinesthetic sensitivity. You only interpret certain visual phenomena through memories you have had when touching those things.

Sometimes in the beginning, very young children try to see, hear, taste, touch, and smell everything. I have seen them try to taste the clay and glue or smell and feel the studio materials, especially if they haven't had the opportunity for tactile experiences. They often have the urge to smear the paint with their fingers. Adults may also go through some of the same processes. Once a father who had never attended class before came to the tissue-paper workshop. When I saw him start to pour out the glue and smear it with his hands, I asked him to please use the brush, and told him that I would clarify my instruction later. After class, I explained that if beginners pour out the glue they can't control the material, and, like the "tar baby" of fable, will get glue everywhere and make everything stick together. He looked at me with disappointment as he said, "But I never get to do anything like that anywhere else."

If before experiencing these projects you are told that there is a way to rediscover the wonder of the visual world, you probably will not believe it. You may not think that you can learn a language that communicates all around the world and

transcends time and place, that captures
fleeting sensations and constructs new
ways of thinking. Yet many people who
have taken these workshops discover these
possibilities themselves.

*If the painter wishes to see enchanting*
*beauties, he has the power to produce*
*them. If he wishes to see monstrosities,*
*whether terrifying, or ludicrous and*
*laughable, or pitiful, he has the power*
*and authority to create them. If he wish-*
*es to produce towns or deserts, if in the*
*hot season he wants cool and shady*
*places, or in the cold season, warm places,*
*he can make them. If he wants valleys,*
*if from high mountain tops he wants*
*to survey vast stretches of country, if*
*beyond he wants to see the horizon on*
*the sea, he has the power to create all*
*this; and likewise, if from deep valleys he*
*wants to see high mountains or from*
*high mountains deep valleys and beach-*
*es. Indeed, whatever exists in the uni-*
*verse, whether in essence, in act, or in*
*imagination, the painter has first in his*
*mind and then in his hands. His hands*
*are of such excellence that they can*
*present to our view simultaneously*
*whatever well-proportioned harmonies*
*real things exhibit piecemeal.*

—Leonardo da Vinci, Italian Renaissance
painter, *Notebooks*

Although none of my own children
elected to become painters or sculptors,
they have all incorporated their early art
experiences into their daily existence. Jef-
frey, an inventive business entrepreneur,
has told me that he gained the courage to
try things his own way, to experiment on
the piano and in the kitchen. As a teenag-
er, he made kinetic sculptures from electri-
cal parts and still works in a creative way
with his hands and tools. Wendy, who cur-
rently works in health care and counseling,
is a strong advocate for arts education in

Many adults come to the parent-child studio classes to do something
educational for their children or grandchildren without high expecta-
tions for their own success. They are astonished to find that they can
invent paintings, collages, and sculptures and complete projects within
their own level of abilities.

schools and has returned as a parent to the
workshops herself.

Charles, a psychiatrist directing a
therapeutic community for drug abusers in
a hospital, has told me that learning to
observe and to communicate visually has
been invaluable. Many years ago, when he
visited India, he frequently encountered
people with whom he shared no spoken
language and for whom almost every visu-
al aspect of the world was different from
his own. When he was suddenly confront-
ed with an urgent need to use his eyes and
gestures to observe and communicate, he
started to draw and wished that it came
more easily to him. If he could sketch
well, he thought, it would not only help
him to communicate, but it also would be
a valuable way of recording thoughts and
images that could not be duplicated by a
camera, simply because they only existed
in his mind. Seeing visual work in this
new way made him think about my class-
es. "It seems to me you are enabling people

to transcribe their very personal feelings and thoughts onto paper," he wrote to me. "When they're finished they can feel that this creation is theirs, all theirs, only theirs. I can't think of a more important skill. This form of expression transcends barriers raised by individual verbal languages." He now stresses how important working with studio materials can be for people with minimal verbal abilities.

## Art and Therapy

Although this program is not intended to replace the specialized kinds of focus in either psychological or occupational therapies, the kinds of activities in these sessions can augment other routines. For further information in guiding art sessions for those who are physically challenged, see Dr. Henry Schaefer-Simmern's book *The Unfolding of Artistic Activity*. He puts forth the view that studio activity is superior to physical therapy alone. For dealing with psychological disabilities, see Edith Kramer's books: *Art as Therapy with Children* and *Childhood and Art Therapy* offer practical advice and personal examples of how she has worked with students with emotional disturbances and at various levels of retardation.

The certified art therapist is required to study normality and pathology in human development. Although art teachers may or may not have this specialized knowledge, they are trained in the use of studio materials and teaching methods. The art therapist is primarily concerned with helping a person to function in society but may have no idea what a quality art experience is. That is why Edith Kramer recommends that art therapists also be practicing artists. In that way they will understand the risks and challenges that their patients face with studio processes.

## Electronic Media

While computers have empowered many aspects of education, they cannot replace tactile and kinesthetic training and the direct personal interaction of a group workshop. The danger of becoming "information rich" and "experience poor" is that one fails to develop the ability for evaluating the meaning, value, and veracity of this information. Physical movement and touching things is a necessary part of perception, and one does not have that experience when pushing buttons while fixated on a screen. Take for example a walk through a summer garden. Full knowledge of the whole sensory environment of sight, sound, smell, temperature, and touch requires being there in person. Spaces walked, climbed, and lived in become internalized into body memory.

While computer-arts programs simulate the appearance of an artist's tool marks, they do not afford the same kind of kinesthetic experiences as do brush and paint touching paper or fingers modeling clay and cutting-out materials. I am deeply concerned by articles quoting young children saying that they like the computer because they can work "neatly" and the teacher does not get angry that their work is "messy." When they say that their hands do not get tired from using the computer, they are also failing to develop their small-muscle skills. Although the computer is a powerful tool that everyone will need to be able to use, it cannot replace the kinds of physical interactions in these workshops.

For an interesting discussion on the relationship of the computer to education, both Theodore Rozak's *The Cult of Information* and Clifford Stoll's *Silicon Snake Oil: Second Thoughts on the Information Highway* offer alternative views to the contemporary utopian promises of technology.

## Aesthetics of the Everyday

*I*n many traditional cultures, aesthetic perception and practice were an integral part of daily life. For example, Japanese tradition requires respectful attention to the quality and form of executing simple tasks, such as wrapping a half-dozen eggs to carry home for dinner or serving tea. Presenting a meal attractively on a plate, viewing the cherry blossoms in the spring, and negotiating the delicate choreography of everyday social encounters were viewed by a part of the society as necessities of life. In every society, ceremonial rites of passage such as weddings and funerals take on special aesthetic forms.

In *The Way of Chinese Painting*, Mai-Mai Sze notes that the earliest Chinese Daoist philosophers regarded painting with a similar attitude as they did prophecy, divination, and alchemy. In Daoism each of these practices had a similar precision of method and approach. The range of paint colors represented the five elements and the preparation of their pigments was thought to have come out of alchemical brewing, for both involved a distillation or refining process to extract colored minerals. Something magical did indeed happen when the brush transmitted spirit to silk or paper. Things changed. Superior artists were revered for their ability to see beyond surface appearances and instill in their painting the ineffable spirit of things.

This reverence for the aesthetic quality of living is still relevant for us today. It functions to balance the personality and to create an awareness of our surroundings so that we can take an active part in improving our environment. Even today we elevate those who display insight in their works, yet every one of us has this capability. However, most do not know how to bring it forth.

Daoist painting in China was seen as part of the *dao,* or ever-moving rhythm and way of life. The projects presented in this book have a similar underlying aim: to celebrate the process of change, to learn to accept and be aware of the present moment. I believe that accepting life is accepting change. These projects focus on changing forms. When you have the courage to change things, you have the possibility of personal growth.

The aim of our workshops is similar to the practice of the Japanese *sumi-e* brush-ink painters: that is, to express free movement of the spirit with effortless self-control. This effortless realization is the fulfillment of life, since once we learn to do anything well, it will seem easy. The activation of the senses in the studio process can be a first step away from imprisonment within the solitary confinement of the self. From this all else follows.

*Y'know the real world, this so-called real world,*
*It's just something you put up with, like everybody else.*
*I'm in my element when I am a little bit out of this world.*
*Then I'm in the real world—I'm on the beam.*
*Because when I'm falling, I'm doing all right;*
*When I'm slipping, I say, hey, this is interesting!*
*It's not when I'm standing upright that bothers me;*
*I'm not doing so good; I'm stiff.*
*As a matter of fact, I'm really slipping most of the time, into that glimpse.*
*I'm like a slipping glimpser.*

—Willem de Kooning, American painter,
*Sketchbook I, Three Americans*

# 2. The Home Work Space

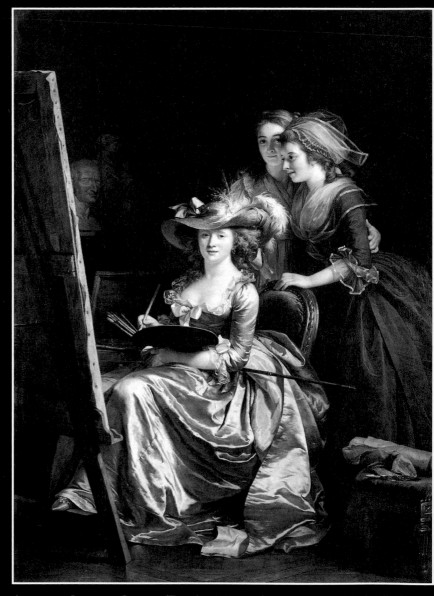

ADÉLAIDE LABILLE-GUIARD (French, 1749–1803). *Self-Portrait with Two Pupils, Mlle Marie Gabrielle Capet and Mlle Garreaux de Rosemond.* 1785. Oil on canvas, 83 x 59½". The Metropolitan Museum of Art, New York, Gift of Julia A. Berwind, 1953 (53.225.5)

Although you would ⬛⬛⬛⬛ress beginners in their party clothes to pa⬛⬛⬛ hen professional artists dressed up in finery to work on portraits, they felt that they were presenting images that dignified the painting profession.

## *Fear of Paint*

𝒲hen I first suggested setting up an area where children could come to paint and make collages at an outdoor Family Holiday fair, an experienced elementary school teacher challenged me, saying, "How could you possibly do that with hundreds of children participating all day? It will be a disastrous mess." Clearly she had not had the experience of successfully organizing a work space and system for using it with children in the studio arts. This lack of knowledge and fear of loss of control is the same reason adults often do not allow children to help in their daily tasks at home, let alone paint there.

I do not think of working with art materials as "messy," although it can be so. When you sit down to dine at a beautifully set table, it is difficult to eat without creating some disorder. Forks and knives are rearranged, plates and glasses will need washing, and crumbs may fall on the floor. Likewise, as you paint, cut, paste, or use clay, things will get redistributed. But they need not get out of hand if you plan and set up the work space carefully. Moreover, each medium has specific properties that you will learn to handle, not only for the success of your final results but also so that you can enjoy the process.

Your planning should take into account the fact that things may often spill, drop, or fall over. Although you must let beginners try things, or they will never learn to do them independently, you do need to make certain choices for them, ones appropriate to their abilities and experience. For example, you can protect your floor with newspapers or a washable covering, keep paint and water containers inside a tray with sides to contain any spills, fill bowls for young or infirm beginners no more than one-third full, and make sure chairs, stools, and work surfaces are at the right height for a successful

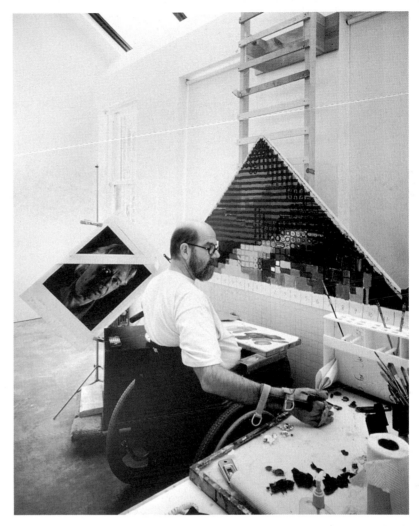

Chuck Close working on *John*, 1992. Oil on canvas, 8' 4" x 7'. Courtesy of PaceWildenstein

Chuck Close arranges his work space so that all supplies are within easy reach.

experience. There are fewer accidents in a well-planned environment, which includes properly fitting smocks. If you set up the work space in the manner discussed in this chapter, and have everyone dress appropriately, you needn't be afraid of paint.

Much of your own apprehension and handling of the studio situation depends on your idea of what is "dirty." Dirty implies a foul or filthy substance, something vile or worthless. Paint has none of

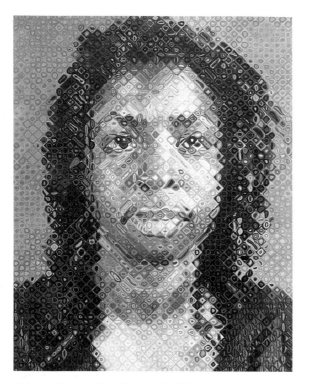

CHUCK CLOSE (American, b. 1940). *Lorna*. 1995.
Oil on canvas, 8' 4" x 7'. Courtesy of PaceWildenstein

Detail of *Lorna*

These examples of Chuck Close's finished work
illuminate his process of working with grids.

these qualities. When you wash your hands after greasing a pie pan, your hands are not dirty, they are greasy. When you wash a brush the water is not dirty, although it may have been darkened by paint. If you equate paint with dirt, you are apt to be apprehensive about studio organization and spilled drops of paint.

## Choosing a Space for Studio Work

Equating the studio process with a special place where specific activities are done helps focus attention and establish a serious attitude. Wherever you are working, it is important to be comfortable and feel "at home" in your space so that you can be free to use your tools and materials. At first, it is necessary to work in the same room with young beginners or in an adjacent space where you can see them, although when they become more experienced you may both decide to separate your work areas. A workable arrangement of space is a basic requirement no matter how small or large, whether indoors or outdoors, in an office, kitchen, closet, basement, studio, or school.

The most critical aspect in setting up is to make certain that your space functions well for your purposes. Organization and routine studio procedures are meant to minimize accidents and confusion, not just to look neat or pretty. A well-set-up space leads to extraordinary freedom and confidence and the realization that there is nothing incompatible between control and aesthetic release. One makes the other possible.

The design of a studio space is similar in its requirement for functioning to that of a kitchen or cafeteria. In both you need places for preparing and setting out materials and using them, areas for waste

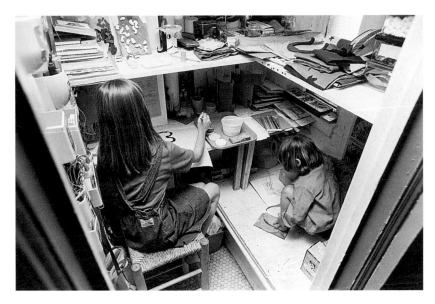

The Mohr family art-studio closet

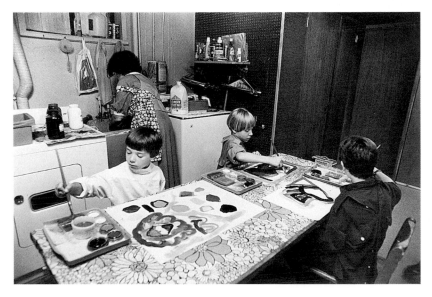

The Ribaudo family art-studio basement

Your home or apartment has areas that can serve as models for many studio setups. A basement or a walk-in closet kept in an orderly fashion are good examples.

Senior beginners working on collages

disposal, traffic control, cleanup, and storage of leftovers. Proximity to your activities, comfort, and good light are necessities, although everything beyond that can be improvised. You might also consider your home traffic patterns. If your chosen area is heavily traveled, there will be more distractions. Remember to keep the work space out of the path of swinging doors to avoid accidents. While a sink is convenient, it is not necessary, since you can keep a plastic dishpan of water nearby to clean tools and hands at the appropriate time.

Even though you need to be in sight of very young beginners at all times, everyone, no matter what age, needs some privacy. If you are both working at the same table, put enough space between you so that you don't become overly directive of another person's work. One experienced kindergarten teacher, an amateur painter herself, had used studio materials with children for more than fifteen years. But

when she attempted to draw while in a teacher's workshop, she discovered she became inhibited when other students looked over her shoulder at her sketch pad as they passed by. She now realized that she had been doing this to children and understood how uncomfortable they must have felt.

Rooms with windows have the added luxury of enabling you to observe the ever-changing conditions of nature and light. They also give the opportunity to point out the colors, shapes, and patterns of buildings, silhouettes of branches against the sky, and the changing shapes of clouds.

*I can sit right here in the dining room of 29 Spring Street, looking at the enormous school building across the street. Hundreds of windows with the sunset reflected on them like molten gold. Then the moon will come over and give it another light, then the windows at night will be totally black, and one window*

*with one tiny light will appear for me.
These are the keys to my existence.*

—Louise Nevelson, American artist, *Dawns
& Dusks: Conversations with Diana MacKown*

*The artist looks out the window. Does he
see things differently? It is not so much
that he is trying to be different; his exist-
ing need forces him to see differently. He
must differentiate in his vision in order
to make it distinctive. He has to trans-
form what is in front of him in order for
it to be seen at all. He can paint it in
various ways, but it is for him to decide
his way.*

—Paul Jenkins, American painter, "Editions
Galilée," in *Anatomy of a Cloud*

*I looked out my window and discovered
things I never thought about before. I
never stopped to realize all the shapes of
the city skyline, how different they look
early in the morning before I send my
children off to school and in the nightime
after I put them to bed.*

—Twenty-nine-year-old mother in Head
Start parents' workshop

On the other hand, rooms where
there are no windows can also work well.
For years I have taught in studios where
the walls contained only bulletin boards,
storage counters, and sink space. I put up
reproductions of works of art, photo-
graphs, and collage materials, and make
arrangements of variously shaped objects
on the table for visual motivation. Some-
times I bring in tree branches, leaves, and
flowers to help beginners build an aware-
ness of shape, line, and color.

## Setting Up the Work Space

*W*hen planning a work area that encour-
ages a sense of order for studio routines,
try to determine what responsibilities you
wish to allot to each participant. Keep in
mind their experience and muscular con-
trol capabilities. It is desirable with young
children to keep supplies out of sight for, if
they are visible at all times, they may
tempt very young beginners to use them at
the wrong time in the wrong place. As
children become more experienced and
skillful in handling materials, you can
make these more accessible for indepen-
dent work. For young beginners some
tasks may be impossible, given the heights
of your furniture. Containers that are too
big to handle may create difficulties and
accidents leading to feelings of failure for
everyone involved.

Avoid confusion by keeping your area
simple and uncluttered by limiting visual
distractions and the number of choices you
have to make. Seeing a lot of different
materials while working is like visiting a
candy store and wanting to taste every-
thing in sight.

### STORAGE

Because storage is important, try to make
the storage area as close to your immediate
worktable as possible. Set aside a closet,
kitchen shelves, a small cupboard, book-
shelves, or chest of drawers just for art
materials. Although drawers are less con-
venient than shelves because you often
have to unbury items you do not see,
shelves must be out of reach of younger
children, lest they spill large paint or glue
bottles upon themselves before they know
how to handle them correctly. (A one-
pound jar of paint dropped on a foot can
be very painful.) Drawers can be fitted
with dividers to organize paper in one
section, scissors and brushes in another
(rectangular cake tins will work here).
Dumping everything into one large con-
tainer without dividers creates chaos and

wastes time and energy when you have to search through everything to get one item. Using regular cardboard shoe boxes or plastic boxes with labels or pasted samples of materials on the outside eliminates having to open all of them to find something.

It is important to show that you value what students have done by handling their work with respect. If you need to store paintings before they are completely dry, gently lay a piece of waxed paper over the horizontal wet surface. I have stacked more than a dozen partially wet paintings this way without smearing them. The waxed paper doesn't stick to the surface and you can save it for reuse. When you pick up a wet painting, hold it horizontally with two hands so that the paint won't run. Dry paintings may be stored between two larger pieces of cardboard hinged with tape to make a portfolio that is easy to keep on a closet shelf, under a bed, in a drawer, or behind a piece of furniture. This method will ensure that you do not crack thickly layered paint surfaces.

## THE WORKTABLE

It is best to work on a flat surface when using water-based paint because liquid paint will drip and run (unless it is very thick) on a tilted or upright surface. For this reason, most art educators feel that easels can be a handicap for beginners.

The work surface should be smooth so that it will be easy to clean and the paper or clay won't pick up unwanted textures. Remember, if you do not have a smooth table, you can pad a rough surface with a few layers of newspaper or wrapping paper and then cover that with a sheet of heavy plastic. If you use paper to cover the table, it is a good idea to tape down the ends so it does not buckle or get in the way. A washable waterproof cover-

ing is a necessity for any surface that may be harmed by water. Whatever you use to cover the work surface, try to find a neutral, solid color because prints and bright shades are distracting.

Because very young or hyperactive beginners have a limited attention span, I prefer to have them sit at a table to work. When they are comfortably seated on a chair or stool at the right height, they are more likely to focus on their work for a longer time. If they are standing or spread out on the floor, they may be tempted to move around if there are any distractions. And if they walk about with a brush loaded with paint, the brush might drip. If your more experienced beginners work well standing up, however, certainly allow them to do so. No matter what you decide to use as furniture, please make sure you eliminate anything that wobbles, rocks, or is unsteady, and adjust the seat to the proper height for the work surface.

## PROTECTIVE CLOTHING

Even though school-grade "washable" tempera or poster paint, white glue, and clay wash out of clothing, everyone with whom I work wears a smock or other cover-up over their comfortable clothing. Not only does it protect your garments, it provides a material to wipe your hands on during work. Wearing a special work outfit also establishes an appropriate attitude and sets the studio experience apart from other activities. I prefer absorbent cover-ups for wiping hands since a plastic one will not remove any liquid residue.

If you use an old shirt, make the body length short enough so that young beginners won't trip on it and the sleeves close-fitting so that they do not drag in the wet paint. Elastic at the wrists can help, but do push up the sleeves so that they are not covering the wrists.

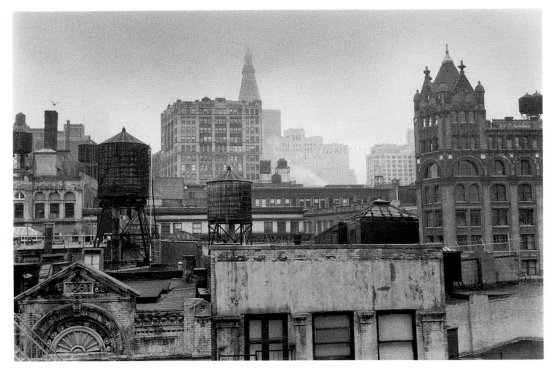

Lois Lord (American). *New York Rooftops.* No date. Gelatin silver print, 8 x 10". Courtesy of the artist

A collection of photographs and art reproductions is also helpful for explaining visual concepts of shape and composition.

## KEEPING A PICTURE FILE

A collection of magazine clippings, museum postcards or small reproductions of art, and photographs of many subjects can be invaluable for inspiring ideas for projects. Acquiring postcards may be a smaller initial investment than purchasing art books for their illustrations unless you can find secondhand volumes. Cards are versatile because you can pin or tape them up while working, display them on a bulletin board, or paste them into homemade or purchased books with blank pages. Magazines and brochures are also good sources of colors and shapes for collages. You might ask friends, neighbors, and your local library for old picture periodicals they are throwing out such as natural history and geographic magazines, photographic calendars, and seed catalogues with examples of a variety of colors, shapes, and patterns.

The Source Books for Studio Work listed in Additional Reading contain many reproductions. Other categories of volumes in the list are more for historic and other background information and have very few pictures.

## Buying Tools and Materials

Try out all tools and materials yourself before giving them to students to use, and please read the chapters on each specific medium to find the precise types of brushes and other tools and materials

recommended. It is best to go to an art-supply store for materials even if you are a beginner. Although some toy and craft stores offer good-quality studio tools, many do not. An art specialty store not only handles materials for professional artists and art students but also for amateurs. The rest of the items you will need are available in hardware, variety, stationery, and office-supply stores as well as supermarkets. A list of mail-order art-supply sources and further information on supplies begins on page 274.

If you have never had the experience of shopping for art supplies, you could end up spending a fortune on beautifully packaged, seductive-looking tools and materials. No matter where you buy supplies, avoid packaged paint sets that contain small quantities of many colors and cheap, soft brushes. (See also the discussion of kits on pages 36–37.) Even if you buy the most expensive of everything, you may still find yourself frustrated when you attempt to use the materials if they are inappropriate for your particular project.

Professional tools, not necessarily the most expensive, but standard ones that work well, can last a long time when used with care and respect. To begin, buy just the basic tools and materials of a quality high enough to really give you a chance to get interested in the mediums. Scissors must be sharp enough to cut easily and glue and clay must be of the right consistency to avoid frustration.

I will always remember a particular meeting with Dorothy Maynor, the opera singer who founded the Harlem School of the Arts. Mrs. Maynor asked my advice about organizing a studio program for parents and children. When I expressed my ideas about the quality of equipment needed for the program, she fully agreed and reminisced about her father who told her when she was growing up in the South that they were too poor to buy anything

but the very best quality merchandise because, otherwise, things wouldn't last very long. The school reflects this attitude in every aspect of its physical and philosophical existence.

Toward the end of one semester, when new brushes were late in arriving, I began to notice that the students' paintings lacked the wide range of expression and great variety of brushstrokes prevalent when the brushes were less worn. When the new brushes arrived, the difference in the students' paintings was remarkable. Because the sparse bristles of the old brushes held less paint, everyone needed to work harder and longer to finish their compositions. Some did not even complete their paintings. Because the new paintings had a greater variety of brush-strokes and larger masses of color, adults in the studio recognized the difference that well-functioning tools made.

Sharing supplies can be a counterproductive method of economizing. In a situation when students of any age share large cans of paint with one brush in every can, it is difficult to mix and control the colors, especially if there is no container of water in which to wash the brushes. It is best to give everyone their own space and to purchase tools for each individual to work with. If it is necessary to share a paint tray, be certain that everyone understands the guidelines for using tools and materials to avoid problems in personal relationships and ruined supplies.

For young children, paint, glue, and clay must be nontoxic. Because toxic materials may penetrate the skin, be certain to read all supply labels. It is common for young children to taste and smell the materials (especially if they are working close to mealtime). I saw an adult student, who was thinking about what to do next, unconsciously stick a wet paintbrush into his mouth the same way some people chew on the opposite end of a pencil. No

one got upset when this happened, because we knew the paint was nontoxic.

Emphasize to workshop participants that each tool must be cared for by using and storing it in an appropriate way. Empty food cans or jars are fine for upright storage of brushes (bristles up).

## COMPARING COLORING MEDIUMS

In general, I prefer to use liquid poster colors in these workshops because they are water soluble, less expensive than acrylic mediums, and result in brilliant, matte-surfaced color. These paints are often labeled *tempera* in art-supply catalogues although they are not made from the ancient tempera formulas. Unlike colored markers, the brushed-on paint produces distinctive textures and makes a great variety of brushstrokes. Because non-water-based mediums as well as many that are water based may permanently stain many materials, look for those labeled "washable."

For anyone who loves to mix colors, a medium like poster paint, which flows easily and responds to a light touch, is the easiest to blend to create the widest range of textures. Because it is opaque when applied straight out of the jar, when you thin it with lots of water you can control the degree of transparency. This paint is especially good for strong colors, contrasts, and spontaneous effects. You can rework your painting when the underlayer dries without muddying your colors, and you can scrub it off when it gets on an unplanned surface like clothing.

I prefer wide-mouth, twist-off tops on paint jars because squeeze bottles filled with poster paints invite squirting accidents for adults as well as for children. Their spouts are may clog up and, if you squeeze hard to unblock them, too much

may come out. Moreover, because their narrow tops prevent you from easily scraping out the jar bottoms with your brushes, you loose some paint with each bottle.

While poster colors also come in powder form, I prefer the ready-mixed liquid in jars. It usually has a good consistency and is convenient to use. However, I know teachers who do use powdered colors successfully. One teacher has young children mix their own powdered pigments as a way of learning to mix colors. Nevertheless, as a beginner, you will allow yourself the best chance of initial success by buying the liquid paint in jars if you don't know what the proper consistency of the mixed powder should be for painting. In addition, if you do buy the liquid paint in jars, you can be reasonably sure you have poster colors even if the label says tempera.

Good quality watercolors and gouache (opaque watercolor) and acrylic paints in tubes may be more expensive than tempera, depending on the specific colors and brands. Although acrylics are water based, they dry to an opaque semigloss or gloss finish, do not wash out of clothing once they have hardened, and, if the pigment dries in the tubes or jars, you cannot recondition them with water; you have to buy a new quantity. Little cakes of hard watercolors require more effort and practice for a beginner to freely mix color and are used primarily for their translucent qualities.

Oil paints are unsuitable for most beginners because they lack the free-flowing liquidity of the water-based poster medium (unless thinned with much solvent), dry very slowly, stain clothing, and are flammable. Also, many colors are toxic. While some artists have applied oil paint to paper, the recommended permanent support is primed canvas or wood. Oil paint also requires excellent studio ventilation to prevent buildup of hazardous

fumes. Many professional painters who formerly used only oil paints have changed to water-based ones because of these adverse health effects from this petroleum-based medium. Since oil paints and canvas are also expensive, you might feel inhibited when working for fear of wasting costly materials.

In situations where the studio environment prevents use of paint, coloring sticks of varying properties are available. Again, look for washability when giving these to very young beginners. When using crayons, it is a good idea to peel off the paper or break the crayons in half so that the sides of the stick can be used to create larger areas of color. This makes possible a variety of textured rubbing effects with crayons, as well as the ability to use the pointed ends for drawing lines. You can also find rectangular crayons with no paper on them and also water-soluble ones whose colors can be blended with a brush and water.

Water-soluble felt-tip markers for drawing and coloring are also available in several widths with varied tip shapes to imitate brushes, and some types can also be blended by brushing water onto the surface of the paper. Unlike poster paint, however, the markers produce no physical texture.

Colored chalk and pastels are also soft and have good color, but they rub off and you must buy a usually toxic spray fixative to bind the powder on the finished work. Hair spray can also be used for this purpose. By contrast, oil-based pastels are useful for experienced beginners who are old enough not to try to taste them or rub them on their clothing. Although not "washable," they are softer than wax crayons, more painterly than colored markers, and more permanent than chalk pastels. It is possible to blend colors and use these on paper and the surface of collages. Be aware, however, that oil pastels

are made by binding pigments with resins, compressed calcium carbonate, oils and waxes, and sometimes small amounts of such solvents as turpentine or mineral spirits. Professional artists' grade oil pastels may have toxic lead chromate and cadmium-containing colors, which will stain clothing and may require mineral spirits to remove them from surfaces. Therefore, it is necessary to look for children's varieties with nontoxic pigments and binders for students who may be likely to put things in their mouth, get the medium on their skin, or apply it to surfaces other than art projects.

## PAINT CONTAINERS FOR THE PAINTING TRAY

I prefer to use plastic stackable cylindrical containers holding about two ounces of paint. I once used half-inch-deep round or square furniture casters, either the glass, plastic, or rubber kinds. They supplied just the amount of paint needed for a session, had enough weight and low center of gravity so that they didn't tip over, stacked easily, and you could set them up ahead of time or store them from day to day with plastic wrap on top. However, they are now difficult to find in stores. If you cannot find casters, deep jar lids are acceptable. Waxed-paper cups cut to about three-quarters of an inch are less satisfactory because they lack stabilizing weight and are easily tipped over. Styrofoam egg cartons very carefully cut in half so that you have two parallel rows of three colors each function better. After the egg cartons have become battered with prolonged use, you can recycle them into collage materials. No matter what you use for the individual color containers, you still need to put them all on a tray with raised edges to contain any drips or spills. What will cause tipping accidents are light containers, such

as small yogurt cups that are not cut down before being filled with paint. They pose a great temptation to place one's brush in them, and the weight of the long brush handle inevitably causes the lightweight cup to tip over.

## BRUSHES

These painting projects require firm-bristled brushes such as those used for painting with acrylics or oil paint, which can withstand pressure without splaying the brush shape or wearing down quickly. A test of the excellence of your brushes is their ability to keep their shape under controlled pressure instead of becoming too soft when wet and spreading or splaying out at the sides like a straw broom. This may be difficult to assess in the store because manufacturers spray their bristles with starch, sizing, or gum to protect them from damage in shipping or while on display. Thus, cheap brushes may look and feel as sturdy as the better grades. Look for a standard, brand-name brush to be assured of getting reasonably good quality.

Do not use watercolor brushes for working with tempera paint. Good watercolor brushes are very expensive and do not work well with these colors. They are too soft, have fine animal-hair bristles and shorter handles, and their shapes are not suited for our purposes. Moreover, young beginners tend to scrub the paper with their brushing, an action that will quickly demolish a watercolor brush.

Although I only put out one paintbrush per person in the beginning, I buy two bristle paintbrushes for each student, one large (one inch wide) and the other narrower (a half-inch wide). You can also use three-quarter- and one-quarter-inch sizes. Look for the bristle style or shape called a *bright*. Although these are flat in appearance, true "flat" brushes (or *flats*)

have longer bristles and hold too much paint for this poster medium. The bright, supposedly named for a Mr. Bright, has a shape that is a bit sharper at the corners and has a shorter and thicker bristle than a flat. The shorter bristle is especially good for manipulating the thicker consistency of the pigment as it is drying on the paper. You do not need an all-natural, or animal-hair, bristle for tempera colors as is required in oil painting. Many synthetic bristles used with the acrylic-polymer medium will also work well here. If you are purchasing from a mail-order catalogue, you may be guided by a picture as well as a titled description, but if you buy this from an art-supply store for the first time, you may need a salesperson to help you find the right brush. However, if the representative asks, "Whom are you buying this for?" and if you answer, "For my child," you may be told that an inexpensive model will do. If you get a cheap brush, there is a good chance that, not only will your paintings end up full of bristles that have fallen out into the paint, but the necessary bristle shape will also disintegrate.

Both children and adults start out with only one large brush. I used to give adults two brushes at the very first session until I realized that the smaller brush became in invitation for some of the older beginners to concentrate on making tight lines instead of freely brushed strokes with a variety of pressures. One child did not want to use her large one at all because she saw her parent using only the small brush. Although the act of painting involves drawing, making shapes of solid color rather than outlining and filling in silhouettes makes it easier for beginners to recognize the importance of shape placement within the frame of the entire paper. That is why I now introduce the smaller brush in later classes after everyone has painted with the large tool for a while and seems to have exhausted their possibilities. At

that point I suggest that they might like to add some tiny shapes or skinny lines with the small brush.

The only other brush needed is an inexpensive quarter-inch general-purpose bristle for applying white glue to collages. This does not need to have a specific bristle shape and should cost under two dollars.

## PAPER

Background paper for painting and gluing on should be chosen for sturdiness and visual appeal. It should not be so thin or absorbent that it wrinkles or bleeds. I recommend using an 18-by-24-inch white (or neutral tan color if no white is available) drawing paper of about an 80-pound weight. Since this is one of the standard drawing-pad sizes, you should have no trouble finding it in art-supply stores. Buying paper as loose sheets may be less expensive. Very absorbent paper such as blank newsprint soaks up the pigments so quickly you may not be able to mix colors easily on them. However, printed-on newspaper will support the liquid in order to blend colors, but you must use only the parts of the paper with small uniform type such as the classified or business section so that the type patterns are not distracting. In a pinch, heavy brown wrapping paper or the nonpatterned insides of paper shopping bags will work if you cut them to manageable sizes. As with all materials, try using them yourself before giving any of them to beginners.

Although you can vary paper sizes later, it is easiest for beginners to gain control of the mediums using a constant paper size so that they won't have to cope with changes in scale at first. If the paper is too big, not only will beginners be unable to reach all of the areas, but they will also be unable to see the page as a shaped field

within which to compose their images. On the other hand, sheets that are too small can encourage cramped fingers and tiny wrist motions with the brush instead of promoting the vigorous, full-arm stroking that allows beginners to loosen up. The 18-by-24-inch paper for painting is large enough to allow beginners to sweep the brush vigorously and freely without going off the edges.

In our first cut-paper projects, we use only construction paper so that beginners can concentrate on cutting, gluing, and arranging. After a few initial classes, I begin to add a new material at each session. When you are working at home, part of the excitement and learning happens when you gather different and unusual materials and begin to transform them into your own compositions. Any paper that is so absorbent that the paint instantly soaks into it makes moving the colors around and changing things difficult. If its surface is coated and is nonabsorbent, the liquid may bead into little drops instead of spreading smoothly. Glue also may not stick to some synthetic-coated surfaces.

### Tissue Paper

Thinner tissues are more translucent than thicker ones and are stronger and less porous than heavier, coarse types. Some tissue may have a prominent texture or grain that is visible when held up to the light and can produce different effects than the smoother, finer kind. Although party-supply and variety stores may call it tissue gift-wrapping paper, art supply sources sometimes call it "art tissue." There are both bleeding (the colors will run when dampened) and nonbleeding varieties. The bleeding type of paper can produce a wide range of painterly effects when dampened with water or the water and white-glue mixture whereas the non-

bleeding colors may be more suited to other specific design ideas. Try both if they are available.

In some supply stores you can purchase single sheets of colors, although many companies produce a mixed-color package. Look for flat sheets without creases from folds.

## SCISSORS

You need two pairs of 4-to-6-inch scissors with blunt tips that cut easily. Please try them to make sure that they cut well. A nonessential option is a larger 5-to-7-inch scissors for yourself; however, you will need the extra pair of small scissors so that you can demonstrate to beginners how to cut using scissors identical to theirs. Omit the extra pair of small scissors if the students already know how to cut, or keep them if you want to be able to invite another friend in to share the workshop sessions. Be certain that you have scissors made for both left- and right-handed people if needed.

If this is your young beginner's first experience in learning how to cut, you will make it difficult for both of you if you buy an inferior pair of scissors. Remember, paper will dull your fabric- or hair-cutting shears, so it is best to get scissors just for paper work.

## GLUE

I use nontoxic school white glue in my workshops for beginners because it has a smooth creamy consistency and washes off with soap and water. Some white glues are water resistant and thus more difficult to remove from clothing when hardened. Look for the school glues that say "washable" on the label. If you are trying this out at home for the first time, you can buy a pint container of white glue, but if purchasing supplies for a large group it is much more economical to buy glue by the gallon and decant it into screwtop jars with attached glue applicators.

## Glue Jars and Brushes

The best jars for glue are those with screw tops and glue applicators that are removable. After the applicators are removed, the opening in the jar lid is the right size for insertion of a separate glue brush. Plastic squeeze bottles and containers such as those used for mustard and ketchup are not functional because they get clogged easily. Then when you squeeze hard to get the glue out, more may spurt out than you intended and cause squirting incidents. Specially made glue bottles with caps that have a projection fitting into the opening of the jar to prevent clogging can be used for adult beginners who have no inclination to squirt liquid at each other.

If it is difficult to find glue jars with a hole in the top, you may have to buy a small jar of other glue just to get the proper container. Decant this glue or paste and set it aside for other nonclassroom uses if it is toxic or if its consistency is inappropriate for these projects. However, you can recondition library paste to the right consistency by adding some water and white glue to it. Remember to fill all beginners' glue containers only one-third full so the glue does not go up so high on the handle of the brush that they get their fingers in it. The jar is also less likely to tip over when the weight is centered in the bottom half. Place a paper mat under the jar to catch spills.

I buy separate bristle glue brushes (general-purpose type) with approximately 6-inch-long handles or shorter because it is extremely easy to tip a glue container if it has a longer handle in it. Little plastic

spatulas that often come attached to the lid of glue jars are not as satisfactory as brushes because they are not flexible. Remember you must wash the glue brushes with water when you have finished with them or they will become hard and difficult to use. If that accidentally happens and you have purchased "washable" school glue, you can soak them in water overnight and restore them to flexibility with thorough washing.

## CLAY

Moist gray or light-colored water-based potter's firing clay, available ready to use, is best for workshop purposes. Since unfired clay can be reconditioned and used again, it makes a relatively inexpensive medium for sculpture. If you have no local art-supply store, a nearby school may sell you some. Or look in the Yellow Pages under Ceramic Supplies or Pottery. Sometimes a hobby store will carry this water-based clay. Ask for moist, premixed potter's clay without *grog,* which stiffens the clay and makes it more difficult to work. The gray-colored product is preferable for beginners because the terra-cotta varieties may have negative associations for young children who have recently been toilet trained. For additional information, see page 275.

## THE KIT QUESTION

It is a misconception that children will not feel confident enough about their efforts to create their own personal imagery, although school-age students may worry about being judged and may be self-critical about their studio efforts. Adults might also feel apprehensive about encouraging original studio activity if they do not know how to guide beginners in the use of materials. If you are faced with

this situation at home, kits with pattern-based projects and coloring books are not the solution.

If you sit down with a piece of paper and simply make abstract marks or doodles, most beginners will be attracted. Don't let them work on your paper but encourage everyone to make their own drawings. If you make representational imagery, however, beginners may be intimidated from trying and are likely to sit back and let you entertain them or else demand that you draw for them. (For guidance in this area, see page 54.)

Since I did not approve of coloring books, when people gave them to my children, I made the mistake of telling them they could change the drawings to please themselves and did not have to stay within the lines. When they got to school, where they were graded on their ability to follow directions and work neatly by staying within the lines, they were reprimanded for not following directions. I realized I should not have commented on the coloring books; rather, I should have encouraged my children to do their own drawings. Coloring-in maps and diagrams are often-used teaching devices for attaching words to concepts, such as linking names to locations, and for memorizing material; however, they do not constitute an art experience.

Paint-by-numbers patterns can also give beginners the impression that they are incapable of making any of their own images. For the most part, all of these pre-planned kits fall into the range of busy work. Publications from the Association for Childhood Education warn that children become conditioned to prefer these commercial, ready-made images by authority figures who praise them when they use these materials. To feel a sense of pride of accomplishment in any studio work, students must know that they made all of it. They realize the deception of

achievement in coloring someone else's picture. One little girl who was used to drawing on her own expressed scorn for coloring books, saying that they were "somebody else's used paper."

Once a student of any age has fabricated a sleek, commercially designed object that everyone praises, how does he or she muster the courage to present a handmade project, which will certainly look much less polished because of inexperience? Kits with patterns give a kind of false security to beginners, especially when relatives buy them. Children, especially, know the end product will not be rejected because it was parent-approved upon purchase. By contrast, when beginners invent something of their own, they risk disapproval. You can show that you encourage their imaginative efforts when you offer studio materials without preset models or examples to copy so that they can feel free to create on their own.

When Albert Einstein, probably one of the most famous mathematicians of this century, was once asked, "What is your most valuable creative asset?" he replied, "My imagination." Beginners of any age who are encouraged to develop their imagination with studio materials may learn to transfer their new perceptual abilities to other areas of thought as well.

### What about Kits without Design Patterns?

The value of preassembled tools and materials packages depends on several factors, including your attitude and guidance of beginners, the quality of the supplies contained, and their flexibility of use for developing personal inventiveness. You cannot expect beginners to know how to use a kit. Even those who have worked with similar materials during the structured studio session might not remember how to use it appropriately. All beginners of any age need guidance and encouragement to continue a process. If your beginner has been given a kit by some well-meaning relative, you might integrate it with these course materials and projects.

Consider carefully the reasons for buying kits. One good reason for buying prepackaged materials is that supplies may not be easily obtained in small towns and rural areas. Another reason is that projects in some kits do encourage the development of coordination skills and personal invention; however, kits with rote patterns do not further the latter. The only way you can really evaluate any of them, whether it is a one-time project or a collection of supplies, is to try it out yourself before giving it to anyone.

Especially avoid kits that provide more packaging than studio materials. These are more expensive than if you bought the materials separately. If you can not get a substantial collection of packaged materials at a reasonable price, then buy single items.

## Presenting the Materials

The way you prepare and set out the materials for an art experience not only determines their visual appeal but also helps establish a respectful attitude toward studio work and builds anticipation for using them. Also take into consideration any physical limitations when preparing each studio medium. Be conservative with the quantities of any materials on display. You can always replenish exhausted supplies of small quantities when needed or asked for. However, if in the beginning participants do not have enough of their own, you should have a general supply of papers, cloth, yarn, and other gluable materials available for their use.

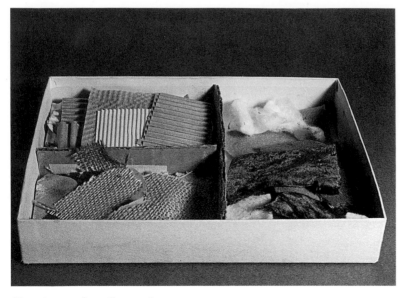

Choosing tray for collage projects

Presenting precut papers in an orderly way helps to focus on the project arrangement.

If you are using paper bags or the backs of heavy wrapping paper or newspaper to paint on, the paper should be trimmed and cut into rectangles before the workshop session begins. Take apart found materials for collage to make them easy to handle and also to loosen them from their previous associations. For instance, cut old clothing into small pieces, separate artificial flowers into petals and leaves, and divide old toys into parts. Avoid any fragile materials that may soon collapse or dissolve.

Visual and tactile qualities become most evident when placed in neutral-colored trays, boxes, or pans. Lining containers with foil or light, neutral-colored, or black paper will make the special qualities of the prepared supplies stand out clearly. When materials are prepared and presented in an orderly way, beginners know that these are the "choosing trays" and are less likely to cut up anything else. I learned this lesson the hard way, when an adult in my class mistakenly cut up one of my treasured demonstration photographs for her collage. Since that experience, I never assume that anyone of any age will know which materials are for studio projects unless I say, "This is for cutting and this is *not* for cutting-up." Try to be very specific about your presentation of materials and also give verbal instructions about their use. When you offer any material to workshop participants, take care to see that it is of workable consistency and manageable size. Any medium that is too difficult to manipulate will be frustrating.

## Paying Attention to Detail

Assembling all the materials and setting up the space may seem unnecessarily complicated at first. But as you begin to use them you will understand that each element fulfills a specific purpose. Your home work space should not be an obstacle course. Do not be intimidated by the initial attention to detail; after a number of sessions the setting up will become automatic. As when making bread, you must use the right primary ingredients in the right amount and in the proper order for a successful result. But once you have learned the process for the basic loaf, you can add raisins, nuts, and other condiments, and even change the shape. In these workshops also, certain procedures never change, even though you may add to the basic studio setup.

## When to Begin: Preparing Participants for a Workshop

Although preschoolers will generally be eager to try anything, even a well-stocked work space may not entice older beginners who have had unhappy studio experiences

elsewhere and feel hesitant to try again. Your well-meaning surprise may be disappointing. Kindling enthusiasm involves not only looking at art but also showing that you are interested in helping others learn skills and succeed with the projects they attempt and that you will refrain from negative criticism of their efforts. Sharing pictures in this book and inviting beginners to local museums and art exhibits can encourage the desire to begin their own studio projects. If you are enthusiastic and energetic, you may inspire them to action.

To put everyone at ease and inspire a sense of trust and expectation, my orientation for adults includes showing adult works by other beginners while explaining that the aim of these workshops is to experiment and explore rather than to make finished products. These classes attempt to develop an appreciation for the processes of art-making, not to train professional or commercial artists. Explaining that they may or may not like the results of every project they do takes the pressure out of having to produce "fine" art. It is important to stress that we do not criticize each other's work or destroy any projects in class.

Young beginners or people with emotional handicaps are not ready to settle into an organized work space for painting if, when you set up the tray, you find that they obviously feel the need to touch, rub, and smear the paint. If this is so, they probably need to have more tactile activities before you offer paint and brush. There are many other things to do. Encourage free play with sand and other natural materials outdoors, modeling dough and clay indoors. One parent told me that she added a little water to a mild soap powder, making it into a thick mixture (good to squish and manipulate), and let her child use it on the empty tub surface for a while before filling the tub with water for a bath. The same mixture can be used for drawing or smearing on a large metal tray, Formica or other washable counter top, or even on a heavy paper. Also, youngsters seem to love to help grown-ups by using absorbent sponges to wipe up and squeeze out. Amy Laura Dombro and Leah Wallach's book *The Ordinary Is Extraordinary: How Children Under Three Learn* offers much practical advice in this area.

I prefer the activities described above to finger painting because young beginners and people with emotional disabilities may not distinguish painting from smearing. Without a sense of boundaries and materials these beginners may see studio tools as toys. If they have been finger painting before coming to class, they also may see their fingers as primary painting tools and learning to master a paintbrush as secondary. You may need to redirect their behavior to something else before starting a workshop. If they are still romping around when you give them poster paints and brushes, they will have no regard for the real purpose of these tools, and it will be wasteful and costly. Moreover, it will be more difficult to teach them respect for the problem-solving aspect of art. You must remember too that they are also mastering life skills by learning concentrated effort as well as studio techniques.

If you have enthusiastic students but no available space for a while, you can maintain interest during field trips to museums, zoos, and even the local supermarket to observe shapes, patterns, and colors. At the beach or park you can encourage sculptural projects with stones and found objects. In the kitchen you can make free-form cookie sculptures and decorations; other activities are suggested throughout this book.

The attitudes of the leaders or role models have to be established before setting up a physical space. If adult

participants fail to recognize this as a serious, although pleasurable, structured endeavor, then you had better postpone the workshop until you can agree on a common purpose for doing it at all. Others sharing your studio environment must also understand your approach even if they are not going to participate. They need to recognize that noninterference includes having a quiet space to work and to think.

Please read the early chapters of the book (through page 83) before beginning your projects in order to understand the basis for these methods. Only then will you be able to communicate the necessary enthusiasm to others.

## The Museum Experience

Connecting the visual aspects of everyday experience with artworks is something many people have not thought about because they assume that objects in a museum have nothing to do with their lives. Museum-going can make moving from the "what" to the "how" of a work proceed more easily when using studio materials at home later. While very young beginners may enjoy nonrepresentational pieces, older beginners often look for a story in a picture. Although viewing virtuoso traditional old-master paintings can be excessively intimidating for beginners, painters from the Impressionist and Post-Impressionist eras may seem more approachable. Highly conceptual contemporary pieces may be more accessible to children although they may bewilder many adults.

When beginners of any age start viewing exhibitions, they may have a short attention span and tire easily. Just as preparation of tools and materials is necessary before entering the studio workshop, it is necessary to familiarize yourself with the layout of your local art center before visiting the various galleries. Especially if you are accompanying a young or a handicapped person, it would be a good idea to find out in advance where the bathrooms, water fountains, access to wheelchairs, seating areas, and nearest exits are. If a museum is large and offers layout maps, get one. It is easy to spoil an experience by dragging around from room to room looking for a particular work after your concentration has run out. For most people, looking at only a few things at a time is much more enjoyable and less confusing than trying to absorb the history of art in one visit. Because some museums are in historical buildings, they may also have interesting architectural details worth examining.

If you force companions of any age to stand while you examine a work for a long time, they are likely to get restless and unhappy. If you are with young children in a particular exhibit, you might let them lead you to what interests them. After doing projects from this book together, you will have a common vocabulary for discussing the work. Questioning instead of lecturing may stimulate discovery of different kinds of shapes, colors, and brushstrokes, which can relate to the studio experience if you don't turn it into a test. Explore the visual qualities of the subjects and how they are painted. For example, in looking at a landscape, can you guess the season or time of day? How do you know? What kind of colors tell you this? When you get the idea, the questions are infinite. Obviously you have to be sensitive to the needs of your companions, young or old; some people love to look first and think and talk later while others have a need to express their immediate impressions.

ROSA BONHEUR (French, 1822–1899). *The Horse Fair.* 1851–53. Oil on canvas, 8' ¼" x 16' 7½".
The Metropolitan Museum of Art, New York, Gift of Cornelius Vanderbilt, 1887 (87.25)

When first visiting museums, you might look for the kinds of exhibits that focus on existing interests or objects with fairly accessible subject matter.

DEBORAH BUTTERFIELD (American, b. 1949). *Untitled (Atiyah).* 1986. Steel, 6' 2" x 9' 7" x 2' 11". Courtesy of Edward Thorp Gallery, New York

Comparing similar subjects by artists from different centuries helps beginners think about how images can be made with diverse materials and depicted from different points of view.

# 3. Guiding Workshop Beginners

In a one-hour workshop adults work with one medium each time but young beginners use all three mediums (paint, collage, and clay). As children gain experience, their attention spans will increase and they may choose to work with only two mediums.

## Beginners' Levels of Experience

*A*ge is not synonymous with experience. One can be experienced in some areas and not in others. Therefore, older beginners are not necessarily experienced in studio work, even though their cumulative life activities may have given them certain advantages. A five-year-old can be an "experienced" studio beginner in the use of art materials and tools while a forty-year-old who has never used these at all is an inexperienced older beginner. In this book, "young" beginners are of preschool ages; "school age" refers to children in grade school; and teenagers are treated as adults if they demonstrate emotional maturity. However, if their hand skills have not been developed, teens may be less dextrous than grade-schoolers and may progress slowly until their coordination develops. In general, the "older beginner" can range in age from about fifth grade to adult. The classes labeled for "Adults with Preschoolers" refer to parents in classes with their children. Any students with physical or emotional challenges may need to begin at a preschool level but may or may not progress more quickly than a preschooler.

## Forming a Workshop Group

*I*f you have never had any experience guiding novices, it is a good idea to start your workshops with only one or two people. Organizing a larger group is easier once you feel comfortable with the studio routine and the chemistry of the group. You cannot assume any level of skills or predict the behavior of anyone. Therefore, unless you have an assistant, you will not be able to do any of your own studio projects in the beginning.

Because one person can ruin a session for everyone, be sure to have a pre-workshop meeting with your participants to discuss the course aims and procedures. Grade-school and older beginners also need to know the ground rules before starting class.

A separate orientation for adults, without preschool or grade-school children, is necessary to establish a realistic expectation of the way the workshop is conducted and *why*. If you organize with other adults, it will take several discussions for you to decide among yourselves how you are going to manage the sessions. Disagreement during the workshops would be unproductive. Who is going to be the monitor for the day or the activity? To what extent should the other adults be allowed to discipline any inappropriate behavior from participants of any age? When one takes the leadership in any activity, all the rest should look to that person as the authority figure. All will have to agree to some basic guidelines and stick to them no matter what, so that everyone will know what is expected of them. It is important to make explicit the routines and point out variations in advance.

The orientation should also cover the boundaries of socializing during the workshop. One basic rule should be that conversation centers on the projects at hand until after cleanup. While youngsters usually adhere easily to this directive, you may have more problems with adults who want to socialize with friends, thus distracting others. If, in spite of this prior agreement, participants still feel the need to socialize while using the studio materials, suggest that they discuss it later unless they are talking about the work.

Your group will also have to agree beforehand on how to deal with disruptive behavior. Never use the art materials as a reward or take them away as punishment

for behavior unrelated to the class. You wouldn't take away a reading or math assignment for misbehavior. This kind of experience is too valuable to take away anyone's potential ability to learn visual language. I generally have alternative materials, such as a supply of picture books to look at or crayons and paper for drawing, for students with short attention spans or emotional disabilities who might otherwise disrupt the rest of the class.

It also helps to know the personality of any group member, no matter what the age. Some overly energetic or disturbed people may be unable to channel their energies and may need encouragement to settle into their work. If you sense that there is going to be an inappropriate use of materials, you must stop it and offer other alternatives. With a child you might say, "It seems as if you really do not want to make collages or paint today." If they answer that they do want to, then reply, "Well, then, let's see what you can do with them." With adults it may be more difficult. You will find examples throughout this book of guidance issues with beginners of all ages and accounts of how these were resolved.

## Class Routines

The routine of attending a regular class sets up expectations for an experience one can look forward to at a particular time. If you are working at home with youngsters, however, it is better not to set too rigid a schedule. You may not know in advance the limits of your beginners' attention spans, or of your own patience. (Remember that attention span is not necessarily dependent on chronological age.) It is difficult to plan a schedule for guiding others until you have had a few positive experiences with the materials alone, so do take the time to test these projects yourself.

Once the group sessions are underway, it is important to keep a regular, consistent routine. Set your own priorities first; you may find it difficult to cope with a work session if besieged with other obligations. Feeling guilty may cause leaders to schedule harried sessions, which may not be in anyone's best interest. Continuity will be preserved if you can manage a full workshop at least once a week. However, when you have limited time or materials, consider substituting a project requiring fewer materials and less preparation of supplies, such as a simple collage. As you all become experienced, you may be able to set up the supplies and let beginners work independently, assuming you have established good working habits from the beginning. In either case, do not schedule a class or offer a medium if you are not ready to handle it comfortably yourself. If you have never used a material or done a particular project, make certain you read the entire chapter on it as well as try it out.

In a one-hour workshop, preschoolers use all three mediums—paint, collage, and clay. This may also be the case for older people with various kinds of challenges. With experience, their attention spans and coordination may increase and they may choose to work with only one or two mediums. Teenagers and adults in my classes work with one medium each time. Even when planning a workshop in a single medium, always have an alternative choice available. If you pressure anyone to stay with one medium after they decide they are finished, you may only turn them against further involvement.

When supervising three activities for preschoolers, it is ideal to have three separate areas, one for each medium, although a single table with some kind of nearby storage container is an alternative. Either way, the sequence is always the same. First, the children paint until they feel

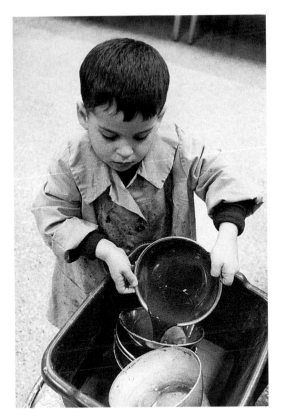

In my classes, once children have made the decision that they have finished painting and they empty their water bowls, they may not go back to painting during that session.

they are finished. (They will not all finish at the same time.) Then they empty their water bowls and move to another table to glue and cut collages. If you do not have another table, remove their paintings and paint supplies immediately, keeping them out of sight. When they finish their collages, also remove that equipment and give them clay from the clay bucket. Allow a minimum of fifteen to twenty minutes for each medium and encourage the youngsters to extend their involvement with each one.

This involves much preclass preparation of supplies. Preschoolers will not wait if you fumble around. The paint trays must be filled and set out alongside the taped-down paper. Collage choosing trays,

glue, and scissors must be ready to use, and the clay and paint must be of proper consistency before the start of class.

If parents attend the workshops with their children, they must be willing to stay involved with their own work unless their assistance is requested by the leader. If you as leader want assistance from participants, you should tell them in advance of the class. For example, before class, assistants might fill paint trays, collect, cut up, and arrange collage materials for presentation, help preschoolers or the physically challenged into their protective clothing, and recondition used clay. At the end they can wipe tables, clean paintbrushes, collect, sort, and store leftover collage materials, and wash out the brush-drying sponges. With a large class of eight or more participants, as much time will be spent on preparation and cleanup as the session itself if you do it all yourself. If you have help it can be accomplished in less time.

Eliminate any possible distractions before you begin a studio session. Take care of hunger, thirst, and visits to the bathroom. Put on aprons, smocks, or other protective clothing at this time. During a class at a boy's school, the exuberant fifth and sixth graders always entered the classroom in a state of excitement and took a while to settle down until we formed the routine of having them put on their work aprons outside of the room. Upon entering they were ready to attend to the studio work at hand, in marked contrast to their previous rowdiness when tying on aprons after they came into the room.

Always keep the same basic order of activities in the workshops. Everyone feels most secure when their expectations are fulfilled. Beginners of any age especially need the security of a routine without having to make too many choices at once. Preschoolers seem to love routine because they like knowing what is coming next

and will ask to hear the same story or play the same games time after time. They never seem to tire of the story about little blue and yellow colors and shapes as often as we may look at it throughout the semester, although their parents may. And even adults seem to devote their entire energies to aesthetic decisions when work procedures become automatic.

You as leader set the standards and demonstrate how to use the work space and tools. Of course you can allow more flexibility once everyone learns and understands the reasons for procedures. As a more experienced leader, you must make choices for a less experienced beginner. Asking, "Would you like to put your scissors and glue away?" implies a choice. Saying, "We need to put our scissors and glue away before we take out the clay" indicates a necessity. Cajoling and bribing students to do their part sets up an unhealthy precedent. If they leave a task that is their responsibility to someone else, they are not learning to participate in the group. When both you and your participants agree that the studio activity is finished, everyone puts away their tools and participates in cleanup.

In my classes, once children have made the decision that they are finished painting, and they empty their water bowls, they may not go back to painting during that session. One mother in my class was very upset the first week when her daughter wanted to go back and paint after she had disposed of her water bowl. When I told her that she could paint again next time, the child was able to accept the rule after her initial disappointment, but the mother was very distressed. She didn't realize that if every participant were allowed to go back and forth there would be chaos. At home, indecision over when to clean up with a beginner who is starting and stopping might cause you to lose patience and spoil the session.

## PLANNING CLEANUP BEFORE STARTING CLASS

It is important to schedule and establish enough time for teaching the routine procedures for cleaning up, especially in a formal classroom setting. In addition, try to warn everyone about ten minutes before the session must end so that they won't continue to work into the cleanup time. Remember to gauge your time so that the pleasure of the workshop is not harmed by a hasty cleanup period.

Wash hands only at the very end of class. Young children love water play, and if you allow washing at any other time during the session they might spend much of the hour doing only that. It is not necessary to disrupt the work process by washing hands every time paint, glue, or clay gets on them. If you are using a filled plastic basin or dishpan in place of a sink as a water supply, do not put it out ahead of time if you are working with preschoolers or people with mental disabilities. If students cannot wipe their hands satisfactorily on their aprons or smocks, wipe them with a special damp cleanup sponge kept handy in case of accidents or spills.

Sometimes adults and teachers end up cleaning everything themselves for the participants and become exhausted in the process. It takes time, patience, sensitivity, and above all, know-how to guide beginners so that they learn setting-up, taking-down, and storage procedures, but it is well worth it. While it is faster and more efficient to manage everything yourself, it also deprives beginners of learning how to work independently. Even handicapped people of all ages can always help with something and will certainly grow in self-confidence, given appropriate responsibility.

How much preschoolers can help with cleaning up also depends on how much time and patience you have. There

are certain things that very young children are incapable of doing without a great deal of help and, if you are going to include them, you must allot more time for cleanup. Also, as a general rule it is better not to let someone help if you really do not want or need their help. You can say, "Thank you for doing your part of the cleaning up. The rest is my job." The extent of others' participation also depends on your home facilities. If your sink is high, for example, people with disabilities and small children will have trouble reaching it.

## STARTING THE WORKSHOP SESSION

Continue to discuss and review the processes before going to the worktables. In the parent-and-child workshop, I talk with the children at their eye level, demonstrating at a very low table the process of using their tools and materials, at the same time trying to make clear the aim and goal of the adult's project.

Most of the time, if you set older beginners down to paint without any preliminary discussion and say, "You can paint anything you want," they freeze and do not know how to start or what to paint. They tend to fall back on the kinds of images they did as a child, which were often copied from a coloring or comic book. That is why a demonstration of process and brief discussion of photographs and reproductions of artworks is so important before starting to paint. For many people, manipulation of the materials themselves may be the primary motivation, and the demonstration of their use is enough to get them started and keep them involved for many sessions. Later, as they begin to be more visually aware, outside stimuli become increasingly inspirational for visual themes and content. If there is

no motivational input, there may be very little output.

Discussion of the visual elements of places and memories of color, texture, and shapes in places you have visited is one way to spark initiative. While working with the materials, original intent may change and paintings take off in different directions. This can occur when studio activity awakens feelings that may have been forgotten, submerged under the pressures of daily life.

A parent once told me how the influence of the workshops had served to relieve tension in an exasperating situation when she and her husband were miserably stewing in an overheated car stalled in traffic. Four-year-old Elizabeth, sensing their distress, blurted out, "Don't be sad, look over there and see how blue is talking to the red in the picture on the side of the big truck and you'll feel much better!"

When the children go to their worktables, each sits in his or her own space directly in front of the paper and paint materials. Beginning three- or four-year-olds may paint as briefly as five or ten minutes or longer than a half hour. There is no predicting how long they will continue. So much depends on the chemistry of the class. Since the energy and attention span of each individual may influence his or her neighbors or someone across the table, do not allow students to leave the table without trying to remotivate them.

Be prepared to try to extend the activity as long as possible by introducing new ideas with simple materials, such as a brush of another size. Speed is not useful here. If you whiz through each medium you will not help students increase their attention span and little will be accomplished in depth. If the pace is slower and more relaxed, students will continue to be involved and not become overstimulated or hyperactive.

## USE OF TOOLS

There is an appropriate way to use tools and materials, and everyone should respect their art supplies and learn how to care for them. Without lecturing, stop improper behavior at once and explain that banging a brush to make marks on the paper is harmful to the tool because it loosens the ferrule, the metal band holding the bristles. Likewise, explain to children that scissors are used with one hand so you can hold the paper with the other one; stop them if they dip scissors into the paste or use them on the clay. Teenagers and adults learn that using scissors to open cans often breaks them and that using the wrong end of a brush to stir a can of paint or cutting clay strips with scissors can ruin the tool.

Never dwell on improper uses, but emphasize the effectiveness of appropriate usage of the tool. All these principles, when applied as general rules with few exceptions, will help everyone get the best results from their supplies and all tools in general.

For example, when four-year-old Jimmy returned to class after several months of absence, he remembered that, the last time he was in the workshop, he had molded cakes and cookie shapes out of some kind of material. Although eager to do it again, he had forgotten which tools and medium he had used to make them. He sat at the collage table becoming troubled and annoyed as he attempted to squeeze and roll the paper. I suggested that, "Because you are making a cutting and gluing picture, it will be easier if you keep the paper flat." "But I want to make cakes." "You can do that with clay when you have finished the collage and put away your scissors and glue."

Once he remembered that he had made cakes with clay, Jimmy proceeded to uncrumple his paper, cut shapes, and glue them down. His misunderstanding became a positive learning experience without feelings of inadequacy attached to it. After he became aware of the limitations of each material and which tools to use, he progressed from session to session, increasing his skills in each separate medium. If he had been made to feel messy, bad, or incompetent, he would not have been so eager to return to the activity another time.

While finger painting may be an exploratory tactile experience, do not allow it when beginners are learning how to use the brush. Any newcomer struggling with coordination feels better when she or he can master activities that develop controlled skills and inspire a feeling of competence. Young children who join adults at the dining table, using tools like a fork and spoon instead of fingers to eat with, enjoy a feeling of power and acceptance.

In the early years of teaching, I did not know what to say when a novice turned the brush around and used the handle to scratch in the paint. Without saying anything, I would try to redirect children to use the bristles by turning the brush around. Sometimes that would work. The problem of allowing beginners to scrape with brush handles is that both ends of the tool may become loaded with paint. While handling one end, the other may drip all over the other side of their paper, on the table, their clothes, and the floor. While an experienced painter will be aware of how to handle the loaded brush with control, unskilled beginners in the workshop may imitate them without that success.

One day, four-year-old Sam took his brush handle and began scratching into his paper with great energy. All of a sudden it came to me that there was a name for what he was doing. "Oh, you want to do *sgraffito!*" I announced with great enthusiasm. He looked at me with amazement and stopped. "Sgraffito is drawing in

paint with a stick. Would you like a stick to try it?" "Yes," he said, and put the brush down. Of course, every other child wanted to try a stick as well. They soon tired of the limited range of marks they could make with the applicator stick and went back to their brushes.

Behavior is contagious for people of all ages. When adults are working alone, certain liberties may be taken with materials. When working in a group, however, not only will young students tend to imitate these techniques, but accidents with materials are more likely to occur in areas used by several people. Splattering on your paper is your aesthetic decision, but splattering on anyone else's work may be regarded as an invasion of territory and destruction of their work, thus creating ill feelings.

Encourage all beginners to use each piece of equipment for its original purpose. Many objects can be used as tools, but found objects are only useful when beginners become more experienced. Ask the experienced students to avoid the temptation of using their tools in any way beginners may imitate without being able to control, such as using the sponge on their paint tray meant for absorbing water from the washed brush, or the brush handle to scratch paint, or picking up containers of paint to pour on the paper.

Once when a young child seemed distressed because he got paint on his hands, I used the sponge from his tray to wipe them. Before I knew it, the child sitting next to him picked up her sponge, dipped it in the water bowl, and started wringing it out over her paper, making a big puddle. From that day on I have never picked a sponge from a painting tray to wipe up anything. It is a good idea to keep a special one nearby for accidental drips or spills.

Similarly, do not offer unusual tools for any medium or substitute any as alternatives unless there is a pressing reason. You will only distract beginners by giving out tools such as sponges, potato brushes, or nail- or toothbrushes that you may have discovered for making marks with paint. Perhaps, when beginners become more experienced, you may paint with found objects as a separate activity. For the same reason, use the scissors only for cutting and avoid using knives or other kitchen implements to make interesting marks in clay. If children see you using household utensils as tools, they may try experimenting with some of these by themselves with unfortunate results.

## WHY BEGINNERS NEED YOUR GUIDANCE AND SUPPORT

Inexperienced people need to learn processes as well as to have support and motivation for their work. Beginners of all ages need encouragement because they find it difficult to motivate themselves continuously. Although they may start off with passion, they may get frustrated and appear to be bored when they do not know what to do next. They do not know how to get new ideas when they see no additional possibilities from the materials themselves or their surroundings. When left to their own devices with extended efforts, the youngest ones have more trouble because they have little control over their impulses and may get sidetracked easily. Unless you guide them carefully, children and mentally challenged beginners may take the glue and pour it out instead of using the brush applicator to make it come out faster. Once they discover that the flowing glue is wonderfully gooey, shiny stuff to slide fingers in, they may continue to pour it just for the pleasure of those sensations. Aside from the waste involved, and the fact that too much glue takes a long time to dry and squeezes

out from under the shapes on the paper, all the materials will now stick to the fingers or table instead of onto the collage. They may now end up like the tar baby, caught up and miserable, with the insurmountable obstacles of having to cut with sticky, encrusted scissors and being unable to place anything on the paper where they want it.

## SETTING AN EXAMPLE

In the beginning, you must take time to demonstrate procedures and support students' efforts no matter what their ages. Later, when they have learned to work independently and have become more self-confident, if you are not doing studio work yourself, try to be busy with something of your own nearby so that you do not become excessively directive or intrusive. If you are occupied, beginners are less likely to demand unnecessary direction and assurance from you all the time. Your quiet work telegraphs confidence in their decision-making ability and demonstrates that working seriously can be enjoyable. Parents have told me that once their children begin to work independently they gain a mutual understanding about noninterference in each other's work.

If you are engaged in your own project and students continually interrupt you to look at their work, you might say, "I'm busy with my work now, so why don't we look at your painting together after we both have finished?" By the same token, if you are delighted with your own work, try to have equal respect and refrain from interrupting others with your comments. Leave the sharing until later.

If you are not satisfied with your artwork, remember that what you may regard as a mistake can always be reworked in a different way next time. That is why I ask adults never to destroy their own work in front of others, especially children. It

shakes everyone's self-confidence. Once a visiting grandparent, who was very accomplished with studio materials, sat next to an adult beginner who had been struggling for weeks with painting and was just becoming comfortable about her work. The novice painter was admiring the work of her experienced neighbor, hoping that she too would come to reach this high level of facility, when the experienced painter ripped up her paper, threw it into the wastebasket, and started on a fresh sheet. What had been destroyed seemed so much more accomplished than her own work that the younger beginner had trouble continuing because of her own feelings of inadequacy. I always tell participants, "If you don't like what you have done, put it aside and come back to it with a fresh eye another time."

*It's very helpful if you can engage in this exercise with as little prejudgment as possible. Don't decide if you like the exercise or don't before you do it. Try to witness what you make without declaring it good or bad, ugly or beautiful. Such declarations seem like very heavy burdens for such young work to bear. In a very real sense, in this work, failure, if there is such a thing, can be viewed as a privilege. To make something successfully on the first try leaves you, in some cases, with little but a souvenir, whereas getting lost may afford you the opportunity to stop, reexamine and begin again and again with renewed insight and perhaps even personally developed solutions to move you on with strength. These are first steps, and like those of a young child they may be uncoordinated, uncertain, and you may fall down, but they may also be enlivened by discoveries of your own and a sense of joy in a new ability opening up.*

—Paulus Berensohn, *Finding One's Way with Clay*

## Talking with Beginners about Their Work

Encouraging students and being supportive of their efforts does not mean being excessively complimentary of beginners' works. Since many paintings seem to look very much alike to the inexperienced viewer, you may at first tend to overpraise in an effort to sustain their motivation. When they discover that you will applaud anything, however, they may begin to wonder if you are really looking at their work and your words may seem meaningless or else manipulative flattery. Moreover, if people feel inadequate, no matter how you compliment them, they won't believe you. If you overpraise a work in progress, the student may be afraid to take another step for fear of spoiling it. Exaggerated superlatives such as, "It's gorgeous! Great!" are not helpful either, since no one can constantly live up to those high ideals. After calling the first painting a masterpiece, will you then feel you have to call them all masterpieces?

Sometimes a self-conscious individual will say to another workshop participant, "Yours is better than mine." When an adult says this to a child it sets up a competitive situation instead of the shared pleasure of doing a studio project. I would intercede, saying, "It is not better. It is different."

Try to talk about studio work without making value judgments. Point out what you see, the events and visual ideas that

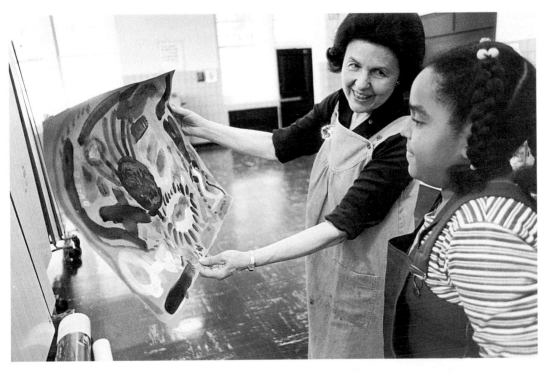

Most of us are sensitive about the way others react to our work. Sometimes a simple comment can send us soaring with confidence or make us feel very inadequate. Try to choose your words with care, so that they will inspire participants to continue the studio processes and to learn to make their own judgments about their work. Otherwise, beginners can become overly dependent on others for constant feedback.

VINCENT VAN GOGH (Dutch, 1853–1890). *Cypresses.* 1889. Oil on canvas, 36¾" x 29⅛". The Metropolitan Museum of Art, New York, Rogers Fund, 1949 (49.30)

I will never forget the first time I stood in front of Vincent van Gogh's painting *Cypresses* after seeing an illustration of it in a book. I had expected to like it but had no idea that I would have such a feeling of inner excitement when I came close to it and could see the quality of paint and the gestures of the vigorous brushstrokes. The painting's extraordinary energy was beyond my expectation. Because I was familiar with it from reproductions, my preconceived ideas had given me a frame of reference in which to receive the image of the original work. My familiarity with his work in the art book made visiting the museum seem like a reunion with an old friend. Sometimes seeing the actual work after viewing a reproduction is all I expect it to be and sometimes not.

are going on within the image, in terms of colors, shapes, lines, and so forth. If you say to a preschooler or grade-school child, "I see you made your colors change," or "Look how you put all those tiny lines inside that big shape," or "You have made a pattern like the one on your shirt!" you encourage them to see things they may have overlooked and you will be sharing and enjoying the experience of looking at the work. For a teen or an adult, you might notice the use of brushstroke or arrangement of shapes in relation to the kinds of examples in the reproductions on the walls. The visual resources help to build a vocabulary for discussions without effusive praise.

## How to Use Reproductions

Although reproductions of artworks can be enjoyable and useful, they are like travel-guide maps and books; they cannot substitute for having the experience of seeing the original for yourself. Unfortunately, reproductions can be deceptive because they are not always true to the color and scale of the original work. That is why the sizes and mediums of artists' works in this book are mentioned in the captions.

It is important to see real sculpture and paintings as well as reproductions of them. If you tell young children that the reproductions are paintings (instead of photographs of paintings), they may be confused or disappointed when they see the real thing. When you look at actual paintings, you see that the varied textures of the paint and brushstrokes suggest that they were indeed made by human hands. By contrast, smooth-textured, glossy illustrations give the feeling that they are produced by machines and not people. Keep in mind also that the reproductions in this book are mostly of oil paintings and you will be working with water-based poster

colors. Therefore, you will get different effects in your own works from those you see in reproductions.

Reproductions are helpful for getting ideas about shapes, colors, and textures and for learning different ways of seeing—they are not for copying. Always try to present a broad range of visual ideas, displaying reproductions of similar subjects that are related to the projects from many places and different periods in history. Showing a wide variety of interpretations and styles encourages each person to paint in their own way.

When my daughter, Wendy, and I took my young grandson, Dov, and his friend to the Arms and Armor exhibit in the medieval galleries at The Metropolitan Museum of Art, Wendy asked, "Whom do these knights remind you of?" The children recognized that the *Star Wars* film character, Darth Vader, wore a kind of costume reproduction based on European medieval armor. How exciting it was that these armored suits came in all sizes, even for children not much bigger than they were. They were able to connect these five-hundred-year-old pieces with their own experiences and also with the film that they had seen. After we finished looking, I asked, "Would you like to have a picture of a knight in armor?" They were delighted with the idea, so we visited the museum shop and got a postcard for each of them. Some children in my workshops have made castles and knights in clay after visiting these galleries.

Although I always put up reproductions and photographs that relate to the adult's projects, young children rarely pay much attention to them because they are so involved with doing their own work. However, I do refer to them occasionally and point out shapes, colors, and different ways of using the brush. As beginners gain experience and show interest in knowing more about art, you might begin to inform yourself as workshop leader about individual artists and the backgrounds of some objects in order to be able to answer questions. But just as patience is required with the students' manual abilities, you need to deal carefully with everyone's conceptual skills. Let them initiate questions about particular artists or styles. There are beautiful, informative books on these subjects that make wonderful gifts for special occasions and are available in libraries. Try to stay away from children's books that distort original works of art through cartoon caricatures and simplification. Examples of fine books for beginners of any age are the art-history series on individual artists by Richard Mühlberger, such as *What Makes a Monet a Monet?*

People who say, "I don't know much about art, but I know what I like!" are making uninformed judgments. By contrast, these projects help you to have an educated basis for your aesthetic judgments as well as to feel and respond to the visual qualities of objects. It is best to select reproductions that have a great variety of historic approaches for workshop display, also trying to keep a balance between abstract and representational styles. If you show only one kind of work, your studio participants may think that you want them to imitate that one.

After a four-year-old filled her paper with many small colored dots during a workshop, she stopped to examine her work. I pointed to a reproduction of a Georges Seurat painting on the wall (see the example of Seurat's work on page 81) and told her, "You know, Christina, there were painters who mixed the colors in their paintings by making lots and lots of little dots." She didn't say anything and continued painting. Later, when Christina's mother arrived, I showed her Christina's paintings and she mentioned that they recently had visited the museum and had seen works by Impressionist and Pointillist

painters. At the end of the semester, when we were reviewing the painting folders to put up an exhibition, Christina paged through the early dotted paintings and lowered her eyes, looking terribly guilty. When she said to me, "I copied these," I replied, "You didn't copy them." I got out the Seurat reproduction again and showed it to her. "Is this the picture you think you copied? They don't look at all alike. You didn't copy. You got an idea. You saw something that you wanted to try, and you did it. You used the idea in your own way and made a very special painting that is different from the one you saw." She was relieved and excited that she had really done something that was her own.

## What about Representational Work?

*T*he important thing in these projects is to experiment with the range of possible effects you can achieve with tools and materials. You start at the beginning by manipulating the materials and enjoying the feeling of moving the brush and paint. I encourage everyone to experiment in this way instead of trying to make representational subject matter, for several reasons. If you labor over making recognizable images instead of keeping your brush moving and blending the paint, you will miss the aim of free experimentation. Several adults in my classes who have been trained in very academic types of representational drawing have sometimes had difficulty allowing themselves to use the brush with sweeping gestures. Making recognizable imagery may become more important than discovering how to stretch your abilities in creating colors, shapes, lines, and textures. It can diminish boldness in exploring the range of your imagination and also discourage you if you do

not have the technical skill to draw as well as you wish. If you evaluate or criticize images on the basis of your preference for representational work, you may also misinterpret much artwork and keep yourself from finding out about many original and direct visions of the world.

> *My concern is with the rhythms of nature . . . the way the ocean moves. . . . The ocean is what the expanse of the West was for me. . . . I form from the inside out, like nature.*
>
> —Jackson Pollock, American painter, in Kynaston McShine, ed., *The Natural Paradise*

If you ask students what they are going to paint, they often have no idea and will make up something to please you. As they get involved, they may forget about their commitment to you, and when you say, "What is that?" or "What a wonderful boat!" they are uncomfortably caught and may feel they have to make up another story. By asking them this kind of question, you force them to fabricate a target after they have already shot their arrows.

Sometimes adults get stuck with images they learned in early childhood. Recently, while looking at an adult's work, I realized what she had been doing all semester was an attempt to break through those initial cliches. Although three-fourths of the paper was exuberantly free in its painterly style, the upper right corner of the page featured that standard symbol for the sun which must have been acquired in the first grade. After I commented on the variety of her brushstrokes, I put my hand over the sun and asked her how this shape was contributing to the whole composition. She immediately recognized that putting it there was a fallback to a recognizable symbol.

If beginners press you about how to paint a specific object, you can help them

Child's story painting

Lisa's turkey painting

Unfortunately, many people have been exposed to a rigid uniform method of representational drawing. Four-and-a half-year-old Jimmy pronounced after painting the standard yellow pie wedge shape with spokes in the upper left-hand corner of his paper, "This is how the first-graders make the sun. My sister's in the first grade and she knows!"

to think about the visual elements of what they want to draw by breaking down the complex image into its visual parts. For example, just before Thanksgiving, five-year-old Lisa came to me saying, "I want to paint a turkey but I don't know how." "I think you can paint a picture of a turkey," I replied. "Let's think about it. What kind of a shape does a turkey have, a long skinny one or a round fat one?" She thought a bit. "A big fat one." "Why don't you start with a big fat one?" As we were talking about shapes, Lisa gazed up at the wall where I had pinned a Chinese pleated decoration that made a circular fan when opened. It

was dark blue at the edges and faded into light blue at the center. She looked down at her paper, dipped her brush into the container of blue paint, and brushed in a large round shape. "I'm making a blue turkey." She looked up at me again, for she wasn't sure what to do next. "What else does a turkey have? Does it have a head? A tail? Something under its chin?" Once she was past the initial decisions about these shapes, she painted with pleasure. Her last strokes were gently smoothed over with the brush as though she lovingly caressed her turkey. She was overjoyed at what she had accomplished herself.

LEE BONTECOU (American, b. 1931). *Untitled.* 1961. Relief construction of welded steel, wire, and canvas, 6' 8¼" x 7' 5" x 1' 5⅜". The Museum of Modern Art, New York, The Kay Sage Tanguy Fund

*That time, I must have been eight or nine, I was going down the stairs mooshing up some sand to try splattering it on a piece of wood to make a drawing, and I remember distinctly thinking, I can do anything in the world, if I only have the tools to do it with.*

—Lee Bontecou, interview with Eleanor Munro, in *Originals: American Women Artists*

FRANZ KLINE (American, 1910–1962). *Black, White and Gray.* 1959. Oil on canvas, 8' 9" x 6' 6". The Metropolitan Museum of Art, New York, Arthur H. Hearn Fund, 1959 (59.165)

*There are forms that are figurative to me, and if they develop into a figurative image—it's all right if they do. I don't have the feeling that something has to be completely non-associative as far as the figure form is concerned.... I think that if you use long lines, they become—what could they be? The only thing they could be is either highways or architecture or bridges.*

—Franz Kline, interview with David Sylvester, 1963, in Kynaston McShine, ed., *The Natural Paradise*

## Craftsmanship: What Can You Expect from Beginners?

Good craftsmanship does not mean making products that imitate standards of commercial production. It is both an attitude and a process of doing things as well as you can. It is taking care of tools so they function well, learning to glue and join pieces so they stay together, preparing the clay so it doesn't crack and fall apart—in short, it is working with the potentials and limitations of each material and tool. (See the discussion of kits on pages 36–37.) In order for you to communicate this attitude, you not only have to demonstrate it yourself but also to understand beginners' capacities so that you do not demand a level of perfection they are unable to attain.

## Displaying Beginners' Works

In my workshop for teachers, I put up everyone's work from the previous week's class to get them to empathize with their students and we discuss how inferior one might feel if I just displayed six out of twenty works. If several different classes use the same room in a day, however, there is not enough time to put everyone's work up between workshop sessions. Therefore, I display the work of former adult students on the classroom walls to avoid singling out people presently in the class as superior or inferior to the rest. Consciously or unconsciously drawing comparisons between people's work can only inspire competition and defensiveness. Consequently, I encourage parents to think about how to display their children's work at home.

Just as copying reproductions places too much emphasis on the final product, displaying everything a novice makes is not helpful to the learning process because it distorts the value of the work as exploration. The danger in exhibiting beginners' work is that by framing a lot of pieces you put a value judgment on their work as overly precious products instead of recognizing that the process from which this evolved was experimental and an important stage of growth.

Be wary of encouraging students to give their studio works as gifts to people who have not asked for them. While close relatives may be delighted with the gesture no matter what is delivered, other people may regard such gifts as an imposition because they may feel compelled to display and praise works that have little interest for them. If you are given such a present, acknowledging pleasure at being given something by someone you love rather than exaggerating its artistic value puts the emphasis in an appropriate place.

Putting up works in private places for the owner's personal contemplation, however, is different from display in public areas of the home or other places where others may feel compelled to judge it. Tacking papers up in one's room or on the interior of a closet door in the work space to study one's weekly progress is a practice used by many artists.

Guide beginners in choosing the one or two works they want to display by engaging them in a discussion of why they like one work over another. This will encourage decision-making, and, as students do new compositions they can exchange the pieces on display. Works in progress may be put up to study in any number of private places in your home on a cork, pressed-fiber, or cardboard bulletin board. Children's small drawings and collages may be effectively hung with magnets on the refrigerator door. If you have already purchased a child's easel and are no longer using it for working (see page 28), you can use it to display their finished

paintings. Paintings can be held by clips that fasten the painted paper to the easel board, and you need not put up tacks or tape on the wall.

Some parents have one or two works nicely mounted and framed to put up in their offices or living rooms. Inexpensive aluminum frames complete with paper mats and plastic or glass, that use spring clips to hold the work in place, allow ease of exchange as the student progresses. Since these frames permit stacking several works behind the one on display, they also provide safe storage for years if you use an acid-free mat or backing board.

## Skill, Creation, and Recreation

*I* see the studio processes as *re-creation*, the act of creating anew, as well as *recreation*, that which is refreshing and enjoyable. After you have worked at acquiring a skill, you can move materials and ideas about freely and welcome changes as they happen. I avoid using the word *play* when working with studio materials because it is so misunderstood. When a child is sent out to play, it may mean, "Go amuse yourself" or "Stay out of my way." Yet play in its best sense can provide an intellectual activity that has a role in the inventive process as well. Moving shapes and colors freely around in your projects by allowing them to interact helps you perceive nuances of color and shape. Focused play becomes a dialogue between you and your materials when you intensely engage the challenges at hand. Yet nondirected play with studio materials can be a kind of amusement that will eventually lose its appeal. No competent sports coach would send a person onto the field to play a game before learning the rules, limbering up, and donning the proper equipment and uniform.

When a person learns to ride a bicycle, usually after directed effort on the part of the instructor and beginner, the first rewards are joy and pleasure in the control of movement. Later the bicycle becomes a vehicle for exploration, transportation, and adventure. Similarly, when beginners start to work with art materials, they experience this same exhilaration of moving the medium and controlling the brush and colors. After gaining control, students can become involved with the movement and communication of ideas. If approached in this way, artwork becomes a conceptual bicycle on which to travel, a tool that can lead to a wide range of experiences.

*I don't hold any brief for one art being greater than another. The word art means work. An artist is a worker, not a person who dreams lovely dreams. You can dream and dream and so what. If you don't build a structure of some kind, you don't make communication.*

—Martha Graham, American dancer and choreographer, excerpt from an article quoting famous artists, *Staten Island Advance*, early 1980s

SANDA ZAN OO (American, b. Burma). *Zat Opening*. 1994. Charcoal on paper, 22 x 30". Courtesy of the artist

*When I'm ready to work, I have all the materials I'll need within arms' reach. Once all is in place I sit in front of a blank piece of paper and meditate on it until a feeling arises in me. Then I take a piece of charcoal in my hand and begin the silent dialogue that bypasses my mouth and blacken the entire piece of paper. Then, still meditating on the feeling, I take an eraser and uncover the white that exists just below the dark surface. Shades and shapes become my vocabulary as the emerging picture and I continue to communicate. Finally the image I see before me evokes the original feeling that moved me to start and I know this particular work is finished.*

—Statement by the artist

# 4. Beginning Painting

PAUL CEZANNE (French, 1839–1906). *Rocks in the Forest.* c. 1893. Oil on canvas, 28⁷/₈ x 36³/₈".
The Metropolitan Museum of Art, New York, Bequest of Mrs. H. O. Havemeyer, 1929, The
H. O. Havemeyer Collection, 1929 (29.100.194)

*In so far as one paints, one draws.*

—Paul Cézanne, quoted in Donald J. Saff, "The Encompassing Eye: Photography as Drawing."
*(Aperture 25, Fall 1991)*

EDOUARD MANET (French, 1832–1883). *Boating*. 1874. Oil on canvas, 38¼ x 51¼". The Metropolitan Museum of Art, New York, Bequest of Mrs. H. O. Havemeyer, 1929, The H. O. Havemeyer Collection (29.100.115)

In all of my workshops, I display reproductions of works of art such as those throughout this book in order to stimulate ideas. As you look at the examples, you will see the great range of possible brushstrokes made by painters through the ages.

WINSLOW HOMER (American, 1836–1910). *Northeaster.* 1895. Oil on canvas, 34³/₈ x 50¹/₄". The Metropolitan Museum of Art, New York, Gift of George A. Hearn, 1910 (10.64.5)

## *Preparing for the Painting Session*

*I*t is most important that you read the entire chapter before starting each studio project so that you have an overview. In the beginning, when you are attempting to learn how to handle the brush and manipulate the paint, it is not helpful to concern yourself with a finished composition or to try to make a pleasing design to show others.

### CHECKLIST OF MATERIALS FOR THE PROJECT

■ Reproductions: In selecting reproductions of works of art for display during this lesson, look for examples that show a great range of possible brushstrokes made by painters through the ages, including traditional Chinese and Japanese paintings and

the works of many different modern painters.
■ White drawing paper, 18 by 24 inches
■ Painting-tray setup:
  Paint tray
  Four colors of tempera paint: white, yellow, red, and blue (omit black for the first few sessions)
  Paint containers to set into the tray
  Bristled paintbrushes: a one-inch-wide brush for each participant and an additional quarter-inch-wide brush for each preschooler (for use in remotivation when their attention strays)
  Cellulose sponge (not plastic or rubber)
  Water bowl for washing brushes
■ Masking tape, one roll
■ Optional: Small precut construction-paper pieces for young beginners

### SETTING UP THE PAINTING TRAY

1. In the beginning, fill the paint containers only half full to avoid spills.
2. Arrange the filled paint containers on the right side of the tray for right-handed people or on the left side for left-handers. Sometimes young children are not sure in which hand they want to hold the brush. If someone is ambidextrous, try setting the tray on the right unless you see the child switching the brush to the other hand. Place white at the front, then yellow, red, and blue. This order, light to dark, seems to work well because preschool beginners usually will start off with the color nearest to them. Starting with lighter colors makes for easier mixing; dark ones would dominate the mixtures if used first, which is why black is omitted until later.
3. Soak and squeeze out the sponge to be used for pressing excess water from the brush. If the sponge on the tray is either

PAUL JENKINS (American, b. 1923). *Egyptian Profile.*
1953. Gouache and ink on Egyptian papyrus mounted
on canvas, 42 x 29". Courtesy of the artist

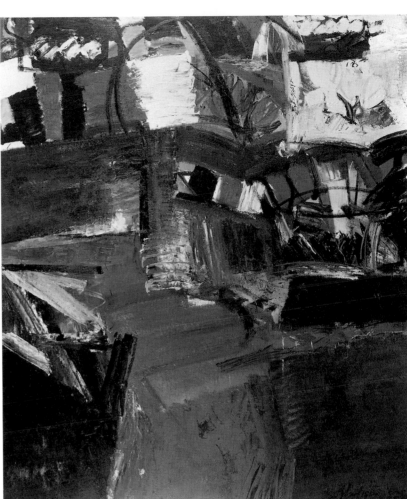

GRACE HARTIGAN (American, b. 1922). *Shinnecock Canal.* 1957. Oil on canvas,
7' 6½" x 6' 4". The Museum of Modern Art, New York, Gift of James Thrall Soby

All three of the painters on these two pages have chosen to use vigorous
brushstrokes to convey the turbulent rhythm of nature. Notice how each
has a different way of applying paint. Winslow Homer used a variety of
strokes to blend color smoothly as well as touches of semidry brushed
white highlights on edges and broken slashes to define rocky shapes. Paul
Jenkins puddled and spread his oil paint thinly in translucent washes.
Grace Hartigan worked thick impasto layers of paint into a densely
packed field of choppy and slashing gestural strokes.

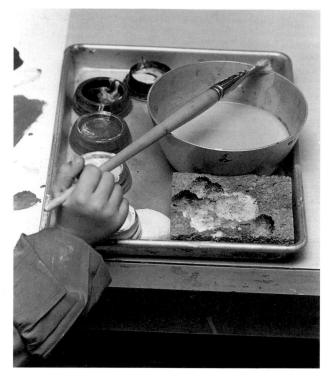

Painting-tray setup

hard and dry or too wet, it will not absorb properly. Set the sponge at the front of the tray.

4. Fill the water bowl half full and place it above the sponge on the tray. If you are going to ask very young children or people who are physically challenged to remove the bowl and empty it during cleanup, fill it only one-third full.

5. Place your large brush in the center of the tray alongside the paints. Keep the smaller brush out of sight for later use in remotivation of youngsters. Adults do not receive any small brush in this project.

6. For young children or people with disabilities, tape down the paper on the table so it won't slide away as they work. Put one-inch strips of masking tape on the upper-right and lower-left corners so the paper is flush with the table edge. Leave the pages of older students untaped so that they can turn their papers and view them

from different directions as they work.

7. Place the assembled paint tray to the right of the paper (or on the left for left-handers), and slide the paint cups, in order, to the right side of the paint tray. If possible, each person should have his or her own tray arranged in this way.

## ABOUT WATER-BASED PAINT

Although enthusiasm for oil painting in European culture during and after the Renaissance overshadowed the long tradition of water-based paints, great artists of the East continue to enjoy this medium. They still use it to depict representational subjects as well as to evoke the inexpressible poetic qualities of nature, such as sound in the air, a ripple in a reflecting pool, or the moment of full bloom of a flowering tree.

The Chinese had names for each sweep of the brush. The initial stroke might be started with a *nail head,* a slight pressure of the bristles to the paper that was held momentarily to make the paint puddle expand before drawing out the path of color. Raising the brush without losing contact with the surface made a thin point called a *rat tail,* while descending pressure splayed the bristles into a broad *praying mantis body.* One twisting stroke that crossed back on itself was called a *phoenix eye.* A sensitive dab would evoke a dripping wet mass of blossoms, a ripe persimmon, or the body of a shaggy monkey. A dry stroke to accent clouds suggested imminent rain. After brushing in pale circular strokes for a cloud, before that liquid dried, a smaller, almost dry brush of darker pigment would be used to touch in textures, skimming the surface so that the bristles barely caressed the paper.

If you are like most of us, when someone mentions painting, you probably imagine an artist at an easel. This image is

often one inexperienced teachers bestow on beginners by setting them up at an easel with paints they cannot control because this water-based medium drips down the upright surface. Now, as you begin your preparatory painting exercises, you will see why working on a flat surface makes it easier to control the poster colors and will understand why I recommended that beginners use a horizontal worktable instead of an upright easel.

Although in the workshops where preschoolers are present adults should sit while painting to provide role models for the children (who may walk around with dripping loaded brushes), when alone, adults may choose to work standing up at the table. Standing encourages larger arm and wrist motions because you will not be tempted to rest your wrist on the table. For this reason, some educators feel that children should also stand when working. However, very young children usually move their arms freely even when sitting, especially if they have not been taught to rest their hands on the table when using a pencil. If young beginners really prefer to stand, I don't make an issue of it as long as they are not wandering around.

## Getting Comfortable with Procedures: Preparatory Exercises for Adult Leaders

*An artist does not skip steps, . . . if he does it is a waste of time because he has to climb them later.*

—Jean Cocteau, French artist, painter, filmmaker, poet, novelist, dramatist, and art critic, in Rudolph Arnheim, *Art and Visual Perception*

*I remember one morning when I discovered a cocoon in the bark of a tree, just as*

HON-AMI KOETSU (Japanese, 1558–1637). *Poem Page Mounted as a Hanging Scroll, with Underpainting of Cherry Blossoms.* 1606. Ink, gold, and silver pigment on paper, 7⅞ x 6¾". The Metropolitan Museum of Art, New York, The Harry G. C. Packard Collection of Asian Art, Gift of Harry G. C. Packard and Purchase, Fletcher, Rogers, Harris Brisbane Dick and Louis V. Bell Funds, Joseph Pulitzer Bequest, and The Annenberg Fund, Inc., 1975 (1975.268.59)

Ancient Asian poets, philosophers, and Buddhist priests, as well as painters, have long sought to master the brush, whether for painting or writing. Indeed the two arts often shared the same piece of paper or silk. Strokes used for writing originally were developed from pictorial representations; later, the painters reborrowed many calligraphic marks from writing to depict objects, such as the branch of a tree or tail plumage of a bird. In addition, writers and poets evolved and developed scripts with visual names such as *cloud writing, dripping dew, snake writing, goose head, hanging needles,* and *tigers'* and *dragons' claws.* They worked with a variety of shaped brushes, some much wider than those you will be using here and others narrower. The softer bristles and different bristle body shapes were suitable for spreading ink.

*a butterfly was making a hole in its case and preparing to come out. I waited a while, but it was too long appearing and I was impatient. I bent over it and breathed on it to warm it. I warmed it as quickly as I could and the miracle began to happen before my eyes, faster than life. The case opened, the butterfly started slowly crawling out and I shall never forget my horror when I saw how its wings were folded back and crumpled; the wretched butterfly tried with its whole trembling body to unfold them. Bending over it, I tried to help it with my breath. In vain.*

*It needed to be hatched out patiently and the unfolding of the wings should be a gradual process in the sun. Now it was too late. My breath had forced the butterfly to appear, all crumpled, before its time. It struggled desperately and, a few seconds later, died in the palm of my hand.*

*The little body is, I do believe, the greatest weight I have on my conscience. For I realize today that it is a mortal sin to violate the great laws of nature. We should not hurry, we should not be impatient, but we should confidently obey the eternal rhythm.*

—Nikos Kazantzakis, *Zorba the Greek*

*Adopt the pace of nature, her secret is patience.*

—Ralph Waldo Emerson, nineteenth-century American philosopher

In every endeavor there is a warm-up period. As in dance and music, exercises precede the studio session. If you have never painted before, you should expect some awkwardness at first. At the age of seven, when I was given piano lessons, my fingers were very agile, and I delighted in playing scales at a rapid pace. I invited a much older relative to join me at the piano one day, saying, "Just look at how I do it. It's so easy." Never having played before, she placed her hands on the keys and with great effort tried to make her stiff fingers strike the notes. She had difficulty in making them work for her. Thinking back on that experience, I came to realize that nothing is easy unless you know how to do it. My success had to do with experience and agility won through exercise at a young age. For many beginners, the joy of painting comes from the sheer pleasure of moving the brush and paint around, and when you have young children as role models, you may find it easier to allow yourself to let it happen to you.

For many inexperienced or even experienced painters, a piece of blank paper resting on the table in front of them can represent a tremendous challenge or even a barrier. Many fear messing it up or making a mistake. Sometimes, the more expensive the paper, the greater the inhibition. Yet this is rarely a problem for preschool children unless someone inadvertently makes a comment that causes them to lose confidence in their own ability.

I encourage beginning painters to let their brushstrokes move across the paper, allowing them to flow into masses of colors. While young children do this naturally, adults may have to cultivate a variety of directional movements and spontaneous marks. Your freedom to do this may come slowly until you limber up.

If you experience some anxiety when faced with that blank sheet of paper, try to give yourself some time alone after setting up your paint tray, without any others around to pass judgment. Because others can read ambivalence and timidity, in order to encourage your students, you have to show some measure of enthusiasm and confidence from the start. Give yourself a fair chance to become acquainted with the

action of painting. Remember that your aim here is to find out how to make the widest range of brushstrokes and color combinations, learning from accidental happenings as well as intentional gestures. Think of it as a dialogue between you and your materials. An attempt at making compositions or recognizable images may inhibit and lead you away from this goal.

As you work, you can also evaluate the studio materials you are using. Are they appropriate for your students? If something is wrong with the color or consistency of the paint, if the paper is too absorbent or wrinkles when wet, or if the bristles of the brush are too soft or defective, beginners of any age may soon feel handicapped and frustrated.

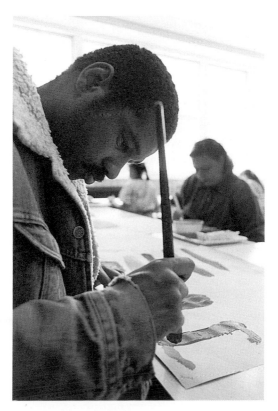

Adult beginner painting

## WORKING WITH THE BRUSH

1. Dip your brush in any one color (you will try them all, so it does not matter which one you start with) and put a stroke on the paper. Although your particular brush grip does not matter much now, try not to think of the brush as a pencil but use your whole arm as if you are painting a wall with house paint.

Moving your strokes across the paper, alternately lift and press down the bristles to vary the width and texture of the color path. If you continue to paint with the same brushload as long as you can before redipping it, you can get a great variety of textures and color gradations as the paint in the bristles diminishes—going from soft, spreading, wet puddles, through crisp-edged swathes, to dry, rough tracks and trails.

I always tell the adults in my workshops if they have a problem getting started, "Dip your brush in any color, close your eyes, and move the brush around all over the paper. When you open your eyes you will find that you have started to paint." You can then create a dialogue between these marks and the subsequent ones by reacting to the initial gesture, connecting other strokes to it, covering it up, enlarging it, and so forth. Legend has it that once when Winston Churchill was standing in front of a canvas complaining about having trouble beginning, a close friend took a brushful of wet paint and made a mark on the surface. Churchill then had no problem taking brush in hand and reacting to this gesture on this work.
2. Now observe what happens when you push the brush, drag it, twist it. What happens when you try the same stroke at different speeds? If painted slowly, the stroke may be shaky, when painted fast it becomes more regular, and your starts and rapid stops create jagged shapes of different widths. See what happens when you

KATSUSHIKA HOKUSAI (Japanese, 1760–1849). *Dragon and Figures.* Ink and brush on paper, 16 x 26".
Collection of The Mary and Jackson Burke Foundation

*In the hand of Hokusai, accident is an unknown form of life, the meeting of obscure forces and clairvoyant design. Sometimes one might say that he has provoked accident with an impatient finger in order to see what it would do. That is because Hokusai belongs to a country where, far from concealing the cracks in a broken pot by deceptive restoration, artisans underline the elegant tracery in a network of gold. Thus does the artist gratefully receive what chance gives him and place it respectfully in evidence. It is the gift of a god and the gift of chance latent in his own handiwork. He speedily lays hold of it to fashion from it some new dream. This excess of ink flowing capriciously in thin black rivulets, this insect's promenade across a brand-new sketch, this line deflected by a sudden jar, this drop of water diluting a contour—all these are the sudden invasion of the unexpected in a world where it has a right to its proper place, and where everything seems to be busy welcoming it. For it must be captured on the fly if all its hidden power is to be extracted.*

—Henri Focillon, French art historian and philosopher, *The Life of Forms in Art*

*Then sometimes, when the artist is working along and free, once in a while there will come this great sense of alarm. As if you have shocked yourself. You combined certain elements in such a way as to work something new and puzzling. It ran ahead of you and did this to you.*

—Helen Frankenthaler, American painter, in Eleanor Munro, *Originals: American Women Artists*

hold the brush perpendicularly and at different angles to the paper. Direct the stroke first through the fingertips, next with the wrist, then from the shoulder, and finally move your whole arm while brushing. Dip your brush into the pigment and touch it down, vibrating, sliding, and rolling the bristles from edge to edge.
3. Add some water to the paintbrush and try all of these again. You will find that the thinner paint creates softer wash tones, translucent and transparent atmospheric effects with diluted paint. Thicker and drier consistencies can be built up into raised *impasto* or thickly laid-on textures.

## Changing Colors and Consistency of the Paint

4. When you are ready to use another color, dip your brush into your water bowl, stir it around several times, and drain off the excess water by pressing it several times on your sponge. If you load your bristles with a lot of paint, you may have to repeat the washing and drying until that pigment has disappeared.

If you want to thin the color you are currently using, *before* reaching for paint, dip your brush in the water and apply it to a painted area already on the paper. Thin the paint directly on your paper, *not* in your paint container, because once you water down your paint supply you cannot rethicken it easily without setting the paint aside for quite a while to dry.

## Blending and Mixing Colors

5. We mix colors directly on the paper in order to see how colors work together with the shape of the background to affect the whole composition. To *blend* colors, put down different colors side by side on the paper and brush some of one color over into the nearest section of the other. The overlapped areas will produce blended colors. To make new color *mixtures,* after applying the first one, wash the brush, press out the excess water on the sponge, and apply a second color right on top of the first while it is still wet. Now mix them together with your brush. Next you might try changing the color from opaque to translucent or transparent by dipping your brush into water and brushing it over previously painted areas, so that the white of the paper shows through the paint in some places. (See the blended tones in Franz Kline's painting *Black, White and Gray,* page 56.)

Identical colors can appear different when placed on top of or near other colors. By using this paint-mixing technique, you will also be repeating the process young beginners use to mix their colors. This method allows great spontaneity and increases your receptivity to effects that you did not expect. Remember that you are experimenting. You do not have to like the end result as a painting, although it is possible that you will.

## Overpainting or Painting Over

6. "Why don't you try using your cover-up paint?" said Jane Bland, one of my teachers, when beginners wanted to start over on a new paper because they thought they had made mistakes. "All of your paint can be cover-up paint; if you don't like what you have done, you can change it." Occasionally I hear myself using those words to allay anxiety that there are any unchangeable marks.

What most beginners fail to realize at first is that layering of paint, or overpainting, is a method by which the greatest variety of colors can be achieved. Seeing bits of various paint layers coming from below the top surface creates painterly

effects. You can paint over everything once it dries. Often it is more helpful to just start adding, changing, and mixing over small areas. What at first may seem to be a dull, drab color field can vibrate dynamically with the addition of tiny strokes of bright colors on top of it. Don't give up easily.

In order to paint over layers without blending the colors, let the layers dry first. You can also completely block out a color by letting it dry, covering it with white paint, then letting that layer dry. Finally, paint over the previous dry layers with any other color of your choice. Of course, the coverage is going to be more complete with thicker paint right out of the paint container than with the pigment that has been diluted with water. (A lot of water might bring up some of the undercoat). At the very end, if you still don't like the painting, keep it to cut up later for collage material.

Try out all your strokes with one color on top of another, blending, mixing, overpainting, and even painting out parts until you feel at ease. Because you will never make a complete painting when you demonstrate procedures, don't agonize over your earliest experiments. But if you are still insecure about your ability to project confidence and enthusiasm, try a second or third session alone to gain assurance. Above all, do not compare your results with finished paintings of others.

*Paint never seems to behave the same. Even the same paint doesn't, you know. In other words, if you use the same white or black or red, through the use of it, it never seems to be the same. It doesn't dry the same. It doesn't stay there and look at you the same way. Other things seem to affect it. There seems to be something that you can do too much with paint and after that you start murdering it. There are moments or periods when it would be wonderful to plan something and do*

*it and then have the thing only do what you planned to do, and then, there are other times when the destruction of those planned things becomes interesting to you. So then, it becomes a question of destroying the planned form; it's like an escape. It's something to do, something to begin the situation. You yourself, you don't decide, but if you paint you have to find out some way to start this thing off, whether it's painting it out or putting it in, and so on.*

—Franz Kline, American painter, from an interview with David Sylvester, 1963, in Kynaston McShine, ed., *The Natural Paradise*

*A picture is not thought out and settled beforehand. While it is being done it changes as one's thoughts change. And when it is finished it still goes on changing according to the state of mind of whoever is looking at it. A picture lives a life like a living creature, undergoing the changes imposed on us by our life from day to day.*

—Pablo Picasso, Spanish artist, from an interview with Christian Zervos, 1935, in Herschel B. Chipp, ed., *Theories of Modern Art*

## Demonstration for Young Beginners with Adults

### PREPARATION FOR THE DEMONSTRATION

After you have experimented with brush and paint and are ready to do it again with beginners, remember that, until they develop sustained focus on their own work, you may not be able to concentrate on yours. Even so it is important initially to set up your paint tray and paper so that you present a role model and will not be tempted to hover over anyone else. Noninterference is not abandonment. You must

be present at the first few sessions to support beginners' efforts with the unfamiliar materials. What is often perceived as boredom is actually frustration at not knowing how to proceed to the next step or what possibilities may be tried out.

At the beginning of the session, explain the procedures of painting in an area away from the worktable. It is difficult for some beginners of any age to be interested in listening or watching if their trays are immediately accessible. The paint looks so inviting that once they go to their places, they may want to start right away.

Remember that no matter what colors or marks you make while doing these projects, try not to act as if you have made mistakes. There are no mistakes in the aesthetic choices for this project; there are only changes to be made and new possibilities to be discovered. Always demonstrate *only* on your own paper and make it clear that everyone works only on his or her own paper.

A young artist-mother told me with amusement that when her very young daughter made marks on her canvas, she incorporated them into her paintings. I could not help imagining what was bound to happen in the future when her child, wishing to be helpful, drew or painted on a finished work that was ready for exhibition.

Just as children should not work on their parent's projects, adults also need to respect the work of their youngsters. A parent whose child had done a painting on a booklet-like, folded-over piece of paper admired it so much that she decided to have it framed as a present for her husband. Without consulting her daughter, the mother cut the painting in half to display both the outside cover and inside page simultaneously before presenting it to the framer. To her surprise, when she brought the framed work home, the child became hysterical over what she felt was the destruction of her work. Setting behavior guidelines for everyone will prevent unpleasant incidents. Self-respect, as well as respect for one another, will be fostered when each person works only on his or her own projects without disturbing the processes or finished projects of others.

At the start of each weekly session, demonstrate painting procedures each time there is a variation in the aims of the project. Reviewing the painting process at least three separate times allows beginners to understand the system. If you are working more frequently, the reviews might not be necessary.

The idea of demonstrating is to show the process of applying paint and of washing and wiping the brush, not to make a painting in front of the class. This demonstration period also gives preschoolers a chance to stay with their parents and look around before going off to their own places. Since I never make a finished composition during a demonstration I am not concerned that students will try to copy what I have done. Once they pick up a brush, the materials inspire action and each person proceeds in their own fashion. Always tailor the demonstration to the chemistry and attention span of the group. You may not complete this sequence with all of the young beginners the first time, although most will be mesmerized. If you are too slow or draw out the process through the entire suggested steps, preschoolers may get restless. If the students are raring to go once they have seen the colors mixed, you might cancel the rest of the steps.

### Demonstration Guidelines for Adults with Preschool Children

1. To begin, pick up the brush off the painting tray and ask, "Do you know what

this is?" Most very young children look at it and are hesitant to say anything, even if they know. Pause. "Is it a brush?" ("Yes!") "Is it a toothbrush?" (A big "No!") "Is it a hair brush?" ("No!" They smile and relax.) "It's a paintbrush, and we're going to paint with it." This is not an absolute recipe but it is something that has worked well for me to help everyone relax in the first session.

2. "What color shall I start with?" Point with the brush to the paint containers, naming each color separately in order. Pause slightly between each one so that if they know the color they can call it out. "Shall I use some white, yellow, red, or blue paint?" If they do not know the names, just point and designate each color. If they say white, reply, "Let's save that for later," because you want to dramatize color mixing with the red, yellow, and blue.

3. Dip the brush into a chosen color, red, for example. "Now, I'll put the paint on my paper." When you put the brush onto the paper, ask if they know what you are doing. "I'm making a brushstroke!" It is important to introduce vocabulary words so that you can talk about the work. Try to use up all the paint on the brush by spreading it in a few separate places across the page while remarking, "I like to think about my whole paper as a place where the colors can sit next to each other."

4. "I want to try another color. Should I use some red or some yellow?" (Some point to it or others may call out.) "What do you think I have to do before I put my brush into that color?" Pause briefly. "I have to wash it." For preschoolers say, "The water bowl is like a bathtub for the brush." Stir the brush in it saying, "Wash, wash, wash." Take the brush out and pause. "What do I do now?" Pause. "I have to dry it just as you dry yourself with a towel after a bath. After I wash, wash, wash, I press, press, press, so the colored water goes into the sponge." Now brush

yellow (for example) onto several places around the paper.

Because the water will get darker as it becomes filled with pigment, it is necessary to reinforce the idea that the water changes color but that it is not dirty. I never call the colored water "dirty." When you wash and press your brush on the sponge for every change of color, you may be able to do several paintings without changing the water, depending on your choice of colors.

5. "I think I'll let the yellow sit next to the red." Spread the yellow closer and closer to the red and then let the brush drift over into the red while exclaiming, "Look what's happening! When the colors bump into each other, they change." Because I always anticipate the children's reaction when they see colors change for the first time, they sense my suspenseful attitude. Treat it as something very special so they realize that it is not only permissible but even exciting to let the colors collide in order to make them change. This introduces the word "change" into their vocabulary in a visual way.

6. Quickly go on to mix these two colors some more. "Look what's happening and how the colors change. Do you know what color I made?" Pause. If there is no immediate or correct response, name the color. It is important not to seem as if you are testing anyone, but rather to reinforce the process that is happening on the paper.

7. "Now, what color should I use?" Repeat the same process of "Wash, wash, wash," and "Press, press, press." Spread this third color around the paper without mixing it into the other colors. "I think I'll let my blue sit next to the yellow and see what happens." Put a dab of blue in an empty section of the paper. "This blue has no color to sit next to. It's all alone, talking to the white paper. Now I'll let my blue talk to some yellow." If older beginners say,

"Colors do not talk," you can reply that "colors tell a story in a different way than words do, without sounds. When you are painting, you are telling a color story or a story about the colors."

8. Let some blue blend with the wet yellow paint on the paper, making green, and then wash and dry the brush before applying some of blue onto the red to create purple. "I'm going to use white now." Wash the brush and ask, "Is this water getting darker or lighter?" After drying the brush on the sponge, dip the brush into white pigment and apply it to several areas of the paper, both unpainted and those places covered with red. The purpose is to show that when you put white on a white paper it seems to disappear, when you put white on red it makes pink, and that you can only make colors change if they are different from each other.

9. As a final step (especially for the adults who may be less adventurous than children), show a few more possibilities for using the brush. "Look at all the things I can make my brush do. I can make it slide up and down or walk around the paper." Also make dots and dabs as well as longer strokes here. "If I want to make a skinny line how can I do it with this fat brush?" (Only the experienced beginners know.) Demonstrate how to turn the handle of the brush so everyone can see how thin the edge of the bristles are, and then make some skinny marks on the paper.

10. "I might even want to use some of my colored water on the paper." Dip the brush into the water and apply it to an unpainted area. Then press out any remaining water on the sponge and dab some thick paint onto that wet area, calling attention to how the color spreads. "Now let's see some of the things you can do with your brush and colors."

11. Seat the children at the center of their workplaces with their paint trays already placed in the proper locations. Be sure to remember whether they are left-handed or right-handed.

## *Demonstration, Part 2, for Adults and Experienced School-Age Students*

1. Discuss the brushstrokes in art reproductions with adults and older beginners. (See also the adult brushstroke paintings on page 82.) Even if the works are mostly of oil paintings, they relate to issues addressed in this project: paint textures, blending colors, a range of brushstroke marks, overpainting, and the quality of previous changes often visible in the paint. Poster colors can be used to create these artistic traits without requiring the steep learning curve of the oil medium.

2. Make suggestions about how to start. Recommend that the students become "action" painters, filling in every part of their paper with brushstrokes and masses of color using all the exercises that were discussed earlier in this chapter. Explain that the reason many beginners often leave unpainted areas is because they do not know what to do with them, not because they have made a design choice. If they want white areas they should paint these in. Anyone who finishes before the end of class may start a second painting.

### *THINKING ABOUT WHAT YOU HAVE DONE*

> *When I use painting, I have the feeling of quantity—a surface of color which I need, and whose contour I modify in order to define my feeling exactly. Let us call the first action "painting" and the second "drawing." (As far as I am concerned, painting and drawing are one.)*
>
> —Henri Matisse, French artist, "Témoignages," in Herschel B. Chipp, ed., *Theories of Modern Art*

At the pre-course orientation for adults, I explain why they will only get one large brush for painting while the young beginners may use an additional smaller one for remotivation. I used to give adults an additional small brush, but I found that older beginners often spent a lot of time drawing lines with the small brush before they even considered the range of brushstrokes and the aims of the project. You may have found that the big brush felt cumbersome at first and that this required you to stretch yourself physically and conceptually. With the big brush you must use your whole arm and you cannot do the dainty, precious fingerwork that is possible with a small pointed drawing instrument. The small brush invites outlining of objects and consideration of drawing only in terms of value or light and dark. Painters Paul Cézanne and Henri Matisse, however, showed that form can be modeled with color areas, a concept we will explore in future projects, both in paint and later in torn and cut-paper drawings.

You may also have been surprised about how the color combinations in your paintings made you feel. Your favorite colors may have fought with each other. Popular color lore, such as fashion-advice columns, has often suggested that emotional associations and meanings of colors are fixed. They most certainly are not and are overwhelmingly influenced by their surroundings. Developing awareness of the relativity of visual effects is one of the important aspects of this course. Although I mentioned this before, please keep your first exercises even if currently you are not very fond of them. You will refer to and use them in later projects.

## Tips for Teaching

Some people may not start to paint immediately. Three-year-old Susan sat in front of her paper and did not paint for more than six classes (which was quite unusual) before she finally gained the courage to pick up her brush. Although I tried to motivate her gently by talking about the colors she liked, her only response was to nod her head yes or no. Because this session was not a parent-child class, she did not see her father or mother working as a role model. She sat watching the other children, and as they finished their paintings and emptied their water bowls, Susan got up and emptied hers also, joining them at the collage table. She loved making collages and clay pieces. When the other children asked, "Why isn't Susan painting?" I told them, "When Susan is ready to paint, she will. Right now she just wants to watch. That's okay. We all can learn a lot of things by watching."

Susan looked forward to the class and her mother responded by giving her paints at home, where she did paint. I suggested that her mother make no value judgments about her daughter's work since I had the feeling that Susan may have been overly concerned about being able to make a "good" painting and did not want to risk failure. Around the seventh week, Susan picked up the brush in class and started to paint as if it were a very natural thing to do.

If you are working at home, remember that beginners will copy everything you do. If you forget to wash your brush while changing colors when you are demonstrating in front of beginners, do *not* place the loaded brush in the water but put that paint somewhere on the paper. While you are demonstrating, once you dip your brush into the paint, try to follow through and put it onto the paper even if you change your mind about the color. If children see you putting brushfuls of paint into the water, they will do the same thing and become confused about when to wash

the brush. Or they may remind you that you did not wash your brush.

Students of any age will also imitate your general attitudes in the class. One mother brought her two children to different classes I was teaching (one to each class). During the first two sessions she and the children worked with tremendous involvement and focus in their respective sessions. After a few weeks, a close friend of the family also began bringing her child to one of the two periods and sat next to the first parent. The mothers began to talk with each other during the workshop, and their children echoed this socializing and did less studio work. A few weeks later, after class the mother with the two children told me she had concluded that her child with the friend in class had less ability and interest than his brother who worked quietly alone. I reminded her that, during the first few sessions, her sons were equally enthusiastic and involved in the studio activities. But after the periods became much more social in focus for the mothers, the studio work also diminished for their children.

Talking interferes with visual thinking and concentration. In order to encourage each person to make their own decisions, I try not to be overly directive and am very careful about my vocabulary and expression of attitudes. Everyone will see and do what interests them. Even though I may call attention to something specific, there may not be an immediate response; since the students may or may not have understood the concept, only time will tell what has been absorbed.

Sometimes young beginners become fascinated by the changing color of the water as they wash their brushes and may even put paint into the water or on the sponge. If they become preoccupied with these activities, they may forget to put the paint on the paper and you may need to remind them of it.

One day, two-and-a half-year-old Sam had his brush full of paint ready to lay on his paper when he heard me say to someone else, "Wash, Wash. Press, Press!" All of a sudden he remembered that he had not washed his brush and into the water went his brushful of paint. Then he put the wet brush onto the paper. He thought it was fun, so he did it again, and forgot why he was washing his brush in the first place. Occasionally every beginner, young or old, forgets to wash and press the brush before changing colors, especially when he or she becomes mesmerized by their own work in progress.

Allowing a workshop participant to paint on surfaces other than the paper or to manipulate paint with the hands after being given a brush is unspoken encouragement for that activity, and others may join in. Try to speak simply, directly, and gently, without nagging. Once in a while, if I see young children or disabled adults having trouble washing the brush, I may hold my hand over theirs on the brush and guide the bristles into the water bowl and onto the sponge.

Some participants may require alternative tool-handling techniques. People with disabilities may need to handle their tools in different ways, and you need to recognize this before offering any suggestions. Once a young friend with an arthritic condition offered to help me prepare a meal. While she was cutting some carrots I noticed that she was holding the knife in an unusual way and I diplomatically offered a suggestion for more efficient use. She said, "Yes, that is the way I used to hold it but I cannot do that anymore." I mistakenly attributed her method of cutting to ignorance rather than to physical disability. If you are unsure of the reason for an unusual technique, you might ask, "Is there a reason why you hold the tool that way?"

If you find yourself continually correcting beginners you may need to prioritize which processes must be modified at once and which ones can be postponed. Stopping inappropriate use of supplies is a necessity, but most will learn on their own how to wash the brush when they recognize the need to do so. It is important for you to be available, but try to concentrate on your own work so that others will not feel that you are impatient and critical. Moreover, you distract them from the painting process when you break their concentration. Older beginners and adults, who can be very self-judgmental, might be disappointed with their results and become discouraged if they feel they are not mastering the procedures quickly enough.

When preschool children realize that they can change the colors by painting over them, they will probably keep doing it because it gives them a sense of power. The end result may be masses of large brown or gray areas. However, they believe the original colors they began with are still there because they put them there. It is like playing peek-a-boo, covering favorite belongings with a blanket, or turning out the lights and making things disappear. It is such fun because they have recently learned that things do not go away even if you cannot see them. Try to allow them to learn this way, even though the end results may not appeal to your taste.

Four-year-old Bonnie painted and painted so that there were at least three paintings on her paper, one on top of another. She started with red, added white, and changed it to pink. Adding blue changed it to light purple. Yellow and red became orange next to the purple, and where the yellow bumped into blue it changed to green. The painting continued to flourish and in the end there were great masses of dark grayed colors from the constant mixing of wet colors on top of each other. As the children were finishing I asked, "Did anyone make green today?" With great excitement Bonnie called out, "I did!" "Where?" I asked. "Right under here," she said proudly, pointing to a dark area on her paper. Older beginners learn more quickly that if you don't want colors to mix together when you paint over the first layer, you have to let the undercoat dry first.

Sometimes a young beginner or even an experienced professional adult artist may have a specific concept or process that only they can explain. For example, one teacher told me how she watched five-year-old Robert first cover his whole paper with brown, then paint over it completely with green, next fill the entire sheet with black, and finally spread white over all that. The final painting was an all-gray field. She wondered if he were fooling around but did not stop him because he was so seriously absorbed in his task. When he finished he smiled up at her and triumphantly announced, "Do you know what I just made? I made a road." He had diagrammed the process of building a road. He painted the earth, covered it with grass, then tar, and finally paved it with macadam. Robert had thought through the whole sequence and from his point of view had represented a paved road very accurately.

Washing a brush, mixing colors, or creating textures will be learned as someone finds the need to use the processes. And the desire to learn processes and techniques often comes from looking at other artwork and discovering the range of possibilities for making alternative aesthetic choices. If beginners don't want to try something you suggest, don't force the issue. It is never worth making a contest or battle of wills. Change the subject to redirect the focus to another visual idea, such as the kinds of gestures one can make with the brushstrokes. Or, if you have any

First paintings by preschoolers

reproductions illustrating different visual qualities, you can point them out. If you are working with young children you could exclaim, "Look at all the kinds of shapes you've made on your paper. What other kinds can you make? Smooth? Wiggley? Bumpy?" Only stop an action if it is something that will cause harm, damage the surroundings, or if it involves using tools for a destructive or inappropriate purpose or meddling in someone else's work. If redirection does not work, you may have to go on to another activity or stop altogether. A lot depends on the size of the class because behavior is contagious.

If young beginners hold the brush in a different way from the one you have demonstrated, don't interfere. If children have grabbed the handle very high up near the top so that they have no control over it or too far down next to the bristles, you might gently slide their hand toward the middle area without saying anything. If they tense up at all, let go. You needn't make an issue of it as long as they can work reasonably well. After they are more secure and relaxed with painting, you can suggest a change: "When I paint I find it works better if I hold my brush this way. Do you think that you might like to try it?" You would demonstrate by using your own brush, not theirs. Once when I tried to change the brush grip of a child at the first session, he put down his brush and announced that he was finished. He seemed to interpret my desire to help him as disapproval or surveillance. Now, depending on the child, I wait until they

have completed several paintings and have learned to trust that I am not criticizing before trying to suggest anything.

## LIMITING ONE'S CHOICES WITH PAINT

A nursery-school teacher once told me that during a parent-and-child interview the mother proudly told her that Johnny could count. She asked him to demonstrate this and he quickly recited the numbers "12345678910," running them together in one gulp and counting off all the digits on the fingers of only one hand. It was obvious that he knew how to say the numbers but didn't really know what they meant.

Like the ancient Chinese, we use only three primary colors—red, yellow, and blue—plus black and white, because other colors can be made from these. In the workshops everyone should know what they are talking about when they name a color and discover for themselves how they are produced. I never buy green, purple, and orange because these are colors you can make by mixing the primaries, and the ability to do it is invaluable. Starting out with a number of ready-mixed colors deprives beginners of having the basic mixing experience. They make additional colors without knowing how their initial colors were produced through combinations of the few primaries, and they find they cannot repeat any of them.

The American artist Chuck Close recounted that in his early Abstract Expressionist period of painting he used to buy hundreds of colors. Later when he felt a need for a new challenge he decided to mix his own colors from just the primaries.

*The minimum number of colors to get full color is three. . . . I used to have five or six favorite colors that I would use.*

*Now I use three colors and I have to use all three. I can't prefer one to the other. Every square inch has some of all three. One result is that I'm mixing colors I never made in my life. I find it very liberating to accept things from the start as the eventual issues in the painting. Every limitation I have made has just opened things up and made it much more possible to make decisions. When everything in the world was a possibility I only tried three things or four things over and over. It's true. It's incredible. I didn't take advantage of that supposed freedom, and once I decided I was going to have relatively severe limitations, everything opened up: I have the possibility of making decisions other than how I feel on a certain day.*

—Chuck Close, American artist, in Linda Chase, Nancy Foote, and Ted McBurnett, "Photo-Realists: Twelve Interviews," *Art in America*

One day in class, a five-year-old who had a lot of paint colors at home demanded to know why he didn't have more colors on the painting tray. I replied, "Because I want you to learn to make your own colors. If you wanted some green and didn't have any, how could you paint things green if you didn't know how to make it yourself." Motivated by the desire to learn how, he proceeded in the next few sessions to experiment with mixing colors. After doing a particularly complex painting with many blends and mixtures, he put down his brush, pleased with his discovery, and said, "Now I know why you didn't give me any more colors."

## TEACHING ALTERNATIVE TECHNIQUES

Dripping and spattering by snapping the brush loaded with paint above the paper

are not techniques I encourage when trying to teach beginners how to use the brush. Without experience, it is difficult enough to be able to master the range of brushstroke possibilities and to gain control in being able to use these purposefully. Children may forget about their original intent in making a painting and just splash paint and water for fun. However, if young beginners discover these processes, don't discourage them if they are able to control the paint. Demonstrate how to hold a brush filled with paint perpendicular to the paper and shake it up and down. Since the possible range of marks available with this technique is narrower than that produced by making brushstrokes, they will probably tire of the activity and return to painting shortly. When they are more experienced and have developed better muscle control, you can show how to spatter with a short, snappy wrist action while holding the brush horizontally. In any case, if the activity gets out of hand, you will have to stop it by redirecting their attention to something else.

The problem with allotting time for teaching alternative techniques to beginners is that they may become sidetracked from the aim of their project. Learning to use the brush takes practice, and the continuity of these successive projects depends on mastering one problem at a time. Sometimes people are fascinated by a new tool or material and get caught up experimenting and testing it for its special qualities.

Four-and-a-half year old Jeff sat down to paint and heard another child ask if she could add some collage material to her painting. Hearing this, he took a small piece of sponge rubber from the collage tray and incorporated it into his painting. At that point, he became intrigued by its absorbent qualities and now painted over and over on it. He always enjoyed the way wet paint spread over his papers, but now seeing the paint disappear into the sponge seemed even more miraculous. At the end of the class Jeff was still excited by his experiment. If he had been engaged in painting his paint tray or the table I would have redirected him immediately; however, he was deeply involved with what was happening on his own paper and not interfering with other children's work or igniting a chain of destructive behavior in the room.

## WHEN IS A PAINTING FINISHED?

All beginners often have difficulty motivating themselves when they don't know what to do next or are not satisfied with their first efforts. Young children, especially, may become impatient and announce that they are finished.

If the adults have really covered their whole paper with brushstrokes and feel they are finished before the rest of the class, they can start painting on another piece of paper. Otherwise, if someone has stopped painting, I frequently ask, "Would you like to turn your paper around so you can look at it in a new way and think about the places on the paper where there aren't any colors?" If they say no, I leave it alone. I ask because if the paint on the paper near them is wet, preschoolers may be reluctant to reach over it to turn the painting around themselves, and their arms may not extend over the painted areas to work on these in the original position. Older children and adults may find the idea of turning a painting upside down difficult to accept, even though this is a traditional art technique for breaking down preconceptions and studying the painting with fresh eyes. Sometimes they prefer the work when seen from a different angle and get new ideas.

You might also ask beginners who have become involved with a tiny section

of the paper if they have considered the other unpainted places as part of the design. You might comment to a pre-schooler, "You have so many colors over here. What other colors do you think you might like sitting next to them?" I ask because they may not have even considered the other side of the paper as part of the visual field. The white paper can work as a shape and also a color, but beginners of any age sometimes do not think of the page as a whole. That is another reason why this first painting exercise for older beginners involves covering the whole page with brush marks.

## Cleanup

*If* you have a group of people who are working only on one activity for the whole session, remember to give plenty of warning and signal cleanup at least ten minutes before the end of the class. When young beginners work on all three studio activities in a one-hour session, they usually finish at different times from each other and clean up as they progress from one medium to another.

When the young students are finished painting and lay down their brushes, they get off their stools or chairs, take their water bowls over to the waste bucket or sink, and empty them. Older students can carry their whole tray to the sink and do more of the cleanup. Although I encourage everyone to do only one thing at a time, many of us often attempt unsuccessfully to execute several activities simultaneously. Adults routinely may try to group jobs, and things sometimes spill, especially when the students are tired or distracted by other people. I show young children and people with disabilities how to place both hands (with their thumbs locked over the inside edge) around the bowl while carrying it to avoid spilling the

water on the floor. Although a little bit of water may spill at the start, even the youngest will be able to accomplish this job by the end of the semester. If students have not had the opportunity to develop hand skills, no matter what the age, they may be clumsy at first. Moreover, people overcoming handicaps may need extra time to work out systems for accomplishing tasks that other people may find simple.

In a group of very young children, if something is spilled during class the leader should quietly take care of it. If one child starts wiping up the floor with a sponge, every other youngster might want to help, and energy will be directed away from the project at hand. At home with only one or two children, however, the person who spilled the water should help to clean it up even if he or she is very young.

When students of any age offer excuses to get out of cleanup and you give in rather than risk a scene, you will sabotage your studio program. Even if young beginners are unable do to very much and you are tempted because of lack of patience or time to allow them to shirk this duty, they should be given something to do. If you would rather not have them do some particular chore, then give them another task they are capable of accomplishing.

If you have a small group of young beginners and want them to participate more extensively, you must have time to supervise it. Try to tackle a single task at a time and add more as they master each one. For example, some two-and-a-half to three-year-olds are able to wash out their water bowl, sponge, and brush and clean the paint cups (if they are empty and already in the sink). You can help everyone develop a sense of the placement of things by explaining, "We do this so that we know where everything is and don't have to waste time looking for things for the

GEORGES PIERRE SEURAT (French, 1859–1891). Study for *A Sunday on the Grande Jatte*. 1884. Oil on canvas, 27 ¾ x 41". The Metropolitan Museum of Art, New York, Bequest of Sam A. Lewisohn, 1951 (51.112.6)

Adult brushstroke paintings

next workshop." Giving a reason for any studio process helps people to remember them.

Checking to see that the brushes are thoroughly washed and stored upright (bristles upward) in a can or other tall container is also important because, if the moist brushes are left standing with the bristles down, even for a short time, they will become misshapen. You can store them lying flat but it is preferable to dry them upright first.

If you have bought large quart jars of paint, you might turn them over occasionally to keep the pigment from settling on the bottom of the jar. Decanting the paint from large jars into smaller syrup dispensers makes for easier pouring and fewer drips to clean up. However, these small containers must have airtight tops. Remember to remove any paint from the jar or container edges while it is damp; otherwise it will harden, prevent the lid from functioning properly, and the liquid inside will dry up. If that happens you can remove the dried paint from the lid with hot water, but you may have difficulty restoring the medium to its proper consistency for painting. Rubbing petroleum jelly around the jar rim or putting a covering of thin, clingy plastic wrap over the top before putting on the lid will also prevent the tops from sticking shut.

If you left your tempera colors uncovered and the pigment has dried out, you can put a little water into each one to resoften the paint slowly. The hardened medium may have to soak overnight or even longer. (This will not work with acrylic paints because their workability after hardening is irreversible.) If you discover this situation just before you are ready to paint, put that cup aside and do not throw out the paint. Just fill another container from the large paint dispenser. Any remaining colors from the painting session that have been mixed together

(either accidentally or purposefully), go into a single jar for use in found-object printmaking. Put the lighter grayed colors into one jar and the darker ones in another.

If young children announce that they are finished after just a few minutes, I try to remotivate them into continuing, first by offering a smaller brush, and then later, perhaps, with small pieces of colored construction paper (which will stick to wet painted surfaces). Either they will become involved again, or they will put one more dab on the paper, saying,"Now I'm done!" That last dab is like the token bite of food when you say, "One more bite for Mommy." It is not really for them, it is for you. Although everyone should feel that they are painting to please themselves, showing interest may encourage them to continue the process of discovery.

# 5. Suggesting Mood or Place with Color

GEORGE INNESS (American, 1825–1894). *Spring Blossoms*. 1889. Oil on canvas, 30¼ x 45¾". The Metropolitan Museum of Art, New York, Gift of George A. Hearn in Memory of Arthur Hoppock Hearn, 1911 (11.116.4)

## *Materials Checklist*

■ Reproductions similar to samples shown in this chapter
■ Painting-tray setup (see page 62)

## *The Effect of Color*

*O*ne afternoon, a group of hungry high-school classmates and I decided to cook spaghetti and eggs. The kitchen cabinet also yielded up a package of food colors, which we decided to use: blue on the scrambled eggs and pink on the spaghetti. When we sat down to the meal, however, pretty as it looked, no one wanted to eat it because the food looked so strange. Everyone sampled it, and it tasted the same as usual, but the inappropriate colors took our appetites away. It was the first time we realized that color could have a physical as well as an emotional effect.

Color is so mysterious in its effects that, despite many books about color systems and theory, it still remains one of the most personal and elusive visual phenomena. Although most of us agree to use dictionary definitions of words when we speak, we perceive colors through many experiences, some of which we don't even have terms for. The more practice you have mixing colors yourself, the finer the discriminations you can make between ones you previously assigned simple generic labels. One young child brought a story book about colors to class because she had excitedly discovered, "They got these colors all mixed up! They called this color orange and it's really a yellowy pink or a pinkish yellow." She had made these literary and aesthetic judgments after having learned how to produce many varied orange gradations with the tempera paints.

Among many misconceptions about color choices is one that holds that happy, normal children always like bright colors. Actually, most youngsters enjoy and use all colors at different times. For example, after a workshop led by an African-American friend who taught in a Harlem Head Start school, a very distressed mother demanded to know why her son's painting was mostly black. "What are you doing to my son that makes him so depressed he paints black pictures?" she asked angrily. Before my friend could ask her how she was certain that black was depressing for Devrell, he piped up, "Mommy, don't you know what I painted? I painted you in your beautiful black nightgown. I love the way you look in it." Another time, when blond, blue-eyed five-year-old Colleen was asked by an adult about the content of her paintings, she said, "I love to paint happy paintings." "What is a happy painting?" the adult inquired. "It has happy things." "And what is your favorite color?" "Black," replied Colleen. Like many young children she loved black because it is so powerful and strong on the white paper and she had not learned to connect it to anything sad. Besides, she was always happy when she was painting.

Moreover, color choices aren't always motivated by aesthetic or even individual preferences when stereotyping determines their usage. Parents once dressed young children in blue or pink according to gender difference and even teachers steered students into using certain colors in specific ways. Seasonal colors are often used as a kind of code to signal a mood, time, or place without observation of any actual colors in a specific locale. For example, although winter is sometimes portrayed as monochromatically bleak, the closed-buds on the tree branches in mid-winter Vermont delighted me with their shades and tints of pink and pale yellow. Attention to detail created the singular and haunting visual memory.

CLAUDE MONET (French, 1840–1926). *Terrace at Sainte-Adresse*. 1866. Oil on canvas, 38⅝ x 51⅛". The Metropolitan Museum of Art, New York, Purchased with special contributions and purchase funds given or bequeathed by friends of the Museum, 1967 (67.241)

When thinking about creating a sense of place with texture and color, you might compare the imagery of Claude Monet's painting above with that of Arshile Gorky's abstract work opposite. The representational qualities of the Monet invite viewers to a place of many pleasures. With the expressionistic Gorky painting, one is drawn into the scene by the enticing colors, fluid shapes, and one's own imagination.

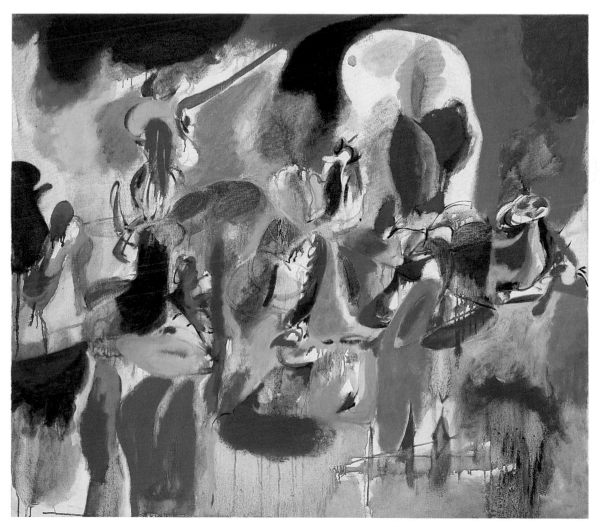

ARSHILE GORKY (American, 1904–1948). *Water of the Flowery Mill.* Oil on canvas, 42½ x 48¾". The Metropolitan Museum of Art, New York, George A. Hearn Fund, 1956 (56.205.1)

Every semester, when a primary focus of our experiments is on color, I post the following quote and read it aloud to the adults:

> *Once one has had the experience of the interaction of color, one finds it necessary to reintegrate one's whole idea of color and seeing in order to preserve the sense of unity. . . . When you really understand that each color is changed by a changed environment, you eventually find that you have learned about life as well as about color.*
>
> —Josef Albers, American painter and teacher (born in Germany), *Josef Albers: White Line Squares*

An art educator I know showed her students predominantly red painting reproductions and asked what they felt about them. Without thinking, a few automatically replied, "They're angry paintings." When she asked what gave them that feeling they reported that their grade-school teacher said that red was an angry color. She then asked the youngsters to look again because many of the displayed works were obviously joyous and lyrical. Putting aside preconceptions about color can be difficult if you haven't had the opportunity to see many ways in which colors can perform by looking at a variety of different artworks.

## The Effect of Color

*F*eelings of attraction and repulsion to certain color combinations may be both practical and cultural. Because light colors reflect light and heat, some people in hot climates may favor these in their daily surroundings and may be annoyed and irritated by brightly colored walls. On the other hand, loud, bright colors in very sunny locales do not appear bleached out in strong sunlight and may complement tropical surroundings with lush foliage. Cool colors are relaxing to some and chilling and depressing to others. Legend has it that the Notre Dame football coach Knute Rockne ordered his own team's locker rooms painted red and the ones for the visiting teams painted blue. He supposedly theorized that the visitors would relax in their soothing blue rooms, while his own team would become keyed up and ready to win in their red quarters. Whether this was a significant factor in the outcome of the games is questionable. Whatever you may conclude about the validity of such a notion, it is based on the psychological truth that we respond both physically and psychologically to colors.

The old cliché "Beauty is in the eye of the beholder" has some bearing here, and, although we do share many cultural experiences in common and reach mutual agreements about some color phenomena, even these change with fashion. Product designers have long tried to engineer color schemes to make us buy things. All of us bring memories and feelings to our perceptions of colors, such as a fond recollection of the color of our room when we were very young or the color of the sky during a pleasurable outing. When I see loden green, I am reminded of the colors I saw when I went to a family wedding in Germany. As we drove through the forest around Bremen and Hamburg, the tree trunks and thatched roofs were covered with moss and the people of the region wore clothing in similar greens.

Sometimes these associations have little to do with the actual colors of a place. For example, one parent in my class decided to suggest her memory of the island of Jamaica in her painting. She tried to capture the warm glowing pleasure she felt when she was in the plane flying home. She started her painting by trying to represent what she saw from the air. As she worked she began to realize that the green foliage and blue and white of the sea and sand had little to do with what she had experienced, and wondered why she could not get the same feeling from her painting. I suggested to her that perhaps a composite of colors from several encounters might evoke more clearly the impression she was seeking. Finally, she made a bright, multicolored mixture of shapes and textures that began to represent the excitement she felt about the vacation by creating a dynamic visual rhythm. The overlapping layers of mixed colors and varied paint surfaces suggested an environment of rare flowers, brightly colored clothing, and Caribbean music. There was no single scene that could have captured

all of these aspects. The personal dimension of the piece would have been diminished if she had only used a naturalistically representational palette of pigments.

Your reaction to your painting may be the result of the joint effect of two or more colors in relation to each other as well as your memory associations with them. When I have shown a reproduction of El Greco's *View of Toledo* in my workshops, many have found the gray and dark blue-gray sky ominous. Yet one four-year-old boy remarked with glee that he thought it was a happy painting because it looked like thunder, lightning, and fireworks in the sky. When an adult in class heard this story she remembered when her mother took her at the age of seven to see this painting. It had scared her and she had burst into tears.

Sometimes a single color can evoke a temporal experience. During a session when the children were making different-time-of-day paintings, Danny, who was brushing on a mauve background, looked up at me and asked, "What time is it in there?" I replied, "What time do you think it is?" He whispered back in a low voice as if it were a secret, "Very early in the morning!"

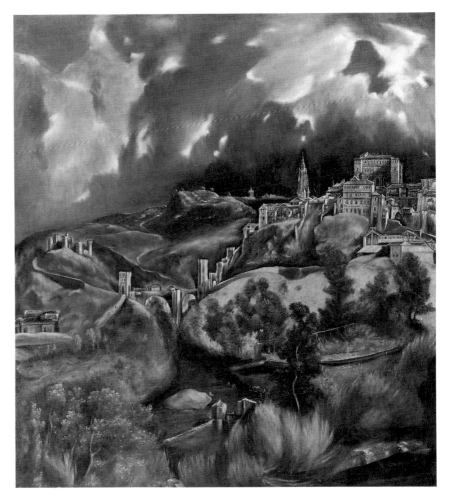

EL GRECO (Domenikos Theotokopoulos, Spanish, born Crete, 1541–1614). *View of Toledo*. Oil on canvas, 47³⁄₄ x 42³⁄₄". The Metropolitan Museum of Art, New York, The H. O. Havemeyer Collection, Bequest of Mrs. H. O. Havemeyer, 1929 (29.100.6)

*If you let your eye stray over a palette of colors, you experience two things. In the first place you receive a purely physical effect, namely the eye itself is enchanted by the beauty and other qualities of color. You experience satisfaction and delight, like a gourmet savoring a delicacy. Or the eye is stimulated as the tongue is titillated by a spicy dish. But then it grows calm and cool, like a finger after touching ice. These are physical sensations, limited in duration. They are superficial, too, and leave no lasting impression behind if the soul remains closed. Just as we feel at the touch of ice a sensation of color, forgotten as soon as the finger becomes warm again, so the physical action of color is forgotten as soon as the eye turns away. On the other hand, as the physical coldness of ice penetrating more deeply arouses more complex feelings, and indeed a whole chain of psychological experiences, so may also the superficial impression of color develop into an experience.*

—Wassily Kandinsky, Russian artist, from Wassily Kandinsky and Franz Marc, ed., *Blaue Reiter Almanac*

## Demonstration for Young Beginners with Adults

*I*f you tailor your language to the experience of your audience, this demonstration can be appropriate for beginners of all ages. In fact, when young children are present with the adults, older beginners can learn very basic information they would probably be too intimidated to ask questions about in front of their peers, for fear of appearing ignorant.

This demonstration serves two purposes: First, it is a review of the painting process, and second, it teaches vocabulary by connecting visual terms to actions. Try to remember to link every new word to an object or practice and change the vocabulary complexity appropriately to match the age group. Before class, set up your painting tray at a demonstration table apart from the painting area.

1. Sample dialogue: "Sometimes people use the names of colors to tell how they feel? They may say, 'I feel blue today.' Do you think blue is a sad color? I don't. When I wake up in the morning and look at a bright blue sky, it makes me very happy. I've heard people say, 'I'm so angry I see red.' Do you think red is an angry color?" Because the opinions will be diverse, it is appropriate to point out that, since people feel differently about colors, "it is up to the people who are painting the picture to use their colors in the ways that tell their stories."

2. "Today the grown-ups (or 'we' if addressing older beginners) are going to make a color-story painting about a feeling, such as sad, happy, silly; a word, such as nighttime, springtime; or a place they remember in the country or city. Are the colors different in the day from at night?" (Most three-year-olds know that it is darker at night and also that pure blue is darker than yellow or white.) "Which are the darkest colors on the tray?" Brush blue paint on the paper, then wash the brush and press out excess water on the sponge. Next you may apply red to the blue area, and some beginners may say, "It's black!" even though the color is dark purple. Mention that it is almost as dark as black and continue to blend more red into the blue until they begin to see that the mixed color really is purple. Again wash the brush and press out water onto the sponge. (The experiment this far could be the beginning of a painting about night or it could change as you add colors.)

3. "Now which is the lightest color?" (They respond, "White!") Brush white onto the white paper in a place where there is no other color and ask, "Do you see the white as well as the other colors?" ("No.") "Why?" ("Because it's on the white paper that is the same color.")

4. "Where is the darkest place on the painting?" Dab the white onto a now-dry dark area. "Do you see it better? It's like when the lights go on at night." You can further review mixing and blending colors depending on ages and attention spans. If the group is still attentive, you might blend the white with the purple for lavender, and then perhaps blend that with some red, and so forth, saying, "I like to think about my whole paper."

5. You might choose a theme, such as "springtime in the park," and ask, "What colors do you think of in spring?" Someone might say, "Green." "And what colors should I use to make it?" ("Yellow and blue!") Paint these colors on the paper. "What else do we see?" Put colors all over the paper; let the colors sit together, and also blend them together as you talk about them as well as demonstrate the process of washing and wiping the brush.

Before attention starts to diminish, send young students to their tables. If you are working with eight or more people, you may need an assistant to help with

seating preschoolers at their painting places. This delegation of authority must be decided in advance. (Remember, however, until you are experienced as a leader, it would be best to limit the number of your participants to what you know you can handle.)

After preschoolers have been painting for several sessions, supply colored paper to paint on so that everyone notices that the light colors seem to pop out in a way that they may not have on their white-paper backgrounds and can create dramatic spatial illusions. If you are working on nighttime paintings, for example, you might give the group dark blue or purple paper.

Adult painting based on an interpretation of the word *celebration*

## Demonstration, Part 2, for Adults and Experienced School-Age Students

*C*ontinue to discuss art experiences and reproductions with the adults and other older beginners. Samples should include both work by adult beginners and historical works by fine artists. Avoid making rules about using color for beginners of any age because color effects come from so many variables, but point out how similar colors are perceived differently according to the influence of surrounding colors. Talk about the colors you have experienced at various times of day. For example, one morning my husband and I visited Impressionist paintings in galleries that were only illuminated by daylight. He remarked, "I didn't know that those paintings were so gray." But when we returned later, the lights had been turned on and the works vibrated with luminous colors. This experience is a good example of how light affects color. The project described below will help them to explore this phenomenon directly.

Adult place painting: *A Fire in the Woods*

## Project for Older Beginners: Suggesting a Word, Mood, or Place through Color

*W*hen you were discovering ways of using your brush and colors in the last project, you probably experienced certain feelings from your results in paint. You may have felt confusion, exhilaration, harmony, or discord. Now you want to think of creating those effects more deliberately.

This time, think of a word, place, or feeling that you associate with a particular color or color combination, or brush each of the colors on your paper and see what they suggest. If you look through your last project and find a section of it that suggests a strong sensation, you might want to enlarge upon it as a beginning for a new painting. Because there are several ways of starting this exercise, each person needs to find a way most suited to his or her own personality. Remember that much invention comes from a willingness to suspend preconceptions; respond to the medium and let ideas come to you.

These color experiments are both a means and an end in themselves. As a means of learning the color vocabulary, they act as tools; however, they may very well become complete paintings also. When experienced painters make experimental sketches to keep renewing their vision, these works become more than textbook exercises or disciplines and are generators of new visual ideas. You can think of these as warm-ups to stretch your imagination as well as to gain further control over your tools and materials.

Try to allow yourself at least an hour for the actual painting and additional time before the session to look at reproductions, and more afterward for cleanup. At the end of the hour you may want to continue your painting, or you can put it aside and continue again in the future.

## PROCEDURE

1. Start by covering the entire paper with a colored background of paint applied in areas of washes that recall a place or experience. You can either start by applying the paint first and then trying to respond to it, or start with the color idea first. Try to imagine your color as a field instead of a shape, or as an atmosphere instead of an object. For example, the idea of a pastoral field may evoke associations such as a green background for flowers or woods and mountains. What colors are in the sky before a storm over a lake or ocean? Ask yourself what time of year is it? What time of day?

2. On top of the background coat, brush in gestural strokes that activate your field with the attitude or energy of the place. You can discover as you work that the brushstrokes as well as the color create different kinds of movements and rhythms, fast or slow, relaxed or excited. They set a sense of what is happening there and become actors on the stage of the background. For example, one parent brushed in a first coat of green, a second coat of multicolored dabs and dots to suggest a field of flowers, and finally executed a black and red slash across the paper to record where someone fell, got hurt, and interrupted the picnic.

If you think of any other elements that you want to add, feel free to do it. The first two steps can be ends in themselves, or stepping stones to representing more complex ideas.

### THINKING ABOUT WHAT YOU HAVE DONE

After starting to paint a mood or feeling you had in mind at the beginning, your mood may have changed and the painting may have become something quite differ-

ent from what you expected. Once an adult told me that she had had a terrible morning prior to coming to class, and she began by making heavy slashing brush-strokes. Then she began to relax, and her painting ultimately conveyed a different mood.

## How Paint Texture Affects Color

Perhaps you have already noticed that your tempera paint color gets a little lighter when it dries. When it is wet and shiny, or has *gloss,* the light reflections give it sparkle and highlights. When it dries it becomes *matte,* or flat and less reflective. Some painters dislike reflective gloss finish common to some paint mediums and apply a matte varnish to their final coat of dry paint while others prefer the gloss and apply a gloss finish to paintings with matte surfaces. You might notice how paint texture influences color the next time you go into a room painted with gloss paint and then into another painted with a flat wall paint.

You may also have observed that a thin *wash* of color gives a feeling of transparency, like a veil or atmosphere,

HENRY OSSAWA TANNER (American, 1859–1937). *Landscape.* (Inscribed on original backing board: *France, 1914.*) 1914. Oil on artist's board, 10 x 13". Collection of Sheldon Ross

while a thickly textured *impasto* creates a sensation of solidity and weight. If you use your tempera paint thinly, the white of the paper shows through the paint and makes the color luminous. You can see the difference most obviously when you put the two textures together side by side, perhaps a wash next to an impasto.

The color of your paper background also influences what your painted colors will look like. If you have started painting on the backs of tan paper bags or have used any other off-white color, your results will be different from what you would see if you had used white paper. In order to avoid letting the color of your paper dictate your results, you may want to paint in white areas. As you practice brushing, you can explore how paint textures alter color and also how to create visual illusions of texture with color only, avoiding the physical tactility of thick impasto layers of pigment.

## How Light Affects Color

Also notice how light appears to change the color on each wall of a room according to its angle and distance from the illumination source. As a child I could not figure out how, when we had our home painted, the painter made all the walls in a room look slightly different when all the paint came out of one can.

## Contrast

*Contrast* refers to the degree that things appear different and stand apart from each other, as for example, dark and light or large and small. When one person in a group is wearing a bright red and everyone else is in black, the one in red stands out sharply by virtue of both color and dark-light contrast. If you plan a salad using contrasting colors of foods, such as red tomatoes, green lettuce, and white potatoes, each item seems distinctive, and you may feel less inclined to decorate the dishes with garnishes. This practice of aesthetic meal arrangement, using contrasts of color, texture, and shape, can be carried to levels of extreme precision by some chefs in, for instance, Japan and France.

Your use of color contrasts may have given your painting a feeling of space and visual vibration. The basic color contrasts are those between light and dark and warm and cool. The first is fairly self-explanatory. (Although young children understand the contrast of light and dark as day and night, I do not try to explain these ideas of contrasting colors to them.) The second kind of contrast you may have used is that between warm and cool colors. Warm colors are those that approach red and orange, and cool ones are those that approach blue and green. Yellow can be either depending on whether it tends toward a greenish direction or an orange one. The next time you look outdoors at a landscape, you might notice how cool and warm colors appear in nature and also how constantly they change.

You may have also used a third kind of contrast by using *complementary* colors, or those that are most unlike each other on the color wheel or scale. A color wheel is a circular graph with a sequence of colors that diagram their relationship to each other. You cannot merely choose colors from the wheel and expect always to get harmonious results; elements such as size, shape, position, lightness, and darkness all determine the specific total effect of your work. Complementary colors are generally considered to be red and green, yellow and purple, and orange and blue. This kind of contrast can be difficult for beginners to control for specific effects, but it also can give visually exciting results. Years ago, I remember reading on a green sofa in my red bathrobe when, all of a sudden, out of

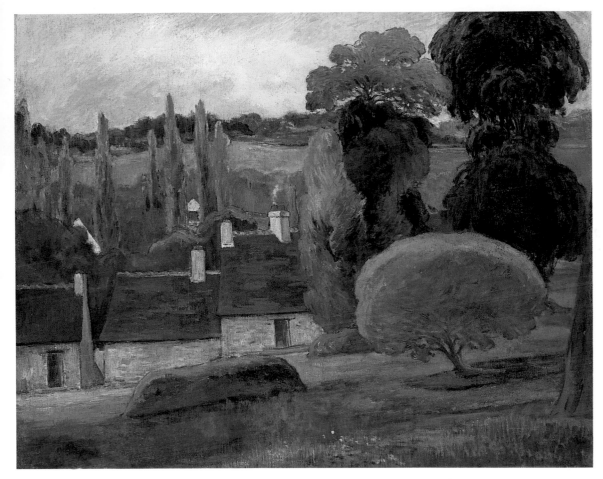

PAUL GAUGUIN (French, 1848–1903). *A Farm in Brittany*. Last half of the 19th century. Oil on canvas, 28½ x 35⅝". The Metropolitan Musuem of Art, New York, Bequest of Margaret S. Lewisohn, 1954 (54.143.2)

the corner of my eye, the colors seemed to be vibrating. The optical illusion was so distracting that I had to move to a chair of a different color in order to continue reading.

## *Tips for Teaching*
### *GUIDING PRESCHOOLERS*

Preschoolers who are continuing to paint as they did in the first session are still involved in moving the paint around and simply making colors change. Although you should continue to remind them of the process of washing and wiping brushes and point out what colors they are making on their papers, save these comments for moments when you will not interrupt their concentration. Their work is full of experiments and beautiful accidents that they often do not know how to repeat. They make marvelous movements with startling effects they are not aware of, nor do they find them necessary to repeat. This does not mean they do not value their work. They like it purely because they have done it and not because of how it looks. As they continue with studio practice, they become

more discriminating visually and come to evaluate their work in terms of its visual qualities. Then their choices stem from deliberate decisions and not merely from chance.

In my classes for preschoolers, I often read aloud Leo Lionni's *Little Blue and Little Yellow*, a children's story about colors and shapes. The book helps illustrate a number of concepts about simple shapes, changes of color, and visual movement in a way that is understandable to them. Although many do not really understand the ideas of blue and yellow changing into green until they have painted for a while, I like the story because it doesn't make value judgments about colors as being happy, sad, ugly, or beautiful. It relates ideas of color families to daily routines common to the children's lives. However, everyone has to create color changes on their own papers to appreciate the phenomenon, and when they do that they tell their own color stories. When they cover one color with another and the color underneath peeks out, it looks as if they are playing hide-and-seek, a game they are familiar with from a very young age.

Deciding whether to remotivate students or to let them stop painting can be difficult for you at the beginning. You can make the mistake of dwelling on or trying to push the activity so long that it becomes unproductive. If that happens, the student may want to stop painting altogether. In addition to the regular paint tray, keep available on the preschooler's painting table assorted pieces of colored construction paper as another way to add shapes to a painting. If they are not interested in this possibility and it is too early in the session to move on to the next activity, I may suggest that sometimes they can learn a lot by sitting and watching other students to get more ideas for their own work.

Young beginners and people learning English as a second language may not know the name of a color they want to make but may point to it. Respond to their pointing by picking up the color shape and asking, "Is this the color you want to make? This is green." This practice helps them to learn the names of the colors.

When beginners of any age become interested in mixing a specific color and ask how to do it, reply, "Which color paper or paint already in the cups looks most like the new one you want to make?" Also look at their painted paper to see if they have mixed the color previously by accident and do not know how to repeat it. This situation happens to experienced artists as well. You may have discovered this phenomenon yourself if you have ever mixed your own wall-paint colors by adding tinting pigments to a gallon of house paint. If you do not mix a large enough quantity to finish the wall you will have great difficulty matching the exact color in a second batch. If students do not succeed in mixing the color they wanted, don't do it for them, but add, "Look at what you did, you made a different color! Do you know its name?" If they don't know its name, you name it. Then you might encourage them to try again in another place.

Five-year-old Willy arrived at a workshop and announced that he was going to do a painting of the pink rabbit he carried under his arm. I began class by showing a great variety of shapes that can be found underwater—coral forms, shells, and scuba divers observing fish and sea life. As we examined the pictures, we imagined what colors and shapes we might see if we were those scuba divers. After we finished our discussion, Willy made a very pink octopus painting and then declared, "Now I'm going to paint my rabbit! What color is it?" I could not believe my ears. "Willy," I said, "You just painted that color." He looked at the rabbit in a puzzled way. "Oh, it's pink!" he

said. "How do you make it?" "The same way you made the octopus," I explained. Another child at the table called out, "Red and white." "Oh!" With a flash of recognition on his face, Willy suddenly became aware of the fact that the pink he had made came from those two colors. He hadn't planned to paint a pink octopus but had intuitively mixed his favorite color.

## GUIDING OLDER BEGINNERS

It is not useful to demand that beginners of any age identify colors because they may feel inadequate or learn to give rote answers without knowing what the words really mean. Besides, many people probably will not really know a great many colors until they mix them themselves. Students learn to make finer and finer discriminations between varieties of colors the more they use the medium. It is very important to realize that even older participants are not necessarily color blind or mentally challenged if they cannot tell you the names of colors. Your precise vocabulary word may not be a part of their cultural background. If you make an exam out of it, they are very apt not to say anything for fear of being wrong. One approach is to involve them in talking about the colors of foods or the clothing they are wearing. When they are excited about something personal and want to share it, they are more likely to talk about it. Even experienced adults may not think about how they have made a particular color in the past until they have a reason to want to make it again.

Years ago I was delighted to discover a Chinese proverb that applies to this learning process:

*What I hear I forget*
*What I see I remember*
*What I do I know*

## TALKING ABOUT BEGINNERS' WORK

Many beginners, and not just children, need to examine what they have done in order to reinforce the process and also to convey a sense of value to the seriousness of their efforts. Talking about colors and brushstrokes does not mean forcing anyone into justifying what they have done or making up stories about their pictures. There is no reason to have a logical explanation for every paint stroke.

One day, when a group of three-year-olds at a Metropolitan Museum workshop were talking about painting buildings, Stacy announced that she was painting the museum. She made a large black line that went around her whole paper. Then she made a few lines inside it with other colors. Finally, she took a brushful of black paint, saying, "It's nighttime in the museum," and proceeded to paint the area inside of the line all in black. I asked, "Are you going to put some colors outside your black shape?" "No, I want it to be white." She was feeling very good and strong about herself for painting a whole museum as she announced she was finished. She had created the big building and her mission was accomplished.

If she had been older, I might have tried to encourage her to think more about the development of the painting. However, to urge her to continue on a painting that she was so obviously proud of finishing would have been unkind and pointless. If I had asked her to explain or to justify what she had done, she might not have been able to verbalize her reasoning (nor should she have to). Although older beginners might want to talk about their choices of color, to reason with three-year-olds about dark and light colors or night and day would be confusing for them, frustrating for you, and would detract from the learning process.

Although skill may increase from week to week, progress is not always evident in people's work. Much depends on what is happening in the rest of their lives. The picture at top right reflects the exuberant energy Julie felt when she painted on her fourth birthday. The following week (lower right), she had a cold and was tired and listless. Three-year-old Cindy (top left) loved painting and occasionally got a little paint on her hands and face. After someone scolded her for being messy, her determination to be neat made her unable to work freely (lower left).

## THE IMPORTANCE OF ACCEPTANCE AND ENCOURAGEMENT IN THE STUDIO

Accept everyone's work as a painting, not as a test of their sense of reality or their ability to talk about it. Remember that a painting is not a mere illustration of experience, it is an invention of experience. Stacy created a color story of her own about painting the museum. The works are not (nor should you require them to be) literal descriptions of how things are in the physical and intellectual world and should not be interpreted as measuring sticks of particular intellectual or emotional growth. Your goal is to try to help everyone to appreciate the qualities of their marks on the paper and to connect them to other events in their worlds.

I remember as a child drawing hunched over my work with my arms around it so no one would comment on what I had done until I was ready to show it. How our lives might have been changed if we had been given support for the learning process from people with whom we could share mutual activities. By contrast, when people from outside the workshop, who have not participated in the studio experience themselves, comment on the works, often they are merely judging the end product.

Judgment or criticism, positive or negative, can hinder development in that some beginners may repeat works for praise or stop altogether. Extravagant praise can sometimes be as disheartening as negative criticism. When in high school, photographer Diane Arbus was constantly complimented about her drawings and paintings. Later on, after she became famous, she told an interviewer that as a student the work was so extravagantly praised that she believed any extravagant praise of work that she did so easily made it seem worthless, as if anyone

could do it. As a result, she stopped drawing and painting and immersed herself in photography.

After hearing my ideas, a deeply concerned parent told me that she realized she had done the wrong thing with her child, who loved to draw. In an effort to be helpful, she had been too critical, and her child had stopped drawing altogether. I responded by saying, "She is only three years old. How wonderful that you understand your error and can now help her to start drawing again."

> *Everybody is intimidated about making marks on paper or marks on canvas. Freedom should be first before judgment and self-criticism.*
>
> —David Smith, American sculptor, from a talk presented at the National Committee on Art Education, The Museum of Modern Art, New York, May 1960

Some parents and adults do not realize how seriously beginners take their words when they declare personal criteria for judging successful artwork. For example, four-year-old Joanna loved to paint masses of color that covered her whole paper completely. One day, in the middle of painting, she suddenly stopped, leaving one tiny spot in the corner, as if she suddenly remembered something else she had to do. After she put down her brush, I asked her, "Are you really finished?" She answered, "I am finished. My father says that to do a good painting you always have to leave some white." "Well," I replied, "Some people think that a painting is good when it has colors all over it. But if you're finished and that's the way you want it to be, that's your choice. You don't have to cover the whole paper. You may leave white spaces if you want to, for they are shapes also."

Meanwhile, her father across the room was putting down colors on his paper, one here and another there, spread widely apart. I went over to him and asked, "Have you ever tried to do a painting by covering your whole paper with colors?" "I liked to do that when I was a kid," he responded.

I told him, "I guess I'm a big kid, because sometimes I like to cover the whole surface when I'm painting." He took my cue and that day he filled his entire paper. He realized that he had inhibited Joanna's free choice in her painting and that she had left that white spot in the corner to please him. After Joanna saw her daddy cover his whole paper, she realized that she could leave white spaces in her work when and wherever she chose to place them.

As Ben worked on a nighttime painting, he covered part of his paper with black. When he finished, he noticed that there were tiny spaces where the white of the paper showed through. He obviously liked them, because he decided to dab white paint on top of the white spaces and also on top of the black paint. I was pleased to see him make this deliberate choice. It was unusual for any beginner, let alone a four-and-a-half-year-old, to be so visually aware as to think about repeating shapes he liked in his painting.

## Stages of Studio Development

People may paint what they know, what they see, what they imagine, or generally a combination of all three. For example, inexperienced grade-school children may paint outdoor scenes leaving a large white area between the sky at the very top of the paper and the ground at the bottom edge. When a teacher I know tried to encourage a child to fill in that large blank space on his painting, she took him to a window saying, "See how the sky and land seem to

At the beginning of the workshop semester, six-year-old Joy treated the brush as a pencil, drawing outlines and making symbols for objects.

After five weeks of class, Joy had developed a sense of color and variety of brushstrokes that created a sense of mood and place. This was her Halloween painting.

meet way over there?" The child replied, "Yes, I see. But that is not how it is. If you and I get into your car and drive way over there, you will see the sky is still up above and the ground is down below. That's how it is." Even if you point out certain visual phenomena, it might not affect their way of painting unless you insist and they acquiesce to please you. Young children paint things as they know them to be and not according to adult perception.

Even though there are stages that everyone inevitably goes through when using studio materials, experience and the quality of guidance play a great role in developing perceptual and manual skills. For example, if the same children are given a special theme to paint from the imagination—such as, "a place I would like to visit with my family," a fantastic creature in a strange land, how the world looks from a spaceship, or a trip to the zoo—they might fill the whole paper with colors instead of leaving that empty band of paper. Again, it would not be productive to make them rationalize why they paint a scene from imagination more completely than one taken from direct observation. Although you might mention that a painting is never the real thing and that everyone is free to make it look any way they want it to, it is still important to curtail giving directive aesthetic opinions during the workshop in order to allow everyone to express their ideas at their own level of development.

While age is an element that cannot be ignored, being older does not mean possessing experience in using art materials. My friend Annie, who is now in her mid-seventies, began painting recently when someone gave her a paint set. I was explaining to her the stages children go through when they start to mix colors. As beginners brush together layers of wet colors they often become gray and brown as

they mix. "Oh I did the same thing when I was starting to paint. My colors seemed so muddy I just didn't know what do," she interjected. Because she was very experienced in sewing, crewel, and embroidery, however, Annie could carry over some of her visual and manual experiences with color and craft materials to the painting process. Consequently, she went through all the stages that the children do, only more quickly.

*Three-year-old Joey: "This part is ugly!"*
*Me: "You think this is an ugly color?"*
*Joey: "Yes."*
*Me: "Is that the way you want it to be?"*
*Joey: "Yes, I like it that way!"*

If you as a leader impose your taste on everyone else, they may not explore a wide range of studio options for themselves. Even adults sometimes lack exposure to many possibilities because they may have limited experience with other cultures. They will sometimes accept another's preferences as their own, especially if that "other" is a parent, teacher, or published author.

For example, young Johnny usually came to the studio wearing his purple shirt. He liked for me to notice it and to mention its color, after which he would say, "Purple is my favorite color." On a special occasion, his seven-year-old sister, Elizabeth, who formerly had been in my class, joined the workshop and did a purple painting. I was intrigued by the fact that both brother and sister seemed to be partial to the color purple. "It seems that your family must like purple. You have used the same color as Johnny's shirt in both your painting and collage." "That's not why I did it," replied Elizabeth, her eyes beaming with delight. "Purple is our daddy's favorite color, and we love our daddy."

*Good painting, good coloring, is comparable to good cooking. Even a good cooking recipe demands tasting and repeated tasting while it is being followed. And the best tasting still depends on a cook with taste.*

—Josef Albers, American painter and teacher, *Interaction of Color*

## "LIGHT GREEN"

*Light green is ugly I hate it I*
*hate it. All the colors do;*
*regular green, pink, orange,*
*purple, red, blue, black.*
*If you see light green step on it.*

—Anthony Bonina, fifth grader, from *The Poetry Connection: An Anthology of Contemporary Poems with Ideas to Stimulate Children's Writing*

When someone asked me, "When do you start to teach which colors are ugly together?" I asked in reply, "Ugly according to whose taste?" Taste is simply the tasting of colors and forms and making choices, much as you do with food and drink. You can learn a personal sense of taste, a feeling of what is fitting and pleasing to you, through direct tasting, so that no experts or rules can convince you to buy what you have found you dislike. By trying out a wide range of possibilities, you learn to make personal discriminations between the sensory qualities of things. You cannot go just by rules. The greatest artists have the courage to break the rules of taste in order to make personal aesthetic statements. I try to expand everyone's visual experiences by being careful how I say things to beginners so that they don't feel I am making aesthetic rules governing what they paint.

# 6. Experiments in Mixing Paint Colors

JOHN H. TWACHTMAN (American, 1853–1902). *Arques-la-Bataille.* 1885. Oil on canvas, 60 x 78⁷/₈".
The Metropolitan Museum of Art, New York, Morris K. Jesup Fund, 1968 (68.52)

APRIL GORNIK (American). *Divining Water.* 1994. Oil on linen, 80 x 76". Private Collection, courtesy of Edward Thorp Gallery, New York

## Materials Checklist

■ Reproductions: In my mixing-colors workshops, I display examples of color-mixing experiments by adults from past classes as well as photographs of nature and reproductions of paintings with as long a time-line in dates of origin as possible.

■ Use the same painting-tray setup as in previous painting projects but add black to the selection of tempera colors.

## Introduction to Atmospheric Color

*In visual perception a color is almost never seen as it really is*
*—as it physically is.*
*This fact makes color the most relative medium in art. In order to use color effectively it is necessary to recognize that color deceives continually.*
*First, it should be learned that one and the same color evokes innumerable readings.*

—Josef Albers, American painter and teacher, *The Interaction of Color*

If you painted colors in an attempt to evoke the memory of a place but found that they did not seem to capture it, this might have happened for many reasons. One of the most common pitfalls for beginners is overlooking the color qualities of light in the atmosphere. French painter Claude Monet did many paintings of the same scene over and over at different hours of the day because he found the quality of light so fascinating from hour to hour. Although this quality may more easily escape notice than the surface colors of objects, transparent atmospheric color is most important when trying to capture in paint the mood of a time and place.

Responding to color means becoming more aware of nuances of what at first glance may appear obvious. For example, when you glance at a field of grass you may automatically think of an expanse of green. When you look closely, however, you may see that it is a field of yellow, yellow-green, blue, blue-green, gray-green, purple, and so on according to atmospheric conditions and distance. Expanses of single colors rarely exist in nature, for each surface and texture is colored by light and shadow in different ways. Most beginners don't realize this until someone points it out to them. When young Adam became very upset while painting a green picture, I asked him what was the matter. "I wanted this to look like moss and it doesn't!" he exclaimed. I replied that moss can be many different colors and brought in some mosses of different colors for the next studio session to show that even a single kind of plant can contain many colors. While his end result may not have presented a *trompe l'oeil* rendition of that flora, Adam delighted in this discovery and in the process of painting varied green colors and textures on his version of moss.

Colors are often muted into colored grays (or grayed colors) that we may experience as subtle feelings without recognizing them. This often happens when you step outside on a cold, gray day and automatically withdraw under your umbrella or back into the collar of your overcoat. Once you become aware of the subtle colored grays in the atmosphere, you will see a greater range of colors than you ever noticed before. Legend has it that an art critic proclaimed no one had ever seen the London fog before American James Abbott McNeill Whistler painted it in the late nineteenth century. You are most likely to attend to these colors under pleasant conditions, especially at dawn just before the sun appears on the horizon, when exquisitely grayed colors of orange and

pink glow in the sky. Walking in warm mist can be particularly enjoyable when you look for the fine shades and tints of blues and purples or whatever color predominates at that time of day.

One parent returned to class the week after doing the exercises in this chapter and reported, "You'll never know what an effect making these colors had on me. When I left the museum it was raining. Instead of ducking my head down as usual, I looked up, and was amazed to see the colors of things reflected through the misty wet air. I had never noticed them before."

Most beginners struggle with unwanted grays while they are trying to mix other colors. As a result, grays sometimes come to be associated with frustration instead of being seen as colors in their own right that can be controlled and developed further. Learning to use grays opens the way to making such interesting effects as iridescence, increased contrasts, and a wide range of atmospheric conditions. Experiments in this project show you how to make grayed colors deliberately, not only so that you can use them to communicate moods and ideas, but also so that you will know how to avoid them when mixing other colors so they do not appear accidentally.

*If one says "Red" (the name of a color)*
*and there are 50 people listening,*
*it can be expected that there will be 50*
*reds in their minds.*
*And one can be sure that all these reds*
*will be very different.*

*Even when a certain color is specified*
*which all listeners have seen*
*innumerable times—such as the red of*
*the Coca-Cola signs which is*
*the same red all over the country—they*
*will still think of*
*many different reds.*

*Even if all the listeners have hundreds of*
*reds in front of them*
*from which to choose the Coca-Cola red,*
*they will again select*
*quite different colors. And no one can be*
*sure that he has found*
*the precise red shade.*

*And even*
*if that round red Coca-Cola sign with*
*the white name in the middle*
*is actually shown so that everyone focuses*
*on the same red,*
*each will receive the same projection on*
*his retina,*
*but no one can be sure whether each has*
*the same perception.*

—Josef Albers, American painter and teacher,
*The Interaction of Color*

## Color-Mixing Projects for Older Beginners

### INTRODUCTION

When you begin, apply areas of loosely brushed color in several expanses on your paper so that you can blend mixtures and paint over the first layers the way you might have done in the last project. For light-colored mixtures, first start with a larger quantity of the light color and then add very small quantities of the darker ones until you get the mixture you want. If you start with a dark color and add a light one to it, you will have to add a huge amount of paint to get a light color and will have much more than you need for one painting. If you tried to mix a light color but started with a dark one first, let the paint dry and begin again or work in another area of your paper. You can also get lighter colors by applying thin washes of paint to the white paper so that the white surface shows through the pigments.

JUAN MOREIRA (Cuban, b. 1938). *Snake and Dove.* 1995. Acrylic on canvas, 32 x 39½". Courtesy of Chelsea Galleries, Kingston, Jamaica

It can be very frustrating to learn through trial and error. A friend of mine began her first course in painting along with much more experienced painters. Her teacher assumed that most of them already knew principles of color mixing. His only instructions were, "Squeeze out the paint from the tube and just start. It will be fun." My friend decided to mix a very light pink by beginning with a large quantity of red and a tiny bit of white. As she kept adding more and more white to the mixing dish, it just seemed that the red kept eating it up without changing. So she continued to add vast portions of the white. By the time she made the pink she wanted, she had expended a great amount of white and had more pink than she could possibly use. She felt so mortified and discouraged that she never went back to the class. My friend's experience would have been less humiliating if both the method of color mixing and attitude of the instructor had been different. If she had mixed a small quantity of pigment on her paper instead of in a separate container she would have discovered more quickly what was happening with the colors and not used up a large quantity. If the instructor had not assumed that everyone had painting experience and knew the process, and had he not been cavalier in his quip about the difficulty of mixing paint colors, she would not have felt stupid. By saying that color mixing was "fun," he implied that it was easy. Nothing is easy until you learn how to do it.

All of the experiments below can be tried in a single session if you are working alone on small pieces of paper. However, if you are working on full-size, 18-by-24-inch papers and also leading beginners, spend several sessions on them. Try one or more during the first session and the rest at other times. The same themes you used in the previous session, that is, suggesting a mood or place or interpreting a particular word (like *misty, somber, strange*), can be used as a starting point for doing these experiments.

Again, if you are leading a group, you should try these out alone before demonstrating them to others. If you want to try all of them quickly, you might work on half-sized papers for numbers two, three, and four. However, the subtleties of the different effects will be more noticeable on the larger size sheets (18 by 24 inches), and you are more likely to develop a larger work into a painting that evokes feelings and ideas. If while you are doing an experiment with color and begin to feel the painting take over with an idea or feeling, let it flow into the imagery and continue the color experiments another time.

Adult beginner's painting, mixing black with all other colors

Adult beginner's painting, mixing colors without black

## EXPERIMENT 1: MIXING GRAY WITH BLACK AND WHITE

1. Start by brushing either black or white onto several areas or your paper. But if you start with black, remember the woman who used too much red paint to make pink. Until you feel comfortable with the process of mixing dark shades and light tints, use small amounts of paint if you begin with the black.
2. Try making washes and different kinds of gestural brushstrokes while blending and mixing the grays.

## Thinking about What You Have Done

The black and white gave you the greatest possible contrast of light and dark. This quality can be very attention-getting and visually exciting in a painting. (See, for example, Franz Kline's painting, page 56.) Contrast quickly grabs the eye and is often used for advertising products. But, as with the contrasting *complementary* colors discussed in the last chapter, some may feel it is optically harsh for extended viewing on a large scale. You may have used it as a

dominant element or employed the principle of contrast more sparingly for accents or focal points within areas of your composition.

## EXPERIMENT 2: MIXING COLORED GRAY WITHOUT BLACK

Use the four colors (yellow, red, blue, and white) without black in this exercise in order to discover the infinite varieties of colored grays.

1. Brush blue on your paper. Then add red and brush the two wet colors together to make purple.
2. Add yellow to the purple and mix it. This will give you a dark, brownish gray or grayish brown.
3. Finally, add white and mix again to make a lighter gray.

The particular colored grays you make will be determined by the quantities and qualities of each pigment you start with. One semester our workshop group received jars of red paint that were red-orange instead of a pure red, which restricted the possible range of colored grays we were able to generate.

See what happens if you add just a little yellow to the purple on the paper, and then more of it. Brush on the second mixture right next to the first so that you can see the difference between them. Continue to experiment by adding the other colors to each other. Again, as in the last project, fill your whole paper with colored grays.

### Thinking about What You Have Done

You will discover that you must have some parts of yellow, red, and blue to gray your colors, even if they are in the form of orange (red and yellow), purple (red and blue), and green (blue and yellow). In other words you were making colored grays by using complementary colors. Depending on the colors you start with, you may also find that you made different browns before adding the white.

Most adults are surprised at their results when they try these experiments because they had not thought in terms of colored grays before but of different shades or tints of the colors. One adult in my class, who wanted to a make a bright green, equated "light" with "bright" and kept adding more white pigment in her attempt at creating brightness. This addition created pale pastel tints instead of a bright green. Or perhaps when you began with a lot of pure or unmixed colors the impression was drab until you began to add combinations of grayed areas for contrast that made bright colors seem more intense than when by themselves.

Continue to think of as many varieties of these colors in nature as you can, such as those you see during a rainstorm or on a snowy day or foggy morning. At the same time, continue to use your brushstroke to suggest the atmosphere or mood of that moment and the textures of the place. During the seventeenth century, colored grays became a symbol of cultural refinement in Japan as part of the decor of the tea ceremony. Participants in the practice were reputed to wear cotton kimonos colored in silver gray, lavender gray, grape gray, and so forth, made by combining red, blue, yellow, and white, without black. They referred to a gray in which all the colors totally cancelled each other out as the color of no color.

You may have accidentally arrived at some colored grays by putting lots of colored water on your paper if the water was filled with various mixtures from washing your brush. However, if you used up all the paint on your brush on different parts of the paper before washing it in the water

bowl, you may have more easily controlled your color mixtures. When you are working alone and the water becomes very dark with pigment, you might change it to mix light colors. I don't recommend changing a paint-filled water bowl in a class of young beginners, however, because behavior is contagious, and every child in the room might want fresh water also even if they have very little pigment in their bowls.

## EXPERIMENT 3: MIXING BLACK AND WHITE AND ONE OTHER COLOR

1. Choose either red, blue, or yellow and mix in quantities of black and white on the paper. Add small amounts of your chosen color each time to see the incremental changes as you paint.
2. On another sheet of paper, use a different color and repeat the procedure. If you have time, try it with a third color on another sheet.

### Thinking about What You Have Done

Remember that when you darken a color you are making a *shade* of that color, and when you lighten it you are making a *tint*. Your perception of how dark or light the color is will also be determined by what colors are sitting next to it.

The first time I did this last experiment myself, I chose yellow to mix with the white and black. I will never forget my excitement when I discovered I could make olive green from these colors. Your own results may vary according to the kind of yellow and black that you use because of different manufacturers' formulas. Some blacks have a bluish tinge, and others have a warmer brown color, and the yellow may be slightly green or orange.

## EXPERIMENT 4: MIXING WARM AND COOL COLORS (COLOR TEMPERATURE)

1. Choose a color. Mix it into every other color you put on your paper. If red was your choice, what kind of feeling do you get? Is it warm, cool, or does it vary in different parts of your painting?
2. Do two more paintings, each time mixing a different color into every other color on the papers.

### Thinking about What You Have Done

When you were mixing your grays in both of these experiments, you may have noticed that the mixture had either a warm or cool feeling. If you used a lot of red or orange, it may have become warm; if you used blue and green, it may have become cool; and if you used yellow, it could have gone either way depending on the type of yellow. In addition, you may also have found that adding white to tint a warm color might have cooled it even though you may have added no cool colors.

Do some of your color mixtures appear to advance when they are placed on an area where you have previously set down a color? Do they recede? Again, this is a phenomenon both of the color itself as well as its interactions with those around it.

## EXPERIMENT 5: CONTRASTING UNMIXED AND GRAYED COLORS

Have you ever noticed how brightly some colors stand out in the muted atmosphere of twilight or on foggy days, for instance the bright red of a traffic light or the yellow flowers in a garden, or light gray and

CHARLES ALSTON (American, 1907–1977). *Blues Singer #1.* c. 1952. Oil on canvas, 40 x 30". Collection of Thomas J. Burrell, courtesy of Ken Keleba House, New York

---

*As to the warm and cool, it is accepted in Western tradition that normally blue appears cool and that the adjacent groups, yellow-orange-red, look warm. As any temperatures can be read higher or lower in comparison with other temperatures, these qualifications are only relative. Therefore, there are also warm blues, and cool reds, possible within their own hues.*

—Josef Albers, American painter and teacher, *The Interaction of Color*

white gulls against a stormy sky? Master painters, such as El Greco in his *View of Toledo* (see page 89), have often contrasted areas of somber and grayed colors with touches of vivid ones to achieve effects of visual excitement.

Through this next experiment you may be able to get a wider range of your color effects by contrasting unmixed colors with areas of colored grays, and shaded and tinted ones, without having complementary colors vibrating against each other in the eye (called optical mixing).

1. Paint a layer of grayed colors on your paper, leaving a few patches of white paper blank.

2. Let it dry for a few minutes.

3. Paint colors straight from the paint cups both on top of the grayed surfaces and also onto the white areas (covering the white paper completely).

4. Now you might try increasing and decreasing the size of the colored areas in relation to each other on a separate piece of paper to compare the two sets of paintings. How do the color effects appear to change?

5. Let the paper dry for a few more minutes, then pin or lean the painting against a vertical surface in order to further examine how the colors function together. Does the color look different when it is upright as opposed to lying flat horizontally? How do your source of light and the direction of that source affect the colors?

## Thinking about What You Have Done

The effects you obtain from these experiments of mixing and blending as well as shading and tinting can enable you to express moods, places, and sensations with more control and subtlety. Another advantage of being able to use mixed colors is that you can more easily observe the effect

of contrasting areas as they play optical tricks on you, as illustrated in the following story.

Early in this century, the manager of a German textile mill called on Johannes Itten, a famed color theorist and teacher, to solve a costly color problem. The manager could not sell hundreds of yards of tie silk because the black stripe on the red background looked green instead of black. Customers insisted the black stripe was green and refused the material. Itten stopped the black from vibrating with the background color by recommending that a warm, brownish-black yarn replace the previous cool black one in order to neutralize the greenish effect.

In the same way, you also can subdue unwanted color effects by adding small amounts of other colors to your mixtures, as well as by tinting them with white and shading them with black.

After you have done these experiments, you might visit a clothing store to look at a rack of gray garments and compare the tremendous variations in colors. Many of these grays have no black in them.

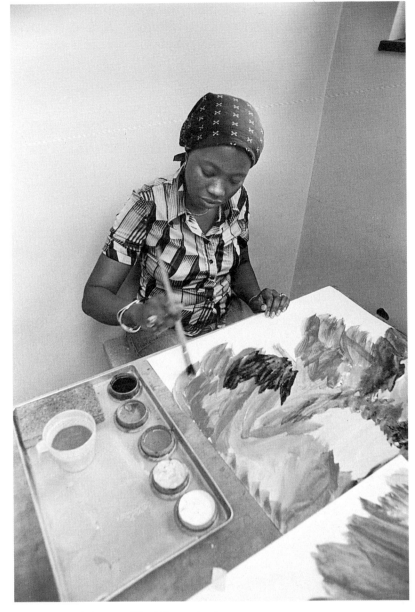

Teacher's workshop at a Head Start school

## Further Experiments with Color Relationships

1. As you continue to explore different color relationships, you might try varying the size of each color area in order to change their relationships to each other. Think of a holly bush with tiny spots of red against a mass of green foliage and compare it to a full-blooming poinsettia plant with lots of large red petals and fewer green leaves than the bush.

2. If you paint the background coat and make marks on top of it with all the warm colors (or all the cool ones) and then duplicate the arrangement using combinations of warm and cool colors, you can compare for yourself the different qualities of mood and sensation that are possible. Some combinations will appear to jump off and move toward you while others will appear to remain static and calm, holding their positions or sinking into the background. Next try reversing the color you

first used for the background with the one you used for the second coat of gestural brush marks, and compare the difference.

## Demonstration for Preschoolers or Grade-School Students with (or without) Adults

Although color-mixing experiments are not usually directed at young children, who are mostly involved with their own painting interests, this demonstration offers theme ideas for mixing colors and reviews the painting processes.

1. "What kind of a day is it today? Sunny? Rainy?" If you are fortunate enough to have a rainy day, you can talk about it as a gray day. If not, you still might talk about gray, misty, moist days and ask, "Do you ever go out when it's raining or look out the window—what do you see? Do you see a lot of bright colors when the sun isn't shining?"

2. Inevitably the children will notice the addition of·black on the painting tray, and you can say that everyone is going to have black paint today. "If someone asked you how to make gray what would you tell them?" (Usually someone responds by saying black and white.) "Yes, that certainly is one way to make gray. But do you know that you can make gray without using any black at all?" They undoubtedly have done that in their first two sessions just by mixing color over color and will recognize the phenomena as you begin mixing the paint.

3. "Do you know what the word *experiment* means?" (They may or may not know.) "To experiment is to try to do things in order to see what happens. I'm going to start my experiment with the color blue." Start by putting blue on the paper and then add red and yellow as you review washing and wiping of the brush, all the while commenting along with them

about the color changes. When a brown color inevitably appears, they may not know the name for it. If not, you might ask them if it is the color of chocolate or someone's shoes.

4. Now add white to the brown and also spread it over many different areas of the paper to get a variety of bluish, pinkish, purplish, and greenish kinds of gray, as well as having a patch of pure white left over for the next step.

5. "Now I'm going to try black." Brush it on an unpainted part of the paper and blend it over into a wet white patch so that it becomes gray. "Did you ever see gray animals in the zoo?" Responses usually include elephants and hippopotamuses. "Did you see any squirrels? Pigeons in the park? See what I found . . ." (as I show feathers of various colored grays). Now the youngsters have some inspiration for what they can do with gray colors and are very eager to sit down and paint.

6. In my parent-child classes, after everyone is seated, a coteacher works with the children as I continue to talk to the adults about the visual references on the wall and further explain different possibilities for experimentation. If you have only a couple of students, you probably will not need an assistant.

## Tips for Teaching

### PRESCHOOLERS

Preschool children will continue to do the same kind of free-flowing expressive painting they began with. Young children understand these color concepts in a very elementary way because they see things in broad categories, while more experienced people draw finer and finer perceptual distinctions. If you are doing these experiments yourself in front of them, don't try

to explain a lot of ideas about color. They will be aware of light and dark contrasts, but they may struggle merely to sort out the primary colors and do not immediately see the difference between, say, an orange-red and a blue-red. They may identify pink but not understand its relationship to red and white (see Willy's story, pages 96–97).

Because the children are present during the adult project demonstrations, I emphasize a review of the process of putting paint on paper, making colors change, and washing and wiping the brush. At home, you can also review the painting process for them if you have noticed that they still need reminding about washing their brushes. However, try to avoid these reminders while they are painting. Moreover, if you tell preschoolers, "Paint what you feel," they probably will not know what you mean, because that is what they have been doing all the time.

People may have very strong aesthetic preferences even at a young age. Early in my teaching experience, in a class without parents, I decided to have a "Green Day" and set up the trays without red paint so that the three- and four-year-olds would discover a variety of ways to mix green without being tempted to use red. Three-year-old Suzy, usually an enthusiastic painter, just sat and became more and more upset. I bent down beside her quietly trying to find out what the problem was but she became nonverbal, started to tremble, and then did very little painting. Later, however, she went on to make two collages and worked in clay. By the time she left the clay table she was her cheery self. As she walked out the door I noticed that she had made two red collages. When I looked in her painting folder, I found that she always used a lot of red and orange and that, when there was a choice of colored paper to paint on, her choice was red.

Later I called her mother to find out how Suzy was feeling and to discuss the incident. She mentioned that the day before class she and Suzy had been at Rockefeller Center where they had seen budding tulip plants. As they looked at the masses of green buds, Suzy had told her with great vehemence, "I hate the color green!"

That experience convinced me that I might rearrange the order of paint on a tray to make children aware of possibilities, but that I should not take away any color from a very young child's tray once I have given it to them. I now include red on the tray on Green Day. Not only can many lovely grayed greens be made with the addition of red, but also a very verbal person may become nonverbal when confronted with an unexpected problem. If Suzy had told me she wanted red paint, I certainly would have given it to her but she could not muster up the courage to ask. For all beginners, it is much easier to add materials to projects than to subtract them later. Very young beginners might feel they were being punished by the deprivation of something they were previously offered. After workshop participants become more experienced, however, they may accept limitations on materials as a challenge. If you find that you have run short on some supply just before the workshop, explain the situation to the students and propose, "Let's see what we can make with the colors we have."

## IDEAS FOR MOTIVATING OLDER BEGINNERS

Preschoolers will be highly motivated by the materials and need less encouragement to begin, but grade-school and adult beginners may at first fear failure. While group projects such as posters for events

and murals offer peer support, preparatory exercises for developing basic brushstroke and color-mixing skills are necessary for individuals to be able to contribute to a group endeavor. Themes such as skyscapes (e.g., stormy weather), "fire and ice," "crystal land," or "the four seasons" may help older students get started. Two projects for grade-school-through-adult students that involve additional outside research are making a painting of the family tree or studying heraldry and creating a family coat of arms.

In order to stimulate personal involvement of all participants, try to keep the group small. Eight students or under is best. Otherwise, the leader should be very experienced, and assistants may be necessary to offer every one personal assistance. Everyone must feel from the beginning that they can do the experiments themselves and also get a sense of accomplishment, or they will not return for a second try.

Teenagers and adults may require more careful presentation of the projects and some information in the form of a review. For example, you might say, "Although most of you might already know this, I'm going to go over the procedures for those who have not tried this recently." Because most people are not aware of exactly what information they are missing, they do not know what questions to ask. You also may need more and increasingly diverse project examples and art reproductions in order to inspire them to begin.

After older beginners (and preschoolers as well) have painted for a while, a special "Color Day" will increase their awareness of how to mix particular colors and to discover the range of different color variations. Before beginning the workshop, I show a reproduction of a painting where the chosen color for the project predominates. On Purple Day, I collect a variety of purple collage materials, arrange them on a piece of purple or white construction paper on a bulletin board, and put out an arrangement of objects in that color, such as eggplant, purple cabbage, or purple grapes. I ask what they have seen that is purple, and they may mention flowers, grape juice, dresses, shirts, or plums.

Some beginners will inevitably make purple just because the blue and red containers are nearest to them. Others will not, but I don't push them to do it as long as they are involved in painting. When purple first appears on the painted papers of the young children, however, I may call attention to it by saying, "Julie, you made purple. It's like the picture of purple flowers on the wall. Do you know how you made it?" Someone else joins in, "I made some too. It's purple." Occasionally during the painting session I point out the different kinds of purples as they appear on the paintings—pinkish, bluish, reddish, dark, and light ones—and help them think about how they have made them.

## BEGINNERS WITH DISABILITIES

Before a painting session for grade-schoolers or people with learning disabilities, you might arrange the paint cups for the Purple Day project so that the order from the bottom up is red, blue, white, yellow, and black. This way the group will tend to use the red and blue first. See if they notice what you have done. If they do, you might ask, "Why do you think I did that?" That leads into a discussion of the color-mixing process.

Do not insist that everyone stick to any set of colors or ask them to rationalize their color choices. If you have suggested Green Day and some have ended up with red paintings, you needn't feel unsuccessful with all your preparations. Merely put away your props and save them for another time when they are ready for such an

idea, or when they spontaneously paint that color.

Sometimes a beginner may not know the names of colors; this does not signal color blindness or a learning disability. Even those who do know the color terms may not want to answer if the leader makes a test out of it. In any case, unlike in schools, where testing a person's ability to follow directions may depend on color acuity, an actual color disability will not pose an obstacle to enjoying these workshops, although it may be an inconvenience.

For example, because she had no alternative, the parent of a three-year-old also brought a seven-year-old sibling with the intellectual capabilities of a two-and-a-half-year-old to class. The child experienced no difficulty in working along with the younger group. While "mainlining" students with disabilities into regular classes is a controversial issue that will be debated for years to come, its success also depends on the subject matter. In this situation, all of the individuals are working independently at their own levels of development, so that there is no sense of competition or comparison.

Noah began my workshop when he was three years old and enjoyed working with the studio materials. His work seemed no different in appearance from any others and his paintings were pleasing to him. Nobody realized he had a red-green color disability. He learned to call the colors that he saw the right names even though he perceived them differently from the rest of us. I learned later that the color green in traffic lights looked white to him, and he could tell when the lights changed. Although this problem made classifying objects according to color impossible, in the workshops there was no reason to do that. Therefore, he wasn't aware of his difference until he was five or six years old, when his father gave him a green pen and he proudly showed the

"red" pen to his mother. Fortunately, he was encouraged to view that issue as a problem to be solved and an inconvenience rather than a disability. He has said that people who are "color-blind" certainly do see colors, but not as most others see them.

Disabilities of all sorts can be worked with in this workshop. A very successful dyslexic father told his children, who all had the same condition, that they, like him, saw the world differently from other people, and this gave them a unique viewpoint. Several children who are hearing-deficient also have done well in my classes. The important thing is to recognize that these students may need to do things differently, and it will help if you research methods for accomplishing this.

IVAN CHERMAYEFF (American, b. 1932). Two studies for *Jacob's Pillow*. c. 1985. Torn and cut paper, 16 x 12". Courtesy of the artist

This torn-paper technique can also be used for portraying gesture. The rough and angular orientation of these torn shapes evokes some of the formal vocabulary of modern dance.

## Materials Checklist

- Reproductions
- Scissors: Four to six inches for young beginners, larger for adults to cut large papers into half sheets
- White glue in glue jars with smaller brush

### FOR OLDER BEGINNERS:

- One 18-by-24-inch sheet of colored construction paper for the background
- One half-sized sheet of construction paper of a different color for torn shapes
- Newspaper cut in 9-by-12-inch pieces to use under the glue container

### FOR PRESCHOOLERS:

- One 18-by-24-inch sheet of colored construction paper for children to paint on
- Regular painting-tray setup
- Optional: Hole punch as a remotivation tool for preschoolers

Looking at art of the past shows how people universally have found similar ways to invent and express their visual ideas. A friend invited me to see her extraordinary handmade copy of pages from a twelfth-century Japanese poetry anthology called *Sanjurokunin-Kashu.* In addition, I saw one original piece taken from the *Ishiyama-Gire,* another of the more than thirty antique Japanese volumes that were taken apart and individual pages sold to private collectors and museums. The original pieces are highly prized works of art. It was amazing to learn that many of the pages of the book were executed in a "joined-paper" technique of overlapping layers of very thin papers.

The ancient pages were made up of both torn and cut pieces of paper in softened, muted colors: deep rose, grayed lime-green, tans, browns, and grays. Some were flecked with little geometric shapes of gold, others were printed, and still oth-

ers were painted. A portion of these suggested landscape; some were lovely compositions of nonrepresentational shapes. The torn-and-cut papers were placed in layers and arranged in many directions. Some of the perforated torn edges looked to me like the tips of marshland grass, and where they overlapped in several layers, these sections suggested waves or rippling water.

What particularly fascinated me was the precision of the torn, undulating curves. I wondered how an artist could possibly tear contours so immaculately or if some virtuoso with a knife or small scissors had cut those serrated edges. My friend explained that the Japanese had put tiny holes in the paper before tearing the edges. Some of the paper was probably torn while the sheet was wet and other pages were cut while dry.

I was delighted to see not only such an old source of torn-paper composition but also one that overwhelmed me by its inventiveness and beauty. Having looked at art in museums for most of my life, I felt I had seen every possible variation of works with paper. But until I saw this work I had thought of the method of working with glued paper primarily as *collage,* a style used by early twentieth-century European artists, not yet recognizing the distinctions in techniques and philosophies separating the mediums. (See the following chapter for a fuller discussion of collage.) The discovery that this medium existed so long ago brought a connection with history, unifying my own experience with that of artists throughout the world.

Having made a torn-paper project previously, one parent returned to class a few weeks after visiting an exhibition of paintings by Clyfford Still. She explained how arranging the irregular shapes in her piece had helped her to understand Still's works. Part of her excitement seemed to

CLYFFORD STILL (American, 1904–1980). *Untitled.* 1946. Oil on canvas, 61³/₄ x 44¹/₂". The Metropolitan Museum of Art, New York, Arthur H. and George A. Hearn Funds, 1977 (1977.174)

*By 1941, space and the figure in my canvas had been resolved into a total psychic entity, freeing me from the limitations of each, yet fusing into an instrument bounded only by the limits of my energy and intuition. My feeling of freedom was now absolute and infinitely exhilarating.*

—Clyfford Still, excerpt from Kynaston McShine, ed., *The Natural Paradise*

flow from her sudden recognition of the use of intervals between shapes as well as understanding how to create a feeling of depth through overlapping shapes. Now she realized how overlap, edges, and directions of the sizes of shapes could effect the illusion of space.

## Shapes and Spatial Perception

Many Europeans and Americans today still accept without question the concept of linear perspective as the "only" method of representing spatial reality, in spite of having seen Asian art, which depicts it in another way.

While you were painting, you may have noticed that other visual cues besides perspective suggest space and depth. For example, in a landscape the bright contrasts of color and clarity of texture characteristic of nearby objects differs from the grayed color and softer, less distinct texture farther away. Diagonal shapes pointing toward a horizon also suggest a perspective indicative of depth. Up to this point, you have been filling the entire space with painted color without emphasizing the qualities of shape that define spaces. Now you will use torn paper shapes to compose because it is perhaps one of the easiest methods in which to begin thinking about these elements on a flat surface. It is possible to arrange and rearrange both the qualities of shapes and their positions.

Visual art, music, and theater use intervals in the phrasing of their mediums. One example in Japanese Kabuki theater is called *mie*. During this pregnant moment in space-time, the actor stops all motion for emphasis. In music, as in the visual arts, the elements of rhythm and phrasing shape the work's interpretation and intensity. In this project, the *intervals*, or shapes other than foreground shapes,

HENRI ROUSSEAU (French, 1844–1910). *The Banks of the Bievre near Bicêtre*. Oil on canvas, 21½ x 18". The Metropolitan Museum of Art, New York, Gift of Marshall Field, 1939 (39.15)

In this work, the diagonal paths toward the trees appear to curve back into depth as well as upward.

HONG-REN (Chinese, 1610–1664). Hanging scroll: *Dragon Pine on the Peak of Huan-shan*. Ink on paper, 75⅞ x 31¼". The Metropolitan Museum of Art, New York, Gift of Douglas Dillon, 1976 (1976.1.2)

Ancient Chinese painters saw space as the equivalent of the active power and principle of change in the universe, and it was filled with energy and vitality.

LOIS LORD (American). *Central Park, New York*. No date. Gelatin silver print, 10 x 8". Courtesy of the artist

In this composition, the position of the photographer at an oblique angle to the paths creates a wedge-shaped grassy area that leads the eye back into depth and also out of the scene to the right.

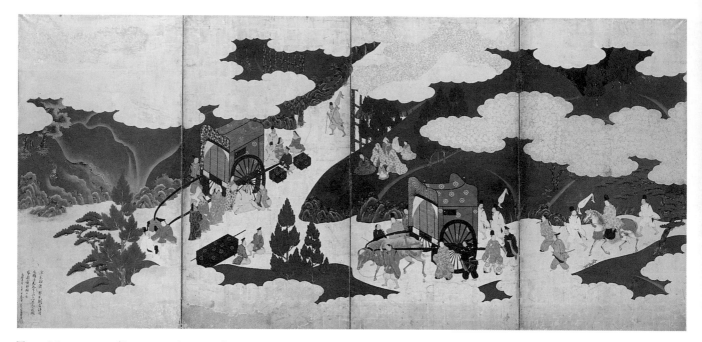

TOSA MITSUYOSHI (Japanese, 1539–1613). *A Meeting at the Frontier,* illustration from Lady Murasaki's *Tale of the Genji.* 16th century. Colors and gold leaf on paper, 5' 5½" x 10' 4". The Metropolitan Museum of Art, New York, The Fletcher Fund, 1955 (55.94.2)

Although the boundaries of objects define space, whether they be the edges of a piece of paper or the walls of a room, the *intervals,* or spaces between elements, also shape the expressive quality of the arrangement.

will compete in visual importance with each other to generate depth reversals and multiple interpretations of spaces.

The advantage of this tear-and-glue method is the ability to move shapes around quickly, changing both spatial intervals and the contours of shapes themselves by layering one piece over another before gluing down the composition. When shapes or arrangements don't come out the way you want, just tear and layer another piece right over it.

If you think of it, everything around you is composed of an arrangement of shapes, from the furniture in your rooms to the food on your plate. If you are like most adults, you can accept design arrangements because you have seen them most of your life in commercial art. Since

you don't have to make a recognizable image here, you may not think of what you are doing as a kind of drawing. Yet drawing is creating lines that define the boundaries and qualities of shapes. Many experienced artists use torn-and-cut-paper arrangements as a sketching tool to inspire ideas for future work, to try out ideas in their compositions, or as an end in itself.

## Why Tear Paper Shapes?

*T*earing allows our fingers to explore the qualities of paper—its physical and visual textures, its flexibility and responsiveness to touch that gives an intimate knowledge of the material. In the same way that we hesitate to disturb the virgin beauty of

ARTHUR G. DOVE (American, 1880–1946). *Reaching Waves.* 1929. Oil and silver paint on canvas, 19⅞ x 23⅞". The Metropolitan Museum of Art, New York, The Alfred Stieglitz Collection, 1949 (49.70.38)

Artists such as Arthur Dove and Clyfford Still have painted shapes with ragged edges that suggest associations with torn paper. This oil painting has edges that resemble torn paper and uses overlapping of shapes to suggest depth.

LOIS LORD (American). *Stone Garden, Japan.* No date. Gelatin silver print, 8 x 10". Courtesy of the artist

It is common for people to feel a sense of outdoor space or natural phenomena in this project. This is not only because the the torn shapes suggest rough textures in nature, while straightedged geometric ones carry more associations with machine-made objects, but also because of the relationship of the torn shapes to the background. The softness of the torn edges and their reduction of detail to a texture can evoke the feeling of being at a distance too far away to see things sharply.

freshly fallen snow, often we are afraid to spoil the perfection and smoothness of a perfect geometric paper sheet by marking it up. You may have less to fear from the blank sheet of paper when you go to paint after making these torn-shape compositions.

Here, you are really paying specific attention to learning to see things purely as shapes and translating three-dimensional experience onto a two-dimensional surface. Using torn shapes instead of cut ones also helps you to recognize and purposefully use irregular edges to suggest qualities in nature, such as the surfaces of tree bark, rocks, rough water, and leaves. The torn edges also have pronounced tactile qualities that call attention to the edges of shapes apart from their associations with textures in nature. When you tear paper without the aid of any mechanical devices, you tend to make many shapes that have both concave and convex contours, even if these curves are very slight.

## Demonstration for Young Beginners with Adults: Tearing Paper

*I*t is helpful to repeat to everyone at the start of the session that "this paper is for tearing and other papers are not!" I have had visual aids inadvertently spoiled by adults who did not realize I was saving those materials for specific purposes.

I do not ask preschoolers to do a torn-paper project. However, if they are present, they should be allowed to observe the demonstration so that they understand what the adults are going to be doing. This also exposes them to a vocabulary that they will eventually come to understand through their own experience with the materials. They also become aware

that smooth edges are different from ragged ones.

Not only is it difficult for the youngest beginners to tear paper shapes, but they also are usually more interested in learning to cut with scissors. Some have also been warned at home that tearing paper is destructive and may be afraid of being punished. Once, while I was demonstrating tearing, one little boy asked, "Does your Mommy know you're doing that?"

1. Since the youngest beginners are watching this demonstration, you can include them by saying, "The grown-ups are going to do a gluing picture today, but I'm not going to give them any scissors. How do you think they're going to make their shapes?" Some students may say "They tear (or rip) them." Often beginners of any age do not realize that there are several ways to tear paper contours.

2. Hold the paper with two hands and try pulling on it to show that this method does not tear the material. Then explain that you need to hold the paper at the edges in order to twist the paper while pulling. Since this is also an opportunity to discuss edges, hold the paper at its edges and point to the differences between the smooth, untorn edges as compared with the rough, torn ones.

A. Tearing shapes flat on the table: Tear a more-or-less straight edge—*without* using a hard-edged tool or table edge or creasing the paper—by placing your hand flat on the paper, using the forefinger and the side of your palm as a guide, and pulling up on the paper.

B. Tearing shapes in the air: Hold paper up in front of you above the table and show how to turn the paper while tearing it to get a shape. Hold up the shape you have torn out, turn it so that everyone can look at it from all sides, and then ask for ideas about what it looks like. After a multitude of different responses,

you might point out that everyone has different ideas about what they see.

C. Making holes: Show how you can poke a hole with your finger and tear an inside shape, making a "see-through" space. Then hold up the remaining paper from which it was torn and peer through the "see-through" shape. Point out that you have made two shapes, an inside one and an outside one. When you put the "see-thorough" shape down on the background, you get another shape from the underneath color.

Examine the possibilities for new shapes from the ones you have torn, as well as the ones left behind in the tearing process, and ask the group if they know what the underneath paper is called. Here you can begin to refer to it as the *background*. Although most adults will already know background and foreground, *foreground* is a more difficult concept for preschoolers to grasp and might be used at a later session, depending on their ages. If the door to your work space is open, you could point out that the doorway is a "see-through" shape and the far wall beyond is the background.

D. Moving the shapes: Look at many arrangement possibilities as you move the shapes around, repositioning them several times, pointing out what happens to the spaces in between the torn shapes. Show how it looks when shapes are pushed to the edges of the paper as compared to when they are well inside the margins. Examine how the background shapes change when you move the torn pieces around and how everything changes when shapes touch or overlap.

After demonstrating possibilities, show a few photographs of open spaces (see-through shapes) in nature, such as the sky seen through tree branches. Since the adults will be working on colored construction paper, this is a good time for the preschoolers to go to their worktables to

Tearing paper shapes flat on the table

paint on colored construction paper. After you point out that a colored background will make other colors appear different from the way they look against white paper, the youngsters will become involved with their work and you can continue your discussion with the adults.

## Project for Adults and Experienced School-Age Students: Creating Space with Shapes

*A*llow at least forty-five minutes to complete this project of arranging torn paper shapes on a background. The goal is to show how the color, direction, placement, and kind of shapes can produce the sensation of depth and projection to make a flat picture seem spatial, suggest movement, and create mood. For example, a wedge-shaped diagonal path on the paper field can suggest depth, depending on the direction in which it is pointing.

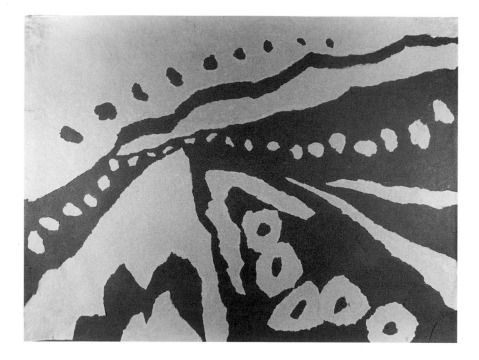

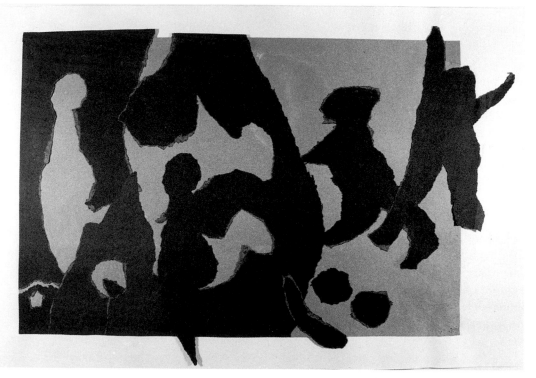

Two adult-student torn-paper compositions

This experiment of arranging torn-paper shapes on a background shows how the direction and placement of shapes can produce the sensation of depth and projection to make a flat picture seem to contain space, suggest movement, and create mood. You can also extend a torn-paper shape beyond the frame of the background paper to suggest additional movement.

No matter what theme you use, try to work freely in a semiabstract way so that you think about the directions of shapes in a visual field instead of illustrating particular objects or scenes. It is best to place the shapes on the background in a two-dimensional, graphic way rather than making parts stand up off the paper. This way you can more easily see how the foreground shapes and the background interact in this project.

Also avoid using a mechanical edge to create geometric shapes; it will make your design more static and keep you from exploring the great range of organic contours available in hand-tearing. By the same token, don't fold your paper in half in order to tear both halves of a configuration at once or to balance equally on both sides of your background paper. Not only will the resulting creases in the paper interfere with the spatial effects, but your symmetrical shapes will also reduce the illusion of movement in any specific direction. Try to prolong the design process by experimenting with many different arrangements before determining which version finally to glue down.

1. Pick up 18-by-24-inch (or 9-by-12) pieces of construction paper for tearing and see how the colors look together by holding them alongside of and overlapping each other. Pair off another combination, or another color next to the first one, until you feel you have a pair that you want to use. As in the previous projects, this will depend on what kind of mood or place you wish to represent. Overlap one piece with the other and then reverse the two to decide which one you will use for the background. Cut or tear the other sheet in half for easier handling if you want to. If you are using an 18-by-24-inch piece and want long shapes for your foreground, cut 9-by-24-inch lengths by dividing the large paper in half horizontally.

2. Tear out a few large shapes first from the half-sized sheets, and then take some pieces out of these. Look at the spaces or holes left in your torn paper and consider using them as shapes in your arrangement in addition to the inner pieces you removed.

3. Tear out a few different kinds of shapes so that you can see a variety of possibilities for arrangements. Put them down onto the background and move them around *without* gluing them until you have tried out a number of arrangements. Pretend you don't have any glue for at least ten or fifteen minutes.

The composition does not necessarily have to express a special idea or mood, although as you work a theme may develop. Examine what happens when you change the outer silhouettes by overlapping, or use overlapped pieces to indicate a direction. What happens when you make two shapes connect end to end or change their initial direction by adding another piece so that you cover only part of it? When do your shapes look as if they are moving out toward the edges of the paper or in toward the center, and when do they appear to stop?

Keep your eye on what happens to the background spaces in between the torn pieces as you continue to fill up the whole page. Notice how the intervals between the shapes change as you move the ones on top around your paper. As the importance of in-between shapes becomes obvious, often you will not be able to tell which is foreground and which is background. Turn your background paper around a few times to see if there might be another arrangement you might like better. You might also want to tear the edges of your background paper to change its rectangular format.

4. Finally, when you have a composition you like, begin to glue the pieces. Do not pick up the shapes to glue them or hold

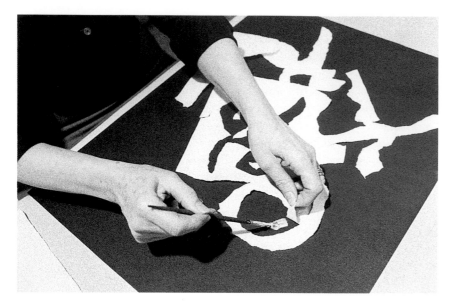

Demonstration of gluing

pieces in your hands. Keep the paper flat on the table, lift the outside edge of each shape, slide a bit of glue underneath, and press the shape down. If you use a small amount of glue in the center of the shape, you are less likely to have any excess glue squish out at the edges, and you can still alter the shape if you wish to do so. Later on, you can slide more glue under the shapes if any are loose.

5. If you want to add an inner shape that gives the illusion of a hole through the paper, after you have glued it down, you can put some paper of the background color on top of the foreground pieces.

6. Now you can hold the composition up vertically and look at it again. If you have any time left during this session, you might take another background sheet of a different color, arrange leftover shapes from the first design on it, and compare the color interactions of the two completed works.

7. Save all your leftover pieces for other projects.

## THINKING ABOUT WHAT YOU HAVE DONE

You may have found that tearing shapes freed you from the concern of trying to make preconceived images so that you were not so worried about getting a shape "right." This allowed you to be more responsive to unexpected results. Yet tearing and overlapping actually did allow you to begin drawing by shaping and reshaping the edges. Postponing the gluing process also promoted the greatest exploration of compositional possibilities.

One woman who already considered herself an "artist" came to the torn paper project with a preconceived idea for a composition. Instead of observing my demonstration and listening to the procedure instructions, she tore out a rectangular form and immediately glued it down as a frame before tearing any other shapes. This anchored her pictorial space and restricted her options in experimenting with other configurations. Although I could have let her finish without saying anything, because of my long-standing relationship with her, I felt I could encourage her to experiment and work more spontaneously without seeming to criticize or hurt her feelings: "Because this is a project to help you find new ideas, I would really like to see you wait to glue down any shapes until after you have explored several different arrangements." She abruptly declared, "But I know what I want to do." "That's fine. You can do it, but please don't glue down the pieces until you've looked at your layout for a while and moved your shapes around," I replied.

She had sabotaged her project in two ways. First, by making a framed border, she had established a strong boundary anchoring or restricting the visual movements of shapes within her rectangle. This frame immediately established a foreground-background situation that

would be difficult to change in her own mind's eye. Second, by immediately gluing the paper down, she further minimized her options for rearrangement and discovery.

My subsequent enthusiasm about her variety of torn shapes overcame her annoyance at my initial suggestion, and she went on to complete an arrangement she hadn't planned in advance. Letting her new shapes overlap the frame and postponing gluing them down led her in a new direction. After class she confided, "Not only did I make a piece I like, I also discovered something about how inflexible I can be and how I often shut off alternative options in my daily life."

While you were tearing shapes, you may have noticed that there was a distinct color change in the paper between the smooth top surface and the rough edge. You may have missed this if you used light-colored papers, but if you had overlapped pieces of torn black on top of each other you would have seen quite a dynamic effect with the shades of the color. You might try an all-black experiment to see this phenomenon if you did not use black the first time. Black construction paper usually has a different shade on each side as well as a third one on the torn edges. Sometimes, if it has faded with age or exposure to light, the contrast is even greater on each side; thus, if you work with both sides, it will look as if you have used three shades of black paper instead of only one.

Whenever you put a shape on a background, you set up a visual spatial relationship between the two elements. If you have overlapped shapes, you can also see how this process suggests space in depth. If you have used both large and small pieces so that they are grouped by size, the small ones may read as far away and larger ones seem closer. If you have torn off your shapes at the edges of the background

paper so that they look incomplete, you have suggested an extended shape beyond the edges of the paper where you continue the scene in your mind's eye. All of these techniques of spatial representation are used frequently in many different kinds of paintings.

Ancient Chinese and Japanese artists found that pictorial space was the most important element in unifying and harmonizing all the elements of a painting, and it had a symbolic significance as well. In Japanese art, the term *ma* signifies an artistically placed interval in space or time that helps accentuate the design. This deliberate use of blank space (not necessarily white space) is designed to create "meaningful voids" of emotional intensity.

Any spatial reversal of your shapes with their background arises when the visual impact of the parts is so equal that there is ambiguity about where to look first. I suggest that students concentrate on looking at one color at a time to see that reversal. Because we cannot receive two different organizations of pattern at the same time, we alternate by seeing it one way and then the other. This foreground-background or *figure-ground* reversal works best with arrangements of shapes that have convex and concave curves, because these are felt as visual forces instead of static areas. The ancient Chinese used this visual effect with convex-concave shapes in their design of the yin-yang diagram representing complementary polarities and principles of energy in the *dao*, or the "way of the universe," demonstrating visually the idea that each element suggests change.

Because your torn-paper composition tends to make the foreground and background seem to coexist more or less as equals, it is easier for you to see this spatial principle of organizing a composition. Beginning painters, who look only at the shapes or objects on the front plane

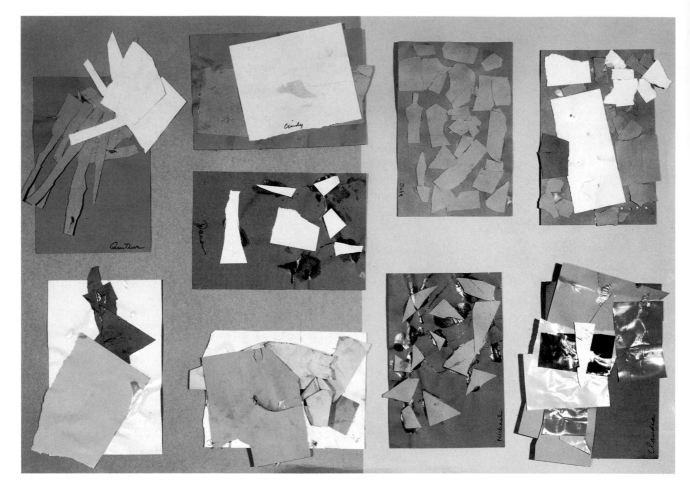

Preschoolers' beginning collages

instead of seeing the entire container of space on the page, often put in objects, surround them with color, and then cannot think of what to do with the leftover spaces in between.

Although this spatial issue in design is often spoken of in terms of *positive* and *negative space,* I stopped using this language in my classes when a nine-year-old boy asked, "Why do you call those spaces negative? They're just as good as the ones you call positive." I realized that *negative* implies something not so good. Both kinds of space are equally important in reality because you cannot have one without the other. It is hard for me to think of brilliantly colored blue shapes of the sky

seen through tree branches as "negative." I talk in terms of "in-between" shapes, "see-through" shapes, and spaces. I use these same terms with older beginners, explaining my reasons, while also introducing them to the academic terms *negative* and *positive.*

## Tips for Teaching

### PRESCHOOLERS' SHAPE-MAKING

The emphasis at this point should be on learning new skills; later come specific challenges with materials and themes,

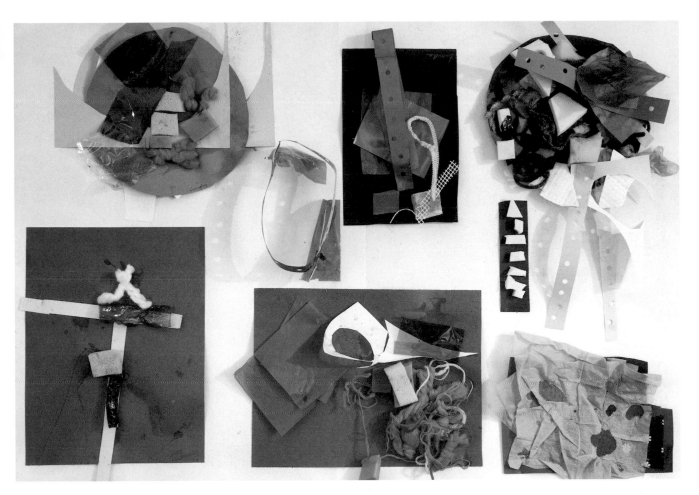

Preschoolers' advanced collages

Most young children learn to cut with scissors during their first semester. However, I do not make an issue of it if they don't grasp the technique immediately. The youngest preschool beginners' first collage experience is choosing simple, precut papers in geometric shapes from a choosing tray and gluing them down onto a paper background. Later they may progress to using scissors to cut their own shapes. However, even if they cannot cut or even tear paper with control, they never feel frustrated because there are alternative ways of making shapes, such as layering and overlapping.

which will be discussed in following chapters. Beginners of all ages always start with construction paper because it is the easiest to learn to cut and tear, and the dye completely saturates the material instead of being printed on the surface of just one side. Preschoolers use the 6-by-9-inch background papers for their projects because that size is easy for their small hands to handle; grade-schoolers use 9-by-12-inch and adults and teenagers use 18-by-24-inch dimensions for their ground planes (or half sheets if the class resources are limited or if they wish to work smaller).

Learning to transform the materials is important. Although I begin with only construction paper each semester, I find that even students who come back for several semesters find it a challenge to use this material to apply new ideas. Once in a while someone might ask for a type of paper they have used before, but once they discover all the things they can do with construction paper they do not feel limited. Although I may add new materials or tools—such as oil pastels, crayons, or a hole punch—for remotivation after the students have been working for a while, I try not to give them a lot of extremely flashy materials at first (such as metallic or patterned gift papers) because they will not develop their works as readily by cutting and building new images but may be satisfied with mere gluing. If you put out a lot of different papers from the first, the students will run through them quickly and learn very little about any of them.

Some preschoolers may enjoy tearing for its own sake, depending on the kind of paper used. I do not give them a special torn-paper project but rather help them to think about tearing as another way to make shapes change. I encourage them to cut with the scissors so that they acquire both skills of cutting and tearing, begin to see the differences between the results,

and learn to make choices as they work. The concepts behind your torn composition may have meaning for them as they become more experienced and more visually aware. They are usually delighted by the idea that, when you are using only two colors, you sometimes cannot tell which is foreground and which is background.

For first and second graders, you might handle torn-paper shape-making pretty much the way to you do with adults, although you would need to use a vocabulary appropriate to their level of understanding.

## PREPARING CHOOSING-TRAY MATERIALS FOR PRESCHOOLERS

Pre-cut all the pieces for the choosing tray or box with low sides before the class session into simple shapes such as strips, squares, and rectangles that are between two and four inches long. These shapes need not be perfect because their function is merely to divide up the paper pieces into manageable sizes. Avoid cutting round shapes so that, when the children want them, they try to make them themselves. (See also pages 145–46.)

## INTRODUCING YOUNG AND DISABLED BEGINNERS TO SCISSORS AND GLUE

As adults, we have forgotten how difficult some activities were to learn. Like riding a bicycle, cutting with scissors is a complex skill requiring the development of certain finger muscles as well as eye-hand coordination. Consequently, I prefer to teach one studio skill at a time, beginning with gluing. Older children or adults who have already developed gluing or cutting techniques can combine both at once.

In addition, some inexperienced preschoolers and people with mental disabilities may think of gluing and cutting as two mutually exclusive rather than sequential activities. Some may only want to glue and glue, and glue some more, and not use the scissors. Others become entranced with cutting everything in sight and only glue a token piece onto the background to please you.

As in painting, some beginners of any age primarily enjoy the physical activity of what they are doing. They will be fascinated by the processes and not particularly care about their visual results. Some may apply a lot of glue and then not want to cover up the shiny wet places. Others may squabble over a particular piece of paper in the choosing tray, get it, put it on their design, and then not recognize the composition as their own after they are finished.

The hole punch is an optional tool that may be especially useful for students who initially have problems with learning to cut with the scissors or who have short attention spans. It is possible to make patterns of "see-through shapes" in rows and use the cut-out holes to paste down. When he was three, one of my own children was not particularly interested in cutting and gluing until he got the hole punch in his hand and was fascinated by the patterns of see-through shapes he could make. This, in turn, led to his greater involvement with cutting and gluing paper arrangements. Over the years, I have also used the tool as a motivating device, like the small paintbrush, to reactivate youngsters when attention begins to flag. When some children get to be three and a half or four, they are more physically active and need to use their bigger muscles. It takes a certain strength to use the punch, but many find it an intriguing instrument. Recently, when I gave a very restless and bright three-year-old a hole punch, it redirected his boundless energy

and kept him fascinated for another ten minutes. His mother was amazed at his concentration because she had never seen him focus on a task for that amount of time.

## DEMONSTRATING GLUING TO PRESCHOOLERS AND STUDENTS WITH LEARNING DISABILITIES

1. I begin by calling this activity a gluing-and-cutting picture (or a gluing picture if they are only gluing) in order to call attention to the process.
2. I put a small precut shape on my 6-by-9-inch background paper, then pick it up and tilt the sheet so that the piece slides off.
3. "What do you think I have to do to make the shape stick to the paper?" (Short pause—they may or may not know the answer.) "Let's try using some glue and see what happens."
4. I put a dab of glue on the background sheet with a glue brush, put the shape on top of the glued area, press it down, pick up the paper, and shake it a bit. "Now it doesn't fall off. It sticks to the paper."

When you are demonstrating, if you pick up a shape and spread glue on it while it is in your hand, the students will imitate you and may get glue on their fingers. They will find the papers sticking to their hands instead of to the background. Moreover, if they put down a shape on the table surface and then apply glue to the back of it, they may get glue on the table around the margins of the piece and find pieces sticking there. Emphasize that putting just a little glue on the background paper makes it easier to change things and you can always add more later.
5. Repeat the process, letting the students choose the shape to be glued. "What do I have to do to make it stick?" and so on.

I do not show the method of slipping glue under the edges of previously arranged shapes to very young, inexperienced children or people with mental handicaps because they will find the process too difficult to handle. Later, after they have learned the first method and start to rearrange their designs, you may introduce this more advanced process of gluing.

If they do not understand the process, some may put glue down and then place the shape somewhere else. They may need a personal reference for the idea of covering over the paste. Everyone knows about being covered with their blanket so you can use the following analogy: "When you go to sleep, do you cover yourself with a blanket?" ("Yes.") "Covering over the glue with shapes is like putting a blanket on the glue."

Sometimes they will place a shape on the glued area, then put a second one on top of the first without adding more glue to it. They may continue to pile on pieces without realizing that they will fall off until at the very end when they pick the paper up to show you what they have done. A few of these incidents will tell them more about the gluing process than if you constantly remind them what to do. When their pieces fall off you might say, "Why do you think that happened?"

Some students love the shiny look of the wet glue and they put more glue on than they need or spread it all over the paper. Don't try to wipe off the excess but suggest instead that they might want to add more shapes onto the remaining glued areas. If they don't want to do that, don't insist on it. Later, after they have gotten over the excitement of brushing on glue, they may be more interested in assembling something.

Often they don't realize that gluing makes an arrangement permanent. Danny announced to me that he was going to make a birthday collage for his father. "I'm going to give him a surprise." He grinned as he carefully chose a variety of materials and glued them down. "I think he will be surprised when he sees all those colors and shapes you glued," I replied. As I moved away to help another student I saw Danny take a fresh tissue from his pocket, meticulously put glue all over his paper, and put the open tissue over the whole surface. "There! Now he can't see it right away and it'll be a surprise when he opens it," he exclaimed triumphantly as he went off to work at the clay table.

Danny forgot to take his birthday surprise with him when he left class. He had the joy of making something without the possibility of disappointment if his father reacted with confusion to the tissue-covered present.

Beginners also may sometimes put glue over the surface of their paper and then fold the page in half like a sandwich without realizing that they cannot open it again when the glue dries.

## GLUING AND ARRANGING FOR MORE EXPERIENCED BEGINNERS

Explain to more experienced school-age and older students that they can arrange part of their design without gluing it, and then slip glue underneath the edges of the pieces. Show them that it is easier to move things about in different arrangements before making a final commitment to the design. Occasionally I find an advanced four- or five-year-old who can handle this concept also.

For example, during her first day in my class, four-year-old Maria was really judging and examining where she wanted the pieces to be and how she was going to position them. She began to prepare the pieces with glue beforehand. Then she

held each piece with glue on it over the paper and moved it around in the air just above the surface until she decided where to set it down. As she worked, she got glue on her hands and the papers began sticking to her fingers instead of the paper. Although she was experienced in cutting and gluing, no one had shown her the possibility of prearranging her compositions. After I showed her how to arrange shapes on the background paper and slide glue under their edges, she worked more easily.

When children are given the freedom to make their own compositions, they often intuitively find striking balances of colors and shapes. Although they work on a 6-by-9-inch background paper, if their composition is expanding beyond the edges you can show them how to attach additional 6-by-9-inch paper extensions. You may also offer them a larger background paper on which to place the whole design without disturbing the prearranged parts. Sometimes children extend their collages naturally as their ideas expand.

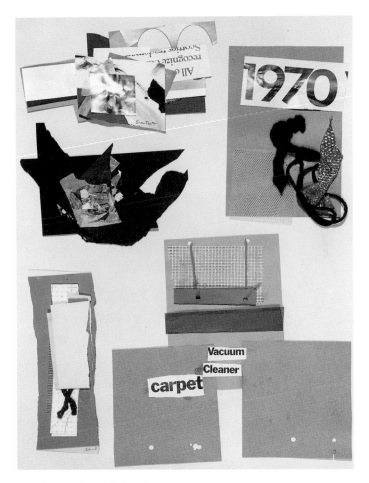

Preschoolers' extended collages

## TALKING WITH YOUNG BEGINNERS ABOUT THEIR WORK

Sometimes if you ask very young children, "What shape is this?" they might answer, "Green," or name an object as a shape. Since they come to recognize the differences between shape and color through studio work, you will find it easiest to explain the differences if the children use all three workshop mediums. Visual ideas, especially those of changing forms and colors, are reinforced in a different way by each one. If you exclude clay, you will have to explain more about three-dimensional shapes. For example, if they work both with collage and clay, they learn that *round* is not just one thing but can take many forms. These are ideas that are difficult to

explain in the abstract and you will have to supply a variety of concrete examples to illustrate them.

Try to talk about things you see on their papers as they happen. If you expound ideas before you have a visual example, the children probably will not know what you are talking about. If they are tearing for the sheer joy of the tearing process, I try to direct their attention to shape-making: "Look at the shapes you are making! Some are little and others are big." Most of their torn pieces will not be any shape you can name precisely except for saying that they are long, fat, or skinny. If they have piled one shape on top of

another so that parts stick out, you might point out that they have changed the underneath shape by covering it up. I do not tell them how to do it. Although they are overlapping their shapes, I use the word *overlap* only when it comes into their own work.

With experience, you will recognize what the problems and concerns are and when someone needs help with something specific. I remember a story of a nine-year-old boy who told his teacher he was having trouble with his picture. He had made parallel railroad tracks, put in some other shapes on either side of them, and sat staring at what he had done. She assumed he wanted the railroad tracks to look as if they were going off into the distance and started explaining how to draw them in linear perspective. He waited patiently until she had finished her whole speech and then spoke up, "Oh, I know about that. What I'm trying to decide is how to put in a danger signal by the side of the tracks." He wasn't the least bit interested in perspective and she hadn't bothered to find out about his concern and how she could be of help.

It is sometimes difficult to remember that students do not share your previous knowledge and vocabulary. Although one could give out a list of art terms, these won't really mean anything until each person experiences the studio phenomena for themselves. When pointing out spaces or shapes to preschoolers, I do not refer to them by their geometric names such as circle, triangle, rectangle, and the like, but instead emphasize how they look (for example, round, pointy, or long shapes and in-between shapes or spaces). Although some may know about egg shapes if they have seen eggs before they are cooked, I don't usually talk about ovals with preschoolers.

Try to be precise with preschoolers and students with learning disabilities so that they do not confuse words for two- and three-dimensional shapes; also be specific about differences between generic shapes, such as round or pointy, and the names of specific objects, such as a ball or carrot. For example, if you hold up an orange as an example of a round shape, point out other round shapes, noting that a ball is also round. Avoid *ball shape* as a term because that restricts their associations of roundness only to balls. Find examples of objects that are most like the kind of shapes present in their own work. If they have a flat round shape, look for another flat round shape that is fastened to a background, like a button on a shirt or a clock face on the wall, to explain *round* and *flat*. When talking about color, try not to confuse the term with shape. For example, if you want to explain the qualities of a certain color such as orange, show many examples of different shapes with the same color—such as a round orange, a pointed carrot, or a rectangular box—so they understand that the same color can exist in different shapes.

*"Then you should say what you mean,"
the March Hare went on.
"I do," Alice hastily replied; "at least—at
least I mean what I say—that is the
same thing, you know."
"Not the same thing a bit!" said the Hat-
ter. "Why, you might just as well say that
'I see what I eat' is the same thing as 'I
eat what I see!'"
"You might just as well say," added the
March Hare, "that 'I like what I get' is
the same thing as 'I get what I like!'"
"You might just as well say," added the
Dormouse, which seemed to be talking in
its sleep, "that 'I breathe when I sleep' is
the same thing as 'I sleep when I
breathe!'"*

—Lewis Carroll, *Alice's Adventures in Wonder-
land,* from *The Complete Works of Lewis Carroll*

LOUISE NEVELSON (American, 1899–1988). *Celebration: Series 570–884*. 1979. Torn paper collage and aquatint etching, 44 x 31½". Courtesy of PaceWildenstein

Nevelson's work illustrates the challenges presented in this chapter: drawing shapes through tearing paper, becoming sensitive to the spaces between the shapes on your paper, and arranging these intervals while forming a background and foreground.

CAMILLE BILLOPS (American). *Dancer Series #4.* No date. Cut paper, colored pencil, and ink,
15 x 22". Courtesy of the artist

Works in mediums with clearly defined edges are also suitable for visual inspiration
in this project.

Textile. Peruvian, Wari-Tiwanaku, A.D. 700–1000. Alpaca wool and cotton, 19⅞ x 40¾". The Metropolitan Museum of Art, New York, The Michael C. Rockefeller Memorial Collection, Bequest of Nelson A. Rockefeller, 1979 (1979.206.393)

## *Materials Checklist*

■ Art Reproductions

### FOR OLDER BEGINNERS:
■ Construction Paper: Start by limiting yourself to only three colors at first so that you can easily see how the colors form the foreground, middle ground, and background.

    A. One piece for the 18-by-24-inch background sheet and two other colors in paper half that size (18 by 12 inches)

    B. Leftover pieces from your torn-paper project to be used for additional experiments. These may also suggest new shapes you might want to cut from the half sheet, or you can trim and reshape them to use as fourth and fifth colors for small accent pieces.

■ Scissors: Since you will be using these large papers, you may find it easier to cut with a six- or seven-inch-long scissors instead of the four- or five-inch blades used by young children. However, if you have a spare small pair, you might try using both. The smaller pair is particularly effective for cutting intricate shapes. While large scissors are made either for left- or right-handed people, smaller blades can be purchased that are designed to be used by both left- and right-handers. In a group, it is most convenient to buy "universal" blades so that you do not have to concern yourself about how many pairs of each are needed. Moreover, some people are ambidextrous and may switch from hand to hand.

■ White glue with glue container and brush

- Optional: Flat-ended toothpicks or applicator sticks for applying small amounts of glue underneath shape edges

FOR PRESCHOOLERS:
- Regular painting-tray setup
- Precut construction paper arches that you will cut and glue to a background paper before class
- Optional: Blendable oil pastels (nontoxic, see page 32) for remotivation and for drawing on collages
- Regular collage supplies: filled choosing tray, scissors, and glue (if you are going to include this activity in the class)

Once, when I was sick as a child, a visiting relative who wanted to occupy me folded a newspaper and cut it into chains of paper dolls. How delighted I was when she unfolded the row of figures with geometric links in between. Although it was a great trick I soon mastered, no one suggested that I could vary the design, rearrange the parts differently, or glue them onto another sheet of paper. The emphasis was on the trick of making multiple identical figures rather than on using this skill to invent my own designs. Naturally, it got boring after a while.

Many years later I was delighted to discover through a photograph that Pablo Picasso had turned this cut-paper doll project into a sculpture. His freely cut chain of standing paper figures glued to a base was a gift he made for a dear friend. Shortly thereafter, I also found a brush-and-ink drawing by him of dancers in a circle that resembled the cutout. I wondered if the drawing was inspired by the cut-paper sculptures.

In school we did various types of paper-folding that involved cutting on the folds to make snowflakes, valentines, and other items. Often if a teacher gave out a tulip or pumpkin pattern to color, copy, or cut out, you were expected to follow specific directions and graded on your ability to do so. If you departed from the rules, the teacher may have perceived this as a flouting of authority and made you feel inadequate, disobedient, or untalented. The result could well have been to discourage you from using art materials because you feared making a mistake and were not encouraged to learn the skill of inventing your own designs.

By contrast, this project involves creating images by cutting shapes with the scissors and then layering them. Making variations and changing your visual ideas is always possible. If you are not satisfied with your initial shape contours, just keep adding more pieces onto the first one until you are.

## A Short History of Glued-Paper Composition

The process of cutting out printed and other ready-made images and gluing these onto a background, also called *découpage,* originated long ago and in so many different countries that we cannot accurately pinpoint its source. It has been used for greeting cards, decorations, valentines, Victorian screens, homemade children's picture books, and decorative coverings for boxes and lamps. In China around A.D. 700, assemblages of cut paper were glued to silk and, even now, paper cutout scenes are a popular art form there. The process of gluing disparate materials onto a background, called *collage,* was made famous in Western Europe during the early part of this century by such artists as Pablo Picasso, Georges Braque, and Gino Severini. These artists focused attention on juxtaposing nonart items from daily existence with painted and drawn ones, contrasting "reality" with art.

The French artist Henri Matisse, who always loved to draw, took the cut-

HENRI MATISSE (French, 1869–1954). *Lagoon.* Plate 18 from the book *Jazz*, published Paris, E. Tériade, 1947. *Pouchoir* (color stencil), double sheet, 16⅝ x 25⅝". The Museum of Modern Art, New York, The Louis E. Stern Collection

and-glue medium into another direction with his extensive series of compositions with papers. At first, he used cutouts to sketch; later, he presented his cut-paper pieces as finished work. He drew images by using scissors to cut papers he had pre-painted with color and assembled the images in layers. Matisse praised this cutout method of drawing as a way of unifying the elements of line with color and outline shape with inside surface:

> It is a simplification. Instead of drawing an outline and filling it in with color—in which case one modified the other—I am drawing directly in color, which will be the more measured as it will not be transposed. This simplification ensures an accuracy in the union of the two means.

—Henri Matisse, French painter, in Jack D. Flam, *Matisse on Art*

## Drawing with Scissors

*M*ost people think of a pair of scissors only as a separating or clipping instrument; they do not perceive it as a tool for drawing lines. From the fifteenth until the twentieth century, most European-based drawing has been joined in the popular mind to a style of representation associated with the pen, pencil, chalk, charcoal, and brush, not with the scissors. As mentioned in the last chapter, although the process of rendering an illusion of dimensionality is often thought of as being produced by *only* shading or changes in the dark-light values of shapes, spatial effects can also be accomplished with color.

When you cut into the paper, your line defines a *contour,* a boundary that stands for the physical edge of a shape, making it distinct from things around it and defining intervals between it and

Two adult-student projects
with cut paper

other shapes. It is possible to make many different qualities of line, such as jagged, smooth, curved, or straight, by various methods of cutting paper. Matisse cut contour lines in paper that suggested the volume of three-dimensional forms as well as two-dimensional shapes; for him, the "scissors can acquire more feeling for line than pencil or charcoal" (quoted in John Elderfield, *The Cutouts of Matisse,* p. 7).

The crucial distinction between cutting as clipping versus "free-cutting" as drawing lies in the specific method of handling the paper and scissors. The first method involves resting the wrists on a table while cutting horizontally, so that one hand simply feeds material to the tool within a flat plane and there is relatively little total arm motion or maneuvering of the blades to make intricate turns. By contrast, in "free-cutting," the material is held up in front of you away from any impeding surfaces so that the hands, wrists, and whole arms can move in flexible three-dimensional motions involving rotation of both the blades and paper. Because you can twist and turn the tool and material, you can generate different kinds of lines and shapes than you could if using the scissors while resting your hands or even your elbows on a table. If you were to free-cut thick paper you might see that the slant of cut-paper edge, known as the *bevel,* would vary in its angle of direction. (You will not be able to see this, however, when working with relatively lightweight colored construction paper.)

## Demonstration for Preschoolers, Grade-School Students, and Students with Learning Disabilities

1. When demonstrating this project, first ask the children: "Would it sound silly to you if I talked to you about drawing with your scissors?" The preschoolers look quizzical and nod yes. "Well, what do you usually draw with?" "Crayons, pencils, colored markers," is the reply. You may add, "Did you ever draw with a stick in the sand or use the pointy end of a feather? When you are drawing, what are you doing?" They are not sure. "You're making a line on the paper. When I make a cut in the paper with scissors I'm making lines in a different way."

2. To demonstrate "free-cutting" with the small scissors, hold the construction paper up in front of you in the air and, using a full range of wrist and arm motions in both hands, feed the paper into the blades while turning it to make an amorphous shape. While doing this, comment, "I can make round, wavy, and pointy shapes by cutting lines this way."

Inevitably preschoolers ask, "What are you making?" And your reply might be, "I do not know. I'm going to give myself a surprise." As you turn the shape around for them to see it from many angles, their reactions will vary. This is a good opportunity to point out that everyone sees things differently.

3. Hold up an example of a torn-paper shape from the last project next to the newly cut ones for them to compare and ask, "Are the edges the same or are those on the torn piece different?" Of course, they can see the difference but they might not pay attention to those qualities unless you point them out.

4. Next, peer through a "see-through" paper from which a smaller shape has been cut out and place it against another, larger piece of background paper in the second color.

5. In order to shorten the demonstration for young people, have a few precut shapes of different colors to move around, over, and under each other to demonstrate how overlapping shapes change the ones

JACOB ARMSTEAD LAWRENCE (American, b. 1917). *Pool Parlor.* No date. Gouache on paper, 31 x 22³/₄".
The Metropolitan Museum of Art, New York, Arthur H. Hearn Fund, 1942 (42.167)

I once heard the American painter Jacob Lawrence, then in his seventies, say that he never got
over the mystery and magic of how the two-dimensional surface of a painting could be made to
appear three-dimensional.

underneath. If the youngsters are more experienced, you might want to explain the word *overlap* as the covering-up of a part of a shape with another shape so that some of the underneath piece shows.

## Demonstration, Part 2, for Adults and Experienced School-Age Students

1. Discuss the reproductions on the wall with older beginners and review the gluing process to offer a few tips for greater efficiency:

■ For the greatest maneuverability, do not rest your elbows on the table when you cut while holding the paper up in the air in front of you. This cutting position allows you to observe the progress of the shape more easily than if you keep it at a horizontal angle as you cut.

■ Don't fold your paper in half to cut symmetrical shapes. These will look static and be less expressive than if you cut continuously drawn contours. A fold in the center divides a shape exactly in half visually and creates an internal line that can distract from perceiving the edges and boundaries of the shape.

■ Remember that you can change the outer edge of a shape by overlapping paper layers until the contour or outline pleases you. (When I first saw an original Matisse cutout, I was surprised to discover how he sometimes glued small pieces of paper of the same color over the edges of original shapes in order to control the spaces and edges in his compositions, thus achieving a sculptural look in his cutouts.)

2. Choose your larger background color and use two other colors from the smaller 9-by-12-inch papers for the foreground and middle-ground layers of shapes.

3. From the smaller papers draw with your scissors by cutting out many kinds of shapes: jagged, smooth, pointed, round,

WILLIAM MICHAEL HARNETT (American, 1848–1892). *The Artist's Letter Rack.* 1879. Oil on canvas, 30 x 25". The Metropolitan Museum of Art, New York, Morris K. Jessum Fund, 1966 (66.13)

As with color, no one line or shape has any absolute meaning. All qualities are relative according to the way they are used and mean different things to different people according to their context. For example, vertical shapes can bring to mind feelings of uplifting aspiration or oppressive obstacles to be overcome while horizontal ones can inspire a kind of calm repose or signal feelings of depression for some people. What happens if shapes are placed at oblique diagonals and acute angles or in opposing directions? When do they suggest tensions or excitement or the opposite quality, locked-in immobility?

ones with holes (or inside shapes). Also look carefully at your leftover shapes to see how you can use these as well as the ones you cut out initially.

4. As you cut your shapes, put the pieces down randomly on the largest background paper so that they may suggest possible arrangements and future shapes. Overlap them and move them to the background edges, pushing them back and forth while observing the new spaces created between the ones you previously laid down. Notice what happens when you place shapes on a diagonal path. Keep cutting and moving your pieces until you find an arrangement you like.

5. Lift the outer edges of each piece and insert a dab of glue on the background under the shape, then press it down. (Remember that if you apply glue to the edges of the cut shape and press it down you will not be able to move the shape if you change your mind about its position. Once you finish the design to your satisfaction, you can insert more glue under any loose edges.)

IVAN CHERMAYEFF (American, b. 1932). Study for *Jacob's Pillow.* c. 1985. Torn and cut paper, 16 x 12". Courtesy of the artist

You might also try combining both torn and cut paper for a wider range of contrasting shapes and edges. Ask yourself how you can create the most striking or subtle kinds of contrasts here by thinking of size, quality of the lines, shapes, edges, colors, textures, and different spaces within the arrangement.

## FURTHER POSSIBILITIES

1. Feel free to add colors after the first experiment.

2. If you have time to make another composition, you might try using a similar basic arrangement and move the cut pieces just slightly together, further apart, up, and down to see how the *intervals,* or spaces between shapes, change the feeling or mood of the work. This is often a subtle change and you might look at it for a while. What happens if you put the whole arrangement on a larger or different-color background paper?

3. As with your torn-paper project, you can use this cut version as a starting point for a painting or add oil pastels to it as another element.

## THINKING ABOUT WHAT YOU HAVE DONE

The sharp edge of the cut shapes and also the increase of the number of colors have allowed you to create very different images

from those of your torn-paper project. You might have noticed when you finished your torn-paper piece that you sensed a feeling of unlimited space, even though you might not have been able to tell which colors were originally placed on the background paper. However, when you cut your shapes this time and overlapped them, the interactions of more colors, shapes, and overlapping combined to produce more defined spatial levels of projection and recession. No longer are the foreground and background reversible and you now have one or more middle grounds or levels of optical depth.

With practice, most people without physical disabilities can learn to use the scissors to draw shapes. Another challenge comes in arranging compositions. One way of arranging the group of pieces within the frame of the background page is by looking carefully at the individual spaces between the cut pieces.

## Tips for Teaching

### DEMONSTRATING HOW TO CUT WITH SCISSORS FOR PRESCHOOLERS AND STUDENTS WITH DISABILITIES

You may not be able to give scissors to some beginners with mental disabilities. Mild retardation is not an insurmountable barrier, however, even though you will have to be very patient when teaching.

You have to demonstrate because most beginners cannot tell exactly how to cut even by watching you do it. Seeing older children cutting with scissors, two-and-a-half-year-old Diane took a pair, put her fingers into the handle holes, pressed the tips against the paper, then sat waiting for the blades to move. She thought that the scissors did it by themselves like a battery-operated toy. In another instance a

While cutting with scissors becomes an automatic reflex action for many of us, it is actually a complex skill because it involves coordinating three separate motions: opening and closing the blades, moving the paper at the same time, and moving the fingers that are holding the paper so you do not cut them. In addition, you have to keep the blades perpendicular to the paper. Of course, you cannot explain all of this to two-and-a-half-year-olds because this process is primarily kinesthetic knowledge, like riding a bicycle. The most helpful thing for you to do with beginners is to acknowledge that cutting with scissors is hard until you know how to do it.

young newcomer to class, who seemed not to have observed my cutting demonstration or her fellow classmates working on their collages, heard me remark about the way the other students were "drawing with their scissors." Apparently the only word that stuck in her mind was "drawing." She grasped the closed points of the scissors like a pencil and tried to make marks with the tips. Don't expect everyone to

Preschoolers' collages

When beginners discover new ways of using the paper on their own, I call attention to their discoveries. For example, many children may cut fringes into their papers because they cannot cut out a large piece to make a shape.

comprehend what you are saying or demonstrating in one session. You may have to repeat the instructions many times while physically showing the process: "Put the thumb in the top hole of the scissors and the second finger (and maybe also the third if the hands are small and the hole is large) into the bottom one. Hold the paper to be cut in the other hand and push the paper into the blades as you move them up and down."

If beginners are having problems with scissors after you demonstrate cutting, position their hands. Holding your hands over theirs helps them get the feeling of opening and closing the scissors. As you cut, say, "Open and close, open and close." Also help them move the paper with their other hand toward the blades until they get the feel of it. If they become irritated when you put your hands over theirs,

explain that you don't want to cut for them but want to help them learn how to do it themselves. Once they get the feel of the physical action of cutting, it becomes an automatic reflex and they don't have to think about it each time. If any beginner becomes tense about this approach, demonstrate with your own scissors in front of them. Be sure to demonstrate with the scissors in the same hand (left or right) that the student will be using.

Start with strips of paper approximately ten inches long by one inch wide, narrow enough to be cut in half with only one snip so that the students can concentrate solely on opening and closing the blades without maneuvering the paper. Then they might start cutting off corners and finally graduate to making larger shapes.

Help them position the blades perpendicular to the paper without holding their hands, so that they move the blades by themselves. ("It is hard to make the scissors move around if they're lying on their side.") Continue to demonstrate cutting with your own small scissors if they need further help, but do not continue if they become angrily frustrated. Gently try again at another time.

I rarely see any two-and-a-half- or three-year-olds upset by their problems with cutting unless adults are impatient and start making comparisons of their progress with someone else's. I have found that most children love to use the scissors once they have learned how.

Your desire for a beginner to start making things can cause you to be so impatient that you may not allow enough time for them to learn without producing finished products. Sometimes young children or people who are challenged with various disabilities will not learn how to cut for months. An old proverb states that one learns to ice skate in the summer after having started in the winter.

## PRESCHOOLERS' PAINTING PROJECT INCORPORATING AN ARCHED SHAPE

While the adults are making cut-paper drawings, I give the preschoolers a project that emphasizes a large see-through shape so that they begin to notice these spaces. Show the preschoolers an example of the paper they are going to be painting on, a sheet with a cut-out arch shape preglued onto a background of a different color. "Do you know what kind of a shape is on this paper?" Show them photographs of many different kinds of arches. "What kinds of things do you think an arch could be?" Answers vary from tunnel, door, picture frame, mirror, to the gate of a castle.

Painting with cutout archway glued to the background

Great Hall of The Metropolitan Museum of Art, New York

For inspiration when doing this project, it helps to show photographs of arches in architecture, in bridges, in natural rock formations, in ancient solar monuments, and in paintings featuring window see-through scenes.

Preschooler painting on an arch project

When young beginners go to paint on their papers with preglued cutout arches, some may totally ignore the archway concept. Others may change the inner color or the entire background and may put animals or people inside the arch.

They might want to vary the shape of the see-through frame using ones in their environments that can be perceived as see-through shapes or "inside and outside" places. They are usually filled with ideas and go off to paint at their work places.

## COLLAGE-MAKING FOR PRESCHOOLERS

The youngsters can experience a process close to true collage when they glue precut shapes in various materials to their background papers. After the children's introduction to gluing and cutting with construction paper alone (which may take two or three sessions), begin to introduce new materials, one at each session, for them to incorporate into collages. Refer back to The Home Work Space, pages 37–38, when organizing these supplies.

The first requirement is to choose a variety of papers that are easy to cut and handle. Stay with different kinds of medium-weight papers such as corrugated and shiny (not metallic) or very simple patterned papers (for example, giftwraps, shelf papers, corrugated liners from inside cookie boxes or light-bulb containers) until they have mastered the scissors and feel confident in tackling new challenges. Do not give tissue paper to any beginners before they have learned how to glue, because the floppy, thin material can be difficult for inexperienced students and people with disabilities to handle.

However, I usually introduce cellophane to the preschool children during the sixth session, after they know how to glue and the week before adults have a project with tissue paper, by adding pieces to the choosing tray. Real cellophane (as opposed to plastic wrapping) is easier for children to handle and cut than tissue is and its transparency is immediately recognizable and intriguing. Young children like the

material not only because it makes colors underneath change but also because many foods come in it. Real cellophane has a wide range of colors and sticks to the white glue effectively, whereas plastic wrap does not work as well.

To prepare cellophane, cut it up in squares. Show it to the children after they have learned how to glue and have already arranged some other kinds of paper shapes on their papers. As they find and use it, help them to examine some of the ways in which it differs from the other papers they have been using. It a good idea to keep a few pieces of the material aside for demonstrations. Then you can present it by holding up one colored square of cellophane in front of your eyes while saying, "How blue, or red, or yellow you look today. You have changed color." (Since you have put some pieces of the material in each person's tray, they also pick up a square and observe this phenomenon for themselves.) Holding the piece over one of your hands, exclaim, "Look how can clearly we can see the shape of my hand underneath! That means it is transparent."

## INTRODUCING NEW WORDS THROUGH THE COLLAGE PROCESS

Many occasions and places you go every day provide opportunities to talk about materials and how they look and feel. Try to use words consistently and precisely when you point to and describe things so that these terms will become part of the beginners' vocabulary. For example, if you tell them that corrugated paper is bumpy, they may not realize what that means until you point out this quality with the paper in their hands and encourage them to run their fingers over it. They will begin to recognize that quality again when they see it and when you connect it with other

materials as well. Bumpy can refer to a line, pattern, or texture. Later they will come to recognize different kinds of bumpiness, "rough bumpy" on tree bark or concrete sidewalks and "smooth bumpy" in corrugated-paper cookie wrappers.

## OLDER BEGINNERS

Beginners six years old and up who manage both gluing and cutting easily can develop the idea of changing shapes by both cutting and tearing them. If they start collecting materials on their own and choose difficult-to-glue textured or heavy items, refer to the texture-collage chapters for more information. You may point out how to make shapes by overlapping them and encourage them to try shapes in several different places before gluing. It may take time before everyone consciously shapes and arranges the pieces with care. Remember to hold back the glue for a while. Eventually, they will begin to see the scissors as a drawing tool to make lines that define shapes. Later, when they begin to cut shapes to assemble into story images, they may try to create recognizable objects.

LUCAS SAMARAS (American, b. 1936). *BOOK*. 1968. Five-process print: silkscreen, lithography, embossing, thermography, and die cutting, each leaf 10 x 10 x $^3/_{16}$". Courtesy of Pace Editions

Lucas Samaras's accordion-folded book has cutout, "see-through" shapes as well as ones that are glued and printed on the pages. Learning to draw with your scissors has numerous possibilities for personalizing cut-paper seasonal projects such as greeting cards, masks on Halloween, a study of flags for imaginary countries, and, later on, hats. Older beginners who need more challenges may work on making books. You might give them blank notebooks or make little accordion-style or fold-over-and-staple books they can fill with their own collage and color stories.

*Materials Checklist*
*Demonstration for Young*
*Beginners with Adults*
*Demonstration, Part 2, for*
*Adults and Experienced*
*School-Age Students*
*Project for Older Begin-*
*ners: Creating Spaces*
*and Moods by Overlap-*
*ping Tissue Shapes*
*Sharing Visual Experi-*
*ences in Relation to*
*This Project*

PAUL JENKINS (American, b. 1923). *Phenomena Stalk the Feldspar.* 1977–90. Acrylic on canvas,

MIKE AND DOUG STARN (American, b. 1961). *Domination by the Same.* 1992–95. Toned silver prints on polyester with Plexiglas, paint, ink, and silicone in illuminated vitrine, 17³/₈ x 35³/₈". Courtesy of PaceWildensteinMacGill

Left:
BETTY BLAYTON TAYLOR (American). *Concentrated Energies.* 1970. Oil paint and rice paper on canvas, diameter 59". Courtesy of of the artist

## Materials Checklist

■ Photographs and art reproductions illustrating translucency (see discussion that follows)

■ White drawing paper: A sturdy 80-pound stock for the background to emphasize the color-changing qualities of the tissue. It must also be heavy enough to support multiple glue-saturated tissue layers. For the first adult experiment, cut the 18-by-24 inch (or 20-by-30-inch standard-size) sheet for the background in half.

■ Tissue paper: Purchase an assortment of different colors but restrict beginners' initial arrangements to only three so they can more easily see how many variations are possible by overlapping layers. Cut the three different colors of the full size 18-by-24-inch or 20-by-30-inch tissue-paper sheets into half sizes for this first effort. Although you may wish to work with full sheets for larger tissue compositions after you have gained control of the process, remember that this paper is fragile and easily wrinkled, so try to keep it flat and in manageable-sized pieces.

Many varieties of tissue paper are made, although in some areas of the country you may need to purchase it through a mail-order catalogue of art supplies for a large selection (see page 34).

■ White glue and paper mat: For gluing tissue paper, blend a mixture of half white glue and half water in a jar you can later cap or seal; four ounces of the mixture may last for several sessions.

■ Glue brush: Use an inexpensive or old half-inch or smaller soft-bristle paintbrush.

■ Glue applicators: toothpicks, applicator sticks, or coffee stirrers (for adults only)

■ Small scissors for cutting shapes for the half-size pages

■ Sponge, dampened, for cleaning up any glue spills

■ Waxed paper, for storing and stacking unfinished or still-wet projects

The translucency and transparency, plus the delicacy of this tissue medium, reminiscent of the glow of colored sunlight, suggest a warm lyric quality. Seeing sunlight coming through overlapping leaves of geraniums against my windows often makes me think of these qualities in doing a tissue-paper collage project. If you ever had a set of filmy, translucent curtains, you might remember how the overlapping folds of the material muted the forms in the outdoor scene beyond the window. We see this same translucent quality in man-of-war jellyfish and some kinds of seaweeds, especially if viewed underwater. When something is transparent, you can see completely through it. The difference between the two qualities is one of degree of vision and light penetration through a material. When you overlap your tissue paper in this project, some of the shapes and lines underneath seem like shadows appearing through the layers.

These visual qualities are not peculiar only to translucent tissue or transparent cellophane but are also common to stained glass, watercolors, transparent glazes in oil and acrylic paints, and other works in mixed mediums. Opaque pigments can represent this luminous effect as well if they are manipulated skillfully to create an illusion of translucency. However, since this quality is easy to see and achieve quickly with tissue paper, we can learn about its visual effects without having previous experience with other mediums.

Although many people think of tissue paper primarily as a craft material, we will use it to explore qualities of translucency you may not have been aware of when using your opaque poster colors right out of the container. The tissue permits quick manipulation of translucent layers, ease of experimentation, and postponement of

finalizing arrangements until many possi-
bilities have been explored. That is not
possible with many other translucent
mediums, such as watercolor, which
instantly and permanently soaks into the
paper, or oil paint, which takes a long time
to dry. In this project you will become
aware of the luminous qualities in paint-
ings and other painted objects and the
kinds of techniques used to achieve these
lustrous effects. It also demonstrates
another way of mixing color and textures.

## Demonstration for Young Beginners with Adults

*A*lthough the vocabulary of this demon-
stration is geared toward preschoolers,
many adult beginners will need a similar
introduction to the qualities of translucen-
cy and transparency in language appropri-
ate to their levels of experience. In the first
part of this demonstration, we teach about
the quality of translucency without gluing
because everyone has already been gluing
for several sessions.

1. "Today we're going to think about
another way to make colors change with-
out any paint by using a special kind of
paper. Do you know how to mix colors
without paint?"

2. Your three prechosen light-colored (yel-
low, light blue or aqua, light red or magen-
ta) thin tissue papers are hidden from view
between two pieces of 9-by-12-inch white
paper. First take out the yellow piece in
one hand and hold it over the other hand
with fingers spread apart. "Do you know
what kind of paper this is?" Since most
have received gift packages with tissue,
they will probably know what it is.

   Take a piece of opaque paper and put
your hand underneath it to make the com-
parison between it and the tissue. "Can
you see the shape of my hand under the
tissue?" Mention that sometimes people

Preschool children's hanging collages with tissue, cellophane, and other
shiny materials

also put curtains on their windows that are
thin enough to let in light but show only
the big shapes of buildings outside, not all
of the parts.

3. Place the yellow tissue onto the white
drawing paper and then take out the blue
piece and position it so that the blue par-
tially overlaps the yellow. Some child
inevitably exclaims, "Oh, green!" If the
resulting color is not obvious, you may
interchange the order of the colored layers
on the white background (still leaving a
portion of the original colors uncovered on
the white).

Two adult students' tissue-paper projects

JUDY PFAFF (American, b. London, 1946). *Untitled.* 1979. Contact paper and Mylar on drafting paper, 42½ x 97". Courtesy of the artist and Holly Solomon Gallery, New York

Pfaff's collage uses overlapping, patterning, and transparency in the layering of shapes. There are no set rules for using individual visual elements for specific effects. As with painted color, each shape is governed by all the qualities of the shapes next to it—position, texture, translucency, and size. Watch how the size of your colored shapes also affects their illusion of depth. The color of the background paper will also influence this illusion.

4. Next place the pinkish-red over or under the piece of yellow so that everyone can see the color change to orange, then put the same red over the blue to make purple.

5. Talk about transparency in jellyfish, bubbles, gelatin desserts, and some kinds of beverages, using photographs as visual aids. "Did you ever eat any Jell-O? If you put fruits and nuts inside, can you see them?" "When you do your painting you might want to use some of your paint thinly so that you can see through it. You may even want to paint an undersea picture."

Then the preschoolers go to their painting table and, when they finish painting and begin making collages, they discover some tissue paper has been added to their choosing trays. Since you will have introduced cellophane as a color-changing element the previous session, when they examine the qualities of tissue, they will see that additional materials can make colors change. Later, when they are working with the tissue paper, help them to examine some of the ways in which it differs from the other papers they have been using. For example, point out that tissue makes a rustling sound when we touch it, that it is floppy and soft instead of stiff and hard (surfaced) like cellophane.

## Demonstration, Part 2, for Adults and Experienced School-Age Students

*O*nce the preschoolers have begun painting, talk with the older group about the

Lois Lord (American). *Evening, West Vancouver, B.C.* No date.
Gelatin silver print, 8 x 10". Courtesy of the artist

Evening landscape shapes become enveloped in layers of
translucent mist.

Lois Lord (American). *Spider Web, France.* No date. Gelatin
silver print, 10 x 8". Courtesy of the artist

Water in many forms can also demonstrate transparency.

reproductions and tissue projects by former adult students that are displayed on the wall. If they have not seen the previous demonstration, you can show methods of arrangement and gluing; also explain both transparency and translucency while using examples of students' work in this medium. To talk about both concepts to preschool children, however, would be confusing to them; even adults sometimes mix up the terms.

When you place a dry, light-colored tissue shape on the white background, the resulting effect is one of *translucency.* You can see some light from the white background. If you wet the tissue and it becomes easier to see more of the underneath color or shapes, it has become more *transparent.* However, if you overlap another tissue paper color on top of the first piece, the overlapped section not only becomes an intermediate color between the two hues, it also becomes more translucent than transparent by blocking the underlayers. Both the shapes and their edges become muted. If the light passes through the layers but you cannot see the shapes clearly, it is translucent. For example, frosted window glass is translucent while clear panes are transparent.

Both transparency and translucency make colors *luminous,* that is, having a quality of radiance that seems as if light were produced from within the color. The degree of transparency and translucency depends both on the thickness and density of the material and also on its color. Even dark blue cellophane or stained glass permits less transparency than light colors in the same material. I point out that, when you place light tissue over dark *opaque* colors, you gray them and they do not change the same way as when you use the tissue on light background colors. When you increase the number of layers of overlapping tissue, translucency further diminishes and textural qualities become dominant.

Amy Ernst (American). *Vistas.* 1991. Collage and ground pigment with rabbit-skin glue on canvas, acrylic, 19 x 23". Courtesy of the artist

Many artists through the centuries have used the ethereal splendor of light to evoke a sense of joy or spiritual feeling. This work is a good example of the use of overlapping and transparent planes for that effect.

## GLUING AND ARRANGING

Place an extra piece of white drawing paper next to your background piece as a repository for shapes you have decided not to use after gluing. Be sure to mention that some colored tissue will bleed, and the dye will color table surfaces as well as your fingers. A nearby damp sponge will remove any residue.

1. Choose three sheets (approximately 9 by 12 inches) of tissue paper of different colors and a 9-by-18-inch white background paper, tear some tissue shapes and lay them on the white background. Rearrange and overlap them in different orders to show possibilities for discovering how the colors will change.

Suggest tearing the first tissue pieces directly with the hands in order to focus on color changes without getting fussy about making detailed shapes. After completing a torn-paper arrangement with light colors on a white background paper, try using cut shapes (or a combination of cut and torn shapes) and also vary the color or texture of the background.

2. There are several ways of mixing colors for this project: Combining both techniques gives an even wider range of shades, tints, and contrasts in texture as well as color.

A. If you lift the edge of a shape from the dry background with no glue on either paper and slide a tiny bit of glue under the edges of the shape with an applicator stick, then the tissue will retain more of its original degree of translucency. Keeping the shapes flat on the background paper, lift their edges and, using the stick for glue application, lightly dot the underneath perimeters at intervals. You do not need to glue the entire border of each shape unless you want to. Notice that you have a mark where you place your glue. That is why it is good idea to follow the contour of your shape when using a small applicator. If you

are dissatisfied with any individual glue marks, you can brush on additional glue in order to blend the edges of this shape into your composition.

B. Using your glue brush, paint down a layer of glue onto the background; place your dry translucent tissue color onto the wet surface, and press it down. The color now becomes more translucent.

C. If you apply glue to the background, press your tissue onto it, and then paint glue over the tissue, the degree of transparency increases again. Painting a layer of undiluted glue straight from the container without water blended into it on the top surface of the whole arrangement can produce a glossy effect.

It is especially important when gluing tissue *not* to hold the paper shape in your hand while applying glue. No matter how careful your application, the thin paper becomes floppy when wet and you may get glue on your hands, where even the tiniest bit of glue will make it frustrating to handle the tissue because your fingers will stick to every piece. And of course, preschoolers may try to copy you when they glue their collages.

4. Because the textures may create surprising spatial illusions, recommend avoiding preplanned visual ideas. Freely tearing and working with the glue can produce a greater range of colors and textures than if one becomes overly precious about the process. Painting with the glue as well as using it as an adhesive offers the opportunity of working with a wider range of effects. If you have bleeding-color tissue, paint a layer of glue on an area of the white background, lay down the colored tissue, and then lift it up after a few moments to produce a pastel dye-transfer shape where the color bled into the paper. Next, take the glue-covered piece and set it down in another place on the white background. The previous dye mark leaves a trace of where it has been and suggests

the quality of movement. If the arrangement does not work out the way you envisioned it, just keep pasting layer over layer. You have a while before the glue dries, so you do not have to rush.

## *Project for Older Beginners: Creating Spaces and Moods by Overlapping Tissue Shapes*

*A*llow yourself at least an hour for your first session because the gluing process for tissue may require more time than for construction paper if you are unfamiliar with the medium. If you are working alone or with a child who is old enough to understand what you are doing, you might keep a small dish of water nearby to wash your glue brush in. It would be very confusing, however, for a preschooler to see you washing your brush while gluing. In fact, many enjoy the chance effects produced by the mixing of the glue with the bleeding papers, which has the feel of painting with tissue paper and glue.

1. Select three different colors of tissue for your first arrangement on the white background paper. Choose at least two fairly light ones out of the three because dark colors, such as deep blue or black, are opaque and tend to obscure light ones. Also, as you make your selections, try arranging warm and cool colors as well as different degrees of light and dark over light by passing the papers over and under each other. Notice the various atmospheric effects that can be achieved.

2. Tear out shapes from the tissue sheets and move them around on the background so they partially overlap one another the way you did with your previous torn- and cut-paper projects. Try two or three layers of the same color and then try layering different colors. See how many new colors and textural qualities you can create with the combinations of papers.

3. Fill your entire background sheet, letting the shapes and colors suggest a theme if you wish.

4. After you have torn a number of large and small shapes and have moved them into a basic arrangement, begin gluing before you finalize the details of any one composition.

5. If it is necessary to end the session with an unfinished and unglued arrangement, place a large piece of waxed paper or plastic wrap over your whole composition to hold the pieces in place. Next, slide a sheet of cardboard or other stiff paper under the background plane so that you can carry it (keeping it horizontal) to a shelf or drawer for storage without disturbing the loose pieces of tissue.

6. Save the rest of your tissue-paper pieces for later projects, putting them in a flat box or resealable plastic bags and the larger ones in manila folders. Even the very smallest fragments can be used on collages, greeting cards, bookmarks, or as accent colors on larger pieces.

### *THINKING ABOUT WHAT YOU HAVE DONE*

To really see what you have done, let the glue dry, and then tack the composition up on a vertical surface to examine it closely. It will not look quite the same dry as it did when it was wet.

### *Creating Luminosity with Translucent Color*

Mixing colors through this method makes clearer the distinction between "tints" of colors, made lighter by being mixed with white, and bright colors that are luminous by virtue of radiating light that is reflected from the white background so that it seems to have been produced from within.

Of course, the more layers of tissue (or paint) you apply, the more you block light coming from the background and therefore diminish the luminosity of the colors.

## Creating Space with Texture

You may also see another set of effects that contradict your color expectations because of the textures and their relative degree of transparency. Although you may have found that in your earlier painting projects, certain colors tended to recede behind the other ones, now you may see similar effects.

Here, rather small texture changes in the surface influence a color's apparent spatial position. Just as you may have noticed that thick, impasto brushstrokes appeared in front of thin, transparent washes *of the same color,* so will textured surfaces rise above smooth ones.

## Sharing Visual Experiences in Relation to This Project

Sharing awareness of natural phenomena can be a pleasurable two-way street. If you only try to hand down your own ideas, you may easily lose the opportunity to receive new insights from other people. A visit to a building with stained-glass windows will be far more memorable than merely trying to describe the qualities of transparent colored light. Early spring leaves, when small and thin, display their qualities of translucence prominently, and visits to a beach may yield examples of shards of translucent glass worn smooth by the action of water and sand. Students in my workshops at The Metropolitan Museum of Art have the opportunity to see both the Tiffany stained glass in the American Wing and also the huge translucent window screen in the Rockefeller Wing. The latter, designed to mute the gallery light, turns the cityscape into a play of shapes and shadows during certain times of the day.

Many years ago, I took a group of young children who were just beginning dance lessons to the Lumia exhibit of moving translucent-colored light shapes accompanied by sound on a large screen at The Museum of Modern Art. They saw the overlapping forms as a ballet of color and began moving in rhythm to the changing light patterns. Later we entered the sculpture garden and watched the pinkish-orange light of the setting sun dance on David Smith's burnished metal sculptures. These many-faceted experiences seemed to bring alive all our senses and powers of observation, making it an especially joyous and memorable occasion for all of us.

LOUIS COMFORT TIFFANY (American, 1848–1933). *Autumn Landscape.* 1923. Stained glass,
11' x 8' 6". Tiffany Studio, The Metropolitan Museum of Art, New York, Gift of Robert W.
de Forest, 1925 ( 25.173)

# 10. Painting Shapes

HENRI DE TOULOUSE-LAUTREC (French, 1864–1901). *Divan Japonais.* 1892. Lithograph, 31⅞ x 24½". The Metropolitan Museum of Art, New York. Harris Brisbane Dick Fund, 1932 (32.88.10)

This image is made up of a combination of individual shapes. If used by themselves, these shapes might be unrecognizable and therefore they might be called *abstract* by some people. Many think that the word *abstract* means something without physical reality, yet abstract shapes most certainly can be touched; they are physically real. Their selection and arrangement in an image can express qualities of an object, situation, feeling, or idea.

## Materials Checklist

■ Art reproductions similar to those shown in this chapter and photographs of shapes in nature and in man-made environments
■ Painting-tray setup

When children occasionally ask me, "Why are you always talking about shapes? Nobody at home talks about them!" I reply, "Because everything is made up of shapes. Your head and hands and the table are all shapes." Then they want to know, "How can you say all those things are one word?" and I explain that *shape* is a word that tells you how to recognize many things. You know an orange is round. If you have a pointy orange shape, it might be a carrot. Shapes are one way of showing how things are different from each other. A house or tree is not one kind of shape but many of them all connected together in different ways.

At a slide talk about his work, painter Jacob Lawrence was asked if he ever made abstract works because the spatial arrangements and shapes in his narrative paintings seemed so close to abstraction. He replied that he made abstract paintings all the time. However, since his main concern was the human condition, he included people in all of his pictures. He first produced more detailed scenes as a note-taking device and then he eliminated from those all but the essence of the story he wanted to convey. (See page 142 for an example of Lawrence's work.)

When we make images in any medium, we first choose what qualities we find most important and then we express an equivalent for these in the art materials we use. Everyone, adults as well as children, sees much more than they are capable of representing. Because we have seen pictures all our lives, we have learned that there are many different ways to represent

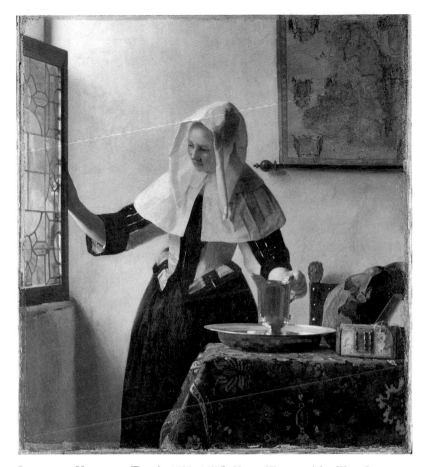

JOHANNES VERMEER (Dutch, 1632–1675). *Young Woman with a Water Jug.* Mid-17th century. Oil on canvas, 18 x 16". The Metropolitan Museum of Art, New York, Gift of Henry G. Marquand, 1889 (89.15.21)

I have found that many adults seem to need to identify each object in a representational way, yet by doing this project I hope you will come to see that scenes and objects can be perceived in terms of pure shapes as well. You can see Jan Vermeer's *Young Woman with a Water Jug* as a harmony of rectangles (walls, window, map, chair back, box, table, and so forth) with variations in the angles and overlapping shapes.

images, even if we have not painted before. When children make marks and arrangements that superficially resemble abstract art, remember that they have a very limited basis for making their aesthetic decisions and that they know only one way to use paint—their way. Although many of their marks are deliberate, a great many others are delightful, unrepeatable accidents.

PHILEMONA WILLIAMSON (American). *Abducting Innocence.* 1988. Oil on linen, 60 x 52". Collection of Sherry B. Bronfman, courtesy of the June Kelly Gallery, New York

Shapes that appear to be derived from no single representational object or place are termed *nonobjective* or *nonreferential,* yet they may call to mind very concrete sensations of joy, sadness, or energy. Some familiar objects may seem unrecognizable when viewed from different perspectives. You know that when you look at a building from a distance, the size and features are very different from when you are next to it and the roof towers above you. Artists deliberately arrange shapes and colors to structure an image in a way that focuses most clearly on the aspects of painting they choose to emphasize. Artist Philemona Williamson told me that once when she was showing slides of her painting

*Abducting Innocence,* which was inspired by Lewis Carroll's *Alice's Adventures in Wonderland,* to a group of grade-school students, one little boy protested, "Alice wasn't black. She was white!" Ms. Williamson, who is African American, replied, "I'm painting about the people and things I see and think about in the world. As an artist, I can choose any colors that please me. If you were painting the picture you could make Alice pink or purple if you wanted to." One girl piped up, "She could have polka dots!" Another volunteered, "She could even have stripes!" Others contributed further imaginative suggestions.

## Composing a Space with Shapes

When you look at a painting, you might recognize that elements of color, line, and arrangement express certain ideas and feelings, but often you do not know how the painter actually made that happen or the order of procedure for putting the parts together. Sometimes, when older beginners draw and paint, they start where they left off in childhood. They place shapes around the page representing familiar objects, such as a sun, tree, winding road, house with chimney spewing smoke, and horizon line, and then color each area as if filling in a paint-by-numbers picture or a coloring book. My friend and teacher Jane Bland called it "laundry list painting."

Because you are working spontaneously, without preparatory sketches or drawings, if you merely progress from one small area to another across your paper, filling in shapes and spaces instead of layering in depth, you may have a more difficult time making your painting hold together as a composition. Spontaneity may diminish because you may feel the

need for a totally preconceived painting in order to begin. If you do not have any specific idea of what you want to do, how and where do you start? At the top, the bottom, the middle?

A star athlete, who was seeking additional college credits to graduate, once told me of his unhappy experience in an introductory painting class where the instructor simply told them to go ahead and paint without any demonstration of process. Not knowing how to begin, he simply became frustrated until he finally exploded in anger at the instructor, "I wouldn't send you out on the playing field without any guidelines or warm-up exercises. How do you expect me to start?" He left when the shocked teacher failed to respond with a game plan. You must have a process for starting a work even if you have no idea what the work will eventually become.

That is why I suggest you use this layering method of first making a general background, and then adding shapes to build up your picture. If you first paint two or three washes of color to cover and divide your entire paper, these areas will already begin to suggest a pictorial situation. Horizontal divisions, for example, almost automatically suggest a landscape or seascape. (See Claude Monet's *Terrace at Sainte-Adresse,* page 86.)

When you use your large paintbrush to make shapes by spreading puddles of paint, you will not be tempted merely to draw outlines and fill them in. When you generate a shape from its inside, your edges will be a result of your internal organization of strokes. (Look, for example, at Vincent van Gogh's *Cypresses* on page 52.) Other examples are Impressionist landscapes where the dab, the stroke, or splash of pigment *is* the blade of grass or glint of sunlight reflected atop water instead of being the interior of an outline. Remember when you were cutting and tearing, your cut and torn edges did not stand out

MARC CHAGALL (French, 1887–1985). *I and the Village.* 1911. Oil on canvas, 75⅝ x 59⅝". The Museum of Modern Art, New York, Mrs. Simon Guggenheim Fund

---

Experienced painters often work in a series of layers, painting one shape over the next instead of stopping at the boundaries of each and moving their brush a few inches left or right to start a new shape. It is somewhat like designing a stage set: putting in an atmospheric backdrop, adding the props, and finally moving the actors across the stage from back to front and side to side.

ELIZABETH MURRAY (American, b. 1940). *Terrifying Terrain.* 1990. Oil on shaped canvas, 87 x 90 x 10". The Metropolitan Museum of Art, New York, The Joseph Hazen Foundation Purchase Fund, in honor of Cynthia Hazen Polsky, 1991 (1991.77)

Many artists outline shapes with contrasting colors for specific effects—for example, to emphasize their edges. You might try making shapes with both this and the layering method to see the results for yourself.

as separate from their shapes. Henri Matisse felt that this quality of visual unity was very important to his work.

> *Color must not simply "clothe" the form; it must constitute it. . . . When I use paint, I have the feeling of quantity, a surface of color which is necessary to me, and I modify its contour in order to determine my feeling clearly in a definitive way.*

—Henri Matisse, French painter, from an interview with Maria Luz, 1951, in Jack D. Flam, *Matisse On Art*

Do not spend a lot of time trying to get any individual shape "right," but instead brush in areas of color freely and directly in this project. Painters and illustrators may work over a shape dozens of times, even using tracing paper to transfer the final result onto a fresh sheet of paper. When you see the end product in museums and books, you have no idea how many sketches and preliminary drawings preceded it. Setting yourself up in competition with finished drawings or paintings by professionals during your one-hour session is to put yourself in a no-win situation. By contrast, these projects seek to give you freedom to experiment with materials.

> *I think of my pictures as dramas; the shapes in the pictures are the performers. They have been created from the need for a group of actors who are able to move dramatically without embarrassment and execute gestures without shame. Neither the action nor the actors can be anticipated or described in advance. They begin as an unknown adventure in an unknown space. It is at the moment of completion that in a flash of recognition, they are seen to have the quantity and function which was intended. Ideas and plans that existed in the mind at the start were simply the doorway through which one left the world in which they occur.*

—Mark Rothko, American painter, *Possibilities,* no. 1 (Winter 1947–48), in Barbara Rose, ed., *Readings in American Art: 1900–1975*

## Demonstration for Young Beginners with Adults

1. "Today we're going to think about different kinds of shapes and how to paint them." Sometimes I may show a small reproduction of a painting by the Spanish

artist Joan Miró filled with a variety of rounded shapes and also display photographs of cactus plants that resemble Miró's figures: "This artist loved to make shapes." When I show drawings by Miró that were inspired by the cactus, some of the children make the connection between the natural and painted shapes and others do not. The point to be made is that people can get ideas from visual sources without copying them. Then we continue to look at photographs of plants and animals with rounded shapes such as pandas, little fish coming out of eggs, and sumo wrestlers.

2. "Now I'm going to make some shapes. What color should I start with?" Dip the brush into a paint container, dab it on your paper, and pick up the brush, "Now I have made a shape. Is it big or little?" Of course you make a little shape. "I think I'll make it grow." Take your brush and spread the paint into a larger shape without picking up the bristles again. Finally make some round and pointy shapes, using the same method of enlarging the painted areas, leaving some spaces between the shapes.

3. Reload the brush and outline some shapes (see-through shapes), or make lines that have shapes inside them to demonstrate another way of making a shape. "What color should I make this inside shape?" Since this is an opportunity to review brush-washing and drying, pretend to begin to put your brush into the color they name without first washing it. Since they love to correct their elders they will stop you and point out that you have not done it, even if they forget to wash their own brushes occasionally. (If working with mentally disadvantaged people, it would be very important to be patient, holding the brush long enough so that they stop you, and not to make a test out of this but to lead them to the right procedures.) If they don't say anything, exclaim, "Oh, I forgot to wash the brush!"

4. Continue to make inside shapes in different colors, sometimes blending the outside lines (or outlines) to demonstrate color changing. Suggest trying to make shapes with letters of their names, numbers, fishes, or the shapes of any of the subjects you looked at in the photographs.

5. Then the preschoolers go to their own work places while you talk with the adults about the reproductions on the wall and the procedures for their own project.

## Demonstration, Part 2, for Adults and Experienced School-Age Students: Making a Painting about Shapes

1. After general discussion, you might consider several ways to start:

■ Think of shapes that are familiar to you, such as round or pointy ones rather than specific objects, and imagine painting them in many large and small variations. If you use the letters of your name, you might turn them on their sides and let them overlap each other.

■ Another source of themes might be a piece of music, a book, or movie titles.

■ Instead of choosing a theme now, just work intuitively by letting your first colors and shapes suggest ideas.

■ Look for and find a spatial arrangement in a photograph or reproduction of a painting as a starting point and rearrange it.

2. Use your large brush to create a background with washes or an opaque layer of paint, making sure you cover the entire page. Try to make several large areas in different colors, blending and overlapping them.

3. Paint shapes onto the background, varying the textures and the kinds of brushstrokes on different shapes, and fill your page.

Two adult-student shape paintings

One possibility is to make two or three groups of shapes communicate across the page by using different gestures or varying the directions of the brush-strokes according to their arrangements. One of these groups could be the most important visually by virtue of its size or color.

4. Let some of the shapes dry until the paint no longer looks shiny, then overlap new shapes in layers without blending the colors. Translucent or transparent washes of shapes on top of opaque ones will show the layers underneath. You may find that you get spatial effects you had not anticipated. You can also make shapes that have already dried lighter by brushing them with enough water to lighten them. This thins the paint to allow paper to show through the pigment.

5. As you examine the spaces in between your shapes, you might also consider painting these with another color.

6. Let your painting dry on a horizontal surface.

## FURTHER POSSIBILITIES

Do a second shape painting at another session using one of your previous torn- or cut-paper works as a starting point. Then you can compare the same composition in two different mediums. Always feel free to deviate from the original composition and investigate new directions.

## THINKING ABOUT WHAT YOU HAVE DONE

In this project you have been putting together the vocabulary of art with ideas from all your previous projects. You have used colors to evoke a theme or mood and the drawing qualities of edges to make shapes, spaces, and lines.

EMILIO CRUZ (American, b. 1937). *Homo sapien Ser.* 1991. Oil paint, charcoal, and beeswax on wood, 8 x 4'. Courtesy of the artist

An infinite variety of shapes exists, and there is no single way to model, paint, or color anything. Your perception of visual qualities depends on your viewpoint in space, culture, and time.

CHARLES HENRY DEMUTH (American, 1883–1935). *I Saw the Figure 5 in Gold.* 1928. Oil paint on composition board, 36 x 29¾". The Metropolitan Museum of Art, New York, The Alfred Stieglitz Collection, 1949 (49.59.1)

Since some of my painting reproductions and examples of work by adult beginners have numbers in them, I ask, "Do you see any paintings that have numbers? They are shapes too." If there is no response, I point out the number shapes in this painting.

At this point you might compare the different kinds of edges you have worked with. Some of the shapes had blended edges so that they might have merged into the background or into other shapes. Other shapes that you outlined with contrasting colors stood out sharply from each other and from the background. When you painted edges you could get all of

these effects working together: ragged, smooth, and combined effects.

Although many paintings use combinations of several types of edges to define shapes, individual painters may emphasize one kind of edge or another in their own personal style. When the effect of edges and the impact of individual shapes is subordinated to a general flow of colored brushwork, the style of painting is called *painterly.* (See, for example, the illustration of a work by Grace Hartigan on page 63.) Another style of painting, where the edges of shapes emphasize lines that lead the eye from shape to shape, is called *linear.* (The work of Charles Demuth exemplifies the linear style.) Neither style is superior. Each can be used as a means of expressing different ideas and feelings. During some periods of art history, one style of working often dominated. Now, neither style predominates.

You explored the painterly approach in your earliest projects where you created mood in a field of color without shapes. If you defined areas of color, they were blended or dissolved in translucent washes or merged with other soft, atmospheric shapes. You may have found this method useful for representing atmospheric images such as clouds, water, smoke, fire, and rain.

## Tips for Teaching
### PRESCHOOLERS' PAINTINGS

Sometimes adults ask children as they come into the art room, "What are you going to paint today?" or, "Don't forget, you said you were going to paint a cow." They often have the idea that, like putting on a smock, you need a subject to work on to be able to start. However, young children and many experienced adult artists rarely preplan their paintings. As they begin to paint, they often make shapes

that take on meaning for them. When children want to paint what they are thinking about, they usually do not announce it in advance but just do it.

When Naomi, almost three, came in, sat down, and immediately drew a large red shape with blue ones on either side, and then more blue ones, she did it with great purpose. Her mother was amazed as she saw the painting develop. Apparently Naomi had told her before class, "Today I'm going to paint a house with blue trees around it," and did it. As far as I could tell it was her only preplanned painting that semester, or at least this was the only one she talked about.

Older children may preplan, although I do not encourage the practice. The mother of four-and-a-half-year-old Shawn told me that every night before class he planned out what he was going to paint the next morning. During each previous workshop he had made a very similarly designed painting, and I was concerned that he had locked himself into painting the same image because he might be afraid of failing if he tried anything new. So I told him, "It's wonderful for people to think about what they want to paint ahead of time, but when you work you may get other interesting ideas that you like better." Although he had started the painting in the same way as he had done before, now he developed the composition more fully and preached to his mother, "When you're doing your paintings you might want to change things and that is all right!"

Children who paint after they have had a vivid impression may diagram it in a very simple way, explaining it as they go along. Some may do a whole sequence of paintings on one subject. A child who witnessed a tornado made a series of big, dark swirling brushstrokes overpowering a small building or other objects on a flat landscape or object shape for weeks afterward.

Steven, also age three, loved tigers and also painted them for weeks—tigers in the woods, in caves, in houses, even floating in the clouds. He may have had a favorite book at home on tigers or may have seen them at the zoo. Steven's images didn't really look at all like the tigers he gleefully described. Sometimes they were behind things so you could not see them at all. But he always knew they were there.

David's cat

Visual judgment varies with the times and personal interpretation. When one five-year-old in my class said he was painting a cat, a second child looked over and said, "That doesn't look like a cat." At this point a third boy got off his stool, came over, studied the painting carefully, and announced with great authority and assurance, "Yes, it *is* a cat!" Personally, I thought it looked like a praying mantis, although I said nothing. A few weeks later I saw a cat stretching against a counter and realized that David knew more about cats than I did.

Painting by a four-year-old who is learning letters

Because they want to encourage verbal skills, some adults have the idea that painting is more of a learning experience if children can tell a story about their work. My four-year-old nephew used to come home from nursery school day after day with very similar paintings but a different story recorded for him at the bottom of the page. He became very skilled at telling stories but learned very little about painting. When I talk with children about their paintings, we discuss the visual qualities of what they have done on their paper. Then what they have actually painted becomes more important than making up fantasy stories. If you allow beginners of any age to make shapes that do not necessarily have to represent something or tell a story, they may feel freer to paint spontaneously without fear of criticism.

Most students will only become interested in representing specific things when these become important to them.

Children's early paintings of people often will not have any arms or may have only a head and a lot of hair, especially if they or their mother have a lot of beautiful hair. The details chosen may be personally significant to them but not to you because they are painting what is important to them at the moment.

As the beginners gain in experience, continue to point out what you see happening in their paintings, especially the way they make their brush "walk, dance or slide around the paper." When you talk about shapes, occasionally you might refer to reproductions of paintings containing a variety of shapes and lines—nonrepresentational images as well as representations of bridges, buildings, roads, and tree trunks—before they start working.

For additional motivation, you could show the insides of old clocks, unusual stones and leaves, the branches of pussy willows in the spring, or a collection of items having different shapes while talking about their visual qualities and the places where one would see them. I have a collection of hats that I have displayed on top of bottles: a pith helmet, beret, sun hat, and a golf or baseball cap. During one session the group had a great time painting what you might be doing when wearing some kind of hat. Because the paintings did not have to stick to the kind of hats displayed in class, a wide variety of subjects developed: African hunters, ice skaters, Hawaiian hula dancers with crowns of flowers, as well as a circus clown. Some made color paintings about a place, others invented fantastic hats of their own.

Naturally, some teachers will have other ideas about learning how to paint and your child may encounter a different approach in another school. For example, Sarah, age four, enjoyed mixing colors and experimenting with her brush and paint. One day she came to class excited with holiday spirit. She began to paint a large

Sarah's Santa

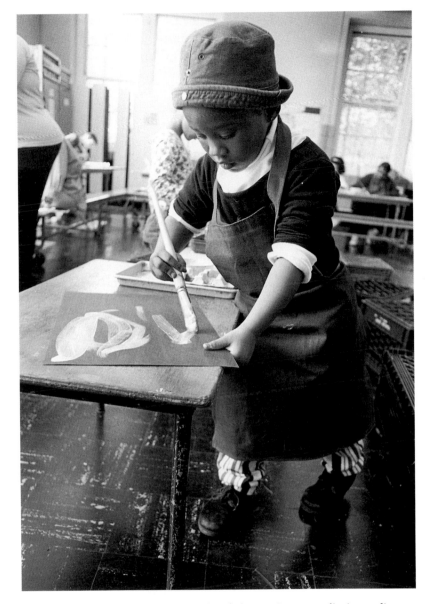

figure, something she had not done before. She created a great big Santa Claus and a pink sun. The following week she made a collage-painting, exuberantly mixing many colors.

After the holidays, Sarah did not return until the last two sessions of the semester. As she worked on her new paintings, she was strained, painstaking, and very quiet. She drew the outline of a house in black and a door in yellow, and then stopped. In an attempt to get her to develop her painting further, I commented, "You made a house. Is it in any special place?" She said it was a ski house and dabbed in some white snow around the house. When I asked if she were going to use any other colors she looked up and said, "The teacher in my other school says you must never mix up your colors if you want to do a good painting, and you must be very neat."

Although I suggest possible generalized themes in my preliminary discussion and demonstration, I would urge you not to assign specific subjects or topics for young beginners. The paint and brush are motivation enough. Children may announce what they are painting while they are working and then change the subject several times during the process. They become involved watching colors flow into shapes and lines, and, when these look like something special, they name it. But it may change with the next brushstroke, and at the end they may forget entirely what they said before.

I explained, "There are many different ways of painting and some teachers believe different things. Here, you may mix the colors the way you want to." My attempts to encourage her to paint in her own way again were futile. She had started in a five-day-a-week nursery school and came to my art class one afternoon a week. I asked if she had art often in her new school. She answered, "Every day, but you don't have to go if you don't want to." I asked, "Do you go?" She shook her head sadly, "Not anymore." As with the detrimental coloring-book incidents in my own children's young lives, I told Sarah to follow the teacher's instructions in school but that here or at home she could draw and paint in her own way.

## WHAT ABOUT COPYING TO STUDY SHAPES?

These workshops seek to encourage personal creativity and to build general visual awareness. By contrast, professional art-school exercises for more experienced students may use copying for studying particular issues of style and representation. Copying is frustrating for beginners who are not capable of this level of specialization. Older beginners are especially afraid of being "wrong" and may be seduced into copying. This can become a psychological crutch for them and impedes developing their own imaginative abilities. When praise for this activity stops, copiers may be unable to face the challenges of personal invention.

Never talk about works of art as "masterpieces"; rather, they are examples of visual ideas to transform within the students' own work, not patterns to be slavishly copied. When using paintings for ideas, let these provide motivation for individual expression.

*After having withered for days and nights before immobile and inanimate nature, we are presented with living nature, and suddenly all the preceding years seem wasted: We were no more at a loss the first time we held a pencil. The eye must be taught to look at nature; and how many have never seen and will never see it! It is the agony of our lives. We have been kept thus for five or six years before the model when we are delivered over to our genius, if we have any. Talent does not declare itself in an instant.*

—Jean-Baptiste Siméon Chardin, French painter, from a speech to the exhibition jury of the French Academy, 1765

*Don't be mistaken. I didn't copy the tree. The tree has a mass of effects upon me. It is not a question of drawing a tree which I am looking at. I have before me an object which exerts an action upon my spirit, not only as a tree, but also in rapport with many other sentiments. I don't rid myself of my emotions by copying the tree exactly or by drawing the leaves one by one in the current popular style, I identify with the tree. I must find my own symbol for the tree, not the symbol for a tree as seen by another artist, but one which grows out of my own spirit.*

—Henri Matisse, French painter, in *Henri Matisse, Écrits et Propos sur l'Art*

MARSDEN HARTLEY (American, 1877–1943). *Portrait of a German Officer.* Oil on canvas, 68¼ x 41⅜". The Metropolitan Museum of Art, The Alfred Stieglitz Collection, 1949 (49.70.42)

# 11. Patterned–Paper Collage

*The Hunt of the Unicorn: The Unicorn Dips His Horn into the Stream to Rid It of Poison.* Franco-Flemish, c. 1500. Silk, wool, silver, and silver-gilt threads, 12' 1" x 12' 5". The Metropolitan Museum of Art, New York, Gift of John D. Rockefeller, Jr., The Cloisters Collection (37.80.2)

## Materials Checklist

■ Art reproductions from a variety of cultures and photographs prominently featuring patterns similar to ones in this chapter

■ Collage background-support paper: You will need an 18-by-24-inch sheet of white drawing paper cut in half (18 by 12 inches) for your first experiment. For subsequent compositions, use 18-by-24-inch white drawing paper or colored construction paper.

■ Patterned paper for shapes: Cut a selection of varied patterned papers into pieces no larger than 9-by-12 inch sizes. Suitable papers are patterned wall paper, giftwrap; colored magazine photos with repeating patterns like those of woven fabrics, waves, leaves; the stockmarket or classified sections of the newspaper with regular-sized repetitive-print patterns. Avoid vinyl-backed or front-coated wall coverings because they warp and their edges often curl when cut into.

■ Leftover pieces of construction and tissue paper from other projects

■ Scissors

■ White glue and small brush or glue applicator

■ Nontoxic oil pastels, crayons, or felt-tip markers for making additional patterns on the glued paper shapes and in between background spaces

### FOR PRESCHOOLERS:

■ Painting-tray setup

■ Precut and torn-paper shapes, with and without pattern, in small rectangles or strips of various widths and lengths for children to apply to their paintings with wet poster colors (for additional motivation after they have exhausted their possibilities with the paintbrush)

■ Scissors but *no glue* (you will not demonstrate gluing here)

SUZUKI HARUNOBO (Japanese, 1725–1770). *Plucking a Branch from a Neighbor's Plum Tree.* 1766. Woodblock print, 10 3/4 x 7 7/8". The Metropolitan Museum of Art, New York, The Howard Mansfield Collection, Rogers Fund, 1936 (JP 2451)

I explain pattern to beginners as a lot of identical or similar small shapes and lines that are repeated many times.

*Warrior Chief, Warriors, and Attendants.* Nigerian, Court of Benin,
16th–17th century. Brass relief plaque, height 18⅞". The Metropolitan
Museum of Art, New York, Gift of Mr. and Mrs. Klaus G. Perls, 1990
(1990.332)

Right:
*Figure from a Housepost.* New Zealand, Maori, 19th–20th century. Wood,
height 43". The Metropolitan Museum of Art, New York, The Michael C.
Rockefeller Memorial Collection, Bequest of Nelson A. Rockefeller, 1979
(1979.206.1508)

Before starting the project, we view reproductions of works of art
from diverse cultures.

## *Making the Familiar Seem Unfamiliar*

When the poet Paul Valéry said, "To see is to forget the name of the thing one sees," he was referring to the fact that you can make the ordinary seem extraordinary by perceiving things in terms of their pure aesthetic qualities rather than thinking of their practical use and recognizable identity. We are so accustomed to judgment, reason, and logic that we may find it difficult to allow our senses free play in order to see pattern and form in the shapes around us, instead of only their functions and identities. If we can develop the observer side of ourselves and learn to suspend the evaluative, we will enrich our entire visual experience. You will see how pattern can also make the visible seem invisible, how it operates almost like magic, and, like color and light, may play tricks on us.

RICHARD HAAS (American). *The Potter Building.* 1974. Oil on canvas, 15⅞ x 20". Courtesy of the artist

## *Pattern in Nature and the Nature of Pattern*

Awareness of pattern is noticing a kind of detail. Often patterns are not recognized all around us because we read them as visual texture instead of pattern. For example, we may see a brick wall and not be able to discern the units of individual bricks at a distance. Instead we see a texture that suggests a tactile surface. Pattern, or individual repetitive units within an object, may only become visible at a close distance.

While many people immediately associate pattern with designs that are applied or painted onto a surface, you can see pattern within natural materials as part of their structure, as in the grain of wood or the veining of marble. Looking at a building, you may find patterns in the brickwork, in the windows set at regular intervals, in the arrangement of windowpanes, and even in the shingles on the roof.

Pattern in nature can be used either to hide or to attract attention. It camouflages tigers, lizards, and many other animals. On the other hand, male birds like the peacock are often colorfully patterned in order to attract females. Our daily visual fare is a feast of color and graphic patterns in advertisements, furnishings, clothing, and many commercial products. Patterned designs in the architecture and artifacts of traditional cultures can hold symbolic and often religious meanings. Persian and Native American rugs, jewelry, woven hangings, and patchwork quilts have become common sources of pattern in our homes, although the original meanings of their patterns are often unknown to us.

HABIB ALLAH (Iranian, active 17th century). *The Assembly of the Birds.* Leaf from the *Mantiq at-Tayr (Language of the Birds),* by Farid-al-din 'Attar. c. 1600. Colors, gold, and silver on paper. 10 x 4½". The Metropolitan Museum of Art, New York, Fletcher Fund, 1963 (63.210.11)

Though ancient and traditional societies had no prejudices against decorative pattern, in recent centuries it has sometimes been considered unfashionable to wear a variety of patterns together. If you wore a striped shirt, you were supposed to wear solid-colored pants and jacket. Now, as in the past, many multi-patterned outfits use pattern next to pattern to give a feeling of warmth and visual texture.

Left:
Unknown British artist. *Portrait of a Lady* (perhaps Queen Elizabeth I?). 16th century. Wood panel, 44½ x 34¾". The Metropolitan Museum of Art, New York, Gift of J. Pierpont Morgan, 1911 (11.149.1)

The bedroom of Louis XIV (southwest view). c. 1640. Period room. The Metropolitan Musuem of Art, Installation funded by Mrs. Charles Wrightsman, 1987 (1984.342)

Lois Lord (American). *Brooklyn Botanical Garden.* No date. Gelatin silver print, 10 x 8". Courtesy of the artist

Lois Lord (American). *Gate, Jaipur, India.* No date. Gelatin silver print, 10 x 8". Courtesy of the artist

Pattern can be a growth configuration in nature, such as leaves sprouting out from a stem at regular intervals or an effect of sunlight and shadow.

Pattern often makes things appear more imposing by making them seem more visually intricate. When you look at a picture of a building, the placement and size of doors and windows also give you clues about the overall volume or mass through the cast shadows or the illusion of shadows. Additional ornament on facade details can make them seem more grand than unembellished ones. On the other hand, flat patterning can be used to give an ethereal quality to solid walls. Medieval Western European cathedral builders pierced their towering walls with patterned stone tracery and elaborate stained-glass windows, while Eastern artists produced extraordinarily complex patterns on their building facades.

Religious imagery has often expressed itself in pattern instead of in figurative images. Architectural sculpture and illuminated manuscripts of medieval times used elaborate pattern to convey the order of a religious life in harmony with natural forces. Geometrically styled patterning has a quality of timelessness that transcends the feelings of mortality a naturalistic image of organic material implies. Because people believed in the occult powers of numbers, pattern was also used as a symbolic code by which religious teachings were transformed into visual mathematical systems.

Islamic religious art opposed naturalistic images of living beings because it was felt that an artist would usurp the power of God by breathing life into inanimate creatures. In the secular court art made for Muslim royalty, however, a stylized or decorative pattern of animals and humans was considered harmless if it cast no shadow, was executed on a miniature scale, or was used to decorate utilitarian objects such as rugs, fabrics, or pottery.

Pattern can be pleasing or unpleasant according to its use and its qualities of size, line, shape, color, and arrangement. While you might like a patterned fabric on your sofa, you might not want patterns on all the furnishings and surfaces in a small room, where they might make the space feel overcrowded and unsettling. Pattern can establish a visual link between the vastness of a large architectural space and the human scale. It can be a way of orienting ourselves when an architectural structure towers over us and extends for a great distance. When organic patterning taken from nature is used in man-made environments, it contrasts with and warms the cool, geometric precision of much architecture.

Pattern is commonly used in utilitarian ways as well. If you have ever had to spend the night in a small motel room with jarring patterns on the upholstery, competing patterns on the wallpaper, and equally flamboyant ones on the floor, you may have wondered if the owner was blind. Probably not. Owners of public places have long known that pattern can be used to hide dirt and scuff marks on surfaces. Perhaps you chose a pattern for your kitchen floor for the same reason.

## Relating Pattern to Your Projects

This project also uses cut and glued paper in a slightly different way from previous experiments, where it was primarily a method for drawing shapes and making spaces. Now you are adding ready-made patterned imagery generated from outside sources.

In the first decade of this century, artists Pablo Picasso and Georges Braque pasted newspaper fragments into their drawings to create a new way of representing the world. Because these nonart elements carried with them memories of their original contexts, their compositions depicted more than just a single point of view in space and time. They created expressions of simultaneous experiences of both the artists' worlds and documents of their outside surroundings, which themselves could also be souvenirs of other times and places. Many successive generations of artists have made assembling and juxtaposing disparate images and objects the basis of their individual styles.

You may have made patterns when working on your paintings if your brushstrokes made a series of repeated marks of the same shape and width. Many painters use this type of patterning to suggest mood and abstract ideas. For example, the repetition of dense, raised, flamelike marks in Vincent van Gogh's *Cypresses* (page 52)

CHARLES BURCHFIELD (American, 1893–1967). *Dandelion Seed Balls and Trees.* 1917. Watercolor on paper, 18 x 12". The Metropolitan Museum of Art, New York, Arthur Hoppock Hearn Fund, 1940 (40.47. 2)

Pattern can delight the eye in an illusion of movement and vibration, unifying an arrangement of many diverse shapes and colors. It establishes a visual rhythm according to the arrangement of its lines and shapes and the spatial intervals between them, in the same way a drumbeat accents a music melody. The animated rhythm in this landscape suggests exuberance; the repetition of curved, serpentine lines moving in interlocking arcs without symmetry plays against the staccato dots of the seed balls, the jagged marks for tree bark, and steady zigzag rows of lines for grass.

bring to mind a kind of radiant energy. By contrast, the pattern of the tiny oval petals of the blossoms on the cherry trees in Yoshu Chikanobu's three-part print *Enjoying Cherry Blossom Viewing at Ueno* suggest the delicate buoyancy of floating bubbles.

Your torn-paper project focused on simplified shapes that gave a feeling of space defining foreground and background as if you were seeing a grand panorama in nature. Your drawing with cut-paper shapes created foreground, background, and middle grounds, which may have suggested more clearly defined objects. Now, adding the small detail in patterned shapes can produce the feeling of being up close. The combination of using torn-, cut-, and patterned-paper shapes allows the placement of more complex spatial arrangements.

This project also explores how to suggest place and mood with pattern. For example, putting pattern in unexpected places in your picture may elicit an unexpected feeling from ordinary shapes. By using pattern very freely, you can experiment with new possibilities of interpreting ideas.

## Demonstration for Young Beginners with Adults

*A*llow yourself about an hour for your first experiment.
1. Since most people have pattern somewhere on them, even on the bottom of their sneakers, you might first discuss the patterns on clothing. What kinds are they? Using photographs incorporating a variety of patterns, such as buildings with windows, gardens, a view from an airplane, and patterns that hide animals, such as tiger's stripes in tall grasses, talk about

YOSHU CHIKANOBU (Japanese, 1838–1912). *Enjoying Cherry Blossom Viewing at Ueno.* 1887. Triptych, woodcut print, 9⅞ x 14¾". The Metropolitan Museum of Art, New York, Gift of Lincoln Kirstein, 1959 (JP 3306)

Adults' patterned-paper collages

what pattern is, and contrast it with solid-colored surfaces with no patterns. The discussion can include patterns around you, such as the floor and ceiling tiles and lights or the view from a window, and you can also view reproductions of works of art from various cultures in which patterns can be recognized.

2. Showing both plain and patterned paper, you might say, "Now I'm going to draw with my scissors to make a shape I never made before." Proceed to cut a medium-size shape with a few curves and some points. Cut not along the patterns on the paper but across them to make a shape. Avoid representational or recognizable images.

3. Take the patterned paper from which the shape was cut and place both the first shape and also the see-through shape onto the white background.

4. Cut a few more shapes from patterned paper. Arrange them on the background paper, overlapping them and sliding some underneath the edges of others, juxtaposing pattern with pattern. Holding a shape of solid-colored construction paper, ask, "If we only have plain paper, how can we make patterns?" Some of the more experienced beginners know that you can make patterns by cutting many small shapes and narrow strips, grouping them together on the background. If no one responds, continue cutting small paper shapes and arranging them to create patterns with repeating groups of shapes and lines so the students will understand what you have said and done. Mention the shapes created by the in-between spaces as you move the arrangements around and overlap the pieces.

5. Before the children go off to paint remind them to think about how they might make patterns with their paintbrushes and also how they might add some patterned-paper shapes to their paintings.

## Demonstration, Part 2, Procedures for Adults and Experienced School-Age Students

After the children have gone to their workplaces, speak with the adults about the relationship between the art reproductions on the wall and their project and demonstrate the following procedures.

1. Take a piece of the half-sized drawing paper (12 by 18 inches) and evaluate the qualities of several 9-by-12-inch pieces of patterned paper by holding them together. You may also wish to use some solid-colored construction paper shapes to establish a basis for an arrangement on the background. Striped paper may suggest a cityscape while other patterns may evoke a garden, florist show, or supermarket.

2. Cut your patterned shapes across the dominant direction of the design. If you find yourself tempted to cut around the representational images, turn the printed paper over so that you cannot see the designs, and draw your shapes.

3. Place the cut shapes onto the background paper so that they will suggest other possibilities. Try to see the background paper as a shape of its own. Although you may not necessarily put cut shapes all over this visual field, try to arrange it so that some pieces overlap or touch each other and be aware of the shapes you are creating with the intervals of background color. Keep moving your shapes around until you feel the compositional design most clearly expresses a theme or mood that pleases you.

4. Do not use any glue for the first ten or fifteen minutes while you arrange and overlap shapes. Then, when you are ready, glue the pieces by lifting the edges to slip the glue brush underneath the shapes. Remember *not* to apply glue by picking up the shapes in your hands.

5. Try to cover every part of your paper with pattern, adding oil pastel or crayon marks to make additional patterns on your plain construction paper. You can also add small cut shapes to create patterns on top of other shapes and can unify your composition by connecting shapes with drawn patterns.

6. In subsequent collages at another session, work on a patterned background using both plain and patterned shapes.

## THINKING ABOUT WHAT YOU HAVE DONE

How did your patterns influence the illusion of size and shape of the cut pieces? For example, what happens when you see a person wearing a small or medium-size print on their clothing versus the effect when they wear large patterns? Patterns can break up the volume of a shape and make it look smaller if the intervals are not so small that they read as texture. Larger or broader designs, however, may dramatize or accentuate overall size, depending on the colors, placement, and proportions. Big patterns may look in proportion on tall people, but the same pattern on a petite individual may dwarf the wearer. Of course, this depends on the direction and color of the pattern as well. It is a common rule of dressing that stripes emphasize direction. Lengthwise ones can make a person look taller and thinner while horizontal ones can accentuate girth.

Artists have long used pattern to emphasize and unify a pictorial composition. You may have used pattern in this way in earlier projects, where your brushstrokes gave direction and movement to the field. Claude Monet's *Terrace at Sainte-Adresse* (page 86) uses pattern to suggest a kind of visual animation even though the figures are in repose. The three

ROBIN SCHWAB (American). *Gift of Tongues.* 1991. Mixed mediums, 98 x 54". Courtesy of the artist

PHILLIP HENRY DELAMOTTE (British, 1820–1889). *The Upper Gallery, Crystal Palace, Reconstructed Building in Syndenham.* 1852–53. Albumen silver print, 6³/₈ x 8³/₄". The Metropolitan Museum of Art, David Hunter McAlpin Fund, 1952 (52.639.[78])

You also may have seen that recurrence of similar units lends a feeling of motion within your arrangement. The pattern of repetition is called *rhythm.* If you line up similar shapes at regular intervals, you create one kind of rhythm. How does it differ from positioning them at irregular spacings? You might think of the difference between the even rhythm of rock 'n' roll compared to the more varied rhythm and phrasing of jazz.

large horizontal areas, of terrace, sea, and sky, set the mood of a calm peaceful day and layer the space in depth. Yet the small, densely patterned marks for waves and repeated shapes of the billowing flags tell of a pleasant breeze. The shapes of the multitude of boats near and far measure rhythmic intervals across the horizon and evoke a kind of energy in the harbor. The repeating patterns of brilliant orange-reds in the flowers and rippling flags in the foreground create a vibrant atmosphere or mood. Even with the repetition of a few basic elements the eye is never bored, never loses interest.

As you continue to do more patterned-paper experiments, you might combine several mediums. You can use tissue to mute some patterns, to change their colors and add translucency to the shapes. When you add paint or oil sticks to your patterns, you might change the colors and extend them beyond their cut edges.

## *ADVANCED COLLAGE OR PAT-TERNED PRINTING PROJECT*

School-age children and adults may enjoy making found-object prints by using a printmaking process to create their own patterns, which they can incorporate into a collage or painting. The printed papers might also be used for holiday cards or giftwrap.

1. Wooden blocks or spools, cross sections of empty, bleached marrow soup bones, toilet-paper rolls wrapped at intervals with thick cord, or other small objects you can grasp firmly can be used for making printing stampers. Additional textures can be generated by wrapping these objects with fabrics or string using corrugated cardboard, or by gluing additional pieces of sponge, cardboard, or packing-foam shapes to a backing.

2. To make stamper inking pads, place in a small plastic margarine container a piece of cellulose sponge just large enough to fill the bottom. (Save old workshop sponges to cut up for this purpose.) Pour a little poster paint onto each sponge and then press the mounted objects onto the sponge before stamping or printing the paper. (Do not put out the regular paint containers during this project because beginners may dip the stampers into the paint cups instead of pressing them onto sponges. Not only will the printing blocks become covered with paint, but also paint will be wasted.)

When the printed papers are dry, you may choose to keep them as they are or you may want to cut them up for use in another collage arrangement. You can also use oil sticks or markers over the stamped images. These last steps transform many easy visual effects obtained in the printing process into personal, inventive, and complex compositions and new visual textures.

## *Tips for Teaching*

### *PRESCHOOLERS' WORK WITH PATTERN*

Although I do not suggest pattern projects for preschoolers, I introduce the idea of patterns slowly and continue to talk about them when they are highly visible. From week to week I continue to point out patterns in the children's clothing and in their collage choosing trays. I have a magazine cover with a pattern of many Babars, the beloved elephant who is featured in illustrations from a very popular children's book series. "If I only had a picture of one Babar, would it make a pattern?" "No," they tell me. In subsequent sessions they often come into the studio eager to show me the patterns on their clothing and tell me where they have seen patterns at home.

As you work on your own project, you might continue to include additional small pieces of patterned paper to youngsters' choosing trays and look around for objects

Children's hanging collages

Patterned-paper collages by preschoolers

While adults are making their patterned-paper collages, add a variety of patterned shapes to the children's choosing tray. I try to find patterns with small repeating shapes in bright colors; however, if you use stereotypical imagery such as valentine hearts, cut through the design graphics, making strips that obliterate the old pattern.

to illustrate that sometimes pattern can be a lot of similar shapes inside of bigger ones. If you keep calling attention to patterns in many varied situations, the children will soon discover that patterns occur in many different places and materials.

One parent reported that the morning after three-and-a-half-year-old Joanna had worked with patterned papers, she interrupted the family breakfast by excitedly announcing to her father, "Your tie looks like the pattern in the painting Grandma sent us!" She led them into the living room to see the Haitian artwork with an area of patterns shaped like the ones on his tie. This youngster also startled a group of adults in the lobby of their apartment building by exclaiming at the top of her voice, "Look at the pattern of flowers on the walls!"

## OLDER BEGINNERS

School-age children (five and up) who already know how to cut, glue, and make arrangements might like to do a patterned-paper collage or might use patterns to tell a story. Show lots of photographs of patterns in nature and point out some of the ways that patterns can tell about things. For example, we know the Dalmatian dog by its spots and the zebra by its stripes. Patterns are a way of telling what a house is made of, whether it is wood, brick, or stone. Many people also make up pretend stories or dreams in which things are patterned and colored in ways we do not see in real life. Beginners of any age may enjoy putting patterns into unusual contexts to produce a whimsical or comic effect, such as using a floral pattern for an animal or architectural shape. They can also combine tissue paper with patterned paper or make a collage painting.

VALERIE JAUDON (American). *Reunion.* 1989.
Stone, bricks, and mortar, diameter 34'.
Located at Police Plaza, New York City

Jaudon's pattern, a focal point for this
plaza's eight connecting courtyards, ter-
races, and walkways, establishes a human
scale for pedestrian walkways within the
large architectural complex.

LOUISE NEVELSON (American, 1899–1988).
*Rain Garden Spikes.* 1977. Black painted
wood, 30 x 12". Courtesy of Pace-
Wildenstein

This sculpture uses multiple patterns to
order a symphony of many different kinds
of shapes and the directional movements
that they produce.

HORACE PIPPIN (American, 1888–1946). *Asleep.* 1943. Oil on canvas, 9 x 12". The Metropolitan Museum of Art, New York, Bequest of Jane Kendall Gingrich, 1982 (1982.55.3)

## Materials Checklist

■ Art reproductions, photographs, and objects representing a variety of both visual and physical textures from art and nature and also a collection of textured objects for feeling and touching for preschoolers

■ Containers to display and to store the textured materials: Clear plastic boxes and resealable bags are best because you can see the contents immediately. You can glue samples of what is inside to the front of shoe boxes and remove the lids for display in class.

■ Heavy or corrugated cardboard, approximately 9 by 12 or 12 by 18 inches, for background support

■ White glue. About twenty minutes before you start working on your collage, pour some glue into a paint container or small dish so that it thickens before you use it. Do not give beginners any instant glue product because it is too easy to cause accidents with them. People have lost patches of finger skin to those products.

■ Regular painting-tray and collage setups

■ Oil pastels for added coloring, if desired

### FOR OLDER BEGINNERS:

■ Materials in a variety of easy-to-glue textures such as cloth, textured papers, sand, beads, buttons, yarn, cut-up egg cartons, coffee grounds, corrugated paper, fake fur, felt, and pieces of carpet

■ Cutting tools, depending on your selection of textures. Remember to get appropriate tools for cutting these or you may ruin both your tool and your materials. For example, using your paper-cutting shears on very thick cardboard may dull the blades. Adults must pre-cut thick material for children because youngsters cannot use single edge blade tools safely. You may be able to tear some of the thinner materials with your hands to give ragged edges for contrast.

AMY ERNST (American). *Lady in a Window.* 1993. Gauze, handmade paper, gold leaf, leather, 15 x 12¼". Courtesy of the artist

Tactile materials in artworks can invite touching.

■ Protective cutting board or dense cardboard for cutting on with single-edge blades. Newspaper is rarely sufficient protection for your table unless you use a very thick pile of it.

### FOR PRESCHOOLERS:

■ An open shallow touching-and-feeling box containing a collection of variously textured objects primarily composed of

LOIS LORD (American). *Bark from Cork Trees, Portugal.* No date. Gelatin silver print, 8 x 10". Courtesy of the artist

neutral or earth colors so as not to confuse young beginners with the distinction between color and texture at this point. Included could be a piece of rope, a dry gourd, a pine cone, a few kinds of tree bark, prickly-seed pods, a piece of rug, a corncob husk, foam rubber molded into eggshell bumps and hollows, corrugated paper, a prickly dry starfish, imitation fur, seashells that are smooth on one side and rough on the other, as well as other textured materials.

As you may have noticed with your patterned-paper collage, the materials for this project have both visual and psychological associations as well as textures. This is one reason I prefer that young children do not use edible foods like noodles or potatoes for texture materials

or printmaking. Just as in the last project, when you cut apart images in order to work with prefabricated patterns, take apart any manufactured objects like toys or artificial flowers so that everyone is restructuring the pieces to transform them into something of their own. This is particularly important when presenting materials to beginners.

Occasionally, in the beginning of a semester, some children may come in to my workshop holding something close for emotional warmth and comfort. After they become involved with holding the paintbrush, the scissors, and clay, they forget about their "security blankets." They become more interested in reaching out and holding the textures of the outside

world instead of being sheltered from it by their blankets.

People of any age who are forced to be extremely clean and neat may yearn for more tactile experience. Often they just need to touch and feel things in order to know them on a kinesthetic level because touching is a way of exploring the world. I have worked with beginners who have never been allowed to take off their shoes and run in sand or grass or to get their hands soiled. After a few weeks, when they feel secure in class, some may try to smear the paint and glue with their hands. Their newfound freedom gives way to venting a need for tactile experience and investigating studio materials. With very young children it may supersede any desire to do something constructive with the materials for a while. You may find that working with textural materials has an emotional and associative resonance that you had not considered before.

Adults also gravitate toward the emotional and physical resonance of textures. Synthetic textures suggest stories:

URSULA VON RYDINGSVARD (American). *Five Cones*. 1990–92. Cedar and graphite, 8' 2" x 9' x 5'. Courtesy of the artist

Leonardo da Vinci noted that natural textures like weathered rock and rough wood are filled with images we project into them, for they are themselves living chronicles of experience. They speak of the natural processes of growth, metamorphosis, and disintegration of the forests and mountains of the past.

fragments of childhood memories of lost and stuffed animals, the intimate association of fabric that protects and caresses our bodies, parts of former furnishings; in short, all the ideas associated with previous use. Periods of design in which very soft, silky, fuzzy materials such as angora, mohair, chenille, or rough-woven textures are popular seem to recur in austere urban surroundings, as if to counter tactile deprivation. We also prize the hand-rubbed wood surface produced by a fine cabinetmaker, which speaks of dedication to a level of craft that is rare and expensive today. Texture variations on handmade pottery and African beads indicate the process of making by an artisan, while industrially manufactured items tell fewer tales in their uniform, seamless, and precise surfaces.

Touching may also replace conscious thought, as we find ourselves reacting automatically to textures. Often we do not actually remember feeling the chair when we sat down for dinner or whether we shut a door. Sometimes we may locate a seat or turn a door handle behind us by feel, without turning around to look. Psychologists have said we depend on messages received through contact to stabilize our visual world. When kittens were carried through a test maze through which the adult cats walked, the carried animals, who never learned the maze by walking through it, did not develop the same visual spatial abilities. Everyone needs kinesthetic information to verify their vision, and we learn new routes faster by walking through them.

We are all put at a great disadvantage if we do not have the physical experience of handling things. Usually those who have been encouraged to touch and handle things will have superior eye-hand coordination and more self-confidence. Children learn to do things for themselves much more quickly if they have not been waited on by adults who lack patience to let learning evolve naturally.

## Texture in Art

Vivid portrayal of texture is a strong attraction in many works of art, which entice you to look closely into the painted world. In Gérard David's altarpiece *Adoration of the Shepherds,* the physical textures of its frame enhance the effect of the illusionistically painted framing elements. Not only does the frame come physically into your space, but also its appearance may change dramatically with the direction of changing light throughout the day. Outdoor sculptors and architects use this shadow-casting property of three-dimensional texture to dramatize the forms they create. When I visited the Taj Mahal in Agra, India, I watched the late-afternoon shadows emphasize forms on bas-relief patterns. They seemed to create textures different from the ones visible early in the morning and made the monument appear more vibrant.

Even though distances in time and space are shrinking because of media images from every remote area of the globe, we often have a sense of being out of touch. Perhaps a need to grasp textures and intimate detail is also evidenced in the popularity of close-up photography today.

## How Texture Collage Began

Texture collage–making began many centuries before modern artists incorporated textured materials into their paintings and sculptures. Ceremonial and religious designs using seashells and other natural and found objects have long adorned churches and homes all over the world.

Many representational painters through the centuries have depicted

GERARD DAVID (Flemish, c. 1460–1523). *The Adoration of the Shepherds.* 15th century.
Triptych. Tempera and oil on wood; center panel 18¾ x 13½", each side panel 18 x 6½".
The Metropolitan Museum of Art, New York, Michael Friedsam Collection, 1931
(32.100.40a)

Because of the wide range of textures depicted in this painting, I show it during
this texture-collage class and also during the preschoolers' project of painting arch
shapes (see page 147).

texture illusionistically. Some in the nineteenth century arranged their pictures in a collagelike way, overlapping flat shapes and juxtaposing disparate images in shallow planar layers. Examples of American artists who have worked in this manner are John Peto, John Haberle, Raphael Peale, and William Harnett (see page 143). The contemporary American artist Audrey Flack continues this tradition in her still-life paintings.

Because recognizable objects have ready-made meaning, without any personal transformations on the part of the artist, many beginners find them very appealing. Yet this very quality also presents a challenge for the beginning student, who, without personal invention, may end up with a mere collection of discarded materials.

## Demonstration for Preschoolers with Adults

You have to consider carefully how you are going to demonstrate textured materials without being coercive or intrusive. Many younger children may become upset when asked to put their hands inside a bag to identify what they are handling. Sometimes adults feel that children or other beginners will appreciate a guessing game, but many people do not like to stick their hands into bags of unknown items for good reasons. I saw a well-meaning teacher walk around a class touching a fuzzy piece of material to young children's cheeks for them to experience the texture. Not only is this unsanitary, some cultural groups consider it socially or religiously offensive for nonfamily members to physically touch anyone with anything. Some people may not want to handle certain materials (for any reason) and should not have to explain their reasons. Not everyone has to touch everything to understand what texture means.

When both parents and children assemble around the demonstration table, explain what you are going to do. The adults will have their own project while the youngest beginners will continue their regular routine with new textured materials added to their choosing trays and heavier background paper.

1. (To the children): "I see that you're here. How do you know that I'm here?" Over the years the answers have varied from, "Because it is art class" to, "Because my brain tells me." "Yes, but how does your brain know? What tells your brain? There are special ways your brain finds out about things" (as you point to your eyes). Then someone says, "Because I see you!" "Yes, that is one way, but if it were very dark how would you know I'm here?" ("We'd hear you!") "What if I didn't make any sounds for you to hear? What would you do then?" Then close your eyes and reach out to touch objects in your surroundings. ("We could touch things.") "Suppose I had a flower in my hand. How would you know it?" ("We'd smell it.") "If you could not smell it?" ("We'd touch it!") "All of the things you do when you use your eyes to see, your ears to hear, your nose to smell, and your hands to touch, help to tell your brain what is there."

"Today the grown-ups are going to do a touching and feeling picture, a texture collage. Do you know what the word texture means? It is how things feel when you touch them. They might be rough, soft, smooth, or prickly (like my dry starfish)."

2. Before I bring out any objects for everyone to touch I ask, "Do you have any real or stuffed animals you like to touch?" All of the children have something at home. It may even be a blanket or pillow. "Why do you like to touch it?" "Because it is soft and fuzzy?" Then I take my prickly dry starfish out of the box. "Would you like to hug this?" Everyone agrees that they would not. I ask them to touch their own

faces to learn the meaning of the words "smooth" and "soft." We talk about the different objects and how each one feels: Is this smooth or rough? Is it hard or soft?

If there is time you might also talk about the textural qualities of the youngsters' clothes or furnishings at home. Combinations of textures can be confusing at first, as for example when something is soft and smooth versus hard and smooth or soft and bumpy (soft, egg-crate-molded foam). Contrast the skin of a tree with their smooth, soft skin. Tree bark can be at times smooth and hard or bumpy and hard.

3. Show them some touching and feeling collages by adults before they go off to paint and mention that they might want to make some parts of their paintings look rough or smooth. Since they have been painting for many weeks, and you have talked about brushstrokes that look rough and smooth, they will know how to do this if they wish to. On their painting tables are set aside small pieces of corrugated (both bumpy and smooth-textured) papers, which they may want to add to their paintings after they have painted for a while.

## Demonstration, Part 2, Projects for Adults and Experienced School–Age Students

Since the following suggestions are merely to get you started, you can depart from them as you develop your own themes. I frequently point out that you can begin a collage motivated by seeing a painting with visual texture and also start a painting after having seen a collage. You might even use an early painting as a starting point by thinking of the qualities evoked by the textural elements in it and how

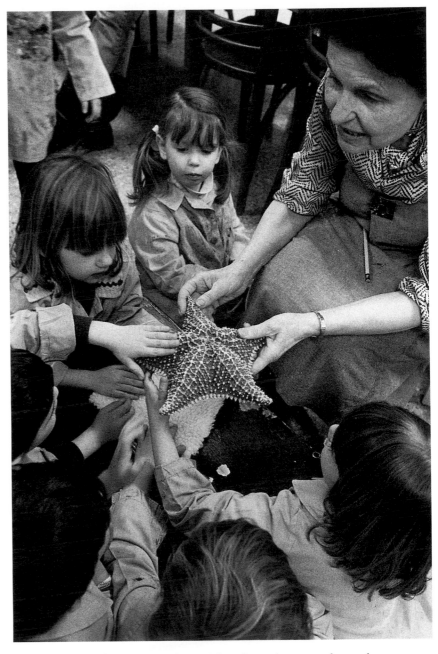

If feasible, show everyone textured materials and pass them around to students who want to touch them.

Two adult texture collages

A collage may be inspired by seeing a painting with texture or a painting made from a collage.

ARTHUR G. DOVE (American, 1880–1946). *Portrait of Ralph Dusenberry*. 1924. Oil on canvas with applied wood and paper, 22 x 18". The Metropolitan Museum of Art, New York, The Alfred Stieglitz Collection, 1949 (49.70.36)

Western artists who popularized collage as a fine-art medium during the first two decades of this century used textures from life in order to contrast painted and drawn art forms with recognizable objects from daily experience.

Textural sculpture by George, four years old, that is raised up off its base and features brushstrokes for additional texture.

they can be translated into a collage. The following are some other possibilities for texture collage:

■ Portrait: Arrange a group of textural objects that represent a person as evidenced by his or her possessions, the interior of someone's pocketbook or briefcase (the neatest, most businesslike persons might amaze you with what they carry around), an undefrosted refrigerator interior, or a special drawer filled with prized possessions.

■ Color Story in Textures: Choose a color and find as many textures as you can in any of its close variations in hue.

■ Portrait of a Place: Choose a range of textures that remind you of a place you have visited or would like to visit, such as a zoo or forest, or one you have seen in a painting or a photograph. Try to make a textural interpretation of the elements that you have found appealing or unappealing.

## PROCEDURE

1. Arrange your textured pieces as you did with your previous collage by moving them around on the background without gluing them down. You might want to use some larger shapes of flat material (cloth or paper) to compose your background and then layer or overlap smaller pieces on top of these.

2. Fill the in-between spaces with other textures, thinking of all the elements of shape, line, pattern, and arrangement that you used in previous projects.

JOAN GIORDANO (American). *Second Skin.* 1994. Copper, copper cable, handmade paper, paint, 65 x 35 x 6". Courtesy of The Walter Wickiser Gallery, Inc., New York

PETRONA MORRISON (Jamaican). *Remembrance (124th St.).* 1995. Wood, metal, glass, and ashes, 8' 5" x 3' 2" x 2' 6". Courtesy of The Studio Museum in Harlem

These two sculptors have also used widely varied materials for maximum contrast and emotional impact.

3. Glue down your materials. Sometimes you can merely lift an edge; for heavier or absorbent materials, lift up the whole piece and puddle the glue onto the background surface; you can use a lot of glue since it will dry to a clear finish. If you do put glue on the underside of an absorbent material, the glue will soak into it rather than adhere securely to the background. To glue down grainy materials such as wood shavings, pebbles, coffee grounds, or sand, spread your glue evenly and generously over the background where you want to place the texture and sprinkle the material on top of the glue. Tilt up your background to remove excess grains onto a piece of newspaper. If you find that you want to fill in spots where the texture failed to stick, let the glue dry and repeat the process. (At home only: If you want to work with very thick layers of sand or sawdust, you can mix the material with white glue to make a grainy paste and put glue on your background before spreading it.)

4. As an optional additional step, *after* your water-based paint and glue have dried, you could paint or apply oil pastel over some parts of your collage, either as a textural element or to add color. You might also make a second texture construction in which some textural materials or objects project away from the base in order to work three-dimensionally.

## THINKING ABOUT WHAT YOU HAVE DONE

Just as in your paintings and glued-paper projects, you have been working with contrasts: of light and dark, of color, of transparency and opacity, and in patterned rhythms. Here you have added another kind of contrast. This principle of contrasting the visual properties of things enhances the characteristics of each element. A smooth texture next to a rough one looks smoother, and the rough surface looks more rugged than if it were displayed alone. While repeating patterns of texture creates the dominant rhythm for the project, contrasting elements can provide variations that accent visual as well as tactile themes.

Texture, like pattern, can be used as an ornament to make something look attractively opulent, as with a richly textured rug. Yet texture can be used to represent other visual ideas as well. Texture in sculpture may communicate both optical and tactile sensations. Polished reflective-metal surfaces can give the impression of shimmering and vibrating in the light, catching reflections so that the object appears weightless (see Umberto Boccioni's *Unique Forms of Continuity in Space*, page 247). If you made a texture collage in one color, you may have seen how various textures appeared to have changed color.

## *Projects for Adults to Share with Younger Beginners*

*T*hese projects are especially good for adults to share with preschool or gradeschool children who have already learned how to glue and cut with scissors. The first project is a "touching" board or tactile scale. Use a long narrow background support. Arrange different types of texture side by side on your background regardless of color relationships. Think of a scale on the piano where each key makes a different sound. The size of the scale depends on your own facilities, but if it is constructed in detachable sections, it is more easily stored and can accommodate future additions. Collecting photographs and art reproductions that feature texture prominently, such as those with animals, rock formations, and objects with other kinds of textures, help beginners to build their vocabulary.

Children's texture collages

The adults will have their own project while the youngest beginners will continue their regular routine with new textured materials added to their choosing trays.

Preschoolers' hanging
texture collages

A friend of mine who taught in a Head Start program made texture display units from used cardboard pieces with openings that once held small yogurt containers. Each child brought in a material that they glued onto a square background and then glued over the round holes in the board. After turning the boards over so that the round holes exposed the textures, she mounted them together into a cube that could be hung or set on a table.

School-age students might also enjoy making a "treasure or memory box" composed of saved objects that can be glued down in a shallow gift box or box lid.

Materials can combine tactile objects such as pebbles, marbles, miniature animals, figures, or doll-house furniture with pieces of magazine photographs illustrating visual textures. For this project they will also need a paint container or small jar filled with white glue. Cardboard strips glued into the bottom of a box lid provide compartment dividers. Small boxes inside larger ones also work well for this purpose.

Once I assisted with a group of very restless six- to nine-year-old boys who could not get interested in the project at hand. I took out a book of fabric swatches of brocaded velvets and textured weaves

Memory box made by a seven-year-old in a studio workshop led by Hilde Sigal at The Metropolitan Museum of Art, New York

and asked those not involved in the project to help me tear them out of the book to use at another time. Taking something apart is usually intriguing for anyone and, as they handled the materials, their pleasure mounted. The boys enjoyed passing the samples around and organizing them. We talked about who might wear clothes made of those elegant materials. "What would make a good suit for a king or curtains for a castle?" Just sorting out and grouping the fabrics ignited their imaginations and became a project in itself. Now they would have enjoyed doing a collage, but, because of their reticent involvement at first, the time had flown and the workshop was over. Even so, they had done something positive during their time there.

## Additional Projects for School-Age or Adult Students

Although I do not talk about blindness with younger children, they know what it is like not to be able to see in the dark at night. Grade-school and older students might like to invent a touching-and-feeling picture for someone who cannot see. Discuss how you find your way in the dark, using your hands to feel the textures, forms, and spaces between things. Repeat this experience in texture collage. This project differs from the previous adult class project in that students are emphasizing intervals between the textures.

In a group where the teenagers and adults were having difficulty communicating with one another, the leader of the group challenged them to make mixed-medium collages illustrating how they felt each was viewed by the other. When they were finished, each explained what he or she was trying to communicate, and some very candid dialogue followed. Making

collages and then talking about them often brings a group together through working with studio materials and sharing feelings afterward.

## *Thoughts on Collecting Found Materials*

*C*ollecting is a way of going from general observations to specific discriminations about the qualities of objects that catch your attention. For example, while walking on a stony hill you may be attracted by the shape of a rock and, when you pick it up, discover the fine patterns of color formed by different layers. Intrigued by this specimen, you may begin to examine other, similar stones and decide to take a few home for future collage constructions. But if you continue to pick up stones without discriminating among them for specific qualities, you could end up carrying a heavy load home.

Look for materials in which you see a possibility for transformation into something personal. While some manufactured items are difficult to transform because of their strong associations, incomplete images such as parts of puzzles or games, building toys, and blocks may be useful. Although discovering all kinds of unusual objects for these projects is pleasurable, very flashy or shiny materials can be a handicap for beginners because they look attractive before anything is done to them. Small quantities of such materials should be reserved for special final touches. Items that already are strong images in themselves, such as doll figures or baby shoes, may draw attention because of their associational qualities rather than their purely visual and tactile ones. By contrast, one artist used lint collected from a clothes dryer and transformed this often overlooked substance into an extraordinary texture collage. A useful exercise in materials selection is to imagine how the items might change in a composition through overlapping, painting, or other means.

Seeing old materials transformed by nature, such as weathered wood or rounded pebbles, has led me to the view that nothing need be lost if you can envision it within a context of your own making. Once, when walking on the beach at the end of Montauk Point, Long Island, and picking up rocks, I noticed something reflecting sunlight. Between the rocks I uncovered a very large metal can that rocks had torn and molded around their own shapes. Its rusted metal patina, contrasting with other shiny parts that had been covered and protected by the sand, made me think about what is preserved or changed by the elements of nature. I also noticed how light and shadows appeared to change the surfaces. Recognizing immediately that this would be exciting to use in an artwork, I began looking for other metal pieces that would be compatible with my first treasure. Later, I attached them to a board backed with a wood frame and also used sand and paint on the piece. Now when I look at the work, I often think of the amazing power of nature to leave its imprint on the strongest of industrially fabricated materials.

RANDOLPH WILLIAMS (American). *Untitled.* 1993. Monoprint with collage, 29½ x 21¾". Courtesy of the artist

People arrange things in different ways not only because everyone sees from their own point of view but also because of cultural traditions and educational experiences.

## Materials Checklist

■ Examples of collage-paintings by previous students and art reproductions of collage paintings

■ White drawing paper for a background support

■ A selection of prepainted papers, printed papers, and construction papers cut into manageable pieces (approximately 9 x 12 inches). Because coated magazine papers may not hold the paint as well as noncoated ones, apply test paint to samples before class.

■ Painting-tray setup. In this project, you will be using paint to integrate your shapes into your collage. The binder in this paint medium will act as glue.

## Learning from Past Work

Even though I always ask my students not to destroy or throw away projects in front of other students, once in a while, after class I will find an adult's unwanted work in a wastebasket. Incomplete paintings often have a variety of colorful shapes and textured brushstrokes that would have made a promising basis for another work. Recycling earlier or beginning works is a way of reorganizing and reexamining what you are doing in order to continue with a fresh eye. In this way, the collage-painting process can generate new ideas and images. If you do not want to cut up any of your old paintings for this project, you can use a variety of construction-paper shapes left over from collage projects or pages from magazines and newspapers.

Collage painting offers entry into the worlds of both painting and texture collage. When you are painting and using collage materials simultaneously, you may find that you can quickly create and move shapes into arrangements. The collage elements become more than merely a

Adult collage paintings

MURIEL SILBERSTEIN-STORFER (American). *Untitled*. No date. Mixed medium collage painting, 18 x 23½". Courtesy of the artist

I began doing collage paintings as a way of using textured materials to enhance the surfaces of my work. Actually I had thought that at a future date I would take the time to paint the textures in a trompe l'oeil fashion. However, as I combined paint, textured materials, and other substances the work took on more meaning for me and acquired a life of its own, thus becoming a completed statement. After looking more closely at the art of other times and cultures, I was fascinated to discover that many artists and artisans have used similar techniques to achieve surprising visual results.

souvenir collection of individual found parts when the paint unifies them into personal compositions.

An aunt of mine, who owned a large number of figurines, did not like their grouping on her living room shelf and, certain that ny involvement in the arts could provide a better way to do it, asked for advice in rearranging them. My reply was that arranging one's home is a very personal matter. If she felt there were too many, then there were too many for her, because she looked at them every day. I mentioned the Japanese tradition of exhibiting only a few items at one time, and then rotating the displayed collection, but added that people of other cultures prefer to surround themselves with many items at once.

Everyone organizes objects according to subjective preferences. Some people may group small plants or souvenirs close together so that the emphasis is on the drama of a large group instead of on individual items. Grouping things away from the center of the shelf creates a visual tension. Moving objects together in the center diminishes the tension by equalizing the spaces on either side. Lining up the objects at even intervals emphasizes a steady visual rhythm that permits viewing of each piece slowly, one at a time. Putting a few dissimilar things together at irregular intervals permits the possibility of creating compositions with great contrasts of textures, colors, shapes, and lines.

When the photographer Brassaï was taking pictures of Pablo Picasso's studio, he moved the artist's pair of slippers a few feet to one side in order to make what he thought would be a better photographic composition. When Picasso saw this, he chided Brassaï for imposing his own design taste rather than recording Picasso's arrangement of his own room. In this situation, each person wanted to make his own personal statement about the place-

ment of objects and the character of the spaces between them.

Some people want to fill every inch of a space with shapes and motion while others may want to focus on a few shapes. When you arrange shapes in a collage painting, you will be combining aspects of painting with texture collage. If you layer recycled painting fragments you may build up a many-leveled surface. If you only paint the arrangement in one color, you might produce something like a texture collage; however, if you paint it in different colors, you are faced with color relationships that may alter the illusions of visual sizes and intervals. These are some of the issues we will explore in this project.

## Before Class: Preparing for the Project

*B*efore the workshop session, review your portfolio of previous projects, making judgments about which ones you might recycle. Some of them may suggest possibilities for further development. Others might have parts with brushstrokes, colors, or textures that you might want to incorporate into a new work. Some may feel incomplete in themselves or not seem to add up to a satisfying painting. The parts might almost be complete patterns or arrangements in themselves, have a pleasing passage of brushwork or interesting texture, shape, or group of lines. You might want to use one of these paintings as a background, overlap other painted or printed imagery, and then paint over all the layers. If you prefer not to cut up any of your previous work, assemble a selection of magazine, newspaper, or other printed papers. In a large class where there is no room to put out all the painting portfolios, I put out 9-by-12-inch pieces of old paintings left behind at the end of the semester.

If children ask why you are cutting up your work, you will need to explain that you are saving the parts of your old paintings that you like best in order to put them together in a new way. If you stress the positive aspect rather than the negative idea of getting rid of the old, they will not be disturbed. If they show no interest at all, do not bother them with an explanation that may be confusing.

## Demonstration for Young Beginners with Adults

*S*ince the adults will be painting again, this is a good opportunity to review the painting process for everyone.
1. After briefly experimenting with brushstrokes, color mixing, and the washing and brush-wiping process, put down your brush and say: "Sometimes when you tell me you are finished painting I may say to you, 'Would you like some colored shapes to use?' Well, today the grownups are going to do a collage painting and add some shapes. What do you have to do to make shapes stick to the paper?" They know to put wet paint on the background and that sometimes they also need to pick up the edges of shapes and put more paint underneath the edges.
2. Demonstrate how to change shapes by painting over edges to make them smaller or by dividing them into a few shapes. Also show how to make a pattern by dabbing paint over shapes, or how to use the brush lightly to mute a pattern or perhaps entirely cover it. After demonstrating this process, wash out the brush and emphasize the need to press out all the water from the brush onto the sponge. It is particularly important that the paint be undiluted with water, or it will be too thin to hold the shapes on the background.
3. When the preschoolers go to their paint

JUAN SANCHEZ (American, b. 1953). 1987–88. *It is the roots of who I am that remains— suppression notwithstanding.* Oil paint, cut and pasted photographs, and wax crayons on canvas, 5' x 8' 7". The Metropolitan Museum of Art, New York, George A. Hearn Fund, 1988 (1988.69a-d)

tables, provide the adults with additional information about the project and the reproductions on the wall. If working with a group of all adults or older beginners, continue with the following additional procedures.

## Demonstration, Part 2, Procedures for Adults and Experienced School–Age Students

### HOW TO START A WORK

Collage painting becomes a way of starting new work when you do not have any preconceived themes in mind. When you use collage materials, you already have something in hand to move around on your background paper. You are not starting from zero and your previous choices may reveal visual preferences you had not thought about.

1. One way to start might be to paint a background by filling the whole page with three or more large divisions of colored washes on the white paper. Remember you can always change this if you wish. Some adults like to start by arranging shapes and then painting in background colors.

2. Place assorted cut- and torn-paper shapes on the background and move them around as you did in previous projects. Do not press them into the wet paint. Overlap

*Imperial Five-Clawed Dragon Robe* (detail). Chinese, Qing Dynasty, 1862–74. Satin embroidered in silks, seed pearls, and silver and gold threads, 55 x 35". The Metropolitan Museum of Art, New York, Gift of Robert E. Tod, 1929 (29.36)

Children's collage paintings with yarn in wet paint

When adding a material such as yarn for the students' paintings, make a distinction between the drawing of lines with the yarn and making lines and shapes with the brush. Permitting a young child who is learning to gain control of the tools and materials to dip yarn or paper in paint in order to drag it around the paper is not a productive use of the material. It can become a smearing activity if there is no control.

edges and shapes and then reverse positions of layers until you come to an arrangement you like.

### *ATTACHING, BLENDING, AND OUTLINING SHAPES*

3. You may have to add more paint under the shapes before pressing them down into the background. If the paint pushes out around the perimeters, creating a raised edge, decide whether to keep it as an outline or else blend it into the painting with your brush. Blending edges so that they disappear into the background is another method of unifying the pictorial surface. You can accentuate a raised edge around your added shapes by brushing on a generous amount of unthinned paint in a contrasting color under the edges of the shape; the paint may squeeze out from under the shape when you pat it down. If the paint dries too quickly or some parts of the cut shapes curl up, lift the edges of the shapes and brush more paint underneath them.

4. Paint over any shapes you want to change.

## THINKING ABOUT WHAT YOU HAVE DONE

This is a summation of all your previous projects. Earlier ones demonstrated many ways to unify all the varied materials and colors: by overlapping shapes, softening edges, and extending the gestures of the brushstrokes to change the shapes of the spaces between them. If your texture collage juxtaposed diverse materials without altering individual textures, there was the risk that the previous memory associations from their former identities would take over the life of your image. This "scrapbook" effect happens when the pieces appear to have little visual relationship other than the memories they evoke. You can avoid this problem to some extent by transforming the materials with color, texture, and pattern. You may have already used this technique if you added oil pastel to your patterned-paper collage.

The point of *composition* is to help you say what you mean. By covering up some shapes or patterns with translucent or opaque paint, you make them subordinate to others. Yet, because the outlines are visible under the paint, the shape is revealed as texture in a muted mode. Contrasting visual elements can play against each other or be organized so they do not compete with each other. Decide which aspect is the most important to your composition and then accentuate it by using contrast or by toning some other parts down with paint.

*Usually you start with an idea, and the whole painting is full of surprises, stops, starts, goes. It's work session after work session, evaluating and sneaking up on the painting, trying to change it. Sometimes the painting starts to relate very directly to either sights seen or experiences felt, other times it just goes off on a tangent that you really*

*can't articulate. Some of the pictures are truly mysterious to me, which is why I so often say publicly that I don't know or don't care what they're really about.*

—Susan Rothenberg, American painter, interview in *ARTnews* (February 1984)

## Tips for Teaching

### PRESCHOOLERS

It is important to repeat the studio vocabulary by pointing out size, shape, colors, and textures in new work, so that these elements become important in the process of painting. I was so pleased when a mother told me her four-year-old was sharing art experiences with her grandfather, who loved to paint. Lisa now converses with him by saying, "Grandpa, let's sit down and talk about colors."

A pet, toy, or special interest might provide an opportunity to talk about texture in relation to studio work. For example, five-year-old Raymond was a student who had been praised at home for his drawings of dogs. As a result, however, he tended to repeat the same dog representation over and over again. When Raymond came to class, I talked about the process of painting and making collages as well as creating portraits of subjects through texture. A piece of fur in the collage choosing tray became a treasured item for him. He put the fur down on his paper and created the look of fur texture with his paintbrush. His work became a painting about his love of dogs without the use of his previous repetitious imagery.

I do not ask any youngsters to cut up their own paintings because that might seem to be a rejection of their previous efforts. Since I often offer them small construction-paper and patterned shapes after they have painted for a while, they have already been making collage

Preschool child's collage painting

I do not need to offer very young beginners new projects each week because their growing skills in mixing colors and making shapes is motivation enough for them to continue exploring with the paint. They enjoy the repetition of working with familiar materials in the same way that they delight in the repeated readings of their favorite stories over and over again. It is reassuring for them to have something they know how to do and feel close to.

HOWARDENA PINDELL (American, b. 1943). *Autobiography: Japan (Kokuzo Bosatsù).* 1982. Postcards, acrylic, gouache, tempera, 15 x 11½". Courtesy of The Heath Gallery, Atlanta, Georgia

paintings. Some children attempt to put down their shapes into their paintings after the paint has dried, when it won't stick to the background. When that happens, point out the contrast between dry and shiny wet paint and talk about things that are shiny and reflect light (if they are ready to think about that aspect of reflection). Perhaps someone might be wearing shiny patent leather shoes. Eventually they figure out that when the paint doesn't shine anymore, it won't hold their shapes. In order to introduce the term, put some pieces of shiny paper in their collage choosing trays and talk about the words *shiny* and *glossy* as describing the reflection of light off the surfaces of things.

As you gradually introduce new papers and textured materials into the children's choosing trays for each session, do not be surprised or disappointed if they become more interested in handling and exploring the textures for a session or two instead of gluing them down onto the background paper. When Julia, four-and-a-half years old, saw me show someone how to tie and knot yarn, she became fascinated with making knots and did little else on her collage. However, the next time, after her curiosity had been satisfied, she used the yarn as lines in her pieces.

## OLDER BEGINNERS

I always plan a specific collage-painting project for older beginners, but they may depart from it as long as they are seriously involved. Visual themes might include: the insides of fruits and vegetables, unusual buildings, imaginary creatures, favorite places, things one likes or fears, or the seasons. Although the themes should be broad enough for the students to interpret in their own way, never just say, "Do anything you want." Often, beginners of any age may not know how to start without

exposure to a variety of options provided by discussion and visual displays.

Experienced grade-school and teen beginners who cut and glue with ease may enjoy doing collage painting incorporating tissue paper and paint. I suggest using printed papers (see page 177) or cut-up photographs from magazines rather than any previous paintings. They might also paint their own texture and patterns on pieces of 9-by-12-inch white and colored papers and then use them for collages. A group working together might share the pieces they have printed or collected. Then they can put new pieces into their collages and see how others have used the patterns they have traded. When the collage painting has dried, both children and adults may enhance the surface with oil pastels. Because this colored drawing medium has an oil base, it must be applied to the last or top layer of materials, after which no further water-based paint and glue will adhere to the work. This additional step is purely optional and is offered as another possibility for enhancing the work. Remember that offering too many materials all at once or too quickly will discourage in-depth exploration of any single one. Students of any age may be seduced into displaying the materials rather than transforming them.

# 14. Paper-Sculpture Hats

*Head of a Colossal Warrior.* Etruscan, 20th-century copy of 5th-century B.C. original. Terra-cotta, height 55". The Metropolitan Museum of Art, New York, 1916 (16.117)

## *Materials Checklist*

- Set up a display of photographs and art reproductions in which people are wearing hats, crowns, or helmets. Include among these an example of a hat with a round brim and another one with a crown.
- Construction Paper: Prepare at least two large sheets of paper for each experienced school-age beginner or adult in the following dimensions:
    - A. One 9-by-24-inch strip for a crown
    - B. One 18-by-18-inch square for a brim
    - C. A few additional sheets of paper for add-on parts and projections. Paper pieces remaining from past projects may also be useful.
- A small amount of found decorative material for experienced beginners: small foam packing pieces, pages of type from newspapers or magazines, and wire. Also useful for decorating are thin structural wires such as florist's wire, trash- or vegetable-bag ties from a grocery store, or pipe cleaners from a variety store. Ask gift or appliance stores for discarded packaging materials.
- Scissors
- White glue and paper mat
- Optional: Glue sticks, stapler, paper fasteners, and mirror

FOR PRESCHOOLERS' BONNETS:
Precut a 9-by-12-inch rectangular construction-paper shape with rounded corners. Include some tissue and patterned paper and some decorative materials in the children's choosing trays, making sure these are soft and flexible so they do not pop off when you curve the two sides of the back together.

- Pieces of yarn for bonnet ties
- Stapler and hole punch

I first experienced this project in the parent-child classes at The Museum of

Full suit of armor. Japanese, c. 1550. Blackened and gold-lacquered steel, flame-colored silk braid, gilt bronze, stenciled deerskin, bear pelt, and gilt wood, height 66" (48 pounds). The Metropolitan Museum of Art, New York, Rogers Fund 1904 (04.4.2)

Below:
Helmet with gilded wooden dragon crest (shown without antennae). Japanese, 16th century. Iron and wood. The Metropolitan Museum of Art, New York, Rogers Fund, 1904 (04.4.2a)

A hat can tell others where you are going or what you are doing. Its shape and decorations can tell about time, place, or climate, about the personality of the wearer, about status, rank, or social role. When imagining the hat of a pope or crown of a king, one thinks of its use in ritual and ceremony, while the helmet of a football player or astronaut brings to mind a protective role.

Helmet. Japanese, late 16th to early 17th century. Iron, brass, lacquered neck guard laced with silk cords; top rises in six wedge-shapes points (called tea-bag shape), height 12¼". The Metropolitan Museum of Art, New York, Bequest of George C. Stone, 1936 (36.25.148. a-b)

Head from a statue of a king (Amenemhat III?), wearing a double crown of upper black granite. Egyptian, c. 1850 B.C. Height 16½". The Metropolitan Museum of Art, New York, Gift of Dr. and Mrs. Thomas H. Foulds, 1924 (24.7.1)

Modern Art with my daughter, who was three years old. At the end of the hour everyone was so delighted with their creations that we wanted to parade through the museum to show them off. Although we had worked on them with great seriousness, the process had generated an instant party and we wanted to share our pleasure. The designers as well as the materials were transformed in the process.

I have made paper sculpture hats with people of all ages and it always works well. Under all circumstances it seems to make people happy. Even a few older men, very hesitant in the beginning because they thought the idea was childish, ended up in high spirits, delighted with what they had done. Sometimes the adults make hats for the children and the children make hats for the grown-ups and then they try on each other's creations.

Although headcoverings sometimes may be dismissed as springtime accessories or fashion postscripts, they have always been both a vitally necessary protection against the weather and a vehicle for flights of imagination. Wide-brimmed sun hats shield the eyes from glare and, before heated transportation, hats were essential when walking in the cold or riding in freezing carriages. Until the invention of hair spray and permanents, fancy coiffures would collapse or be destroyed by the weather without the protection of headcoverings in wet weather. With no central heating, hats were worn indoors and nightcaps in bed for warmth. Over the years, these objects of necessity became transformed into extravagant symbols of glamour and social status. Some casual hats are soft, floppy affairs, other hats are more architectural and geometrically formed. The crowns of kings, armored and protective helmets, officers' hats, and popes' and nuns' headpieces are more sturdily structured and often very sculptural.

ALBRECHT DÜRER (German, 1471–1528). *Portrait of Ulrich Varnbuler.* 1522. Woodcut, 17⅛ x 12¹⁵⁄₁₆". The Metropolitan Museum of Art, New York, Avery Fund,1919 (19.70.6)

Hats can be seen as pieces of sculpture. They go up in the air and you can see all around them. If you can see your hat project as sculpture instead of thinking of it as only a hat, you can invent more freely and depart from the usual symmetry common to most head coverings. Hat-making is a subject for organizing sculptural form in the same way you used themes for arranging your collages and paintings to convey a mood or visual idea. Many artists have been commissioned to design sculptural and painterly costume pieces for theater and dance companies: Pablo Picasso, Marc Chagall, and David Hockney for theater and opera, and Picasso and Henri

HENRI GREVEDON (French, 1776–1860). *Pourquois pas!
(Why not!).* 1831. Lithograph, 12½ x 11". The Metropolitan
Museum of Art, New York, Harris Brisbane Dick Fund,
1940 (40.121.2)

REUBEN MOULTHROP (American, 1763–1814). *Sally Sanford Perit.* 1790. Oil
on canvas, 36¼ x 29¾". The Metropolitan Museum of Art, New York, Gift of
Edgar William and Bernice Chrysler Garbisch, 1965 (65.254.2)

Monumental or miniscule, eigtheenth- and nineteenth-
century hats became splendid ornate gardens of jewels
and flowers, feathers and fur. Hats for both genders
adopted abstract sculptural forms: men's tricornes and
bicornes, bowlers and boaters rivaled women's bonnets
of haute couture.

Matisse for the Russian Ballet. Historical outfits such as ancient suits of armor are also good examples of sculptural costumes. (See the illustration of fifteenth-century Italian armor on page 247.)

Introducing the study of sculpture with the theme of making a hat is less intimidating to beginners than telling them they are beginning to sculpt. This project covers many basic three-dimensional concepts in a lighthearted way as well as connecting with the dynamics of shape and composition from past projects. When students look back at all the elements they have incorporated into the completed piece, they realize what they have learned and are proud of their accomplishment.

## *Demonstration for Young Beginners with Adults*

*As* always, vary the length and vocabulary of this presentation according to the ages and attention spans of participants.
1. Introduce the subject of hats and ask the preschoolers when and why we wear them: when it rains, to keep warm, and so on. "Did you ever go to a party and wear a special party hat?" Most of the children have had that experience. "A hat can tell others where you are going or what you're doing. It can tell about the time, place, or climate: about the wearer, who may be an athlete or who may have a police or military rank."
2. "Today everyone is going to make a paper sculpture hat. Why do you think I call it sculpture?" Some already know the answer from previous work with clay. "Because, just as sculpture does, a hat goes up into the air and you can see all around it. Now I'm going to show you one kind of hat that some of the grown-ups may want to make today. You will make a very spe-

cial collage hat after you finish painting."
3. Find a photograph or an art reproduction of someone wearing a round-brimmed hat. At the museum workshops, I show a reproduction of Rembrandt van Rijn's painting of his son, Titus, wearing a hat with a brim. "This is a reproduction of a painting by Rembrandt who loved to make paintings of people in beautiful clothes and hats." Then point to the brim of the hat. "Do you know what this part is called? This is the brim. What kind of a shape is it?" ("A round shape.")
4. Brim construction: Hold up a square (approximately 18 by 18 inches) of construction paper while asking, "How can I make this into the brim of my hat?" (They may or may not know, depending on their age.) Put the point of your scissors into the paper and cut out a circle approximately seven inches in diameter near the center. "I'm making a see-through shape so that it can fit on my head. It doesn't have to be a perfect circle because nobody's head is perfectly round." Then put it on top of your head and leave it there while asking, "How can I make this shape round?" (They know that I must cut the corners and tell me so.) Take the brim from your head, cut at least two corners from the square, and, if you wish, cut a see-through shape from one of the remaining corners.
5. Crown construction: Hold up another reproduction of someone wearing a crown. "Can you guess what the top part of the hat is called?" I show another Rembrandt painting with a woman wearing a crown. "The part that goes up into the air is called the *crown*, just like the top of your head is also called the crown." Sometimes I may remind them of the nursery rhyme about Jack and Jill, where Jack fell down and broke his crown.

Take a long rectangular piece of paper and explain how to make tabs for fastening the crown to the brim while

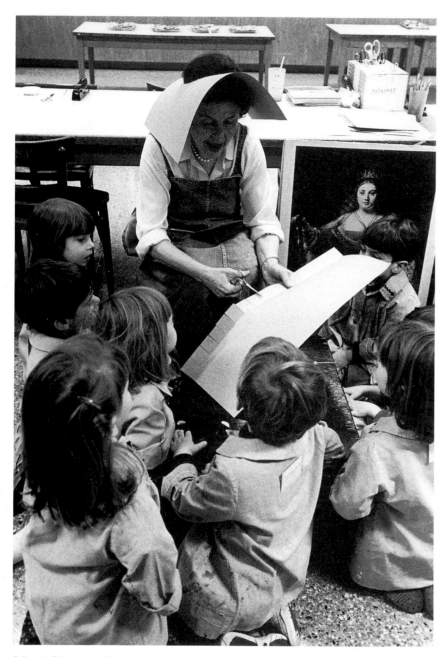

Muriel Silberstein-Storfer cutting tabs while demonstrating the construction process

demonstrating the tab-cutting process. Here you may also explain to the young children the difference between a decorative fringe and a functional tab.

After tabbing, roll the rectangle into a tube and put the brim over this *unglued* cylinder. The brim will hold it in place while you pick it up and put it on your head to show everyone. Take it off of your head and put it down on the table to continue.

6. In order to encourage everyone to examine all of their leftover shapes, demonstrate how to make a long thin "slinky" spiral shape from the round, flat cutout leftover brim piece. This originally flat shape can be pulled up to make a three-dimensional spiral projection or can be wound around the crown. "Some people have made smaller ones to drape as curl-like appendages or weave in and out of other open shapes."

7. "This is only one way of making a hat. You are going to make another kind of hat." Show some more photographs and art reproductions of paintings and sculptures with different kinds of hats to demonstrate that hats can be made in very unusual shapes.

Before the children go to their places to paint, suggest that they might want to make a painting of a hat or somebody wearing a hat. After the youngest beginners are painting at their worktables, continue to show the adults how they may change the basic hat configuration.

## *Demonstration, Part 2, Adult Hat Project: Making Variations on a Theme*

*A*s always, looking at many reproductions will inspire ideas for making this project. The images offer an opportunity for discovering new ways to transform and

personalize the basic structure instead of merely embellishing the surface of the parts. Many people cannot wait to start decorating the hat and thus do not think of developing any three-dimensional shapes underneath the trimmings. Just as you divided the backgrounds for your paintings and glued-paper experiments, here you are doing the same thing by building up your forms first. Think of yourself as an architect establishing a three-dimensional building structure and then manipulating the relationships of individual components.

While building the basic structure, try to think of things that will make it more three-dimensional instead of using the paper sheets flatly. (See the work by Albrecht Dürer illustrated on page 221.) Possibilities include rolling the brim, cutting out concentric spirals and pulling them open to make them stand and curl over, fringing parts and folding the tabs in various directions, or cutting holes so that a part becomes a see-through shape.

Avoid the kinds of patterns and procedures, found in some kits, that are difficult to change or transform once the initial cuts are made. Your goal is to assemble separate shapes into a complete arrangement just as you did with your collages. Each piece can be changed both before and after it is joined to another part. Moreover, you may discover your own ways to put the parts together. Try assembling the crown and brim pieces so that they do not resemble the top hat indicated in the basic proportions of the sheets of paper; layer several brims going up the side of the crown; or put the brim on top like a graduation mortarboard instead of at the bottom. Cut the crown shorter or keep raising it up by cutting tabs into the edges of each crown cylinder to glue onto other pieces. Cut your wraparound brim into many shapes, put a visor on one side, turn the brim into ear flaps, glue it up onto the

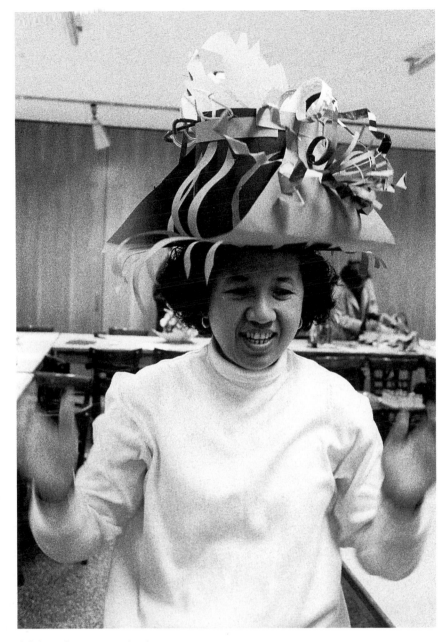

Adult student wearing her hat

Making a paper hat

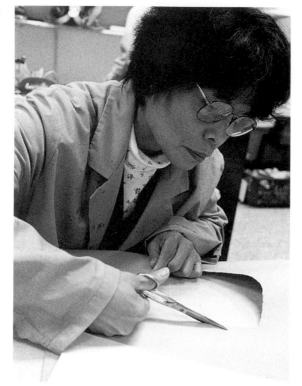

Cutting the hole in the hat brim

side of the crown, or fringe it. Treat your hat as a three-dimensional collage; if you cut off too much in any place, glue on additional pieces.

1. Brim: Using your 18-inch-square sheet of construction paper, cut a rounded shape in its center by poking your scissor point through the sheet and cutting a round circumference about seven inches in diameter or smaller, depending on the size of your head. Be conservative about the size on your first cutting. Then try the open shape on your head, enlarging it if necessary. Do *not* fold your square in half to cut out the hole. Not only will folding put an unwanted crease through the center of your brim, but it may also produce an oversized opening. By folding the brim in half you would also be likely to establish a static bilateral symmetry that might prove difficult to depart from.

Remember, this is a sculpture, subject to the same principles of contrast and variation as your previous compositions. Using

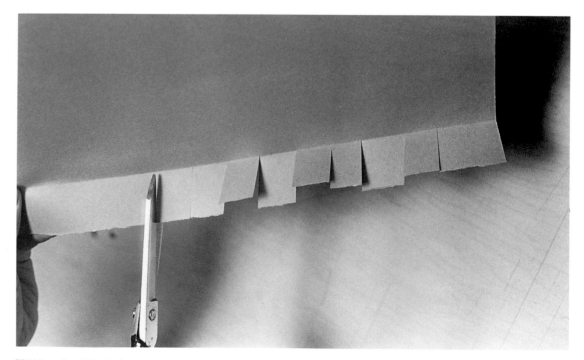

Tabbing the folded edge

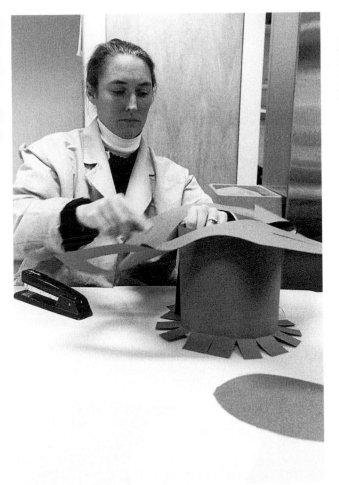

Putting brim over crown

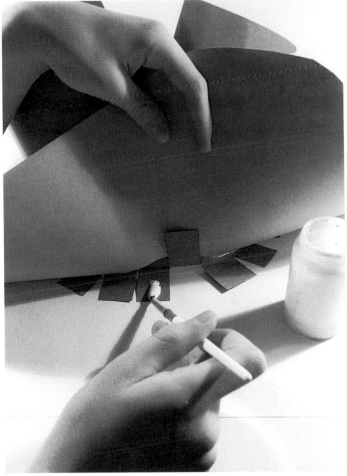

Putting glue on tabs

the theme of a hat does not rule out asymmetrical balances. I often suggest cutting the hole for the brim off center to create a less visually static structure.

If you have made the opening too large, there are several methods of making it fit. For example, you can pleat or flute the inside edge of the hole by stapling or gluing it. Sometimes this is so effective in shaping the brim that I have seen students enlarge the hole still further and make more pleating.

2. Crown: Make tabs on your 9-by-24-inch strip of paper by folding over the long edge about an inch and a half and creasing it. Then reopen the folded edge and make cuts about one inch deep at every inch along the now unfolded edge.

3. Assembling the parts: Roll your crown strip into a cylinder (but do not glue it closed yet) and insert it into the hole in the brim. You should not seal the crown edges in advance of the assembly because you will have to overlap its edges more or less in order to make the crown fit into the diameter of the hole in the brim.

4. Glue the cylindrical crown onto the brim by lifting the sides of the brim and applying glue to the tabs. Leave two tabs on opposite sides free if you want to make

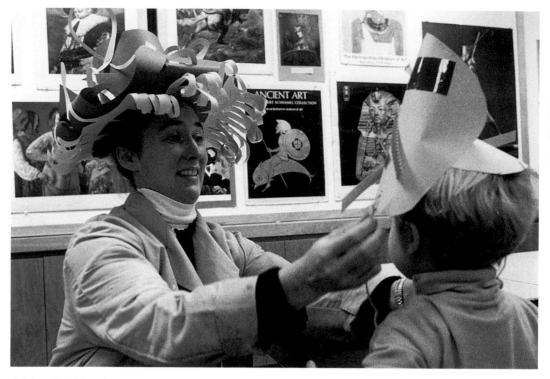

Adult and child with paper extensions on their hats

tie-on holes in them. Keep the vertical seam of the cylinder open so you can mold the shape gluing the tabs of the crown onto the brim to attach the two parts.

5. Shaping the basic structure: Try many possibilities for altering both the brim and crown from the initial proportions. For example, if you leave the crown open you might cut into its sides to fringe it, and bend the fringes outward. If you cut the crown into strips that curve across the top of the head you may then glue them together into a dome. If you cut see-through shapes into the crown or brim you can pull other materials through these apertures or leave them open.

6. Adding more shapes: After you are satisfied with the three-dimensional structure, you may begin to attach strips of paper curled with scissors, or wire to build protruding linear or planar shapes. These elements may overlap other forms, just as you overlapped, painted, and cut forms on your earlier projects.

7. For subsequent hat projects, you might want to add paint or oil pastels to create additional patterns or to accentuate certain shapes. Using found textural materials for giving the surface a unique character would be another possibility.

## THINKING ABOUT WHAT YOU HAVE DONE

When you made your collage paintings, you thought about many different ways to indicate what was important in your arrangements through the devices of contrast and repetition of colors, textures, lines, and sizes of shapes. A hat can be considered in the same way by using the

principle of contrast in the basic hat parts: The brim was a planar surface, the crown was a volume, and added strips, wires, fringing, paint, or oil-pastel marks produced lines. Each of these elements had a different quality of shape.

Emphasis on one of the parts may have been determined by its color and size. If you painted one section in very bright colors and the rest in muted ones, the bright area will have stood out. If you made a tall top hat, the voluminous crown may have dominated. A sun hat with a wide brim and low crown might have made the planar aspect of the brim most prominent. If both brim and crown were small, but added long strips or parts projected out from the hat, the piece might have emphasized linear qualities. The comparative relationship between parts is called *proportion.*

How you ordered the proportions on your arrangement determined your emphasis, or the visual theme expressed by the whole composition. Each part made a kind of gesture into space. If you had a tall crown rising from a narrow brim, the hat may have conveyed the idea of vertical monumentality, exemplified by the Empire State Building. If the brim was the biggest part and it spread out sideways and curled upward, the main gesture might have been one of horizontal flight like that of a bird. If you had a large ballooning or expanding top like a chef's hat, it might have reminded you of the growth of a mushroom or an expanding popover biscuit rising out of a baking pan. If all the parts are of equal size and visual weight, no specific quality will dominate.

Your collage painting used overlapping paper or painted shapes to join areas together visually. Here you may have joined shapes either by putting them up against each other with tabs at their edges or by making individual parts penetrate each other. If you had stacked several

brims up the sides of the crown, the crown would have appeared to penetrate the brims. If you had paper strips, wires, or other materials attached inside the crown that stood out from the hat, they would penetrate the crown. This interpenetration of shapes is a kind of three-dimensional overlapping.

## Craftsmanship

Craftsmanship is a learned skill and also displays an awareness and ability to make elements hold together visually as well as physically. Every wrinkle has to be considered as part of the design. If you make only one crease, it may look like a dent, but if you make several of them, it may become a pattern. Even if what you do to the paper is an accident, if you shape or dramatize the event, it looks intentional. Legend has it that when First Lady Jacqueline Kennedy was photographed with a dent in one of her pillbox hats, milliners seized on the idea of producing hats with a conspicuous crease in the shape as a fashion statement.

Emphasize craftsmanship in this project so that older beginners gain mastery of their tools and materials to make forms stand up and hold together with repeated handling. If you do something you are not satisfied with, it is not a mistake if you can figure out a way to use it as a further development in the design so that it looks purposeful.

## Advanced Projects: Other Three-Dimensional Forms in Paper

After doing these projects, free-form paper sculptures and hanging collages are now within the capability of you and older,

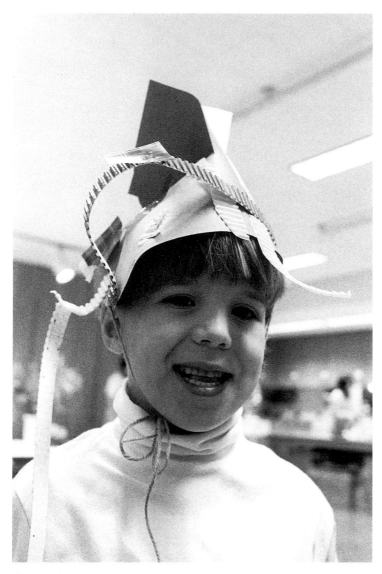

Child in finished collage hat

## Tips for Teaching

*W*hen you are guiding beginners, try to space your distribution of both materials and information. Beginning teachers are often so insecure about their own abilities to interest students in the projects that they may overcompensate for lack of knowing what to say by overloading the class with too much material or information too soon. You may be inclined to do this with older, school-age children who may act indifferent to cover up their own lack of self-confidence and experience.

### PRESCHOOLERS' HATS

A hat with a brim and crown is far too complicated for preschoolers. In this workshop, when I demonstrate how to make a hat with a crown and brim, it is simply to let the children know what the grown-ups are doing so that they are less tempted to want to go over and watch them instead of working on their own activities. The youngsters also pick up a certain amount of information this way. I do not expect the youngest ones to be able to slit, overlap, and close the back since a loaded collage often presents a challenge as to where to put the slit. I may refer to it as a party hat or for the boys, a Robin Hood hat.

 After the young beginners finish their paintings, they make collages on the 9-by-12-inch precut rectangular shape (with rounded corners). While they are working, I show the children an example of a collage that has been made into a hat and suggest different possibilities for developing their own collage hat. If the children have cut into their collages to such an extent that it would be difficult to function as a hat, offer another background paper onto which they can glue their pieces. When they finish, an adult will slit, over-

more experienced beginners. However, you will have to do a bit of research and experimentation on your own to guide advanced projects such as making full costumes in paper. Exploring these together and sharing your trials and errors may be more enjoyable than if you assume an authority role. Histories of art and costume books will provide good source material for getting ideas.

lap, and staple the edges closed. Some-
times the children prefer to keep their flat
collages and make an entirely different
arrangement specifically for a hat. Finally
I punch holes in the appropriate places for
putting on the tie-strings.

Rather than making everyone adhere
to a rigid idea, if younger children have
other ideas and wish to try more compli-
cated hats, together we work to figure out
ways to make a head covering that they
like. Some finished hats are most unusual!

## SCHOOL-AGE BEGINNERS' HATS

More experienced school-age children
may enjoy making hats with a brim and
crown. However, because the tabs of the
crown are difficult to handle, the students
need a certain amount of dexterity and
perseverance to accomplish this. Be careful
you do not take over and assemble the
pieces of the hat for them. If you find that
the crown-with-brim hat is too difficult
for them to enjoy making, switch over to
the simpler collage bonnet or have them
make a collage, open-top crown without a
brim and without tabs from a wide strip
that can be wrapped around the head and
fastened.

If the students prefer, they can make
three-dimensional masks instead of hats.
The masks can be structured for any
degree of experience, from simple shapes
to elaborate paper sculptures. Show illus-
trations of Asian, Oceanic, African, and
other ceremonial masks for inspiration.
Although some people can use paper bags
creatively for hats or masks, I prefer to let
everyone have the experience of cutting
out and assembling pieces themselves
in order to encourage learning how to
construct forms.

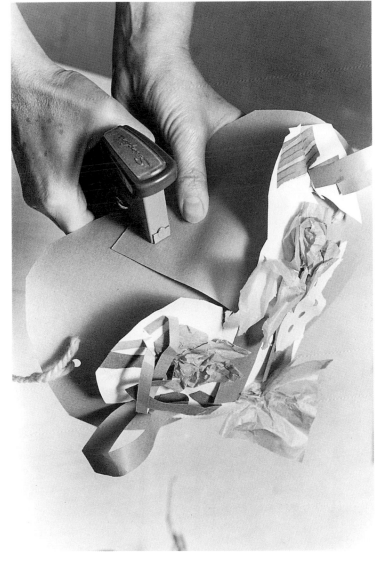

Stapling preschooler's hat: Cut a slit about one-third of the way up
the center back, overlap the edges of the cut to form a bonnet shape,
staple these pieces, and add the tie strings.

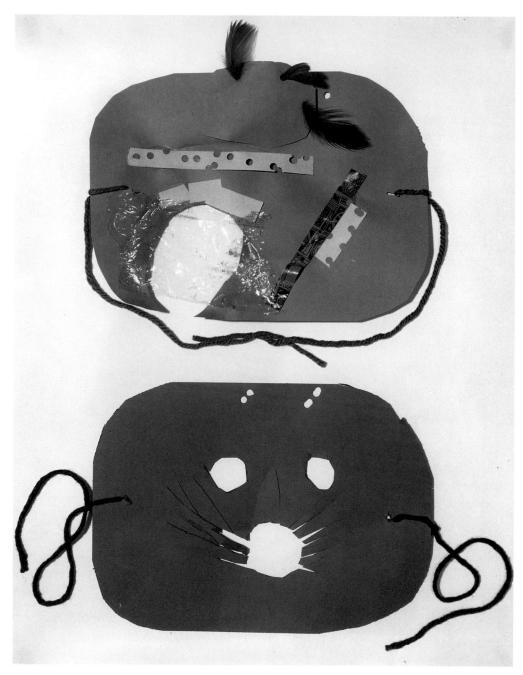

Masks by four- and five-year-olds

Making hats and masks can be an especially enjoyable activity at birthday parties or holiday celebrations.

At Halloween, you can turn to mask-making, substituting reproductions and photographs of masks for those of hats and talking about why and when people wear masks.

*Wood Sculpture.* Upper Volta Province, Nigeria, 19th–20th century. Wood, twisted fiber cord, and pigment, length 16¾". The Metropolitan Museum of Art, New York, The Michael C. Rockefeller Memorial Collection, Bequest of Nelson A. Rockefeller, 1979 (1979.206.201)

*Mask.* East Sepik Province, Papua New Guinea, 19th–20th century. Abelam-style painted basketry sculpture, height 14½". The Metropolitan Museum of Art, New York, The Michael C. Rockefeller Memorial Collection, Bequest of Nelson A. Rockefeller, 1979 (1979.206.1563)

# 15. Clay Sculpture: Getting Acquainted with Clay

*Sculpture is like a journey. You have a different view as you return. The three-dimensional world is full of surprises in a way that a two-dimensional world could never be.*

—Henry Moore, British sculptor, in Robert Melville, ed., *Henry Moore: Carvings and Bronzes, 1961–1970*

*To form something with clay, whether to use or to look at, is one of the most basic human experiences available to all of us. In an age of ready-mades, where we are not given an opportunity for full participation in the object of our lives, the highly plastic material of clay offers us that now rare experience of seeing something through from the very beginning.*

—Paulus Berensohn, *Finding One's Way with Clay*

*Materials Checklist*
*Preparing the Clay for Use Before the Workshop*
*The Art of the "Bump and the Hollow"*
*First Experience with Clay: Preparatory Exercises for Adult Leaders*
*Acquainting Young Beginners with Clay*
*Preparatory Project for Preschoolers: Foam Constructions*
*Demonstration for Preschoolers with Adults*
*Demonstration, Part 2, for Adults and School-Age Beginners:*
 *Making Fantastic Shapes and Mythic Creatures*
*Sculptural Environments for Grade-School*
 *Beginners*
*Foam Constructions for Older Beginners*
*Reconditioning Dried Clay*
*Wedging Procedures for Clay to Be Fired*
*Tips for Teaching*
*Expanding Experience Beyond the Studio Walls*

Zebu vessel. Iranian, c. 900 B.C. Earthenware, 11⅝ x 5½". The Metropolitan Museum of Art, New York, Roy R. and Marie S. Neuberger Foundation, Inc., Gift, 1961 (61.263)

AUGUSTE RODIN (French, 1840–1917). *Burghers of Calais.* 1884–95 (1985 cast). Bronze, approx. 82½ x 94 x 75". The Metropolitan Museum of Art, New York, Gift of Iris and B. Gerald Cantor, 1989 (89.407)

## *Materials Checklist*

■ Reproductions to illustrate contrasts and similarities of types of shapes, edges, textures, and open spaces within sculptural forms. When you discuss these, also try to review the vocabulary from the painting classes, including the concept of *gesture,* or directional movement of form. Before and after demonstrating the clay working process, I also use a large quantity of smaller photographs from magazines showing a wide variety of forms in nature to illustrate that all shapes exist somewhere in nature or myth no matter how fantastic they may seem.

■ Approximately five pounds of gray, water-base potter's clay (enough for two people for this first project)

■ A small covered plastic garbage pail (a four-gallon size will hold about fifty pounds of clay), a plastic liner bag, and damp cotton rags to cover unworked clay for long-term storage inside the covered container

■ Resealable plastic bags or thin plastic such as dry-cleaners bags to store unfinished works you wish to develop further.

Wrap the clay shape in damp paper towels or rags before enclosing it in plastic and store it in a relatively cool place (not windowsills or radiators).

■ A sturdy table for preparing the clay
■ A movable sculpture surface or base such as 12-by-12-inch square of vinyl sheeting, floor tile, linoleum, or other smooth surface for setting your piece on and turning it as you work
■ A rigid 12-inch square of stiff cardboard to put your finished piece on while it is drying. Up until this project, young children have been working directly on the waterproof, smooth surface of a table without using any base.
■ Waxed paper to cover the cardboard base while applying and drying the wet glue to the piece so that this coating does not stick to the base
■ A mixture of half white glue and half water, about one ounce total for two people for preserving unfired shapes. You may already have a jar of this mixture left over from your tissue-paper projects. Add a bit more glue for the sculpture coating if the solution is too runny to stay on vertical surfaces. You may also have to use undiluted glue for attaching heavier materials to your Mythic Creature.
■ An inexpensive, soft paintbrush, approximately one-quarter inch in diameter, for applying the glue mixture
■ Tongue depressors to carve into the clay
■ Sponges or cloths for cleanup
■ Optional additional materials for the second adult clay project: pipe cleaners, textural and decorative materials, such as those listed below for the preschoolers' constructions

### FOR PRESCHOOLERS' CONSTRUCTIONS:

■ Toothpicks, corrugated paper strips and small shapes, packing foam, pipe cleaners, straws, applicator sticks, plastic mesh (optional)

## Preparing the Clay for Use Before the Workshop

*I*t is very important that the clay be soft and malleable for both young and older beginners. Many people do not have the muscle strength to work hardened clay and, if they have difficulty shaping the material, they may become discouraged. As they develop more coordination, strength, and skill, older students can help prepare the clay for these workshops themselves.

Make sure you check the consistency of your clay *the day before* each workshop session so that if it needs reconditioning you do not have to spend class time preparing it. This is especially important if you are having workshops with young children with limited attention spans or even with older beginners who have little time to spend on the studio project. (See page 251, Reconditioning Dried Clay.)

## The Art of the "Bump and the Hollow"

*S*culpture emphasizes the physical and tactile qualities of things: hardness and softness, heaviness and lightness, tautness and slackness, smoothness and roughness. One reason three-dimensional forms are so compelling is that they physically project out at you and assert their presence in space.

Painters also have often made sculpture in order to learn intimately the forms of what they want to paint. For example, Edgar Degas sculpted dancers and horses to explore issues of form and movement in the same painting subjects. Henry Moore also prepared for his larger works by making small models, or maquettes, about the size of the shapes you will be working with in your project.

The French sculptor Auguste Rodin once called sculpture the art of the "bump and the hollow." When you put your fingers into the clay and squeeze, move, and turn it in your hands to pull out forms, you will begin to see what sculptors and potters have experienced through the centuries when working with clay. Touch a soft piece and it instantly records your unique fingerprint. Many people find that working directly with the hands is emotionally compelling. Kneading, stretching, and rolling clay can be compared to working bread dough, yet the potential for shaping forms is everlasting. Others say that working with clay gives an immediate sensation of thinking with their hands. The flexibility of clay is a quality people seek in their own lives, the ability to change things and to move into new forms.

A woman in my class who enjoyed all the projects became elated when she put her hands into the clay. After class she told me, "Now I have found what I most want to continue doing. Working with clay is like coming home." She subsequently took other courses in sculpture.

Although many people find an instant affinity with the medium, some take more time to feel comfortable with it. One participant confided to me that it had taken her almost the whole hour before she gained enough courage to press her fingers deeply into the clay and do more than merely make lumps on its surface.

*Feeling the wet of clay*
*Is feeling a connection*
*With all the civilizations*
*    of humans*
*Forming the same material;*
*A connection of the soul,*
*Sensuous and plain;*
*A connection with time,*
*When there are moments*
*Like a rush through eternity*

—Poem by the artist

MIMI GROSS (American). *Portrait of Jody Elbaum.* 1980. Unglazed ceramic before painting, 23 x 18 x 13". Courtesy of the artist

Many beginners model bas-relief shapes on top of the material without exploring the possibility of constructing form by pulling it out from the interior of the clay.

## First Experience with Clay: Preparatory Exercises for Adult Leaders

*B*ecause it is important for you as the leader to be enthusiastic and comfortable with the medium, before you start your project, take enough time to feel at home with the clay with the following procedures.

1. Pick up a prewedged (see page 253) lump of clay approximately six inches in diameter and begin squeezing and pulling at the piece. If you find it too heavy or unwieldy to work in your hands, you may have to pull off some material from the main mass to make it more manageable.

2. From the very beginning, keep turning the clay in your hands as you press into it and look at it from all sides. Working up off the table makes the process easier and more stimulating to the discovery of imagery when modeling forms. Beginners often end up working on the surface because they manipulate the clay while it is flat on the table.

Continue working the shape in your hands instead of flat on the table. Then you will be able to turn it easily and can feel how the surfaces turn and wrap around the sides. Most of all, you will more easily be able to generate forms that penetrate clear through the mass of clay, discovering forms you might never have found if you had just left it on the table. While working on a base is a necessity for shaping forms too heavy or large to hold in the hands, the small size of this project should pose no problems for people without physical handicaps.

3. Exaggerate and build out bumps and deeply gouge hollows into the mass instead of only working gingerly on the surface. Think "fat and heavy" for this project because very thin projecting parts will be fragile and may crack off easily if bumped or touched. (When sculptors model these forms for public display, they may fire the work or have the piece cast in metal.)

4. You will find that if you pinch the edges of shapes so that they are very thin they may crack off as the clay begins to dry. Some beginners think that if you smooth down a surface crack with water it mends itself. It does not! When clay dries it shrinks, and the crack will reopen. You have to work both edges and press the crack closed.

### JOINING SHAPES

Once, when I was demonstrating how to join shapes, one adult said she had been taught in school never to add on pieces, but rather to only pull them out of the main mass. Some instructors apparently discourage beginners from making complex sculptures by joining separate forms together. Pulling-out, or *extrusion,* of shapes may make it easier to create transitions between parts because extruded forms appear to grow out of the main body of the piece; however, some young beginners lack the patience and necessary hand strength to squeeze the clay for extended periods and also need time to develop the strong muscle coordination for this practice. We will learn both methods of joining shapes.

Almost everyone is quite capable of securely joining separate pieces once they know how. If the clay is extremely soft and plastic, you press one piece onto the other firmly and work the surfaces together with substantial pressure using your thumb to

blend the surfaces on all sides of the joint. If the clay is a bit firmer, roughen up the two surfaces to be joined with a tool such as a stick or tongue depressor, press them together, and work over the joined clay parts in the same way. The important thing to remember is to connect the parts with enough pressure on the roughened surfaces so that you make an internal bond and not merely a surface joint made by smoothing over the clay.

Remember that the thinner parts, made either by pulling out or by joining on, will dry more rapidly than the thicker ones and may crack the piece if it dries too quickly. Clay sculptors and ceramicists cover wet clay loosely with plastic to slow the drying and shrinkage.

If the clay has become hardened, and you want to continue adding parts, you will not only need to roughen the surfaces to be joined, but you will also need to work moisture into the joint to soften it. (Some ceramic sculptors also use cider vinegar here and then weld the parts together with finger pressures.)

## Acquainting Young Beginners with Clay

Since in the one-hour classes at the museum, preschoolers use paint, collage, and clay during every session, I work at the clay table with them from the very first class, without attempting to make any representational imagery. We pound, push, pull, break, roll, and stick our fingers into the clay. Some begin to manipulate the clay immediately and others are hesitant. Your job is to help them discover how it is possible to shape the medium. First the preschoolers begin to stack or pile up pieces and pat down the clay. Then, as their hands gain strength and skill, they begin to form simple shapes.

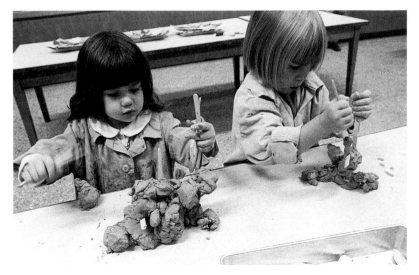

Two preschoolers with piled-up shapes

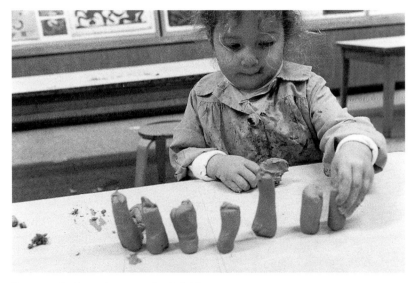

First simple shapes by a preschool child

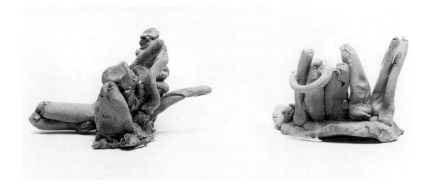

Preschoolers' joined shapes

Never force beginners to use any material. If your enthusiasm has failed to entice anyone into handling the clay, offer them a tongue depressor or other stick to shape it. Usually, before they realize it, they are putting their hands into the clay.

If there is conversation, try to direct it toward describing what the youngsters see in terms of shapes and gesture. Point out how they can make their shapes change, how a round shape can become a long one or a "see-through" can be closed up. To illustrate familiar gestures, roll a shape and then bend the clay over, sit or stand it up, and describe what you are doing. It is important both to show and tell what you are demonstrating or someone may not understand. "You can make your shapes stand up or lie down. What do you do when you go to bed? Do you lie down?" (They always answer yes.) Then I make my standing shape lie down. "And what happens when you are awake? Do you get up? I think I'll make a standing-up shape." Then make the clay stand up again. One day when I made my shape lie down a child offered to make a blanket for the lying down shape and another made a pillow shape. Older beginners, around six years old, will understand the meaning of the word *gesture,* but preschoolers' vocabularies are more limited to their daily experience.

If I still see after a few weeks that preschoolers are still piling up clay bits without manipulating them, I may close my eyes, squeeze the clay, and say, "I'm going to give myself a surprise." And when I open my hands I say, "Look at the shape I made. What else can I do to it?" Often, they will offer alternative ideas for shaping it.

After some of the children saw a Thanksgiving Day Parade, we discussed the sizes and shapes of the inflated balloons and floats. We talked about what a parade is and the possibilities for making our own parade of shapes on the table.

Sometimes the children contribute pieces to a parade with enthusiasm. Other times, no one is interested until perhaps a week or two later, one of the children may decide to make a parade, and the idea will take off with vigor once it has become their own. However, if everyone is busy shaping their clay, I say very little. It is not necessary to have conversation if everyone is engrossed in their work.

To recycle clay pieces, break them up into small pieces and put them back into the storage container lined with a plastic bag. Then cover the clay with damp rags and close the plastic well before replacing the clay storage container with an airtight lid.

## Preparatory Project for Preschoolers: Foam Constructions

*I*n this project, designed to be done in the classes prior to when preschoolers make clay pieces to save (pages 242–45), youngsters learn to connect foam materials with flexible pipe cleaners, sticks, and straws. Previously, rigid applicator sticks and tongue depressors were simply remotivation aids when working with clay. It is helpful to demonstrate how to bend these new materials because, otherwise, preschoolers will just poke them into foam the way they put sticks into clay. The purpose of using flexible connectors here is that the children learn both to shape the linear elements and also to join forms.

Since regular routine is comforting for young children, I start with the clay first in this session before going to the packing foam. This project is not a substitute for working with clay but an addition to it. The fact that the foam is a stiff material puts the emphasis on *connecting* rather than on *changing* shapes.

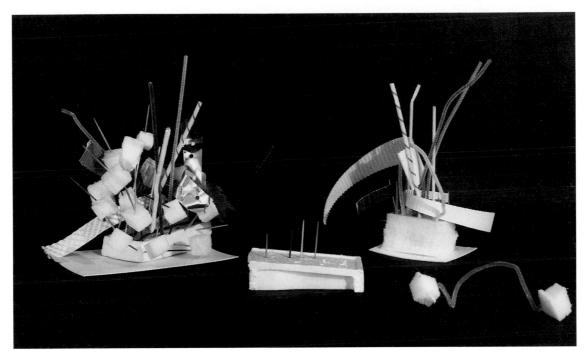

Three- and four-year-olds' foam constructions

Three- and four-year-olds' flying machines

After the class has finished working with clay for the day and the youngsters have washed up, I distribute one-to-two-inch irregular and rectangular pieces of plastic foam and wooden toothpicks (the ones with two pointed ends). We sit around a table together and I demonstrate how to connect the shapes with toothpicks, pipe cleaners, strips of colored and corrugated papers, and plastic straws to build larger assemblages of forms. If the children have assembled plastic slotted shapes, building bricks, or other assembly toys or games at home or at preschool classes, they will probably understand how to put these materials together. Finally, I bring out a few colored feathers and let each person choose one to insert into their shapes. If you put out too many decorative materials at the start, beginners may merely embellish single foam pieces without connecting any of them. Hold some of these back until after the students have begun to connect their shapes.

You can also cut up used plastic-foam cup bottoms to make round see-through hoops, and relatively soft egg or nontoxic foam food cartons to make other shapes. Although variety and art-supply stores sell sheets of polystyrene in varying thicknesses, this can be expensive to purchase for a large group. Appliance and gift stores often discard packing slabs, chunks and bits of all sizes and widths. Because some grades of packing foam crumble when you break them and are not as easy to work with, try out all materials yourself before offering them to beginners.

Of course, if you find that some beginners are not interested in this project but have something of their own in mind, encourage their initiative. Once I planned a special project for a group of four- and five-year-olds to help them think about connecting shapes. I gave them clay and sticks to make a construction and then suggested that they make a painting based on the idea of contrasting and connecting shapes with lines as they had done with the clay. David, however, was not interested in the sticks once he got his hands into the clay. He molded a dinosaur and then did two complex paintings of dinosaurs that amazed and delighted him as well as demonstrating that he understood how to connect one shape to another. If I had been more concerned with his ability to follow my instructions about using sticks than applying the concepts of shape-connectedness, he would have missed a self-generated, truly creative experience.

## Demonstration for Preschoolers with Adults

1. Although young beginners have been working with clay during every studio session, begin this clay project by asking the children, "What are you doing when you work with clay?" Puzzled looks are usually the reply. "Are you doing a painting?" ("No!") "Are you doing a collage?" ("No!") "What are you doing when you make a shape stand up and you can see all around it?" They call out, "Sculpture!" "Where do you see sculpture?" The answers are varied: "In the museum; in the park; in front of buildings; in people's houses."
2. "Where does clay come from?" ("From the store.") "Yes, but before it gets to the store, clay is a special part of the earth and people dig it up like sand at the beach." In front of you on the demonstration table is a piece of clay on a 12-by-12-inch vinyl sheet that is covered with a wet paper towel or rag. As you take off the wet towel, ask, "Why do you think I covered it with something wet? To keep it soft?" If there is no response, break off some moist, ready-to-use clay and ask, "How does this feel? Is it soft?" Also show them a piece of hardened clay and ask, "What happens

when the clay is dry? You can't press your fingers into it and change the shape."

3. "Today the grown-ups are going to make a shape or creature that nobody ever saw before. When you are making a creature that no one has ever seen before it can have six arms, three tails, or ten legs, or any combination of different kinds of animals."

Once when I said that a six-year-old looked disgusted and said contemptuously, "Very funny!" He seemed to think I was talking down and trying to fool him because he was a child, and he was not going to be taken in. However, when I pulled out photographs of sculptures of Asian gods with many sets of arms and one of Ganesha, the Hindu elephant-headed God of Good Fortune with a human body, he became fascinated. Then he recognized that one could be serious about making something imaginary that might seem silly if judged by everyday standards.

4. "The shape is going to go up into the air and you can see all around it." Then squeeze the clay to make a vertical shape and turn it around so that they can see all sides, remarking that they are also going to work on a base that they can turn around. As you press your fingers into the clay and reach into the interior to form a hollow, ask, "How does it look inside? Is it dark or light?" ("It is dark.") "How can we make it light?" Start to push your fingers all the way through and they say, "Make a see-through place."

If the youngsters are restless, shorten this demonstration. Show them some photographs of clay sculptures without reviewing the process of joining shapes and send them off to paint.

5. Later, after the children paint, make collages, and sit down at their places at the clay table, they find that their clay is on a piece of cardboard. Then tell them, "Today we're going to keep our clay on this base.

*Yamantaka with His Sakti.* Tibetan, 18th century. Cast bronze, 6⅞ x 6". The Metropolitan Museum of Art, New York, Bequest of William Gedney Beatty, 1941 (41.160.95)

You can roll and make shapes on the table but you need to put them on the board in order to save your creature."

6. After the children have finished shaping their clay forms, demonstrate briefly how to decorate them—bending pipe cleaners, inserting toothpicks into corrugated strips, and explaining anything else you plan to use—and place the new materials in the center of the table. It is important *not* to distribute these before they manipulate the clay into shapes. Since they made foam constructions the session before, this demonstration can be brief. All the

*Ganesha.* Orissa, Indian, 16th century. Ivory,
7¼ x 4¾ x 3½". The Metropolitan Museum of Art,
New York, Gift of Mr. and Mrs. J. J. Kleman, 1964
(64.102)

GILLIAN BRADSHAW-SMITH (American). *Elura.*
1974. Painted canvas and mixed mediums, height 87".
Courtesy of Cordier Ekstrom Inc., New York

materials used in the foam project can be used, but feed these to them slowly. At the very end, they may choose a single colored feather to add to their work.

Whereas adults remove their finished pieces from sheets of plastic when they are done and place the clay shapes on waxed paper to paint with glue and water, preschoolers' work is often too fragile to pick up from the cardboard. After class, the adults should paint both the clay constructions and also their connection to the base with a mixture of white glue and water. It is necessary to glue the clay to the base so that the piece will hold together for the next painting session, when children may subject it to vigorous brushing.

## Demonstration, Part 2, for Adult and School–Age Beginners: Making Fantastic Shapes and Mythic Creatures

Since the children work in clay at every session after painting, the demonstration-review for the adults on how to join shapes continues after the children sit down at their own work places. Discuss reproductions of artworks on the wall and the properties of the clay, pointing out that the medium will suggest shapes as they work with it. Like the Alaskan Native American carver who replied he did not know what he would make from the tusk because the form was still inside, encourage everyone to allow shapes to emerge from within the clay, rather than to impose preconceived ideas upon it. Bones, pebbles, and rocks have also inspired many sculptors working in clay because of their subtle transitions from one shape into the next, a variety of thicknesses, and beauty of form. Their rubbed hollows and bumps offer subtle asymmetry suggestive of direction or

Preschoolers' clay creatures, ready for painting

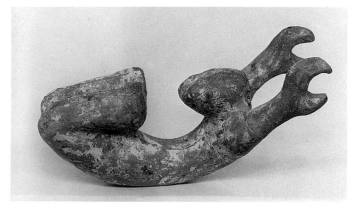

Tomb figure (of an acrobat). Chinese, Han Dynasty, c. 206 B.C.–A.D. 220. Fired clay with traces of ceramic, height 3⅝". The Metropolitan Museum of Art, New York, Fletcher Fund, 1935 (36.12.14)

CHAIM GROSS (American, b. 1904). *Angels and Acrobats,* or *The Hennenford Family Acrobats.* 1981. Cocobolo wood, 31½ x 11½ x 4". Courtesy of the artist

UMBERTO BOCCIONI (Italian, 1882–1916). *Unique Forms of Continuity in Space*. 1913. Bronze, 48 x 15½ x 36". The Metropolitan Museum of Art, New York, Bequest of Lydia Winston Malbin, 1989 (1990.38.3)

Mechanical forms have also inspired many artists. Although in his writings Boccioni claimed inspiration from the machine, this sculpture has a visual affinity with much earlier times.

Suit of Armor. Italian, Gothic, 1460. Steel, height 5' 8".
The Metropolitan Museum of Art, New York, The Bashford Dean Memorial Collection, Bequest of Bashford Dean, 1928 (29.150.7)

Adults' clay pieces

gesture. But clay also has the potential for an infinite variety of textures, edges, and pointy shapes as well.

Also talk about types of edges, or the *contours* of form, and how gesture may or may not suggest movement as you turn a clay piece around, calling attention to how light affects form through the shadows and highlights created by the bumps and hollows and see-through shapes.

> *I'll produce several maquettes-sketches in plaster-not much bigger than one's hand, certainly small enough to hold in one's hand, so that you can turn them around as you shape them and work on them without having to get up and walk around them, and you have a complete grasp of their shapes from all around the whole time.*
>
> —Henry Moore, British sculptor, in Robert Melville, ed., *Henry Moore: Carvings and Bronzes, 1961–1970*

The aim of this project is to make fantastic shapes and mythic creatures. The reproductions on the wall illustrate how painters and sculptors have used creatures to express many different themes. For example, the sculptured horse was a symbol of power, dynamism, and speed. Heraldry and coats of arms have featured animals for many centuries and some have combined vegetables and animals, people and animals, and machines and animals to give poetic resonance to their images. Hybrid creatures such as the minotaur, sphinx, flying horse, centaur, or other part-animal, part-human, part-demon, and half-angel shapes embody the polarities of human nature.

> *As I looked, behold, a stormy wind came out of the north, and a great cloud, with brightness round about it, and fire flashing forth continually, and in the midst of the fire, as it were, gleaming bronze.*

*And from the midst of it came the likeness of four living creatures. And this was their appearance: they had the form of men, but each had four faces, and each of them had four wings. Their legs were straight, and the soles of their feet were like the sole of a calf's foot; and they sparkled like burnished bronze. Under their wings on their four sides they had human hands. And the four had their faces and their wings thus: their wings touched one another; they went straight forward without turning. As for the likeness of their faces, each had the face of a man in front; the four had the face of a lion on the right side, the four had the face of an ox on the left side, and the four had the face of an eagle at the back.*

—Ezekiel 1:4–10, The Bible

## PROCEDURE

1. Begin working your clay as you did last time and continue shaping it into a fantastic creature or shape that nobody has seen before. Manipulate the clay in order to make a variety of gestures so as to develop a feeling of movement.

2. This time put your clay piece on a base, which can be cardboard, canvas, oilcloth, or Masonite, and continually turn the piece while working on it.

3. After completion of the form, coat it with a glue-water mixture and save the mythic creatures to paint during the next workshop session. If you have not finished a clay piece to your satisfaction during this session and want to work on it another day, sprinkle it with water and wrap it closely in a damp cloth, wet paper towel, or thin sandwich-wrap plastic before covering it up again with another layer of plastic sheeting. If you are going to return to it soon, it is not necessary to use as much wrapping. Just try to make it airtight.

MARTIN SCHONGAUER (German, d. 1491). *Saint Anthony Tormented by Demons.* c. 1480–90. Engraving, 11⁷⁄₁₆ x 8⁵⁄₈". The Metropolitan Museum of Art, New York, Jacob S. Rogers Fund, 1920 (20.5.2)

If you have completed your shape on a smooth rigid surface without a piece of flexible sheeting between it and the baseboard, you may detach it from the board with a wire, heavy thread, knife, or spatula under the clay. If, however you used a piece of oil cloth, paper, or plastic sheet, you will be able to peel away the clay form easily without any other tool.

4. To save your finished shape, detach it from the work base and smooth any rough

edges at the bottom. Set the piece on waxed paper on top of a solid base. Paint over the whole surface and especially any projecting parts with the glue-water mixture.

5. Place the shape on its base in a cool place (not a sunny window ledge) because, if you rush the drying, it may crack. Even after the surface of the clay looks dry, moisture must evaporate from its center. If you put it on a hot radiator or in a warm oven while it is wet, steam may form in the interior and break the shape open. As the piece dries, it becomes lighter in weight and color (turning to a pale buff or gray) as well as becoming warmer or closer to room temperature. If the surface is cool, it is probably damp inside.

6. Cleanup: Scrape off wet clay from your table surface with a tongue depressor or small spatula before using a sponge to finish the job. If you begin with the sponge instead of a scraper, the sponge may become clogged with clay and you will have a muddy table. The dry powdered clay from scraping can go back into the clay container.

### THINKING ABOUT WHAT YOU HAVE DONE

Just as you opened up spaces in your collages to see through to the surfaces underneath, here you may have opened your form and established both inner and outer shapes. Openings, or see-through shapes, multiply the number of your surfaces and the possibilities for accentuating varied textures and edges. Notice how, as in past projects, the light on forms affects their color, and the color influences the visual weight of forms.

The malleability of clay allows one to explore gestural movement in a dynamic way. Ask yourself how shapes on your piece connect with each other. Does your piece have a flowing or an abrupt rhythm? Do the lines of your shapes turn to extend around to the back or sides? If you have not turned your piece while working on it, you can still glue on additional materials.

Many sculptors have found that the power and vitality of clay shapes can also come from the fact that they can be generated by pressing outward from inside the sculpture as if they are growing. Do your bumps feel as if they are attached to the surfaces like barnacles, or do they feel as if they are growing or pushing out from inside the clay? This quality comes both from the character of the modeled contours and from the transitions between the shapes they define.

## Sculptural Environments for Grade-School Beginners

*M*ore experienced beginners may be challenged by placing shapes next to each other to make environments, cities, or complex constructions by combining clay and applicator sticks, coffee stirrers, and tongue depressors. The combination of mediums allows them to build up forms into the air and also expand horizontally. They may also enjoy collaborative efforts in which each person makes a shape. You might show and discuss photographs of sculptural shapes you have collected.

Even older beginners often model only one side of the clay and forget that the form is three-dimensional. It is a good idea to distribute 9-by-12-inch turnable bases (cardboard or a vinyl sheet) to work on because, if the clay sticks to the table surface, the students will not be able to turn the piece at all. In the early sessions, call attention to rotating the pieces from time to time so that everyone will work on all sides of the clay.

JOHN RHODEN (American). *Configuration.* 1975. Bronze, 5¹/₂ x 11¹/₂" x 5¹/₂". Courtesy of the artist

## Foam Constructions for Older Beginners

*T*eenagers and adults may enjoy using the preschoolers' foam materials to make constructions or special environments as a separate project. They can glue pieces of plastic foam to cardboard with white glue to make a base and then construct a spatial environment by suspending and raising up forms with wire or wood sticks inserted into the base. Allow the white glue to thicken by setting it out in a shallow paint container or jar lid for about twenty minutes before use. To make bigger shapes with the foam, laminate them together with white glue by coating each surface and using wood sticks to peg the joints before you glue them. The one-inch sheets or thinner foam layers may be cut with a pair of large scissors, mat knife, or paper cutter, but you can saw larger pieces with a hacksaw blade (without the saw frame). Larger pieces of wire, applicator sticks, dowels, electrical wires, and any number of other materials you may have used in your texture collages are all useful here.

## Reconditioning Dried Clay

*I*f clay is too stiff, you must take the time to make it soft by working water into it. Moreover, if you add water immediately before the session, the clay will not absorb it quickly enough to make it inviting to touch. The slippery, muddy surface will be unappealing to handle and clay that is too wet will stick all over the hands, making it impossible to form shapes. If you are reluctant to touch the clay yourself, your beginners probably will not want to handle it either, except those who might be tempted just to smear with the clay.

Even though you may be able to afford to buy new clay for each project instead of saving and reconditioning used material, the reconditioning process can be a learning experience in itself, one that teaches beginners to see the process of change as the clay becomes soft and workable. Similarly, when you buy cakes from a bakery, your children do not have the opportunity to learn how these are made if you have never made one at home for them to observe the process.

1. If, for any reason, your clay has become a bit stiff but has not totally dried out, and you want to use it soon, break up any hard lumps and push your thumb or a stick into the still moldable pieces; put water into the hollows and work the water into the clay to soften it further. If you are reconditioning clay for the next day, break it into small pieces and put very wet rags over the top so that the water will slowly absorb into the clay. If it is rock hard, you may need a hammer to break it up into small

Mimi Gross (American). Work in progress. 1990. Foam rubber over rubber-coated copper armature. Courtesy of the artist

Mimi Gross (American). *Parade—Kyoto, Tokyo, 1988–89.* One of five figures. Foam rubber, copper tubing, and Guerra acrylics, 8' x 6' 10". Courtesy of the artist

pieces. Put it into a container, and add water gradually and conservatively.

2. Cover the clay with plastic or an airtight lid and let it sit for a few hours or overnight. Then see if it has absorbed all the water. If the clay is still too hard, add a bit more liquid. Avoid adding so much water that you end up with a container of liquid mud, which could take as long as a couple of days to return to the proper consistency.

3. Mix the wet clay with your hands or with a stick and let the clay settle. After the sediment has settled, remove any excess water on top of the clay with a cup or poultry baster. Let the clay stand until enough excess water evaporates (with the lid off the container) and it is the right consistency to work. If you have added a lot of water this may be a day or two. Again, this also depends on the amount of clay you are reconditioning. A bowlful dries faster than a bucketful.

4. Finally, work the clay again to a smooth consistency before you start another project.

## Wedging Procedure for Clay to Be Fired

*B*ecause we do not use a kiln and my workshop students constantly reuse the clay, we do not fire our clay pieces. If you decide, however, that you want to increase the permanence of your work by doing so, you will have to further prepare your clay before using it. *Wedging* is the process of working clay to achieve textural uniformity and to remove any bubbles so that, when it is fired, the clay will contain no air pockets and the material will shrink uniformly. This can be accomplished by squeezing, pounding, twisting, stretching, and folding the clay over on itself.

Take a 9-inch-diameter lump from your clay container and pound it down into a slab. Next, fold over one side and then another and pound it down again so that you squeeze and stretch the material as well. Continue folding and working the clay until you can feel that it has a uniform consistency. A nonstick rolling pin is an optional tool for flattening out the medium after folding it over on itself.

Even if you began with prewedged clay, if you reuse it, you will need to wedge it again before firing it. In addition, notice how, with repeated working, the plastic or malleable properties of the material improve. Because clay becomes more and more pliable with age and use, potters prize vintage material over that which has been newly purchased.

## Tips for Teaching

### ISSUES IN SAVING YOUNG BEGINNERS' WORKS

Up until now preschoolers have been exploring the clay without saving the pieces. They have been working directly on the table surface without needing to stay within the predetermined boundaries of a base.

If the youngsters are still continually assembling and taking apart their clay pieces for the sheer pleasure of the process, wait until they can enjoy making a more finished form before you start this project of making shapes to save. This means that older students should avoid saving their pieces in front of the preschoolers. If youngsters were to see this, it would set a precedent for saving their first unformed lumps. The reason for making a project to save with the preschoolers before some of them are truly ready is because the adults in my classes will be bringing a clay piece home and the children will want to have one as well. Moreover, by this time in the semester most of the children have gained

considerable experience in handling the clay. At home, of course, the situation is quite different. If you have developed a work extensively, certainly you might want to consider saving it.

The problem with encouraging beginners to save their very first clay pieces is that they may get the impression that they are making precious objects. Learning to manipulate clay is a slow process because it takes quite a while to develop hand-muscle coordination. Therefore, many beginners will not be able to control and join their shapes at first. If you return your shapes into the clay storage container, young beginners will probably follow your example.

Parents who save the work of young children are initiating a form of praise that may hinder their creative growth if it is not done with discretion. For example, four-year-old Peter made a piece resembling a bird on a nest by shoving a stick through a lump of clay, calling it a bird with wings. Next he shoved his thumb down into the center of a another clay mound and announced it was the nest under the bird. When his mother saw something she could label she was visibly overjoyed and told him, "Why don't you ask your teacher if you can save it?" I had to say that we would not be saving clay today but we would have a special time when we would save our clay work. Meanwhile, we were practicing using the clay to learn more about making all kinds of shapes. If I had allowed one person to save clay, everyone else would have also wanted to save theirs. It is unfortunate when this happens because many of the children will pick up just any lump of clay and ask, "May I save this?" merely to join the crowd. Besides, I have found that the children look forward to the day when they can save their clay piece, and it has a special value for them.

## REMOTIVATING YOUNG BEGINNERS

If you feel you need a new focus to reinvolve the children, take out a piece of rope or clothesline joined together at the ends and lay it on the table to form an enclosed rounded area. "What do you think this special place might be? A circus ring? A merry go-round? A swimming pool or a lake in the park? A corral for a rodeo? A cage in the zoo?" The children might respond with any of these thoughts or many others. The rope is flexible and can be changed to define a space in which to place different kinds of shapes. It even can be raised in places to make a passageway. I sometimes give preschoolers a few wooden blocks to provide other possibilities for placing shapes and stretching their imaginations. The sculptures in the museum, park, or city streets are usually placed on pedestals, and these may be something new to investigate. Youngsters can learn the meaning of a new word and incorporate "pedestal" into their vocabulary. However, they may decide to do something else with the blocks that you give them.

There are several reasons why beginners may stop working on the clay. If it seems difficult for them to make shapes with the material, they may look for diversions. In the beginning, students of any age will need more attention from the leader when they do not know what do to next. Instead of asking for further directions, however, the younger ones may stop and claim that they are tired or finished. The important point in remotivation is to show enthusiasm for sustaining and extending the process of experimentation, rather than for praising finished products, so that beginners are encouraged to move forward rather than rest on past accomplishments.

## PRETENDING VERSUS DOING

Sometimes young beginners label an amorphous lump of clay a house, car, or whatever and merely move the clay around the table without attempting to transform it into any shape at all. If pretending shifts the focus into telling stories rather than manipulating the material, I try to encourage them to think about the visual appearance of the things that they are talking about and avoid praise for labeling unformed lumps of clay. When some very verbal children persist in this fictitious process so that their talking interferes with any clay work, I might say, "Don't tell me with words. Show me with your clay." Children's enchanting conversation is often seductive for adults, but youngsters will not learn how to make shapes if they are too busy entertaining an audience for applause.

Although most children love working with clay, there is a limit to how long they will continue at first. They may become restless after a few minutes unless some idea sparks their imaginations. With very young children, I may ask if someone would like a stick to use with the clay. When I first show this tool, I ask, "What do you think you can do with this?" I only give out one stick per person at first. Later I distribute several more. I find that if I present sticks early in the session to beginners, they may merely shove the sticks into the clay without doing any other shaping of the medium. I keep encouraging them to make constructions by experimenting with different possibilities and taking them apart. I may add small clay shapes onto the ends of sticks and then insert the free ends into other pieces to connect them.

A few sticks in a lump of clay almost invariably call up an association to birthday candles and lollipops, and for some, to the main social event of their lives—a birthday party. Because this distracts them from the clay, I attempt to redirect their attention back to the shapes they are making by putting sticks into the clay and turning the shapes upside down while asking, "What do tables and people and animals have to hold them up?" They say, "Legs." Then I show how to make shapes stand up on sticks and also to use them to build up in the air and out to the sides. We also think about the sizes and shapes of forms. "Does an elephant have the same kind of legs as a giraffe? Could an elephant stand on a giraffe's legs? How many legs do animals have? Do all their legs look the same?"

## Expanding Experience Beyond the Studio Walls

The combination of looking at reproductions, photographs, and working with clay accelerates visual awareness of sculptural forms in the environment. For example, four-and-a-half-year-old Nora carefully watched the installation of a biomorphically shaped Henry Moore sculpture on her street. When her mother showed her a photograph and story about it in the newspaper, she insisted that they clip it and send it to me. She felt she had a personal investment in the piece and reported to me how it looked in different weather, how it had shapes inside of other shapes, and how shiny it got when it was wet.

*The artist is a receptacle for emotions that come from all over the place: from the sky, from the earth, from a scrap of paper, from a passing shape, from a spider's web.*

—Pablo Picasso, from an interview with Christian Zervos, 1935, reprinted in Herschel B. Chipp, ed., *Theories of Modern Art*

# 16. Painting Your Clay Shapes

*Materials Checklist*
*Demonstration for Preschoolers with Adults*
*Demonstration, Part 2, for Adult and School-Age*
*Beginners*
*Tips for Teaching*
*Holiday Project: Hanging Ornaments*
*Continuing Your Work with Clay*

Ceremonial fence element. Eastern Iatmkul tribe, Kararau Village,
East Sepik Province, Papua New Guinea. 19th–20th century.
Wood, paint, and shell, height 60½". The Metropolitan Museum
of Art, New York, The Michael C. Rockefeller Memorial
Collection, Gift of Nelson A. Rockefeller, 1969 (1978.412.716)

## *Materials Checklist*

■ Photographs and reproductions of Asian, African, Oceanic, and Amerindian art, focusing on examples of polychromed sculptural objects, masks, animals, and figures. Natural-history magazines display photographs of creatures with colors and shapes beyond the bounds of anything you might dream up yourself—especially lizards, insects, fish, and snakes. It might also be helpful to review your painting and collage projects using shapes and pattern for painting ideas on your clay piece.

■ Your regular painting-tray setup

■ Extra paint containers such as jar tops or small dishes for mixing paint. (You will be able to mix and blend new colors directly on the clay itself but may want to mix larger quantities of single colors in mixing dishes.)

■ Your dry clay piece from the last session and the base

■ White glue for mending any broken parts. For projecting shapes you can also wrap neutral-colored tissue paper around a glued joint and apply additional glue over its surface.

■ Newspaper placed under the piece while you are painting it

■ Heavy or corrugated cardboard or a rigid sheet of paper-covered foam, approximately 8 to 10 inches in diameter, depending on your sculpture. You may cut it again later if you decide to customize the shape of your base to your piece. To prevent the cardboard from warping under the liquid paint, glue several layers of corrugated cardboard together. Making the top layer slightly smaller than the rest also helps prevent warping.

### FOR OLDER BEGINNERS:

The regular one-inch-wide bright brush for painting the base and large shapes and tiny, pointed watercolor brush for details and patterning

■ Leftover pieces of tissue paper to add to the clay surface for accents or as a papier-mâché coating

### FOR PRESCHOOLERS:

The large one-inch wide bright and the regular quarter-inch-wide bristle brush. Preschoolers risk ruining a more expensive soft-pointed watercolor brush with their heavy brushing motions on the clay.

Many people who are very serious art collectors delight in seeking out indigenous pieces of art by local artisans when they travel to different parts of the world. These works may be unique sculptural figures, often brightly colored, lacking in commercial slickness, with a vigor and directness deriving from their handmade origins. When you paint your clay form, it may very well develop a character of its own and become something to be cherished as concrete evidence of a special time in your life.

People have been painting their sculptures since prehistory. Yet late in the nineteenth century, the sculptor Auguste Rodin allegedly raised his hand to his breast and declared, "I know it here that they did not color it," referring to the discovery that the ancient Greeks painted their sculpture. Indeed, until the middle of this century, some academicians still disapproved of polychromed sculpture because it was not in the tradition of classical pieces—or so they thought. When nineteenth-century archaeologists recovered ancient pieces, the paint had often worn off the marble, and bronze and terra-cotta statues were covered with patinas. Although the patinas assumed many varied colors, they were considered natural because they were the result of chemical reactions of the surfaces to the elements. Paint was regarded as something that covered the natural surface and violated its integrity.

*Tomb Guardian (Zhen-mu-shou)*. Chinese, Qi Dynasty, c. 525–575. Earthenware, height 12¼". The Metropolitan Museum of Art, New York, Purchase Sotheby Parke Bernet, Ann Eden Woodward Foundation Gift, 1979 (79.438-217813)

*Sphinx and Acroterion*. Greek, 530 B.C. Marble, height 56⅛". The Metropolitan Museum of Art, New York, Hewitt Fund, 1911, and Anonymous Gift, 1951 (11.185D)

As seen on this carved scene from a grave marker, the Sphinx is not the evil monster of Theban mythology but the guardian of the dead. The body is that of a lioness with wings added; the neck, head, and hair are those of a woman. Both the Sphinx and the relief on the shaft of the stele are by the same sculptor, perhaps Aristokles.

Helmet mask. Malekula Island, New Hebrides. Wood, straw, compost, paint, tusks, glass, height 26". The Metropolitan Museum of Art, New York, Nelson A. Rockefeller Collection (65.103)

Chokwe chieftain's dance mask. Angola. Painted fabric, 20 x 20". Collection of William Brill

Many sculptors of this century, however, looked at African, Asian, and Pacific art and realized that polychromy added another expressive dimension to their forms. They saw that color could emphasize qualities in structure and expression. Color affects the apparent shape and size as well as the illusion of volume and massiveness. It can suggest a kind of naturalism or a fantastic dream quality. It can adapt a form to its environment, as with the camouflage of animals in nature, or attract attention, as does the peacock's tail. Some modern artists have taken cues from coloring techniques used on commercial objects like cars and product packaging as a way of reflecting contemporary life. Those who may be uncomfortable about painting their clay pieces with opaque pigments might consider the possibility of experimenting with a variety of translucent, or even bronzelike, colored patinas.

## Demonstration for Preschoolers with Adults

This demonstration is designed to show where visual ideas come from, where to

Figure. Mycenaen, c. 1400–1100 B.C. Terra-cotta, height 4½". The Metropolitan Museum of Art, New York, Fletcher Fund, 1935 (35.11.16)

Figure. Mycenaen, c. 1400–1100 B.C. Terra-cotta, height 4½". The Metropolitan Museum of Art, New York, Fletcher Fund, 1935 (35.11.17)

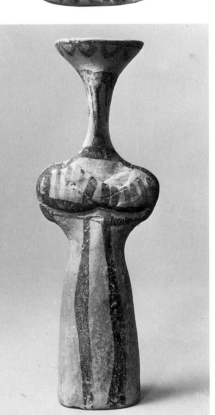

find them, and how you might use them. 1. "If I wanted to paint my clay creature where do you think I might get some ideas?" Experienced children point, saying, "Those things on the wall might give you ideas." I reply, "Yes that is why I put them up. Where else might you look?" ("In the museum? In books?") We look at photographs and reproductions and discuss the wide variety of colors and shapes that both artists and nature have given to real and imaginary creatures. Point out that some of the colorful animals look as if they have been painted with a brush. Once a mother told me how upset her daughter was when someone criticized her painting of blue and red frogs, saying, "Frogs are green. They do not look like that!" Since then I have been collecting pictures of real frogs in multicolored patterns. I have discovered red frogs with blue legs, green ones with big red eyes, and others with orange spots and black stripes. I always show these to the children when I ask, "Do frogs always have to be green?" 2. "When you do your paintings, you might want to think of making some of your shapes into creatures with wings, or legs, or whiskers, that would live under the water or fly in the air." Some may be motivated to go in that direction and others may not. It really doesn't matter just as long as they are involved in their own works. After they finish their paintings, the preschoolers paint their clay creatures or constructions.

## Demonstration, Part 2, for Adults and School-Age Beginners

*A*s you continue to view reproductions of painted sculpture from around the world, show the group how to assemble their own visual resource booklets and files

with a sample containing photographic articles taken from magazines, newspapers, small posters, and postcards. The three-hole archival plastic sleeves for preserving the items are available at art-supply, photography, office-supply, or stationery stores, and inexpensive three-hole notebook binders, yarn ties, or plastic-coated wire will keep the pages together. This is an excellent activity for adults to share with young beginners because it encourages youngsters to start their own clipping files, which may be used not only for these studio projects but also for other subjects. Since many communities have paper-recycling days, your neighbors with used magazines may give them to you if you let them know the kinds of imagery you are looking for.

## PROCEDURE

1. Peel the waxed paper from the base of your dry piece and trim off any roughened glue edges on the clay.
2. Set the piece on newspaper to protect the table surface.
3. Choose your colors while thinking of how you might dramatize a particular quality of your clay sculpture.
4. One way of beginning is to paint a base coat of tempera over the whole piece to serve as a background for the other colors, the way you did with your painting backgrounds. Another possibility is to cover all or part of your piece with glue and tissue paper as a ground. To do this, paint the surface of your clay with a mixture of glue and water and then smooth on the tissue paper with your brush. Paint over the tissue paper for patterning and blending colors or else use tissue paper over the paint to add different textures. The tissue paper and glue can also be used as a method for reinforcing potentially fragile edges and joined or projecting parts. If you are going

Figurine. Brazilian, Caraja tribe, 20th century. Clay, height 7½". The Metropolitan Museum of Art, New York, Gift of George Biddle, 1971 (1971.106.1)

Adult student's painted clay work

to leave part of your clay unpainted, it should look purposeful and not like a forgotten patch without definite shape.

5. Use your small soft watercolor brush only to create patterns, accent parts in different colors, or extend shapes with lines because it will wear down quickly if you use it to paint large surfaces of clay.

6. If you choose not to paint patterns or even opaque colors onto your piece, you can still enhance its massive qualities with layers of transparent washes, using the following procedure:

■ First apply a base coat of white to provide a reflective surface underneath the washes. This will make the surface luminous, or light-reflecting, even if you choose to paint it with transparent earth-tone colors afterward. If the first coat of white is thin, let it dry and apply a second coating. Be sure that these paint layers are dry before applying any transparent or translucent washes of color.

■ Start with very thin and light colored washes of paint and then progress to darker ones if you wish to deepen the color. Although you may have created visually dynamic results with opaque colors by starting with dark ones and layering patterns of light pigment over them, the reverse is preferable with transparent paint.

■ If you need to mix a large quantity of a color, mix the transparent and translucent colors in spare paint containers and not on the piece itself. You might combine two or three different washes for color depth. If you do not care for your results, paint the piece white again and start over.

7. After you have finished painting your clay on the newsprint, you must consider the relationship of the piece to the base in terms of size, shape, color, and pattern.

To save time, I present precut cardboard rectangles of different sizes for my classes of adults and children so that we can all finish the project together. At home, where you have a more leisurely pace and fewer participants, you might let the beginners choose to cut their own bases to their individual shape and size preferences.

Before gluing your clay piece to the base, move it around on the horizontal plane to find a position that works well. It is not necessary to position the sculpture in the exact center of the base if you consider the dynamics of asymmetry as a compositional principle.

8. As an optional step, if you want to preserve the surface of your work for long-term display or storage, after the paint dries, spray or paint your piece with a clear plastic finish. You can purchase this in either a matte or shiny gloss, or semigloss satin finish. Once you do this, however, you can no longer apply poster paint to the piece in order to change it.

If you plan to take a clay piece to be fired in a ceramic kiln, do not paint it until after the firing. Remember that a fired clay piece will shrink even more than it did at room-temperature drying and any cracks will widen. If you paint a fired piece, you could use tempera colors, but acrylic will have a harder finish that is less easily washed off during cleaning and dusting. No matter what kind of paint you apply after firing, even oil paint, you cannot use window or other surface cleaners on it.

9. Possibilities for Future Sessions:

■ You might want to develop the base further by arranging and gluing cut- or torn-, colored- or patterned-paper shapes onto it.

■ If you want to extend or change the shape and size of your base, place a larger cardboard piece underneath the original one and continue painting it. Then when the paint dries, insert glue between the cardboard layers with a brush and weight it down to prevent warping.

■ Some adults have made special-texture collages as bases for their clay pieces.

Adult student's
painted clay work

## THINKING ABOUT WHAT YOU HAVE DONE

Your piece may have seemed more emotionally neutral in the gray clay, but now that it is painted it may have become more highly expressive. Before painting, you may not have made any particular part of your piece dominate the clay composition. When you applied paint, however, the colors may have established a theme. Your colors may have emphasized one shape and also established a visual rhythm through pattern and line.

Your paint choices also may have dominated the form with color and pattern in a way that diminished the massiveness of the clay shape. You may like it as it is or, if you are not satisfied, decide to continue working on the piece. If you are involved in a class situation, there may not be time for an in-depth appraisal. If you are in a position to extend your session, however, you might think about other aspects of coloring clay forms.

If dark colors camouflaged the texture on your piece, next time you might want to apply a lighter opaque coating or several translucent light washes over the darkly painted surface. Sculptors often apply many thin coats of color or chemicals to their sculptures to achieve weathered

LEIGH BURTON (American). *Rodanthe.* 1987. Painted wood, 26 x 19 x 5½".
Courtesy of the artist

effects. If you wish to emphasize further the textures of light colored surfaces, then brush colors into the crevices of the piece and wipe this color away from the high points on the clay surface.

## Tips for Teaching

*A*lthough young children who are still action-oriented like the idea of painting their shapes, they may decide they are finished after putting on a few dabs of color. They may lack patience to sit long enough to finish the job, especially if they have already done a painting, and more supportive guidance may be needed. It is very common for beginners of any age to ignore the side they cannot see, so it is important to remind them to turn the piece around and think about the other sides of their sculptures and decide what colors they would like to use. Do not push students to color everything once they feel they are really finished. After they have taken them home, they might continue at a later date.

If the preschoolers show interest in continuing, offer assistance only when they request it. One four-and-a-half-year-old, who had made two clay creatures in previous sessions, wanted to paint both of them after first completing a painting. This was quite an ambitious undertaking for a student of his age. Although he worked diligently on the first piece, it was obvious that he was losing momentum on the second one. "You mixed so many colors!" I said in an enthusiastic tone of voice, while turning it around so that we could look at it from all sides. "What color would look good on the base sitting next to the other ones?" These comments rekindled his determination to complete the work and he actually spent about forty-five minutes painting that day. At

the end of class he said very quietly, "I feel proud of what I did!" "You should feel proud and I'm also very proud of you because you worked so hard even though you felt tired," was my reply.

The fact that he persisted was due to several things. Although he was highly motivated, there came a point when he needed reassurance to continue working because every other child had left the painting table and he was all alone. Often, when young beginners extend their period of concentration, some adults have the mistaken notion that the child is slow. It may be quite the opposite: the child's capability for working independently in a focused way may be greater than that of the others. One woman, who spoke very little English, withdrew her granddaughter from the class because, based on her cultural background, which stressed regimen, she believed that the child could not keep up with the rest of the group. In reality, children who rush through activities may have not developed their attention span in order to focus for any length of time on any one task. The granddaughter was deeply involved with her painting, and I was delighted to let her pursue her work because it seemed important for her to continue what she was doing until she made the decision that she was finished. However, in many schools teachers push everybody to finish simultaneously because of the need to coordinate individual courses within the daily curriculum.

In the studio workshop, that pressure does not have to exist. If you have two or more projects prepared but the students are deeply involved in one activity, do not rush them but do remind them that if they stay with one, they may not be able to do the others by the end of class. In my workshops, the children usually paint the clay after doing a painting. At home, if painting clay is the main activity, they may work at it for a longer time.

Advanced five-year-old's painted construction

Painting a clay piece on a cardboard base

VINCENT LETO (American, b. 1943). "Mask" tree ornament. 1978. Salt dough and tempera paint, 3¼ x 3 x 2¼". Collection of Mablen Jones

## Holiday Project: Hanging Ornaments

*T*his is not a substitute for working with real clay but a holiday activity. You can purchase a ready-to-use, self-hardening plastic modeling clay such as Crayola's Air-Dry Model Magic™, or you can make an inexpensive modeling dough from a mixture of salt, flour, and water that requires oven baking. In the latter medium, the salt acts as a preservative so that the pieces do not get moldy or decay. Unlike the Crayola product, which can be modeled into upright freestanding forms, the soft flour dough will not stand up. This medium must be modeled flat while soft, and it only achieves maximum hardness through baking. Ornaments made of

either material will last for years if taken care of. Both materials can be mended if broken and pieces can be added on with white glue.

### SALT-DOUGH RECIPE

Add one cup of salt to two cups of bleached white flour and mix thoroughly. Pour in half a cup of water as you stir slowly. Add just a bit of liquid at a time until the mixture is smooth and thick. If you find it too dry, add more water. (You may find other variations of this recipe in housekeeping magazines.)

After mixing, knead the dough until it is uniform. If you do not knead the dough sufficiently, pockets of salt will break open on the surface and put holes on your shapes while baking. Next, make your shapes. If you plan to hang them up, remember to poke a hole in the tops so that you can pull a thread or wire through for hanging. Since the dough is very soft, it is best to construct forms on a piece of aluminum foil or cookie sheet so that they do not fall apart when you pick them up to put them in an oven.

Bake in a conventional oven at 300 degrees Fahrenheit for approximately eight to ten minutes, or until lightly browned.

If pieces are quite thick, you may have to bake them at a lower temperature for a longer time in order to cook the insides without burning the surface, and you may have to try a preliminary test piece before you fire a batch of ornaments. If you do burn the surface, the toasted color and form may be something you choose to repeat.

After the salt-dough shapes are cool, they can be painted with poster colors or

inexpensive watercolors with small brushes and hung by thread or fine wire through holes in them. If by chance you forgot to put a hole in the piece for hanging, you can take a hand drill with a fine bit and drill an opening after the piece is baked. The Crayola forms are not baked and do not achieve the degree of hardness of the baked ones; a nail or needle will penetrate through the air-dried medium without difficulty. The Crayola forms can also be painted with tempera colors or felt-tip markers.

## Continuing Your Work with Clay

*I*f you find that you want to learn advanced techniques and fire your pieces, many studios associated with ceramics shops offer classes and sell materials. Avoid those that only offer courses in "China painting." These classes sell unfired ceramic items, already made in precast form molds, that you merely decorate with glazes. This is no more inventive than painting fingernails or polishing shoes. On the other hand, these shops usually will sell clay and sculpture equipment and offer firing services for a fee.

Many good books on ceramic materials and techniques can be useful if you decide to continue studying clay work in-depth. Paulus Berensohn's *Finding One's Way with Clay,* although now out of print, is an excellent one for beginners. You may find it at your local library.

> *Imagination is a very precise thing, you know—it is not fantasy; the man who invented the wheel while he was observing another man walking—that is imagination.*
>
> —Jacques Lipchitz, American sculptor, Hallmark bookmark quotation

Headdress ornament. British Columbia, Canada, 19th–20th century. Wood, paint, and shell, height 7⁵⁄₁₆". The Metropolitan Museum of Art, New York, The Michael C. Rockefeller Collection of Primitive Art, Bequest of Nelson A. Rockefeller, 1979 (1979.206.443)

# 17. How to Continue

*You must travel at random, like the first Mayans, you must risk getting lost in the thickets, but that is the only way to make art.*

— Robert Smithson, American sculptor, *The Writings of Robert Smithson*

*Where to Find Studio Classes*
*What to Look for in Studio Classes*
*Sharing Art Experiences*
*Taking Note of What You See*
*What Fosters Imagination?*

ADOLPHE BRAUN (French, 1811–1877). *Climbing the Alps.* 1855. Photograph. The Metropolitan Museum of Art, New York, David H. McAlpin Fund, 1947 (47.149.2)

$\mathcal{N}$ow that you have acquired a knowledge of how to set up workshops at home or wherever you will be working, you might welcome further information and guidance or look for the camaraderie of a another studio group to develop further your skills and visual sensitivity. Especially when working with young beginners, you will often find it necessary to become more involved with their needs than your own. If a time and place to work at home free of family demands is not available, going out to a class will eliminate domestic distractions. If you find it difficult to guide beginners, try seeking additional educational help. Some problem situations require outside advice or a cooling-off period.

## Where to Find Studio Classes

$\mathcal{L}$ook at the Yellow Pages of your telephone directory for the addresses and telephone numbers of your nearest art schools, colleges, and universities for continuing-education programs or alternative-learning classes. Check also listings for museums, arts councils, social and human services, and social settlements. Inter-generational programs, community or religious centers, and creative-arts rehabilitation centers may also offer studio instruction. If you have none of these local facilities, you might phone or write to your state arts council for further advice.

Perhaps a local artist or public-school art teacher would consider doing an extra class if you can find enough interested people to enroll and pay for the instructor's guidance. You might even have a retired art teacher living in your town who would enjoy working with beginners and have more flexible hours than those still teaching a regular schedule. Your local board of education and school principal may be able to give you some names and addresses. For many years, an elderly woman used to come by the studio to pick up discarded materials from classes at the museum. When I inquired what she did with these, I found out that she was a retired art teacher who used the materials to provide collage, painting, and drawing experiences for her neighborhood youngsters. Every so often she told me about a letter she received from an adult who wrote to thank her for the inspiration she provided in their younger years. She also provided me with another good story to share with parents and teachers whose tendency is to toss their excess materials carelessly into a wastebasket.

## What to Look for in Studio Classes

$\mathcal{A}$lthough you now have a basis for evaluating outside studio programs, here are some things to consider if and when you look for them. In all cases, it is important to understand the aims and attitudes of the guiding teacher. Even if there is a brochure from the institution, its statement of purpose probably reflects the aims of the school administration instead of individual instructors. Try to visit a class in action to find someone who is sensitive to individual needs and who also challenges students with materials and ideas. An instructor with a great deal of personal arrogance is not particularly helpful to any beginner. The best teachers will encourage students to recognize their innate capabilities, even if beginners feel insecure about learning new processes.

When you visit the studio class, preferably when the course is in session, observe the kind of work being done there as well as the facilities. As you look around, try to determine whether the instructor encourages personal experimentation or whether he or she favors

imitation of his or her own style and preferences. Art-education pioneer Victor D'Amico always took pride and delight in seeing the variety and inventiveness in the output of his students' work. He said that if any two pieces had looked alike, he would have felt that he had failed as a teacher.

What can you observe about the setup and atmosphere of the working environment? Is the facility orderly? Are there storage areas? Is there enough table-surface space for each student? Are the work spaces conducive to focused work? Is the room a passageway for other activities? Even if the facilities are not the best or newest, if the instructor establishes a mood of respect for individuals and the environment, there is a very good chance that the course will be wonderful. I once taught in the bleak and barren community room of a housing project. Yet, the respectful attitude, sense of order, and quality of the materials so impressed one little boy that, after several sessions of intense nonverbal involvement, he suddenly announced, "This is the most beautiful school in the whole world."

When visiting several classes for yourself or a child, evaluate the instructor's teaching methods. Even if a school is popular, it may not suit your needs. It may look like a lot of fun, but everyone may be doing busy work and not learning much. At another extreme, when techniques and copying are emphasized, it is possible that students will not be able to apply what they have learned to personal projects. When one of my sons was in the sixth grade, his school art program had a well-equipped facility with all kinds of tools and materials. Each week his instructor would teach a different technique with a new medium: charcoal, pastel, watercolor, acrylic paints, and so forth. But she made no attempt to encourage anyone to initiate their own personal imagery or content.

Finally she announced to the class, "I want you to make a painting using your own imagination." My son reported that because no one knew how to start, they all fell back on stereotypical imagery they had learned in the past. The boy who always drew boats did boats and others used familiar cartoonlike images. They had learned nothing about building a vocabulary of shapes and forms, personal invention in composition, and expression of mood or visual ideas.

The following are questions to help evaluate the type of instruction you are observing:

1. Are students required to follow a strict preplanned program or is there room for individual variation on the themes?

2. Do the instructor and school encourage unhealthy competition by elevating only a few students' work over others, or do they applaud diverse ways of seeing and working?

3. Are the students made to feel uncomfortable when they do not know how to do something? Is the instructor willing to repeat a demonstration for beginners who are not immediately able to understand an instruction?

4. Is information taught as isolated academic exercises or does the teacher encourage students to draw from and incorporate their individual experiences and ideas in their work?

5. Is value placed on personal initiative and expression or is the emphasis on learning techniques in order to make pleasing end products? Although experienced students may seek classes to learn techniques for specific design or craft objectives, everyone, and especially beginners, needs periods of exploration and experimentation.

After you observe a class, if any of these issues concern you, ask the teacher to explain the reasons for the procedures. You cannot always assume the intentions.

Perhaps there is a good reason for the structure of the class. If you disagree strongly, do not try to change the program. It may work very well for someone else. Move on and try to find something more to your liking. If you feel that a class is mostly right for you, evaluate both the positive and negative points. Even if you are not totally enthusiastic, give it a chance if the financial commitment is not too great. Inquire about tuition refund policies in advance. Some schools have a one- or two-week try-out period for a semester-long class. Although they may not have a cash refund policy you may be able to receive financial credit toward transferring into another class.

Beyond these basic requirements, your personal needs may differ from those of other beginners. All beginners should have the opportunity to sample a variety of both two- and three-dimensional mediums so they can learn to transfer skills among the many kinds of studio work. In any field, beginners who concentrate on only one specialized area too early may lack the ability to adapt to new situations, mediums, and ideas. Because you as an experienced adult have been examining a wide range of ideas in this book, you will have a basis for choosing a medium you like best. Some people are fascinated with pure painting, others love mixed-medium collage or assemblage, while still others feel most at home with clay. The most valuable learned skill of this studio training is acquiring a method for learning how to learn new things.

## Sharing Art Experiences

Although you, your children, or other beginners may become interested in different mediums and ultimately enroll in separate classes, the shared experience of beginning studio work together can con-

tinue throughout your lives, creating a common bond of interest, intensifying simple visual pleasures, and influencing your personal development in unexpected ways.

Once, toward the end of a semester at the museum, after a class I became so excited by the growth and progress that I saw in the students' paintings that I gathered them up and climbed the stairs to a friend's office in order to share my enthusiasm. When I arrived, the door was open and he was in conversation with the chief curator of paintings. I felt awkward and a little embarrassed as I started to explain that these were paintings from my parent-child workshops. The French-born curator interrupted me:

"I understand," he said. "Why do you think I am here today? It is because of my parents! They surrounded our lives with art. Every time we were to meet my mother to go anywhere after school, even to the dentist, we always gathered together in a different gallery in the Louvre, one time in front of a Rembrandt or a Leonardo painting, the next time before a Michelangelo sculpture. Mother always made certain that there would be time for sharing the experience of looking at paintings and sculpture together. It was always the most special time for us."

Although a museum visit can be a special event, it is possible to view your everyday environment in an aesthetic way as well. I will never forget the day I walked out of the museum after doing a Color Day project using many different kinds of green. Everywhere I looked, green popped out at me, from the trees, people's clothing, the cars in the street, traffic lights, and even the green patina of bronze trimmings on mansard roofs. I recognized how one could become sensitized to particular visual elements through studio practice. We are all surrounded by shapes, colors, lines, and textures. No matter where you live,

once you learn to see in this way, the possibilities are endless.

## Taking Note of What You See

Many parents in my parent-child workshops have made a point of assembling and carrying portable studio-supply boxes for their young children while traveling. In addition to occupying the youngsters, this availability of studio supplies encourages visual recording of impressions. Artists through the centuries have found it invaluable to compile their viewpoint in journals or combination sketch-, note-, and scrapbooks.

In this recording process, it is important to suspend judgment about design values and to emphasize just the things that catch your eyes and mind. Pictorial editing will come later if you decide to incorporate them into a composition. Items such as interesting textures, architectural details, or shapes of leaves can be reused in different works in several mediums. Spatial layouts of the whole environment can be sketched with a few lines and shapes in a small drawing book.

As often as I have attempted to point out to beginners that they have been drawing with paper shapes and also with paintbrushes, they have often assumed that drawing is only done with a pointed instrument. With your awareness of shapes, spaces, and edges, you are capable of transferring this knowledge into sketching with other studio instruments and drawing gestures and shapes within spaces in your book.

### PORTABLE SKETCHBOOK AND MATERIALS

■ Carrying bag: Your record-keeping supplies must be light and portable enough to fit into a shoulder bag, one small enough to be allowed past museum gatekeepers. Moreover, if your bag is heavy, you will rarely carry it anywhere. Small shoulder bags and waist-held pouches are easily accessible, but tiny drawstring backpacks can neither hold much nor can you gain access to their contents quickly. Choose a container compatible with the notebook you will carry and for its ease of access.

■ A small spiral-bound notebook that can be folded back to stay open easily and fit inside your carrying bag

■ Pencils with erasers: Regular soft ones are fine but you either have to carry several of them or else carry a retractable one with refillable leads or a pencil sharpener. Large leaded carpenter's pencils can also be used for texture rubbings. If you carry several short lengths of inexpensive pencils you need not worry excessively if you lose one or its point breaks or wears down. Additional, optional markers include:

■ A flowing-ink pen (not ballpoint) for great variety of expressive line. Water-based, nonpermanent ink can be blended into washes with a water-soaked brush later.

■ Water-based, inexpensive felt-tipped markers for filling expanses of colored areas are useful if you are working in color. For black and white sketching, however, pencil is preferable because you can get a range of tone from light to dark and width of line from thin to thick. Although you can also represent texture with markers, inexpensive rigid-tipped markers tend to be less sensitive to line variations than soft pencils or flowing-ink pens.

■ Resealable sandwich bags for collecting such items as pebbles, shells, seed pods, and fallen leaves

■ Tissues for blending pencil and for cleanup if necessary

It cannot be emphasized enough that in these sketches you are not trying to

make art. If you make harsh judgments about the success or failure of your recording efforts, you will lose sight of their purpose, which is to examine the surroundings in which you find yourself. These are not pictures you would plan in advance to display to other people. Although when you do feel you have done something special you might want to share it, this notebook is like a diary and you may prefer to keep it private.

## What Fosters Imagination?

*I work in whatever medium likes me at the moment.*

—Marc Chagall, Russian artist, Hallmark bookmark

Recognizing that the world is a museum for stocking your imagination is only one step for building your visual resource bank. Accompanying studio activities with museum visits makes it possible for you to perceive the wealth of visual imagery in new ways. On your route to your favorite museum gallery, take a side trip to an exhibit you have never seen before or one you are not so familiar with, especially if it is from a different historical time and place. By seeing the multitude of methods by which people throughout history have given form to their impressions, feelings, and concepts, you may come to devise a personal way of representing your experiences. The raw material is out there and the workshops give you a vocabulary in which to express it. For me, and I hope now for you, looking at and living with art, and sharing it with those you love, will always be a joyful and gratifying experience.

CHARLES NÈGRE (French, 1820–1880). *The Gargoyle of Notre Dame.* c. 1851. Modern print from paper negative by André Jammis, Paris, 13⅛ x 9¼". The Metropolitan Museum of Art, Rogers Fund, 1962 (62.604.1)

# List of Suppliers

Although the catalogues from many of these art supply companies feature a great many attractive crafts supplies in addition to the studio tools and materials we have listed for the projects in this book, it would be a good idea to limit yourself to purchasing only the necessities at first. Part of the visual-education process is to master essential skills in basic tool handling and to open yourself to seeing new formal possibilities in recylable materials in your environment. It is part of the voyage of discovery to share these finds with other beginners.

If you have a very limited budget, texture-collage projects can be assembled from materials you probably already have at home. Moreover, fifty pounds of water-based modeling clay (priced under twenty dollars in 1996) can keep ten beginners going for quite a while if you recycle the clay.

## Painting Supplies

Although tempera (formerly called poster paint) and brushes present the greatest financial outlay, resist the temptation to buy cheap natural-bristle brushes and "student" grade pigments because the results probably will discourage you. However, the less-expensive "student"-grade tempera may be suitable for the very youngest beginners, under three years old, until they start to become visually aware and less action oriented. If you can assemble a group of people to form a workshop, many supply centers will give you a price reduc-tion as the bulk quantity rises. Even without a special discount, the price per person drops when you can split large jars of paint among several people.

## Extra Information about Paint

All paints are distinguished from each other by their binders, the substances that hold the colored pigments in suspension. Pigments, the coloring matter, were originally made from minerals, plants, sea animals, and insects, although now most are made chemically. The same pigments may be used in oil paint or water-based mediums. Although different colorants have varying inherent degrees of opacity and transparency as well as permanence, the medium binders create distinctive reflective and absorbent qualities and textural consistencies. For those who want to know the specific components of their paint, I recommend Ralph Mayer's book *The Artist's Handbook of Materials and Techniques,* published by Viking Press in New York. Updated editions have been produced continually for several decades.

Sometimes tempera is also called poster paint (although now there is another brand called poster colors for sign painting) and some manufacturers use the word *tempera* as part of their label to distinguish their finer grades of these water-based colors from cheaper "washable" student grades. Even though these paints are not currently made with the traditional tempera components of egg yolk and gum arabic but with plastic polymers instead,

they have become popularly known as tempera. Since new brands of water-based paints are being developed all the time, you might want to consult with a local art-supply store about current products.

## Clay

The particular clay we buy from Sculpture House Casting in New York City for my workshops is called Hugo Grey, a stoneware, medium-gray body when wet that dries to a cool light gray (unfired). Local clay companies in your area may have a different name for their gray mixtures. Moist, ready-to-use potter's clay is generally sold in plastic twenty-five-pound bags, two to a box. While mail-order places generally require that you purchase a whole box, you may be able to get a single bag at a local retail ceramics studio. Because truck shipping for heavy materials such as clay can run up your bill, you might look for local sources for this material if possible.

Always get moist, premixed clay *without grog* that is ready to wedge and use. Mixing powdered clay with water can be extraordinarily frustrating and messy for anyone without a clay-mixing machine. Also, inhalation of clay dust can cause silicosis. Grog, small particles of baked firebrick, makes the clay stiffer and harder for young beginners to shape easily. It is used in ceramics and for large clay sculptures to reduce shrinkage and increase the structural properties of the medium.

Avoid the nonhardening, oil-based plastalene used for professional model-making or other concoctions, which are meant to be cooked in the oven. Some of these compounds are too difficult for small hands to manipulate and are more expensive than water-based clay. Plastalene also stains clothing and has a distinctive odor that can also linger on hands and clothes.

If you are traveling and want a convenient white claylike medium for youngsters to shape with ease, Crayola's Modeling Magic™ can provide an opportunity for making small, air-hardening sculptures. Although it may be too expensive for everyday use and can not be reused once it stiffens, the product does not stick to other surfaces, requires no water, and later can be painted or colored with markers.

### Natural Clay Sources

Since clay is a type of earth, sometimes you may have a vein of it beside a neighborhood stream. Natural clays, even when most pure, have a wide range of composition and are not regarded as consisting of a single mineral. Like a rock, it has variable characteristics and comes in many colors and textures. A great many rock-forming minerals break down easily into soft mudlike substances. Feldspar, the most common mineral of all crystalline rocks, breaks down into kaolin, which is a main ingredient of potter's clay. Silica from quartz sand is another component. Found clay may be usable as it is or it may require much effort to remove twigs, stones, and other foreign matter. I suggest that you begin with prepared, purchased clay to decide if you enjoy the medium enough to put forth such efforts in harvesting and preparing any found clay supply. In addition, as a beginner you will not know what the optimum consistency is for modeling unless there is a local ceramics studio where you can examine some workable clay.

### Mail-Order Companies Offering Free Catalogues

Be sure to inquire about shipping charges, which vary both with distance and company policies and can dramatically escalate your bill.

## ART SUPPLIES WHOLESALE

4 Enon Street (Route 1A)
North Beverly, MA 01915
8 A.M. to 5 P.M., Monday to Friday
Tel: Local 508–922–2420
National 800–462–2420
Fax: National 508–922–1495

Although this company has no water-based potter's clay, they do carry professional-grade supplies at reasonable prices. There is a thirty-dollar minimum order.

## THE COMPLEAT SCULPTOR, INC.

90 Vandam Street
New York, NY 10013
Tel: 212–645–9430
Fax: 212–645–3717
Orders: 800–9–SCULPT

This company, stocking a wide range of clay bodies, other sculpture mediums and materials, how-to books, technical support services, and professional tools, offers a free catalogue, discounts to students from recognized institutions, 10 percent discounts for educational institutions, and discusses other discounts for bulk orders on an individual basis. There is no minimum order amount. The owners say that their Special Buff, low-fire clay is comparable in composition to the Hugo Grey used by our workshops. They use the United Parcel Service to ship anywhere in the world.

## DICK BLICK

P.O. Box 1267
Galesburg, IL 61401
Tel: 309–343–6181

P.O. Box 26
Allentown, PA 18105
Tel: 215–965–6051

P.O. Box 521
Henderson, NV 89015
Tel: 702–451–7662

To order, call 1–800–447–8192, weekdays from 8 A.M. to 4:30 P.M., central daylight time.

Although this company carries no poster colors or water-based potter's clay, it does run specials on professional-quality brushes and other items.

## JERRY'S ARTARAMA

P.O. Box 1105
New Hyde Park, NY 11040
Tel: In Continental USA: 800–U–ARTIST
In NY, HI, or AK: 516–328–6633
Fax: 516–328–6752

Call 9 A.M. to 5 P.M., eastern standard time, Monday to Friday for inquiries and for individual price quotes. There is an extended twenty-four-hour, seven-day phone recording and fax system for credit-card orders.

Reasonably priced brand-name arts and crafts materials with a fifty-dollar minimum for credit card orders. For orders under fifty dollars add an additional four dollars plus shipping charges. The company has volume discounts and its catalogue claims that if you can find a lower price on any product it sells that it will beat that price by five percent. Jerry's sells no water-based potter's or firing clay.

## NASCO ARTS AND CRAFTS

Toll-free orders: 800–558–9595
Fax: 414–563–8296

Hours: Weekdays 7 A.M. to 6 P.M., Saturdays 8 A.M. to 12 noon, central daylight time

## NASCO-FORT ATKINSON

909 Jamesville Avenue
Fort Atkinson, WI 53538–0901
Tel: 414–563–2446
Fax: 414–563–9595

## NASCO-MODESTO

4825 Stoddard Road
Modesto, CA 95356–9318
Tel: 209–545–1660
Fax: 209–545–1669

A complete, one-stop-shopping catalogue with about-average prices and discounts for large quantities. Do not let the attractive photographs seduce you into purchasing materials for mindless craft projects, however. Nasco's potter's clay is called firing clay.

## PEARL PAINT

Mailing Address: 308 Canal Street
New York, NY 10013–2572

There are at least fourteen outlets for this professional art-supply company around the United States. To order catalogues from anywhere in the USA or to find your nearest branch:
Tel: 800–451–PEARL or 212–431–7932 in New York City
Fax: 800–PEARL–91 (area codes 212, 516, and 718 dial 212–274–8290)

For technical information, bids, price quotations, and international orders:
Tel: 800–221–6845
Fax: 800–PEARL–91

This company has excellent prices. The catalogue does not list water-based potter's clay, but this may have changed by the time you read this.

## SCULPTURE HOUSE CASTING

155 West Twenty-sixth Street
New York, NY 10001
Tel: 212–645–9430
Fax: 212–645–3717

The Doing Art Together workshops regularly order water-based Hugo Grey stoneware clay from this company, which has been in business since 1918. Although there is a charge of four dollars for catalogues to individuals, they are provided at no charge to schools. If you decide to concentrate on sculpture with advanced techniques, this catalogue offers specialized tools not regularly available in most arts-and-crafts chain stores. The company asks for a minimum retail order of fifty dollars for orders within the USA. Inquire about export policies and charges.

## UTRECHT ART SUPPLY CENTERS

33 Thirty-fifth Street
Brooklyn, NY 11232

Hours: 8 A.M. to 4 P.M., eastern standard time
Utrecht has eight branches in the USA, in New York City, Philadelphia, Washington, D.C., Boston, San Francisco, Berkeley, Chicago, and Detroit.
Tel: 800–223–9132, for credit-card orders and to find the nearest outlet
718–768–2525, in New York City
Fax: 718–499–8815, twenty-four hours, seven days a week

This company has professional-quality tools and materials and asks for a forty-dollar minimum order for shipping in the USA. Export orders require a four-hundred-fifty-dollar minimum plus a seventy-five-dollar fee for papers and handling. With the exception of water-based potter's clay, most basic supplies are available at competitive prices.

# Additional Reading

Some of these publications are no longer in print. You may find them at your local library or at used-book sales and thrift shops. Although we have noted which ones were out-of-print in 1996, some works may become republished. Therefore, it is a good idea to consult *Books in Print* at your local library before searching for any of these.

## Recommended Reading on Educational Philosophy and Methods

Ashton-Warner, Sylvia. *Teacher.* New York: Touchstone Books/Simon & Schuster, 1986.

Bland, Jane. *Art of the Young Child.* New York: The Museum of Modern Art, 1968. Distributed by the New York Graphic Society, Greenwich, CT [not in print].

Cline, Foster W., and Jim Fay. *Parenting with Love and Logic: Teaching Children Responsibility.* New York: Pinon Press, 1990.

D'Amico, Victor. *Creative Teaching in Art.* Scranton, PA: International Textbook Co., 1953 [not in print].

D'Amico, Victor, and Arlette Buchman. *Assemblage, A New Dimension in Creative Teaching in Action.* New York: The Museum of Modern Art, 1972. Distributed by the New York Graphic Society, Greenwich, CT [not in print].

Dombro, Amy Laura, and Leah Wallach. *The Ordinary Is Extraordinary: How Children Under Three Learn.* New York: Simon & Schuster, 1988 [not in print].

Fraiberg, Selma. *The Magic Years, Understanding and Handling the Problems of Early Childhood.* New York: Charles Scribner's Sons/Simon & Schuster, 1981.

Holt, John. *How Children Fail, How Children Learn.* Rev. ed. Reading, MA: Addison-Wesley, 1995.

Jefferson, Blanche. *Teaching Art to Children, Content and Viewpoint.* Boston: Allyn and Bacon, Inc., 1969 [not in print].

Knobler, Nathan. *Visual Dialogue: An Introduction to the Appreciation of Art.* 3rd ed. New York: Holt, Rinehart and Winston, 1980.

Kramer, Edith. *Art As Therapy With Children.* New York: Schocken Books, 1971 [not in print].

————. *Childhood and Art Therapy.* 1979. Reprint. New York: Schocken Books, 1995.
Although originally written for the treatment of disturbed children, Ms. Kramer's sensitive and practical advice is useful for teachers of studio beginners of any age.

Linderman, Earl W., and Donald W. Herberholz. *Developing Artistic and Perceptual Awareness, Art Practice in the Elementary Classroom.* 4th ed. Dubuque, IA: William C. Brown Co. Publishers, 1974 [not in print].

Lord, Lois. *Collage and Construction in Preschool Through Junior High Schools.* New York: Bank Street College Publications, 1995.

Marshall, Sybil. *An Experiment in Education.* Cambridge, England: The Cambridge University Press, 1966 [not in print].

Mayer, Ralph. *Artist's Handbook of Materials and Techniques.* 5th ed. New York: Viking Penguin, 1991.

Pile, Naomi. *Art Experiences for Young Children.* New York: Bank Street College Publications, 1995.

Roszak, Theodore. *The Cult of Information: A Neo-Luddite Treatise on High-Tech, Artificial Intelligence, and the True Art of*

*Thinking.* Berkeley: University of California Press, 1994.

Schaefer-Simmern, Henry T. *The Unfolding of Artistic Activity.* Berkeley: University of California Press, 1948 [not in print].

Smith, Nancy R. *Experience and Art, Teaching Children to Paint.* 2d ed. New York: Teachers College Press, Columbia University, 1993.

Stoll, Clifford. *Silicon Snake Oil: Second Thoughts on the Information Highway.* New York: Doubleday, 1995.

## Source Books for Studio Work (How-to Manuals)

Albers, Josef. *Interaction of Color.* 1963. Reprint. New Haven: Yale University Press, 1975.

Berensohn, Paulus. *Finding One's Way with Clay.* New York: Simon & Schuster, 1972 [not in print].

Edwards, Betty. *Drawing on the Right Side of the Brain.* Rev. ed. Los Angeles: J. P. Tarcher, 1989.

Mayer, Ralph. *The Artist's Handbook of Materials and Techniques. Fifth Edition, Revised.* New York: Penguin, 1991.

Meilach, Dona Z. *Creating Art with Bread Dough.* New York: Crown Publishers, 1976 [not in print].

Samuels, Mike, and Nancy Samuels. *Seeing With the Mind's Eye: The History, Techniques, and Uses of Visualization.* New York: Bookworks, a Division of Random House, 1975.

## Picture-File Sources

Although a collection of new picture books or illustrated art volumes can be prohibitively expensive to assemble while you are setting up a studio, postcards, magazines, and used volumes are fine for a resource file. Pictorial magazines such as *International Wildlife, National Wildlife, National Geographic, Natural History,* and *Smithsonian* are superb sources of visual inspiration. Also, many seed catalogues advertised in the gardening sections of newspapers are free. Those from Park Seed and Burpee have lots of color photographs of plants and flowers.

Watch for picture-book sales and avoid fashion magazines, which age quickly and badly. Dover Publications, Inc. (31 East 2nd St., Mineola, NY 11501) has an extensive free catalogue for both inexpensive postcards and posters and a large archive of backlist pictorial books. Choose photographic art volumes that emphasize forms, textures, patterns, and composition. Also call your local museums to inquire about catalogues and reproductions.

## Art-Appreciation and Other Books that May Be Shared with Preschool and Grade-School Children

Look for art-history volumes that speak sensitively and avoid any that insult your intelligence, even if they are directed at beginning students. Children can also detect the condescension of "dumbing-down" so prevalent in books directed at them. Even if youngsters do not yet have a large vocabulary, you can explain concepts and they will grow into the books and cherish them instead of rapidly discarding them.

Angelou, Maya, and Jean-Michel Basquiat. *Life Doesn't Frighten Me.* New York: Stewart, Tabori & Chang, 1993.

Beardon, Romare, and Harry Henderson. *Six Black Masters of American Art.* Garden City, NY: Doubleday-Zenith, 1972 [not in print].

Carroll, Lewis. *Alice's Adventures in Wonderland,* in *The Complete Works of Lewis Carroll.* New York: Vintage Books, A Division of Random House, 1976.

Gensler, Kinereth, and Nina Nyhart. *The Poetry Connection: An Anthology of Contemporary Poems with Ideas to Stimulate Children's Writing.* New York: Teachers & Writers, 1978.

Hoban, Tana. *Is It Red? Is It Yellow? Is It Blue? An Adventure in Color.* New York: Mulberry Books, 1987.
Also see other titles from Hoban's series of photographic children's books about color, shape, pattern, and texture.

Lawrence, Jacob. *Harriet and the Promised Land.* New York: Simon & Schuster, 1993.

Lionni, Leo. *Little Blue and Little Yellow.* New York: Morrow, 1994.

Mühlberger, Richard. *What Makes a Monet a Monet?* New York: The Metropolitan Museum of Art/Viking, 1994.
Also see other titles from Mühlberger's series of well-illustrated books about individual artists such as Picasso, Rembrandt, and Van Gogh.

Rieger, Shay. *Our Family.* New York: Lothrop, Lee and Shepard, 1972 [not in print].

## Aesthetics (Books for Adults)

Albers, Josef. *Josef Albers: White Line Squares.* Exhibition catalogue. Los Angeles: Gemini G.E.L., 1966.

Arnheim, Rudolph. *Art and Visual Perception: A Psychology of the Creative Eye (The New Version).* Berkeley: University of California Press, 1974.

Chipp, Herschel B., ed. *Theories of Modern Art.* New York: Joshua C. Taylor, 1964.

Elderfield, John. *The Cutouts of Henri Matisse.* New York: George Braziller, 1978.

Flam, Jack D. *Matisse on Art.* Berkeley: University of California Press, 1994.

Focillon, Henri. *The Life of Forms in Art.* New York: Wittenborn, 1948.

Gombrich, Ernest H. *The Story of Art.* New York: Prentice Hall, 1995.

Hall, Edward T. *The Hidden Dimension.* Garden City, NY: Doubleday, 1990.

Henri, Robert. *The Art Spirit.* New York: Harper Collins, 1984.

Hofstadter, Douglas. *Metamagical Themas: Questing for the Essence of Mind and Pattern.* New York: Basic Books, Inc., 1985.

Itten, Johannes. *The Elements of Color.* New York: Van Nostrand Reinhold, 1970.

Janson, H. W. *History of Art.* 5th ed. New York: Harry N. Abrams, Inc., 1995.

Jenkins, Paul. "Editions Galilée," in *Anatomy of a Cloud,* by Paul Jenkins with Suzanne Donnely Jenkins, Harry N. Abrams, Inc., New York, 1983.

Kurakawa, Kisho. *Intercultural Architecture: The Philosophy of Symbiosis.* Washington, DC: American Institute of Architects Press, 1991.

Lee, Sherman. *A History of Far Eastern Art.* 5th ed. New York: Harry N. Abrams, Inc., 1994.

Lord, James. *A Giacometti Portrait.* New York: Farrar, Straus & Giroux, 1980.

McShine, Kynaston, ed. *The Natural Paradise: Painting in America 1800–1950.* New York: The Museum of Modern Art, 1976.

Munro, Eleanor. *Originals: American Women Artists.* New York: Touchstone Books/Simon & Schuster, 1982.

Nevelson, Louise. *Dawns & Dusks: Conversations with Diana MacKown.* New York: Charles Scribner's Sons, 1982.

Rose, Barbara, ed. *Readings in American Art 1900–1975.* New York: Praeger, 1975.

Smithson, Robert. *The Writings of Robert Smithson.* New York: New York University Press, 1979.

Sze, Mai-Mai. *The Mustard Seed Garden Manual of Painting.* A Facsimile of the 1887–88 Shanghai Edition, formerly published as *The Way of Chinese Painting.* Princeton: Princeton University Press, 1978.

Tuan, Yi-Fu. *Passing Strange and Wonderful: Aesthetics, Nature, and Culture.* Washington, DC: Island Press/Shearwater Books, 1993.

# Index

# Photograph Credits

The authors and publisher would like to thank the museums, galleries, and private collectors named in the illustration captions for supplying the necessary photographs. Additional photograph credits are listed below. The authors and publisher extend special appreciation to Seth Joel, for donating the reuse of some of his photographs from the original edition; to Lois Lord, who supplied her personal collection of prints; and to Joanne Tully, who worked tirelessly to capture in print the energy of recent studio workshops. The numbers below refer to page numbers.

Yura Adams: 41 below
Alexei Alfonin: 157, 193
Karen Bell: 187
Jacob Burckhardt: 246 right
Geoffrey Clements: 63, 150
Patricia Cruz: 169
Bevan Davies: 179
D. James Dee: 155, 164; courtesy of the Paula Cooper Gallery, New York: 166
Bill Jacobson: 12, 23
Seth Joel: 25 (2), 64, 111, 123, 172, 200 left, 206, 226 below, 231, 245 above, 248 above, 261 below, 263
Mablen Jones: 237, 264, 266
Eeva-Inkeri: 244 right
Ena Kostabi: 11
Lois Lord: 29, 119, 156, 182, 194
Hanna Machotka: 26
James Mathews: 55 (2), 77, 83, 98, 128, 129, 133, 146, 153, 173 left, 189, 190, 204, 205, 214, 232, 239 bottom, 241 (2)
All rights reserved, The Metropolitan Museum of Art: 10, 14, 15, 22, 41 above, 52, 56 right, 60, 61, 62, 65, 89, 118, 119 left and above right, 120, 121 above, 137, 142, 143, 162, 163, 170, 175, 177, 178 (2), 181 above, 184, 188, 197, 200 right, 218, 219 (2), 220 (2), 221, 222 (2), 233 (2), 234, 235, 243, 244 left, 246 left, 247 (2), 249, 256, 258 (2), 259 left, 260 (2), 261 above, 267, 268, 273
Copyright © The Metropolitan Museum of Art: 2 (1988), 81 (1990), 84 (1996), 86 (1989), 87 (1986), 95 (1983), 102 (1992), 161 (1993), 176 (1988), 180 (1982/89), 181 below (1989), 185 above (1979), 192 (1992), 212 (1988), 213 (1980)
Al Mozell: 191 below
Copyright © The Museum of Modern Art, New York: 56 left (1995), 63 (1996), 139 (1995), 165 (1996)
Carl Nardiello, courtesy of Mary Burke: 68
George Obremski: 201, 210, 265 above
Sheldon Ross Gallery, Birmingham, MI, 93
Courtesy of Muriel Silberstein-Storfer: 147 above right, 216 above
Tina Spiro, Chelsea Galleries, Kingston, Jamaica: 106
Courtesy of the Studio Museum in Harlem: 259 right
Jerry L. Thompson: 195
Joanne Tully: 17 (2), 19, 42, 45, 51, 67, 82 (2), 91 (2), 100 (2), 107 (2), 124 (2), 126, 140 (2), 145, 147 left and below right, 154 (2), 168 (2), 171, 173 right, 185 below (2), 199, 209 (2), 224, 225, 226 above, 227 (2), 228, 230, 239 above and middle, 245 below, 248 below, 251, 265 below
Patty Wallace, courtesy of Valerie Jaudon: 191 above
Ellen Page Wilson: 24

## Artist Copyrights

Copyright © 1996 Artists Rights Society (ARS), New York / ADAGP, Paris: 157, 165, 193; © 1996 Estate of Arshile Gorky / ARS, New York: 87; © 1996 Succession H. Matisse / ARS, New York: 139; © 1996 Mike and Doug Starn / ARS, New York: 151 above

*Editor: Harriet Whelchel*
*Designer: Darilyn Lowe Carnes*

Cover photographs of a Doing Art Together workshop by Carol Rosegg

Doing Art Together, Inc., is a nonprofit organization working in cooperation with the
New York City Board of Education and The Metropolitan Museum of Art

Authors' Note: Many of the children's names given herein are pseudonyms.

Library of Congress Cataloging-in-Publication Data
Silberstein-Storfer, Muriel
      Doing art together / by Muriel Silberstein-Storfer with Mablen Jones.
             p.       cm.
      Includes bibliographical references and index.
      ISBN 0-8109-2667-9 (pbk.)
      1. Art—Study and teaching (Elementary)—United States.   2. Art—
Study and teaching—United States.   3. Artists' studios—United States—
Handbooks, manuals, etc.   I. Jones, Mablen.   II. Title.
N362.S5     1997
372.5'044'0973—dc20                    96-32703

Published in 1997 by Harry N. Abrams, Incorporated, New York
A Times Mirror Company

This is a revised and updated version of *Doing Art Together*, first published in hardcover by Simon
& Schuster, Inc., in 1982, and in paperback in 1983

Printed and bound in Hong Kong